THE COMPLETE GUIDE TO

DIGITAL GRAPHIC DESIGN

THE COMPLETE GUIDE TO>>

DIGITAL GRAPHIC DESIGN

Consultant Editors
Bob Gordon and Maggie Gordon

Watson-Guptill

Publications

New York

COLLEGE OF ST. ROSE

ALBANY, NEW YORK

741.60285

C 73769

First published in the United States in 2002 by Watson-Guptill Publications a division of VNU Business Media, Inc. 770 Broadway, New York, NY 10003 www.watsonguptill.com

© The Ilex Press Limited 2002

All rights reserved. No part of this publication may be reproduced or used in any form or by any means—graphic, electronic, or mechanical, including photocopying, recording, taping, or any other information storage and retrieval system—without prior permission in writing from the publisher.

This book was conceived, designed, and produced by THE ILEX PRESS LIMITED Cambridge England

Art Director: Alastair Campbell
Designer: Jonathan Raimes
Design Manager: Tony Seddon
Editorial Director: Steve Luck
Project Editor: Lachlan McLaine
Technical Editor: Keith Martin
Picture Research: Heather Vickers

Contributors

Design Basics: Maggie Gordon
Design For Print: Jonathan Raimes
Advertising: Paul Springer
Packaging: Richard Gooch
Signage: Ian Chilvers
Exhibition: Sue Perks
Internet & Multimedia: Phil Taylor
Games: Jonathan Smith
Type Color Image: Bob Gordon

Any copy of this book issued by the publisher as a paperback is sold subject to the condition that it shall not by way of trade or otherwise be lent, resold, hired out or otherwise circulated without the publisher's prior consent in any form of binding or cover other than that in which it is published and without a similar condition including these words being imposed on a subsequent purchaser.

Library of Congress Cataloging-in-Publication Data

Gordon, Bob, 1944-

The complete guide to digital graphic design \slash Bob Gordon & Maggie Gordon.

p. cm.

Includes index.

ISBN 0-8230-0783-9

1. Computer graphics. 2. Image processing—Digital techniques. 3. Graphic arts. I. Gordon, Maggie. II. Title.

T385 .G658 2002 741.6'0285—dc21

2001008287

ISBN 0-8230-0783-9

Printed and bound in China

For further information on this title refer to: www.cggraphicdesign.com

INTRODUCTION	6
DESIGN FOR PRINT	12
DESIGN FOR ADVERTISING	14
DESIGN FOR PACKAGING	16
DESIGN FOR SIGNAGE	18
DESIGN FOR EXHIBITION	20
DESIGN FOR THE INTERNET	22
DESIGN FOR MULTIMEDIA AND GAMES	24

CONTENTS

DESIGN BASICS	26
01.01 THE VALUE OF DESIGN BASICS	28
PRIMARY SHAPES	29
POINT, LINE, AND AREA	30
DYNAMICS, EMPHASIS, AND CONTRAST	32
THE MECHANICS OF TYPE	36
DESIGNING WITH TYPE	38
THE DESIGN PROCESS	43
LAYOUT	49
DOCUMENT SIGNPOSTING	50
IMAGE SELECTION	52
DESIGNING WITH COLOR	54

SURFACE DESIGN
02.01 Design for Print
THE SOFTWARE
SCREEN TO PROOF
PROOFING
THE PRINTING PROCESS
FINISHING
CHOOSING PAPER
CASE HISTORY
02.02 DESIGN FOR
ADVERTISING
ADVERTISING
ADVERTISING SPECIALIST PEOPLE DESIGN
ADVERTISING SPECIALIST PEOPLE DESIGN CONSIDERATIONS
ADVERTISING SPECIALIST PEOPLE DESIGN CONSIDERATIONS CORPORATE IDENTITY

58	02.03 DESIGN FOR	••
60	PACKAGING	98
62	DESIGN TOOLS	101
66	MATERIALS	102
71	KEY KNOWLEDGE	104
72	DESIGN CONSIDERATIONS	106
78	PLANNING	
80	AND PRODUCTION	109
82	CASE HISTORY	110
	02.04 Design for Signage	112
84	GRAPHIC DESIGN AND SIGNAGE DESIGN	114
88	DESIGN CONSIDERTONS	116
90 92	PLANNING AND PRODUCTION	120
04	CASE HISTORY	122
94	02.05	
96	DESIGN FOR EXHIBITION	124
	THE NATURE OF EXHIBITION DESIGN	126
	EXHIBITION GRAPHICS PROCESSES	129
	DESIGN CONSIDERATIONS	130
	PLANNING AND PRODUCTION	131
	CASE HISTORY	132

SCREEN DESIGN	134
03.01 Design for the Internet	136
WHAT IS THE INTERNET?	138
BROWSERS	140
THE CHALLENGE FOR THE PRINT DESIGNER	143
MONITOR RESOLUTION	144
FILE SIZES	146
COLOR AND TYPOGRAPHY	148
WEB GRAPHICS	150
HTML	152
WYSIWYG	153
INTERACTIVITY	156
JAVA AND JAVASCRIPT	158
DEVELOPING A WEB DESIGN STRATEGY	161
PLANNING AND PRODUCTION	162
CASE HISTORY	164
03.02 Design for Multimedia	166
THE DIFFERENCES BETWEEN MULTIMEDIA AND WEB DESIGN	168
THE DESIGN PROCESS	171
AUTHORING APPLICATION AND THEIR ROLES	172
PLANNING AND PRODUCTION	175
CASE HISTORY	176
03.03 Design for games	178

TYPE/COLOR/IMAGE	180
04.01 TYPE	182
04.02 COLOR	188
RANGE OF ACHIEVABLE COLOR	192
COLOR ATTRIBUTES	194
04.03 IMAGE	196
UNDERSTANDING DIGITAL IMAGE- MAKING	198
SCANNING AND RESOLUTION	204
FILE FORMATS FOR BITMAPPED IMAGES	207
WORKING WITH BITMAP IMAGES IN PAINTING PROGRAMS	209
WORKING WITH DRAWING IMAGES IN VECTOR PROGRAMS	212
GLOSSARY	214
BIBLIOGRAPHY	218
INDEX	219
PICTURE ACKNOWLEDGMENTS	224

INTRODUCTION

"Digital," "graphic," and "design" have become three very potent words in our vocabulary. There can be few people living in the developed world whose lives have not been touched or influenced by information and design technology. Personal computers and the ubiquitous silicon chip have found their way into the homes and workplaces of millions of people irrespective of background, age, or culture.

One of the most common words bandied about as an all-encompassing descriptor is "digital." This is almost inevitable, since computers depend on streams of electronically generated "digits" to function. So we have digital telephone lines, digital printing, digital radio, and digital television, among the many areas connected with information, communication, and design. Virtually all data, whether it is in the form of words, numbers, images, sound, or movement, can be digitized and transmitted using a range of technologies. Digitization has created a common method of recording and transmitting data, allowing a high level of interactivity across many forms of media. This interactivity allows sound, image, text, and other creative elements to work together in a single context, and has radically changed designers' working methods by providing access to the vast storehouse of knowledge on the Internet and corporate Intranets and enabling them to send and receive a range of media electronically via email from their own computers.

Digital data transmission speeds are constrained by the size of files, the medium through which data flows, and the speed at which computer processors can handle the information. But every day sees an improvement in all of these areas—files can be compressed more efficiently, fiber optics, allowing speed of light transmission, are being used more and more, and processor speeds are getting faster and faster. Together with increases in transmission speeds there is a growing convergence of media transmission that is bringing about a merging of personal computing, television, radio, telephone, publishing, games, web, email, and ecommerce technologies.

Flat-screen technology is now fast replacing CRT monitors and computers together with other peripheral devices are getting smaller. This development takes us into an era where the quality of visual content is going to play an increasingly important role in the way we communicate to a wider range of audiences. The quality of visually received information is the responsibility of the digital graphic designer.

There are, however, a number of aspects of graphic design that remain for the most part unaffected by technology. These include generating and developing ideas and concepts, the basic principles of design and typography, and creative problem-solving—all attributes that distinguish graphic design from other professions. Digital developments have given designers a range of first-class tools for exploring, extending, and realizing ideas in flexible, faster, and more costeffective ways.

Digital developments have given designers a range of first-class tools for exploring, extending and realizing ideas in flexible, faster, and more cost-effective ways.

Design finds its way into every aspect of daily life, from the look of clothes, buildings, and consumer goods, to reading matter, entertainment, interior and exterior environments, communication, and all visual experience in which graphic design plays an important part. It is almost impossible to avoid being bombarded by visual messages in the environment—an environment to which the graphic designer should bring order and clarity. Much of what is published in print or on screen has a tendency to be visually discordant or jumbled, but in a world that is so informationor message-orientated, it is increasingly important for the digital graphic designer to strive for higher visual standards. Understanding how audiences react to visual material, their levels of concentration and comprehension, and how they can be influenced by cultural or fashion trends is key to the problem-solving process for the graphic designer. Equally important is understanding how eve and brain work together in scanning and understanding the typeset word and the power of harmonious composition.

The digital revolution overtook traditional graphic design working practices with extraordinary speed. Designers now need to be fully conversant with the fundamentals of computer-driven processes, be able to rapidly learn new skills, and in a field that is constantly expanding, they can expect to be continually developing these skills.

Many features of the reprographic processes have remained essentially the same over the last few decades, albeit enhanced through computerized devices. Computerization has, however, made a significant contribution to the decline in the number of specialist crafts and tradespeople and, as more control of production functions is transferred to the computer desktop, it has also considerably increased the responsibility of the digital graphic designer.

Printing had for many years dominated the way in which graphic designers worked. Packaging, exhibition design, and advertising all related to printing processes. Traditional printing methods, which dominated the major part of the twentieth century, have undergone rapid revolutions. During the 1960s, offset lithography took over from the labor-intensive letterpress (or relief) printing and within a decade became the most common form of reproduction. This major change was followed closely by computerized typesetting, which was subsequently absorbed into the digital technology of the personal computer.

Through the concentration of design and production features of software applications, the digital graphic designer now has unprecedented control and responsibility for design realization and production. For instance, a file containing all the information necessary for output can be either handed over or digitally transmitted to the printer. The printer's equipment then makes films and plates exactly as directed exclusively by the electronic file and the job can be printed with little other human intervention. Naturally, as good working practice, professional designers and printers would normally meet to discuss a complex job, although the fact remains that a high proportion of the decision-making and graphic assembly control is embedded in the digital file produced by the designer, hence the meticulous care that needs to be taken in its preparation.

THE ROLE OF THE DIGITAL GRAPHIC DESIGNER

Paradoxically, in an era that has seen many industries and professions having to specialize in order to survive, the digital graphic designer has been required to diversify. The most significant growth is in the explosion of the Internet and multimedia industry. Many graphic designers are fully engaged in Web page design involving typography, imagery, animation, movies, and even sound. The computerization of graphic design work, with the development of numerous, disparate, yet often overlapping, software programs has

associated with repetitive design or editing tasks have been reduced considerably by automated features built into most applications, such as "search and replace," "auto-spell-check," "auto-image-import," "style sheets," and "actions," to name just a few. If you can't find a feature that automates a repetitive task, you can be sure it will be included in the next upgrade.

Because graphic designers can work across so many fields, they need to be familiar with a wide range of different production and manufacturing processes and related support professions and skills. This may often include photographers, illustrators, musicians, writers, and filmmakers. Digitization of sound, image, animation, movie, and production processes has enabled professionals to collaborate and work across an increasingly wide spectrum.

The emergence of the personal computer and desktop publishing programs, together with their wide availability to nondesigners, could have signaled the beginning of the end for the practicing graphic designer. Photography, as a profession, could also have died out as automated and high-quality

Professional graphic design will continue to thrive because ideas and innovation, good composition, and a creative eye cannot be "packaged."

greatly enlarged the range of work in which they can be involved. In addition to the rich creative elements of many programs, including sound and animation, there are many built-in productivity and labor-saving features.

Previously specialized areas of graphic design now share similar software programs for image and text origination.

The digital power readily available to the designer is now immense. Every aspect of graphic design can be created and finished to a high professional level on a single PC or Apple Macintosh workstation. Not only has the creation of actual projects been made easier, but the way in which they can be previewed by both designer and client has transformed the way in which creative people work—from technologies such as PDF files for wide distribution, to walk-through software for three-dimensional designs, to packaging software that folds and makes up packs from flat designs, to slide shows and movies that can be used for "real life" presentations. Many of the chores

cameras became accessible and easy to use for anybody and everybody. However, like professional photography, professional graphic design will continue to thrive because ideas and innovation, good composition, and a creative eye cannot be "packaged."

Graphic design is an immensely exciting and vibrant activity in which to be involved and, as such, is a rewarding profession to follow. But it requires vision, stamina, and good humor combined with creativity, innovation, and analytical and methodical ways of working. Designers need a working knowledge of budgets, manufacturing, and reproduction processes. Successful graphic designers aim to devise inventive solutions to visual communication problems in response to clients' needs and in order to do so, often work with clients in formulating a brief and working strategy prior to starting any visual work. A good understanding of human nature and the cultural environment as well as the ability to lead or be a team player together with a keen eye for detail is what distinguishes the truly excellent designer from the average.

Good design is the product of the creative intellect supported by innovative use of sophisticated digital tools and cannot be bought "off the shelf."

ABOUT THIS BOOK

The aim of this book is both to inspire and inform the reader by exploring a wide range of visual communication and graphic design contexts while introducing essential, related design methodology and concepts on which to build. It explores the diversity of graphic design and showcases the work of inventive and talented designers using digital media for the development, realization, and production of projects.

The Complete Guide to Digital Graphic Design demonstrates different facets of digital graphic design and seeks to demystify some of the technical jargon that is often associated with computing and the design world.

The introductory pages show examples of work from a wide range of visual communication contexts, setting the scene for further in-depth exploration within individual sections.

Part One, Design Basics, explores some of the fundamental principles that underpin good and efficient graphic design. This section is, in essence, "away from the screen" because it involves thinking and creative processes related to idea generation and informed design decision-making. It includes an appreciation of the "building blocks" essential to good graphic design, shape and form, spatial awareness, what type is, and how to work with it. The emotive use of color and how color can work for the digital designer is also looked at, as a powerful tool rather than just decoration.

Part Two consists of subsections that explore defined areas of surface graphic design. These subsections include design for print, advertising, packaging, signage, and exhibition.

Part Three looks at Web design for the Internet, Intranets, multimedia, and games. This part is particularly useful for those who may feel somewhat swamped by the terminology in this area. It shows clearly how designers have to respond and adapt to a fluidity of display by different Web browsers and computer platforms, and compares this with the more stable environment of a multimedia project.

Leading practitioners from each field take an in-depth look at their specialist areas. Where equipment or software, additional to the core list introducing these sections, is considered important, this is highlighted. Specialist processes, which include four-color, offset lithographic printing, are discussed together with related creative and support professionals mentioned as appropriate. At the end of each section, a case history is explored and the critical and key creative and production stages involved in arriving at the final design are explained.

Part Four takes a focused look at the technical intricacies of color, type, and image.

The use of color is discussed in the Design Basics section but it is essential for the practicing graphic designer to understand how color is created and why, for instance, different sets of primary colors are used for discussing monitor matters (RGB) from those used in printing (CMYK). As mixing, controlling, and adjusting color plays such an important role in graphic design, the attributes and terminology of color and how it works are looked at closely.

Digital type, too, has a language of its own. The Design Basics section covers working with type from an aesthetic and functional point of view, but on a technical level the graphic designer has to appreciate how type is handled by the computer. What are bitmap or outline fonts, for example? Why might we need Adobe ATM as essential software for use with type? Typefaces and font files, managing fonts, font libraries, buying fonts, and font copyright are also explained.

Computer programs have made retouching, montaging, and technical and fine art image making readily accessible to the designer and artist. The essential way in which bitmap programs work is compared to the very different way vector-based programs operate. The creation of special effects, the use of painting programs or drawing programs, and how they interact with each other is discussed and explained.

lucy bullivant:musing on the contemporary museum >When museums outgrow their institutional facilities, they don't necessarily have to marry old and new by extending on one site. The satellite idea creates a complex field of activity less bound by place. Architecture grounds each one in a context – it's down to the staff to design the field. Everyone is an architect in this business nowadays. museum implies the facilities of collection, endowment, preservation and curatorial pedigree. It doesn't automatically signify retailing elements. Is the term 'hybrid' architecture a simplication of the need to cre ate a dynamic relationship, in formal and programmatic terms, that endures in a climate of change? >Contemporary museum design pitfalls: gratuitous and not so revelatory form-making [every museum architect should reveal as well as display], and seduction by the myths of flexibility. If neutrality is an illu->Curators have to be very flexible, even de-curate the architecture, sion, flexibility is a holy grail. but everyone works better with parameters. >Museum design now bridges the physical and the virtual worlds. How do we describe such an architecture, and how does it change the way we see muse ums? Improvisational tactics in lieu of physical facilities: the virtual friends' room [how far can you go with the museum without walls'? One mouse for every friend, perhaps, which is also a camera into all the other spaces, or is that another typology altogether]? The contents and ambience of a museum (whether more masculine or more feminine) are frequently disturbingly various: the architecture cannot afford to be, but nor should it entirely lose the mystery of the gathering place, of chosen, untouched objects from the underworld. In this distillation, there is no other kind of secular solace. Pompidou – that quintessential expression of the democratizing of knowledge and culture, a child of its time [1977]. But, [referring to the new renovation], how do you update utopia when it's lost its original meaning, its ethos of cultural democracy? Now, with the new pay to enter policy, you can't see one of its best exhibits, the views of the city of Paris, for free any more.

>Don't forcet take away museum experiences. Where to is going [consumer choice], museums are following: at Frank Gehry's scon to be completed Pop Music Museum in Seattle visitors make their own customised disk from a sound bank >We have a museological climate where retailing elements frequently impinge on cultural pleasure, as harmlessly diverting as a form of museum downtime as they usually are. The ace caff with the museum attached' allows us to carry out more of our personal lives in these spaces. The muse-um community is interested in civic values in a place they want to feel is theirs too. After all, the fortunes of outdoor public space have waned, and perhaps the museum is a better, more rainproof place anyway in which to renew the idea of the civic agora. >Museums in the city: the relatively rare building of a new street smart metropolitan museum or its extension redefines the local urban fabric, causing its value as real estate to soar. >We need 'trickle down' on occasion to work more slowly [yes, developed to the control of the contr opers), not to upset context into a total face lift that excludes the locals. On the other hand, if museums don't get above themselves, something else is bound to fill the space. >Cultural multiplex at one end of the spectrum, single theme museums at the other; you can't generalise, Isn't it reassuring that museum architecture as a subject and as a response is too rich and too layered to be conveyed in a rhetorical, 'talking to your one circulation choice walk', acoustiguide recording? N ucy Bullivant is an architectural writer and curator, Archis and Domus correspondent, and director of >enter, her international exhibition/events consultancy.

herbert girardet/urban futures/rethinking the city >At the start of the new millennium cities a their resource use dominate life on earth. In the last 100 years, human numbers have grown fourfu-whilst both the world economy and urban populations and have grown about 15 fold. Today, half of live in cities while most of the rest dispends on urban markets for their economic survival. One spec now uses about half of nature's entire annual production, and we are increasingly undermining the ty of the global environment. We have to rethink how we run our urban economies, energy, tra you me gouse anyouth men, we never to train in how we during to notal reconstruct, each give an asystem systems, and the way we construct our buildings. If sustainability was the main farme of refle for the way we plan urban spaces, structures and processes – how would things change? Solid sets scaled of unbrastation tooks, ottles would be well advised to model their functioning on natural e tems. These are generally systems of permanence, whereas currently man-made systems are defin tems. I nese are generally systems or permanence, whereas currently main-made systems are demit high levels of entropy. Cities have a linear metabolism, consisting of the flow of resources and proc through the urban system. Nature's own ecosystems have an essentially circular metabolism in a very output by an organism is also an input which renews the whole living environment of which part. The web of life hangs logether in a chain of mutual benefit. To be sustainable, cities have to d op a circular metabolism, minimising waste discharges, and using and re-using resources as efficie possible. >Thinking differently is an important starting point in the process of remodelling our of The real challenge however is to act differently. People all over the world are working on how their cities more sustainable, in both environmental and social terms. This exhibition is intended enhance that process in the city that started it all: London. It is, at present, a city of vast global dedencies. Its ecological hostorint extends to an area the size of the UK, about 125 times its own surface series, it is douglook boolpring extends to all area the size of the U.A. about 1,50 times its own surface been self at the work of this demanded out-high stuffice areas to supply themselves three planets would be needed rather than the one we have. It makes series for people to live in ordies. They have the obtential for great resource efficiency (through dozed-loop concomies, dwirely and mutually in the past economic growth has meant automatic growth in the consumption of resources and services of all kinds Sustainable development, in contrast, requires new solutions to ensure that economic well-bei Sustainable development, in contrast, requires new solutions to ensure that economic weri-being is founded on efficient use of resources, minimising pollution and waste. New energy systems can supplan technologies we inherited from the past. It is clear that many new local jobs can be oreated on the vay, life exhibition the main focus is on these areas where the potential for change is greatest. These section form an agenda for constructing the future sustainable city.

The quest for sustainability requires : strengthening of local democratic processes. Methods such as neighbourhood forums, action plan and consensus-building should be widely used, because they usually lead to better decision community groups, local and central governments are increasingly aware that efforts to impro-mirrorment must focus on clibs and urban lifestyles. Eco-friendly urban development could w

the greatest challenge of the twenty-first century, not only for human self-interest, but also for the sake of

ship between cities and the biosphere on which humanity ultimately depends

act differently:living city

14 April to 04 May decide who to vote by viewing videos of the candidates policies on sustainability Living City Forum Tuesday 09 May 6.30pm with Herbert Girardet, Patrick Bellew of Ateller Ten, Robin Murray of Ecologika and Dickon Robinson of Peabody Frust. Chaired by Paul Finch, Publishing Editor, emap, the event will outline practical steps to take forward possible outcomes of the Living City initiative Sustainability Forum Tuesday 16 May 2.30pm to 5.30pm Event for technology and design teachers ntact: Pamela Edwards Green Kids Workshop Saturday 10 June Bring the children to family day at RIBA by the Centre for Sustainability, is free

of the world's land

the world's waste

of the world's resources

London's total

ecological

extends to around 125

times its

and discharge 75% of

Living City events Mayoral Candidates

> grid structure and clear typographic signposting to guide the reader and maintain interest. Design by Studio Myerscough, UK

Left: A double-page spread for the

Royal Institute of British Architects's

annual report. Such multipage book

work relies on a strong underpinning

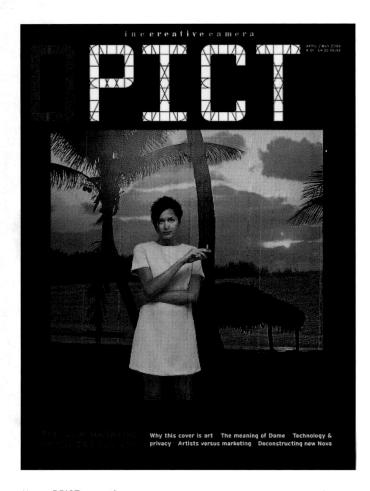

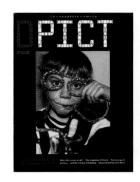

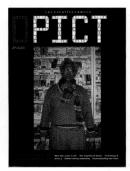

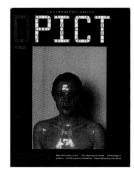

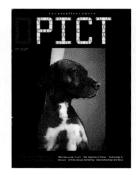

Above: DPICT, a creative photography magazine, was able to take advantage of IBM's Infoprint Color 100 printer to print 560 different, personalized covers for its launch edition. The computerized selection, delivery, and output of discreet text and imagery is beginning to alter our perception of volume publishing as new printing technology is exploited.

Design by *DPICT*, UK

Right: The Providian 2000 annual report focused on the financial services company's employees and the cities where they lived and worked. In doing so the report humanized what might otherwise seem a faceless corporation. The sensitive and creative imagery and interesting assembly of disparate typographic elements are facilitated by the flexible tools of the page layout application.

Design by Cahan and Associates, USA

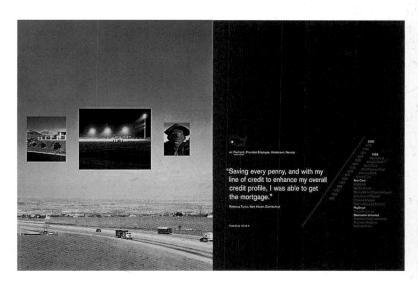

showcase 13

DESIGN FOR ADVERTISING

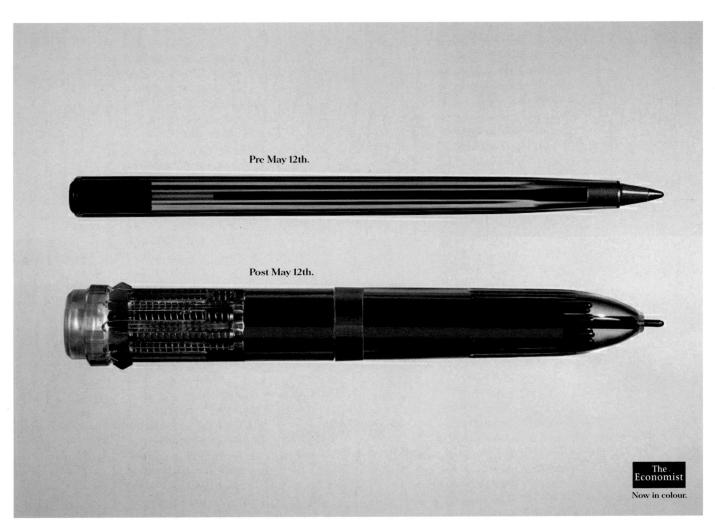

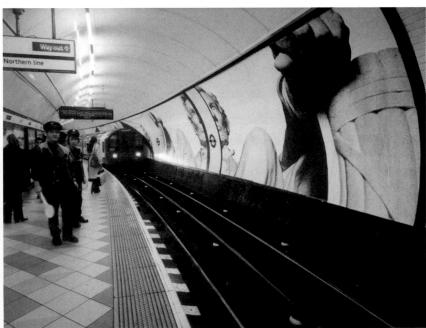

Left and above: A series of British Airways posters by M & C Saatchi displayed in London Underground stations. Digital printing allows for customized, large-format posters, made in small quantities, providing advertisers with opportunities for focusing on specific target audiences.

Design by M & C Saatchi, UK

Top: Double-page spread advertisement for *The Economist* magazine, "Now in Colour." A simple photographic image is used to make a powerful point. Design by Abbott Meade Vickers, UK

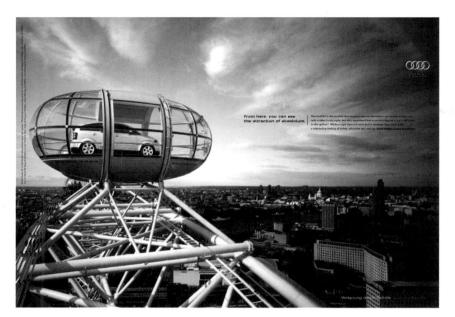

Left: This advertisement works by association: the slick engineering used to produce London's Millennium Wheel is compared with that of the Audi. In advertising this is called "borrowed interest." In visualizing the composition, the image would have been mocked up either as a Photoshop collage or as a "moodboard" (usually rendered in marker and pencil). Note the treatment of the sky (the negative space), flattened in tone and color to make the body text legible.

Design by Bartle Bogle Hegarty, UK

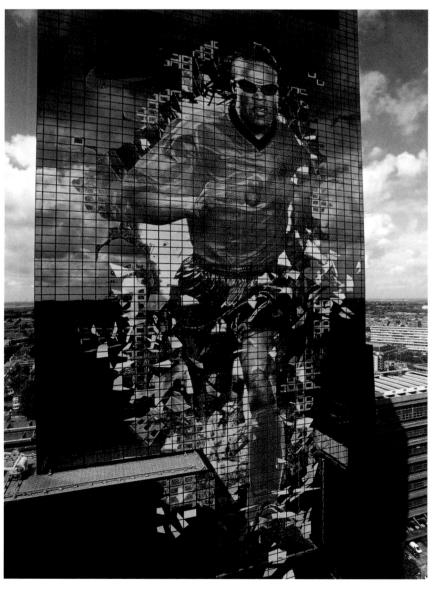

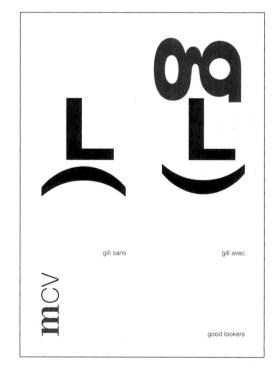

Left: Claimed to be the world's largest building graphic at over 490 feet high, this promotion for the Dutch national football team was produced by large-format digital printers VgL, who printed 4500 panels covering 100,000 square feet. Printed on 3M Perforated Window Marking Film (PWMF), the graphics do not stop people from being able to look out through the building's windows.

Design by Wieden and Kennedy, Netherlands Above: This full-page magazine advertisement for the recruitment consultants MCV aimed at creative professionals proves the power of simplicity and wit.

Design by Peter Stimpson, UK

DESIGN FOR PACKAGING

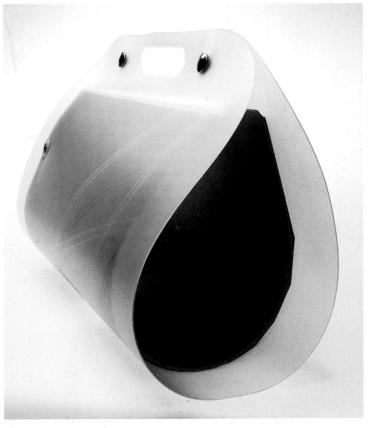

NEW 1018 TERRAME

Left: The catalog for an exhibition of fashion design by Jill Ritblat was wittily designed to be carried as a handbag.
Designed by Area, UK

Above: Wrapping paper is highly flexible and, ultimately, the simplest form of packaging. This example, designed by Summa for a Spanish supermarket, uses color coding to identify delicatessen items, meats, vegetables, fish, and bread products.

Design by Summa, Spain

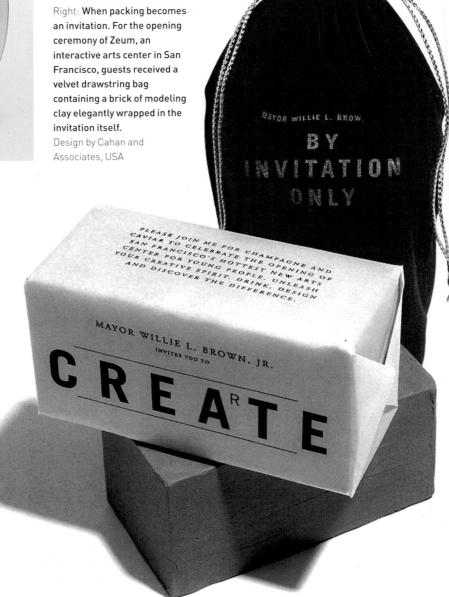

Right: Making a virtue out of simplicity, this entirely typographic solution by Simon and Lars for a small bakery reflects the fresh, uncomplicated, yet upmarket, product.

Design by Simon and Lars, UK

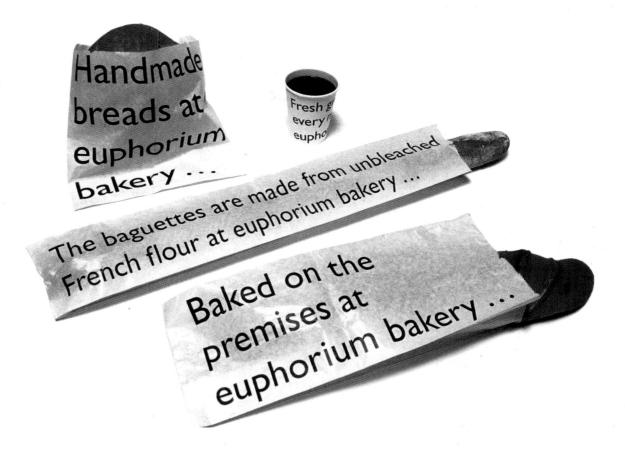

Right: The Veuve Clicquot champagne laminated cardboard "Magic Box" unfolds to create a strong, insulated, and perfectly watertight ice bucket.

Design by Veuve Clicquot, France

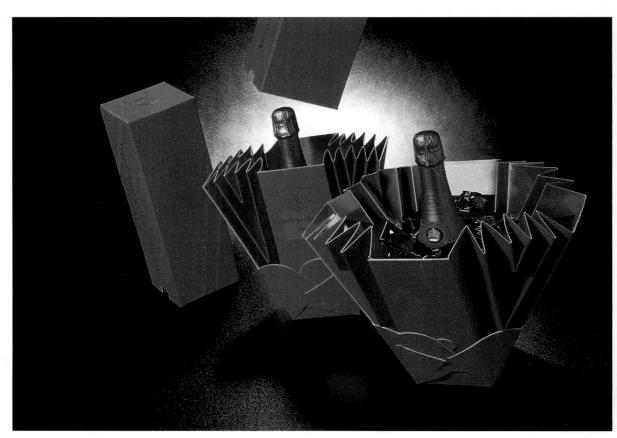

DESIGN FOR SIGNAGE

Left: Taking digital design quite literally, the interior and exterior graphics for Apple Computer's research and development campus borrows pixellated imagery from the company's distinctive graphical user interface.

Design by Sussman/Prejza & Co., USA

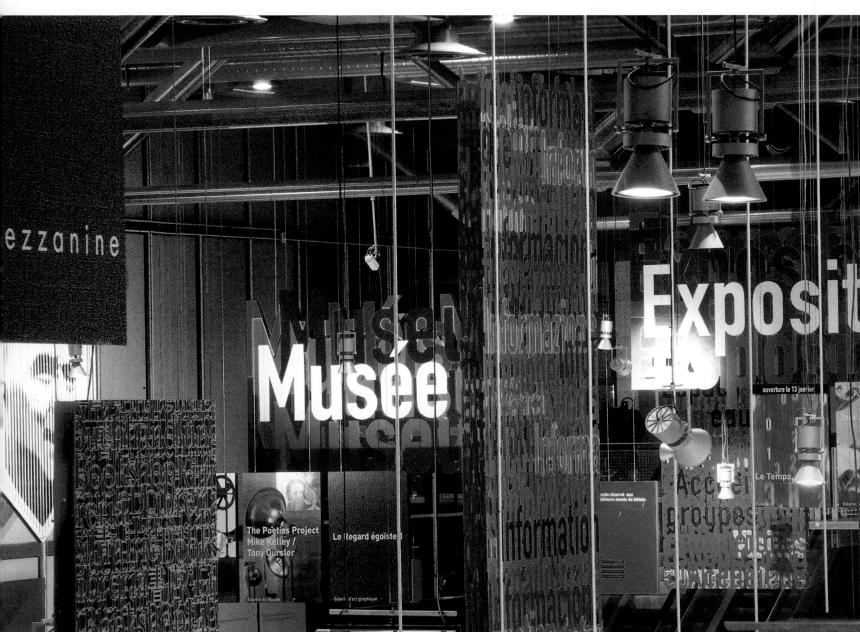

Below: Signage sometimes has to be subtle and understated in order to fit into interior environments. Choice of materials and scale of presentation is all-important, as can be seen here in the elegant freestanding lobby sign.

Design by Sussman/Prejza & Co., USA

Right: These signage icons for various sporting activities installed in the Nishi Kasai district, Tokyo, are integrated into street furniture, which minimizes their intrusion without compromising their effectiveness.

Design by Edogawa Ward, Japan

Left: This signage system reflects the strong colors used for the Georges Pompidou Center in Paris and creates a special energy for a building devoted to the promotion of the visual arts. Design by Integral Ruedi Bauer & Associés, France

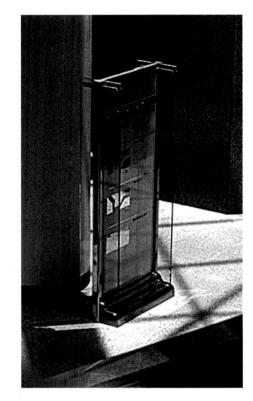

Below: Signs are not always explicitly designed as such. This decorative element on a Swiss school has become a familiar landmark and works much as a purpose-built sign would.

Design by Niklaus Troxler,
Switzerland

showcase 19

DESIGN FOR EXHIBITION

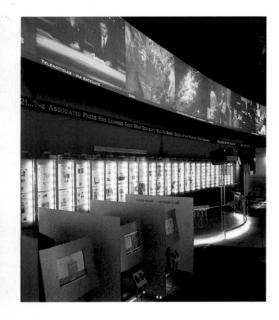

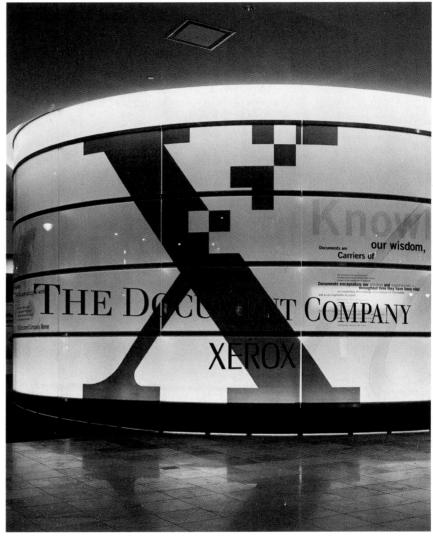

Above: The Newseum, located in Washington, D.C., deals with all aspects of news gathering and reporting. The exhibition design incorporates the illuminated front pages of newspapers and a video newswall as well as computer stations for interactive learning. The visually dynamic space reflects the constant flow of information, news, and data in the modern world.

Design by Ralph Applebaum Associates, USA Above: The design of the Xerox trade stand is dominated by a 33-foot-high example of the memorable, partly pixelated, capital X that represents Xerox everywhere.

Design by IDEO, USA

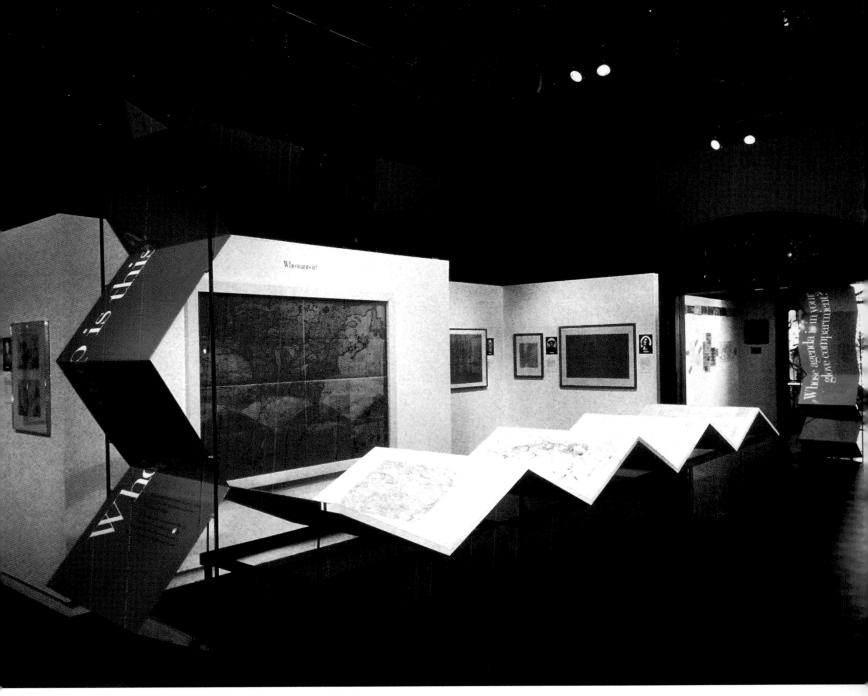

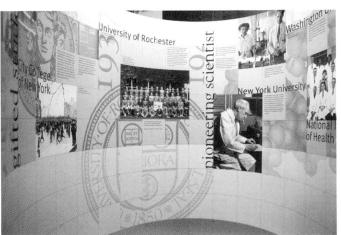

Left: This curving wall, created for a University of Rochester exhibition, demonstrates how design for exhibition can be a liberating pursuit—unconstrained as it is by paper-size formats or the ubiquitous rectangle of the $\,$ computer monitor.

Design by Poulin & Morris, USA

Above: The "Power of Maps" exhibition at the Cooper Hewitt National Design Museum in New York incorporates exhibition panels that reflect the folding nature of maps and how they are used.

Design by Pentagram, USA

DESIGN FOR THE INTERNET

Above: www.knoll.com
This is a refreshingly direct, strong, and uncluttered website created for Knoll, a furniture design company.
The site's simplicity ensures that it loads quickly and is easy to navigate.
Design by NB:Studio, UK

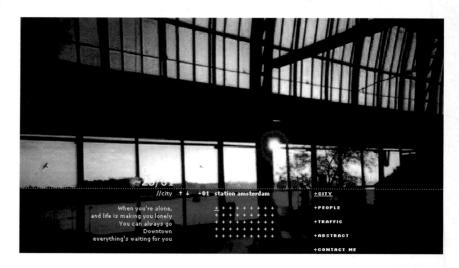

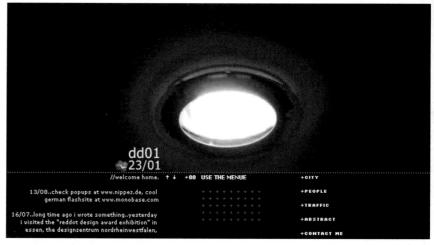

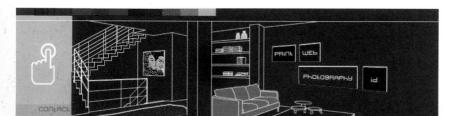

Left: www.yes-indeed.net
French graphic designer, Donna
DiStefano, has used strong
imagery and a clean-cut interface
to create this site as a showcase for
her many design talents.

Design by Donna DiStefano, France

Above and top: www.designers-drug.de
This site contains urban photographs
taken by the German designer Daniel
Althausen. Pictures are displayed by
category: city, people, traffic, and
abstract. Subject matter ranges from
the Amsterdam station at sunrise to
passengers traveling on a train. It has a
lean yet lively interface, making
navigation easy and interesting.

Design by Daniel Althausen, Germany

ART DESIGN FASHION LIFESTYLE

Above: www.memphisnotebook.com
Memphis Notebook is an online
magazine dedicated to art and
design. The site is laid out like a print
publication with predominantly
textual content. However, the use of
large photographic images mixed
with unusual typography ensures it is
far from boring.
Design by Memphis, USA

Right: www.guinnessstorehouse.com
A well-planned and highly animated
site designed with Flash. Lots of
interactivity and added music make
the tour a lively experience.
Design by Imagination, UK

STOREHOUSE

STOREHOUSE

STOREHOUSE

A FERMENTATION PLANT AT ST JAMES GATE
BREWERY, DUBLIN, HAS BEEN TRANSFORMED
INTO A PLACE WHERE YOU CAN EXPERIENCE
ONE OF THE WORLD'S BEST-KNOWN BRANDS
IN A TOTALLY UNEXPECTED WAY, WITH BARS,
A GALLERY AND SEVENT, IT'S THE HOME,
HEART AND SOUL OF GUINNESS.

showcase 2

DESIGN FOR MULTIMEDIA AND GAMES

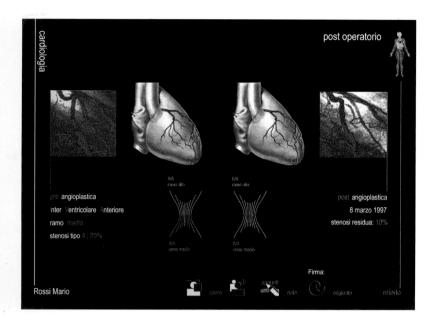

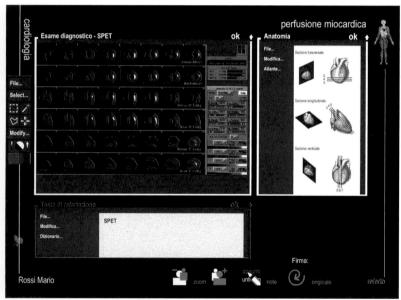

Above: Multimedia can be used to produce effective educational tools for many specialist professions. These screens are a sample from an interactive multimedia project that explains the use of technical imaging equipment for medical diagnosis.

Design by Maddalene Beltrami and the Ospedale Maggiore di Milano, Italy

Below: InterStitch created this motion-graphics video for the San Francisco chapter of the American Institute of Graphic Arts (AIGA) to promote a lecture series. The video was a hybrid of analog and digital design. Digital video was shot and composited in Adobe AfterEffects with animated graphics and three-dimensional modeled elements. The lecture series discussed the topic of truth in beauty. The video addressed this topic by presenting the dissection and construction of its own form.

Design by InterStitch, USA

Below: This animation formed part of a winning bid for a project development competition. Created in Adobe Premiere, it was presented on a laptop and via a LCD projector. Design by RTKL

Top: The Settlers IV
Computer game design is an arena where digital graphic design is often pushed to its technical limits and is very much a team exercise.
The graphic designer will typically only have reponsibility for a small part of the overall look of a game.
Design by Blue Byte, Germany

Above: EA Sports NHL 2002
Even the most advanced threedimensional games require some
interface design and this is where
the skills of the multimedia designer
come to the fore. The challenge for
the designer is to present
information and choices with perfect
clarity while maintaining the mood
and overall look of the game.
Design by EA Sports, USA

DESIGN BASICS

01.01

Basic design principles are the building blocks of graphic communication. To appreciate their value and relevance it is best to begin by looking at their particular characteristics away from an applied context.

Graphic designers find themselves working at both large and small scales across increasingly varied areas at local, national, and international levels. The flexible, innovative perspective they need must be underpinned by basic principles if they are to make informed design decisions and aesthetic judgements. These principles are common to other design disciplines and provide a valuable constant in the midst of the continually developing opportunities with which the graphic designer is presented.

PART 01. DESIGN BASICS
CHAPTER ONE

THE VALUE OF DESIGN BASICS

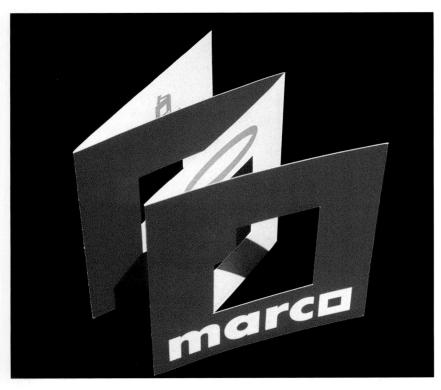

Left: Promotional brochure for the Museo de Arte Contemporaneo (MARCO) de Monterey in Mexico. The square, derived from the shape of the building, forms the basis of the museum's logo and overall visual identity.

Design by Lance Wyman, USA

Above: Circular architectural forms soften the large ticketing area in Chicago's O'Hare Airport and offers an organic-looking background to the starkly contrasting rectangular information panels, ensuring that the latter stand out.

Design by Carol Naughton & Associates, USA

PRIMARY SHAPES The familiar shapes—square, circle and triangle—together with their three-dimensional derivatives—cube, sphere and pyramid—underpin all the structures seen around us. There is very little that will not break down into, or visually relate to, some form of primary shape.

The square, like the cube, is a wholly static form with no directional pull. It can be used to frame, exclude, include, attract, or define area or for modular division, and it will sit comfortably in almost any arrangement of multiples. Even when rotated and in a more dynamic, diamond form, it retains its inherent, fixed quality. Minor modification to a linear square will, however, begin to direct the eye and also create associations. For example, if the corners are opened, or if a side is removed or tilted, the eye will move into the shape and associations of exit or entrance will be made. An extended square, or rectangle, directs the eye along, up, or down its length and beyond, making the eye look for common alignments.

The circle has two main attributes—it provides a powerful focus for the eye and at the same time invites it to take a journey around either itself or a circular layout of any kind of elements. In contrast, a series of circles suggests self-contained units and so makes the eye "jump" from one unit to the other, quickly tiring it. Although circles do not easily fit together, the eye can be made to spin across the surface by physically linking a series of circles. The pace of the spin is controlled by the size of the circles.

The triangle is a balanced and completely stable form in both two- and three-dimensional forms, but also suggests a dynamic energy, even when equilateral. Unlike the circle or square, the triangle has proportions that can be altered to give it directional force without affecting its basic shape. The eye finds this directional force difficult to ignore.

It is important to understand the significant influence that these key forms has on the viewer's perception. Such an understanding will enable the designer to confidently organize the form and content of a design in order to communicate a visual message.

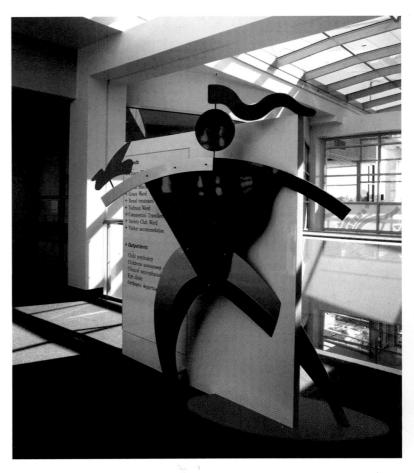

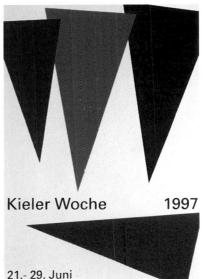

Above: The primary shapes and bright colors that underly this three-dimensional children's hospital sign are familiar things with which a child can comfortably identify, even in unfamiliar surroundings. Variations on the playful and cheerful signage theme are used throughout the system.

Design by Emery Vincent Design, Australia

Left: This poster for a sailing regatta uses a simple, primary shape inspired by both sails and small directional flags used in the regattas. Overlapped and cropped, the shapes evoke a sense of activity and celebration.

Design by Niklaus Troxler, Switzerland

POINT, LINE, AND AREA These are the basic elements used in all graphic design and, as with primary shapes, the way in which they are used will affect the overall perception of any communication. Most basic visual design decisions involve some representative combination of these shapes and elements. These may be used explicitly or implicitly, and with varying levels of complexity.

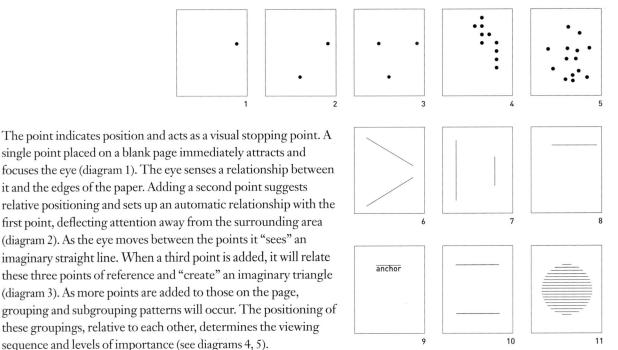

- 1. A point of focus.
- 2. Points suggesting a line.
- 3. Points suggesting a shape.
- 4. Organized grouping of points, leading the eye from start to finish in an ordered way.
- 5. Random grouping of points. This causes the eye to scan the area constantly looking for starting and finishing points.
- 6 & 7. Lines creating an illusion of depth.
- 8. Placing a line closer to one edge of an area will direct the eye along it.
- 9. Centering a line on a page closer to either the top or bottom will anchor it visually.
- 10. Lines may be used to direct the eye to a given area.
- 11. Rules of different lengths build an image. Lines of type can produce the same effect.

Line essentially indicates direction and so leads the eye. It will also encourage the eye to continue beyond its length. It may be either implied through the juxtaposition of two elements, as with a point, or actual, as in a drawn line, a line of text, a typographic rule, or a set of images or other elements. The strategic placement of several lines can create an illusion of depth (linear perspective) (diagrams 6, 7). Lines may also be used to suggest form, delineate, enclose or divide, emphasize, and act as a visual marker (diagrams 8, 9, 10, 11).

Area is a defined surface or plane, and it acts as a visual container, drawing attention to its content or edges. Graphic designers are concerned with area as a means of defining format and proportion and as a way of pacing Left: With the competition of both Web and CD-ROM, designers of brochures, catalogs, and promotional print are having to reconsider the possibilities of size, format, content, and surface quality. This inventive exhibition "catalog" mixes techniques and materials to produce a pack that works as a visual and tactile experience that informs and entertains. Design by Jo Stockham, UK

Right: Creating an axis through proportional division of space can be an effective way of visually coordinating radically different sized elements within a single design concept, such as an exhibition or display.

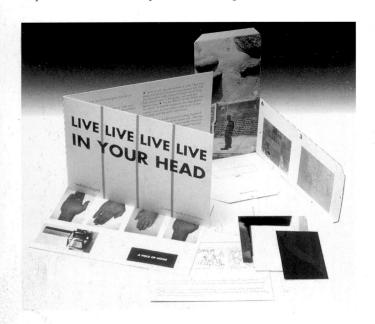

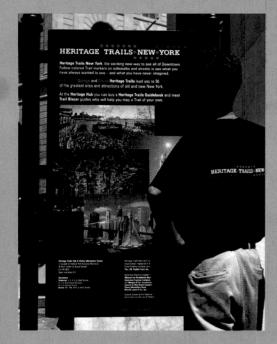

the viewing within a design at any scale. It is easy to be distracted by disparate

area is also a powerful element in its own right—"empty" areas can create energy

otherwise) may be dictated by either job

proved to be particularly suited to a wide

range of uses. Print, for example, makes

frequent use of the 8½- x 11-inch and 11- x

rectangle having sides in the ratio of 1:1.414,

square root of 2. Repeated folding parallel to

the short side allows paper in this proportion

17-inch paper sizes, which are based on a

the latter remarkable number being the

known as dynamic white space.

eye from one place to another. This energy is

Choice of format (rectangular or

content or production practicalities or both.

Left: Historic and contemporary sites in downtown Manhattan are linked in a series of walking tours, each color coded and physically identified by colored dots set into the sidewalk. The series of dots is distinct yet subtle enough not to intrude on the environment. Design by Chermayeff & Geismar,

Right: Created for a group producing film commercials, the design of this letterhead was quirkily inspired by the white of the three shirts blending into the white of a conference table in a dimly lit studio. The small proportion of image to white space gives the design a dynamic that forms the basis of the group's visual identity. Design by Alan Fletcher, UK

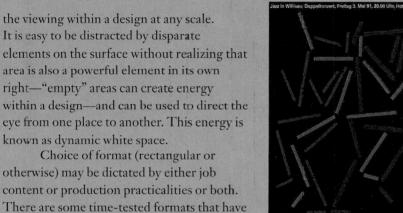

Above: In this poster for a jazz concert, simple lines, strategically placed, symbolize saxophonist, dancer, and trumpet player. Their dynamic positioning is designed to capture individual movements. Design by Niklaus Troxler,

Switzerland

to be halved into further rectangles—all in the same 1:1.414 proportion—giving the designer a flexible range of proportionally related sizes with which to work.

Although screen design formats generally follow the maximum allowable vertical and horizontal dimensions, there is no reason why this must be rigidly adhered to.

Equal division of an area conveys a static feel, while contrasting division communicates greater dynamism. The golden section has been used for centuries as a formula for creating harmony. In this formula, the relationship of the smaller area to the larger area is equal to the relationship of the larger area to the whole—approximately 8:13.

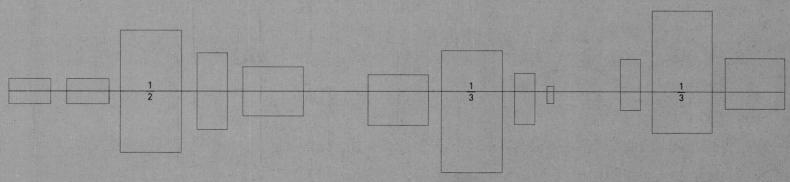

DYNAMICS, EMPHASIS, AND CONTRAST Visual emphasis is a means of specifically directing the viewer, ordering complex information by creating a visual hierarchy and highlighting elements. Four basic ways of creating visual emphasis are through the use of size, weight, color, and disposition.

Headline

os espacios que se aman, que se besan, pour una puerta que no se sabe si separa o une. Aquí todo tiene la suficente claridad y la deliciosa oscuridad de la armoniá. No nos sabemos dentro hasta

Left: Typesize is generally used to rank text into levels of importance—in this case headline, body text, and small print. Drop caps (the large "D") are often used to indicate the start of a new section of text.

que unos pasos más allá de la primera puerta, nos encontramos fuera del edificio; nunca sabemos qué es demasiado. Todo recuerdo de este viaje será el instante en que abandonamos esa sensación de recogimiento, memoria irrecuperable de un espacio inmenso, inmensamente fugaz.

Small print following definition of a man was written by R Buckminster-Fuller in 1938 "A self-balancing, 28 jointed adapter-based biped; an electrochemical reduction plant, integral with segregated stowages of special energy extract in storage batteries for subsequent actuation of thousands of hydraulic and pneumatic pumps with motors attached; 62,000 miles of capillatines.

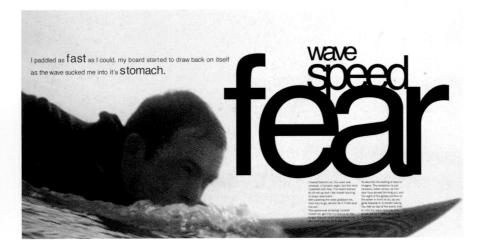

Above: The contrasting type size and positioning of the headlines in this book spread, together with the diagonal, inward direction of the image bring the reader directly into the experience. Using lowercase letters at a large scale, tightly kerning them, and reducing the scale of the surfer to match the letters, accentuates the emotion and drama. Design by Barney Pickard, UK

Right:

- 1. The exact central placement of an element within an area will produce a fixed appearance.
- 2. Placing an element close to the top edge of an area will encourage the eye to travel upward beyond it.
- Placement to the left and a third of the way down the page draws the eye downward.

The skilled use of emphasis is essential to communicating with clarity and pace and works to focus and progressively direct the viewer through or around a design. Emphasis, like all other design basics, should always be considered in relation to the design as a whole. Many examples of size, weight, color, and disposition used as emphasis can be seen in newspapers and magazines where the visual pace is broken down into small parcels of information. These are identified (or emphasized) in many different ways, for example, by a heading (size), bold introductory text (weight), a colored rule or tonal change in text setting (color), and the placement or discrete arrangement of elements (disposition).

Size creates emphasis through contrast in proportions of format, type, image, relationship of elements, dimension (length and height), and volume (area and depth). Reducing an element to a small size on a large format can be just as powerful as enlarging it to fill the area, if not more so.

Weight suggests visual substance and mass, which can range from heavy or bold to light. It is often used in conjunction with size but works successfully when incorporated across uniformly sized elements. Contrast in weight alone between individual words or lines can be effective in large amounts of text. Changes of weight between elements or blocks of continuous or

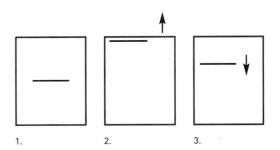

Below: The Trocadero complex in London uses of the latest technology to create energy, excitement, and power within the seven-storey space. Natural light is excluded in favor of vibrant color lighting. With more than a hundred different, independently controlled light sources, rotating billboards, a video wall, TV screens, sound, animatronics, lasers, and smoke machines, the Trocadero is a prime example of a digital entertainment destination.

Design by RTKL and Jonathan Spiers & Associates, UK

La puerta con dos casas es lo permanente, inacesible. Esta casa de alforia se encuentra en el territorio de los acontecimientos simultáneos. Dos espacios que se aman, que se besan, pour una puerta que no se sabe si separa o une. Aquí todo tiene la suficente claridad y la deliciosa oscuridad de la armoniá. No nos sabemos dentro hasta que unos pasos más allá de la primera puerta, nos encontramos fuera del edificio; nunca sabemos qué es demasiado. Todo recuerdo de este viaje será el instante en que abandonamos esa sensación de recogimiento, memoria irrecuperable de un espacio inmenso, inmensamente fugaz.

La puerta con dos casas es lo permanente, inacesible. Esta casa de alforia se encuentra en el territorio de los acontecimientos simultáneos. Dos espacios que se aman, que se besan, pour una puerta que no se sabe si separa o une. Aquí todo tiene la suficente claridad y la deliciosa oscuridad de la armoniá. No nos sabemos dentro hasta que unos pasos más allá de la primera puerta, nos encontramos fuera del edificio; nunca sabemos qué es demasiado. Todo recuerdo de este viaje será el instante en que abandonamos esa sensación de recogimiento, memoria irrecuperable de un espacio inmenso, inmensamente fugaz.

Above: Text set in three different weights of the same typeface—light, regular, and bold. These variants can be effectively used to create a visual hierarchy with continuous text as well as to lend tone and texture (typographic color) to text.

La puerta con dos casas es lo permanente, inacesible. Esta casa de alforja se encuentra en el territorio de los acontecimientos simultáneos. Dos espacios que se aman, que se besan, pour una puerta que no se sabe si separa o une. Aquí todo tiene la suficente claridad y la deliciosa oscuridad de la armoniá. No nos sabemos dentro hasta que unos pasos más allá de la primera puerta, nos encontramos fuera del edificio; nunca sabemos qué es demasiado. Todo recuerdo de este viaje será el instante en que abandonamos esa sensación de recogimiento, memoria irrecuperable de un espacio inmenso, inmensamente fugaz.

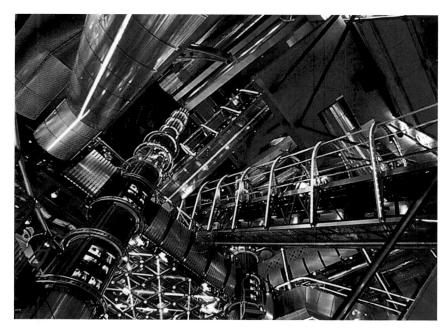

Left: The signage system developed for this hospital site uses distinctive colors and shapes directly influenced by the idiosyncratic design of the hospital building. The building has a strong identity of its own and the signs have to be very distinctive in themselves, yet visually link with it. This sign picks up the strong color and quirky shape of a nearby red wall and is illuminated internally at night.

Design by Tom Graboski Associates,

display text will set up different spatial planes and can influence the viewing and reading order. Degrees of density and openness in text and the tonal value of images can be used to increase or decrease levels of emphasis.

Color not only creates highlights but also adds depth to every aspect of emphasis through association, mood, temperature, and emotion. Appropriate color choice can be based on any one or combination of these areas. Random choice or personal preference in the use of color can wrongly emphasize or detract from the content or message. Interaction and/or contrast between individual colors together with the level of saturation (intensity) and brightness (tone) will significantly modify the degree and volume of emphasis (see Designing with Color). Typographic "color" created by weight change from one body of text to another can also be used as a means of subtle emphasis or contrast.

Disposition, like color, interfaces with every aspect of emphasis. It is so integral to visual communication that its potential is often undervalued. Disposition is inextricably linked to area and is concerned with the strategic placement of elements. It can subtly or dynamically draw attention to elements within the overall design area. For example, the small folio sitting on its own at the bottom or top of a page does not shout but is instantly found by the reader through its unique positioning. Similarly an indent (the placement or disposition

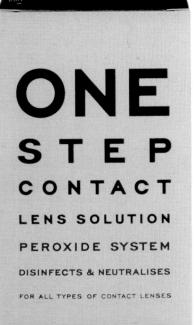

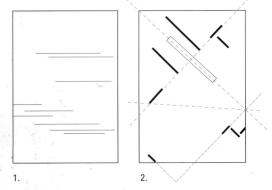

Right: One of a series of posters in which the capital letter "A" was used as the key design feature. In this example the size, angle, and distortion of the letter plays with the idea of a shaft of light contrasting with the predominantly black space.

Design by Pentagram, UK

Left: This contact lens solution packaging makes a clever play on the opticians' eye chart and uses the varying type sizes as a way of ordering and highlighting elements of the product.

Design by Williams Murray
Hamm, UK

1. Asymmetrical placement works best if the elements are informally grouped with the space in between and around used to lead the eye though them.
2. Diagonal arrangements need to be carefully structured so the eye does not dart from element to element. Basic directional lines can help you to avoid this.

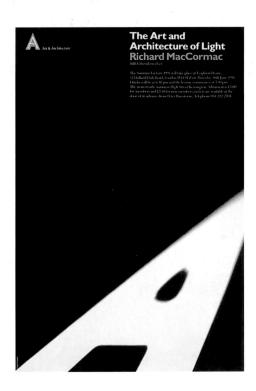

of the first word in sequences of paragraphs) quietly creates pace for the reader. It is surprising how successfully judicious use of disposition can work without recourse to other methods of emphasis. However, poorly considered placement of elements on a page can set up confusing dynamics that may hinder the reader.

Contrast is used to create and sustain visual interest, in the same way that tone and intonation add interest to speech. Without contrast, graphic communication would become dull and flat, with little to attract attention or sustain interest. Contrast draws on visual opposites or dissimilarity to emphasize, differentiate, set up competition, attract, and change the reading pace. It can be both quantitative and qualitative, obvious or subtle. Its use should always be considered in direct relation to the concept and the design as a whole. Because there is little limit to the areas in which contrast may be used, it can be helpful to initially look for potential within the main emphasis groups—size, color, weight, and disposition.

Everyday visual opposites (loud and quiet, warm and cool, balance and motion) can also be a source of inspiration for graphic contrast. To be effective, contrast needs to be appropriate to the concept and be closely linked to emphasis. Overuse may result in a lack of focus in the design, with elements fighting for the viewer's attention and the eye being pulled in different directions.

Oct 04 Mark Robbins

Oct 11 Craig Dykers Snohetta

Nov 01 Alberto Kalach

Nov 08 Tod Williams+Billie Tsien

1999 AIA SFMOMA

Architecture Lecture Series

moreModern

interest and strains

When gos use a too bog, the intrinsin earlie of the influent and streamers is lost to you. Tomorrie, this may be a roller, but I find an refuser part of the researing reball of tea.

At this inclusion is a predictional orcognitude in which a measured annual of bottom that is placed. Recovers as it to see that this merited control or spicered in the target before the boiling value is a disted. It's reportant not by the spicered in the target before the boiling value is a disted. It's reportant not by the spicered in the spicered recovers and provide to decide the major amount of its count of the spicered recovers and provide decided as they absorbed within a flying district decided to the spicered recovers and th

Many liteds here been created as traditional complements to tax in the triticum, chaptem, you will fed ecipies to accompany your tex, whether it's hot, some speciel, or spland. You sate of till derived and except program shall use this are exacuted ingredient. And, for a purse that referables, there are recipies for nation a resource arms of relations and addish.

SPICY BLACK BEAN SOUP

\$18765 4 TO E

There are many versions of this so a midwritter day. Period et in the in our perfor—chamity or smeeth. Of

> In a large song part over medicam hrea, waren olf. Add vegetebber and garlier and savino word tender, obsert a planners, Add dealered between to song pot. Add stock, water, custom, congene, und customere, thing to foot over high hous. Reduce heat to mendicum be ward cook, conceruated locars are tender, about a busers. Add sain and peopler and cook, unconcerned. In suitamina beauting.

Transfer in batcher to load processor and public to deviced cousin term; Return soup to pan, add time rates and classics, if destred, as reloat. Luffs into boots and serve, pseulog toppings expansion,

Exap chapped yellow exice
 Exap chapped colory
 Exap carret, chapped
 Seleves garlic, mincest
 Cope dried black beass, picked over

4 cups water

I tempose ground cumie

I tempose dried oregane

's tempose ground corlander

I tempose ground corlander

(optional)

1050cm26
Grated Montercy Jack chosse
Chopped formatoes
Sour cream or plain northit yogur

Conned beans are used in this soup for convenience and quick preparation

I cays chapped red enion
2 shows partir, minered
4 shows partir, minered
4 shows partir, minered
6 shows partir, minered
6 shows partir, minered
6 shows partir, minered
1 cays challen shock or brotth
I cay creation from the swith rich a
1 tesspoon proced cases
1 tesspoon order thipse
10 tesspoon chill powder
1 tesspoon chill powder
1 tesspoon chill powder
1 tesspoon chill powder

I transpoon salt
Freshly greated paper to taste
TOPPINGS
Chapped cliantro or parsky
Grated Monterey Jack cheese
Chapped broaters

To there's easy, pairs fail of the beas will short soon prevents. Kermin in Duth from said its well, laided in prevents with rich prets agriculture with rich prets agriculture with rich prets agriculture with visions. Pers the editional hypotogra seption from the prets agriculture with visions. Pers the editional hypotogra seption from the prets agriculture with visions.

197

(190) THE BIG BOOK OF SOURCE STEW

THE MECHANICS OF TYPE The designer needs to understand how type is constructed and assembled as well as have an aesthetic appreciation of it. Letters of the alphabet are made up of complex combinations of straight lines and curves that give them their individual character.

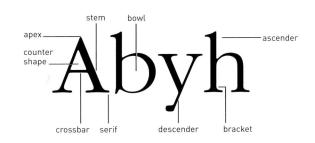

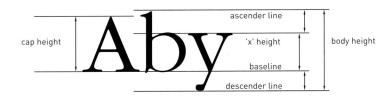

Far right and below: Comparison of the variation in cap and x-height between four typefaces of the same point size.

All letters have common, notional points of reference in their physical make-up, regardless of the typeface design, style, or size. These notional points are the baseline (the line on which all letters sit), the x-height (the height of the lowercase letters), the ascender line (the extent of the vertical upstrokes of lowercase letters), and the descender line (the extent of the downstrokes of lowercase letters).

The terms used to identify the different parts and structures of letterforms within this notional framework help to ensure accurate recognition and reference (see diagram above). Some characters have detailing unique both to

Times

La puerta con dos casas es lo permanente, inacesible. Esta casa de alforja se encuentra en el territorio de los acontecimientos simultáneos. Dos espacios que se aman, que se besan, pour una puerta que no se sabe si separa o une. Aquí todo tiene la suficente claridad y la deliciosa oscuridad de la armoniá. No nos sabemos dentro hasta que unos pasos más allá de la primera puerta, nos encontramos fuera del edificio; sabemos qué es demasiado. Todo recuerdo de este viaje será el instante en que abandonamos esa sensación de recogimiento, irrecuperable de un espacio inmenso, inmensamente fugaz.

Palatino

La puerta con dos casas es lo permanente, inacesible. Esta casa de alforja se encuentra en el territorio de los acontecimientos simultáneos. Dos espacios que se aman, que se besan, pour una puerta que no se sabe si separa o une. Aquí todo tiene la suficente claridad y la deliciosa oscuridad de la armoniá. No nos sabemos dentro hasta que unos pasos más allá de la primera puerta, nos encontramos fuera del edificio; nunca sabemos qué es demasiado. Todo recuerdo de este viaje será el instante en que abandonamos esa sensación de recogimiento, memoria irrecuperable de un espacio inmenso, inmensamente fugaz.

Bodoni

La puerta con dos casas es lo permanente, inacesible. Esta casa de alforja se encuentra en el territorio de los acontecimientos simultáneos. Dos espacios que se aman, que se besan, pour una puerta que no se sabe si separa o une. Aquí todo tiene la suficente claridad y la deliciosa oscuridad de la armoniá. No nos sabemos dentro hasta que unos pasos más allá de la primera puerta, nos encontramos fuera del edificio; nunca sabemos qué es demasiado. Todo recuerdo de este viaje será el instante en que abandonamos esa sensación de recogimiento, memoria irrecuperable de un espacio inmenso, inmensamente fugaz.

Garamond

permanente, inacesible. Esta casa de alforja se encuentra en el territorio de los acontecimientos simultáneos. Dos espacios que se aman, que se besan, pour una puerta que no se sabe si separa o une. Aquí todo tiene la suficente claridad y la deliciosa oscuridad de la armoniá. No nos sabemos dentro hasta que unos pasos más allá de la primera puerta, nos encontramos fuera del edificio; nunca sabemos qué es demasiado. Todo recuerdo de este viaje será el instante en que abandonamos esa sensación de recogimiento, memoria irrecuperable de un espacio inmenso, inmensamente fugaz.

La puerta con dos casas es lo

themselves and to the typeface, for example, the ear of lowercase g or the tail of uppercase Q. However, although letterforms are recognized by these specific characteristics, the overall shape of the characters and the counter-shapes (enclosed areas) also contribute to the character of a typeface. Although there is considerable individuality

Times

Palatino

Bodoni

Garamond

within the different characters of a typeface, typefaces are designed to form a cohesive whole and give a global color and texture when typeset. Appreciating the physical make-up of type helps the designer to identify points to look for and so facilitates typeface choice for different purposes.

Although the size of type is described by a common system (usually in points), you need to be aware that different typefaces at, say, 10pt, may look quite different in size (see examples above). This happens because of the relative proportions of the characters. Helvetica, for instance, has a large x-height and comparatively short ascenders and descenders, while some Garamonds have a

POINTS AND PICAS.

Right: The small unit, the point, is strictly 0.013833 inch or 0.35136 mm. The larger unit, the pica, is made up of 12 points.
All type sizes (measured over the overall body of the type) are measured in points.
Larger distances, over a page, especially column widths, are often measured in picas.

one Pica EM

12 pts

relatively small x-height and longer ascenders and descenders. These differences in proportion result in different typographic color when text is set—the bigger the x-height, the more open the texture and color, making it essential to look at different sample settings. For the same reason, the number of characters that will fit on a given line length varies between typefaces at the same size. Even if this makes little difference to small amounts of copy, it can make a considerable difference to many pages of text.

THE POINT SYSTEM

Digital processing allows designers to work on screen in a range of interchangeable measurement systems, to their own choice. However, when dealing with type, most people find it more practical to work with a common system that allows everyone to grasp and quickly appreciate the values being talked about. The point system used for measuring type—unique to the printing industry—has, surprisingly, remained the same since the days of metal type. In the days of phototypesetting, an attempt was made to use millimeters as a basic unit for type measurement, but it was never taken up.

Type size, as shown in the diagram, is determined by the size of the type body (which, in the past, was a piece of movable metal) rather than by the actual letter. Nowadays, the body can be considered as the distance between the top of the highest part of the letterform (usually an ascender) to the bottom of the lowest (a descender), plus a notional amount of clearance, which varies from typeface to typeface.

The typographer's point is approximately 0.014 inch or 0.35 mm. Such a very small unit is necessary when describing very small sizes of type. However, attempting to express large measurement in points is cumbersome, so a larger unit of 12pt, the pica em, is used. In many programs, it is possible to select pica ems or picas as a unit of measurement, for example, horizontal measurement for setting column widths. In practice, digital graphic designers will probably find themselves working in several measurement systems—points

for type, picas for column width, and inches for scanning resolutions (dpi).

The em (without the pica) is a measurement notionally based on the width of a capital M. Therefore, the value of the em is the same as the point size being used. All units of digital letter spacing and character construction are based on dividing the em of the given type size (be it 8.9pt or 24pt) into thousandths—infinitely more subtle than in earlier times.

Below: In many programs it is possible to select pica ems (picas, i.e., 12 points) as a unit of measurement, however, in practice, digital graphic designers often find themselves working with several measurement systems—points for type, picas for columns, and inches for scanning resolutions (dpi). All units of digital letterspacing and character construction are based on dividing the em of a given type size (for example, 8.9 or 24pt) into 1/1000ths—infinitely more subtle than in earlier times.

12 pts

DESIGNING WITH TYPE When working with type, the graphic designer automatically draws on the influence of centuries of development. Typeface design evolved as printing technology developed but, given the flexibility of digital technology, recent typeface design has had few constraints. Radically different and new letterforms, often challenging typographic convention, have emerged alongside the redrawing and digitization of many classic typeface families, which were originally designed for hot metal.

Digital flexibility has enabled the new concept of the Multiple Master font, in which the user can manipulate a typeface family into many variant forms by controlling properties such as width, weight, and optical scale without distorting the essential characteristics of the letterforms.

Many of the huge range of typefaces available fall broadly into one the following groups: serif, sans serif, glyphic, decorative and display, script, blackletter, and contemporary. (The more recent, innovative digital typeface designs follow their own rules and do not fit easily into these groups.) The terms used describe the overall character derived from basic characteristics such as whether or not the letters have serifs (a short finishing stroke at the end of the main stroke of a character), the shape of any serif, the contrast between thick and thin strokes, and the angle of stress or axis of the letters. These combine to give a typeface its unique character and rhythm. They should be carefully considered when you choose a typeface. Trying out different text settings is always useful in assessing the typographic color and rhythm in a particular context (see The Mechanics of Type). Type is not a limited graphic medium; it can be used in its own right as "image."

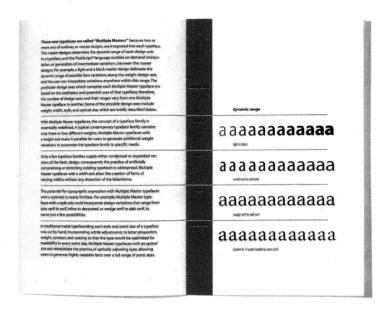

Zapf Chancery

ABCDEFGHIJKLMNOPQRSTUVWXYZ abcdefghijk[mnopqrstuvwxyz

Vag Rounded

ABCDEFGHIJKLMNOPQRSTUVWXYZ abcdefghijklmnopgrstuvwxyz

Gridnik

ABCDEFGHIJKLMNOPQRSTUVWXYZ abcdefghijklmnopqrstuvwxyz

Serpentine

ABCDEFGHIJKLMNOPQRSTUVWXYZ abcdefghijklmnopqrstuvwxyz

Reactor

ABCDEFGHIJKLMNAOPQRSTUVWXYZ

Left: Variants in weight and proportion are shown in this example of a Multiple Master font, which maintains the intrinsic character of the letter style. Multiple Master fonts are extremely useful where a broad typographic hierarchy is required without any loss of character. Design by Adobe, USA

Above: Recent innovative typeface designs (commonly produced digitally) follow their own rules and do not fit easily into the standard typographical family groups.

Right: Characteristic examples of typeface families.

1. Old Face: marked axis inclined to the left, subtle change from thick to thin in the letter strokes, bracketed serifs that are angled on the ascenders, and an "e" with a horizontal bar. Capital letters are sometimes shorter than ascenders.

2. Transitional: axis that is slightly inclined to the left (can also be vertical), bracketed serifs that are angled on the ascenders.

3. Modern Face: vertical axis,

abrupt contrast between thick and thin letter strokes, unbracketed (or minimally bracketed) hairline serifs.

4. Geometric Sans Serif: normally monoline letterstrokes, based on simple geometric shapes. Often with a single-storey lowercase "a."

5. Humanist Sans Serif: some contrast in the letterstrokes, based on Inscriptional letterforms, with two-storey lowercase "a" and "g."

6. Slab Serif: monoline or with minimal contrast in the letter strokes. Unbracketed, heavy serifs.

Abqoe Abqoe Abqoe Abqoe Abqoe Abqoe Abqoe Abqoe

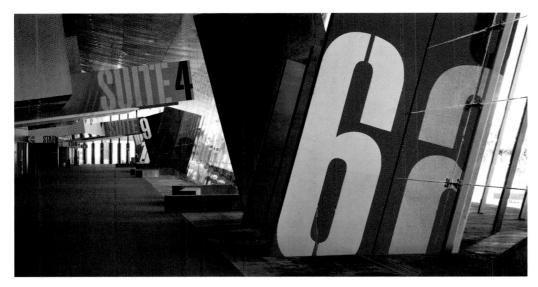

In a context where pictorial images are inappropriate or do not exist, a heading, single word, or letterform can be inventively used as a graphic focal point to create interest, evoke mood, or set the scene for the rest of the design scheme. Visual onomatopoeia, in which type is made to suggest the meaning of the word visually and "talk" to the viewer, is also an engaging way of getting the message across.

DECIDING ON A TYPEFACE

Typefaces are the voices of words and determine the visual tone of the text. The success of typographic communication depends as much on the choice of typeface as on the use of space and layout. Deciding on one typeface over another is a matter of visual judgement, fitness for purpose, and style. A close look at the basic characteristics of different typefaces within the broad groups will help to make the choice more manageable. A typeface can be specifically chosen to reflect, or contrast with, the content and mood of the text in relation to feel of the overall design, but care should be taken to ensure that this does not conflict with the message or overpower the look of the text. Identifying the purpose and

Above: The giant type on these signs at the Melbourne Exhibition Centre work as a powerful graphic element. Although cropped and placed at odd angles, the type still retains its legibility. This dynamic typographic signage is integral to the building, adding to its unique and unmistakable character.

Design by Emery Vincent Design, Australia context of the text—advertising, signage, packaging, print, web, or multimedia, the audience, and the location in which it will be read—will all help to inform the choice of size, weight, and style of typeface.

Type is used for informing, entertaining, providing reference, instructing, directing, or otherwise involving the reader in some way. Each of these contexts will require a different level of concentration and reading pace, and both concentration and reading pace are relevant to the choice of typeface. For example, road signage has to be instantly recognizable; using a decorative face for a directional road sign might dangerously distract the driver's attention from the road while he or she deciphers the information. Reading may be sustained (as for a book), intermittent (as for a magazine, on a website, package, or exhibition panel), or focused (as for a set of instructions or reference source). Text may need to be read under compulsion (as for a warning), or as an option (as for a disclaimer). The choice of size, weight, and style of the typeface, as well as the typeface itself, should be linked to the reading pace. For example, it would be inappropriate to set instructional text in small, closely spaced, bold type; the difficulty in reading and understanding would be reflected in the reader's attitude to the task.

It is generally felt that serif, rather than sans serif, typefaces are easier on the eye and less tiring to read over lengthy continuous text, but there is no hard-and-fast rule. It is worth reflecting, however, that complete novels are not often set in a sans serif face. Discussion over the relative merits of serif and sans serif text faces will inevitably continue.

Interstate Light Compressed Interstate Compressed Interstate Bold Compressed

Interstate Black Compressed Interstate Light Condensed Interstate Light Condensed Italic Interstate Condensed Interstate Condensed Italic Interstate Bold Condensed Interstate Bold Condensed Italic Interstate Black Condensed Interstate Light Interstate Light Italic Interstate Regular Interstate Italic Interstate Bold Interstate Bold Italic Interstate Black Interstate Black Italic

Below: Lively, characterful letterforms, symbolizing the past, present, and future of the New York Public Library, combine to celebrate the start of the Library's second century. The widely varying

Left: A selection of typefaces from the extensive Interstate family. Using related typefaces within a document will help to ensure a professional-looking result.

Right: Variants in weight and proportion are shown in this example of a Multiple Master font, which maintains the intrinsic character of the letter style. Such fonts are very useful where a broad typographic hierarchy is required without loss of character.

Design by Adobe Systems, USA

Below right: This office space and facade for Gensler Design, San Fransico, reflects the company's own design approach. Innovative graphics are used throughout the interior, where individual workstations are mixed with shared work areas. Giant dingbats above the entrance make for unusual typographic imagery. The only sign identifying the company is very small and can be seen on the lower right-hand side.

Design by Gensler, USA

aaaaaaaaaaa Now just £70/DM 235'/FF 699 each! See offer, page 9 Multiple master typefaces: infinite flexibility at a singularly low price 22222222222 aaaaaaa aaaaaaaaaa

Below: The stark contrast in size gives this CD cover a range of levels of interest in type as image and information. Individual letterforms were enlarged and the resulting abstracted shapes layered using PhotoShop. The typeface (developed specially for the project) creates a visual tension between the heavy rounded letterforms and the crisp arrow-shaped countershapes.

Design by Swifty Typografix, UK

styles and sizes of letterforms are strong and interesting enough to work both individually or together in monochrome or color at very different scales, making them highly flexible and suitable for merchandising and packaging. Design by Chermayeff & Geismar, USA

Right: Exaggerated kerning and a degree of baseline shift transform a simple word into a powerful typographic impasse in this spread from the book "Just One More." The size and scale of the letters in relation to the page, together with the sharply contrasting text sizes, reinforce the message.

Design by Barney Pickard, UK

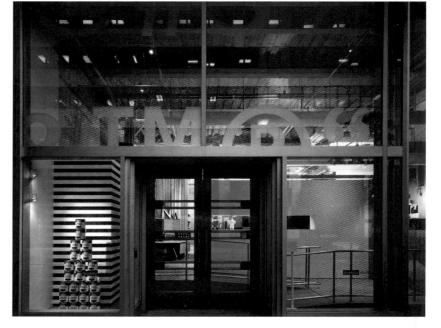

Positive tracking

Modernism, as we have know it, has served as the aesthetic, spiritual and moral conscience of our time. It embodies the essentially democratic idea of the creative artist as the inventor of a personal style, a unique vision of the world.

Display faces are specifically designed for use with only a few words, as the term suggests. They are not normally suitable for continuous text. Gimmicky or quirky typefaces are usually best used for display work only. Text types can be enlarged to display sizes, but doing so may create letters with distorted proportions, which will affect the type's appearance and may affect legibility.

Most typefaces are designed with a basic roman (upright) and true italic (or oblique) style and perhaps one or two other weights (light, bold, etc.). Other types have extensive families of weights ranging from extra-light to ultra-bold and of styles ranging from condensed to expanded. Using a classic extensive type family such as Univers (which has twenty-two variants) can be useful when complex information needs different levels of emphasis; it will ensure that changes of type will work well together stylistically.

TYPE FOR SCREEN DISPLAY

Text for monitor display should be set at sizes larger than for print since small letterforms cannot be formed accurately by the restricted number of pixels on screen, so making them difficult to read. Similarly, typefaces with fine serifs are unsuited to screen display—fine detailing is lost in the screen rendering. However some type companies, notably Agfa Monotype, have produced fonts called ESQ (Enhanced Screen Quality) that have been enhanced for on-screen viewing.

The color of both background and type needs extra consideration, since monitors can be bright and harsh to the eye. Colored or dark backgrounds can help to ease monitor glare.

The space between lines of type is known Word as leading

Negative tracking

Modernism, as we have know it, has served as the aesthetic, spiritual and moral conscience of our time. It embodies the essentially democratic idea of the creative artist as the inventor of a personal style, a unique vision of the world. Modernism fosters a dynamic

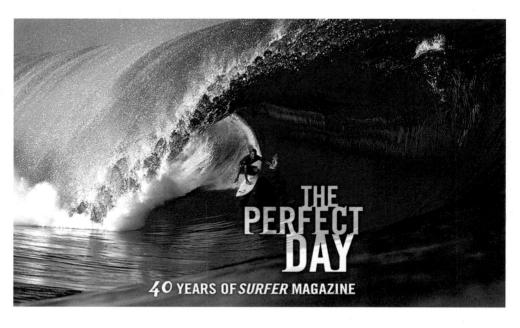

Above: Minus leading between the three words of this book title creates a simple, typographic image that echoes the image of a perfect ride, on the perfect wave, on the perfect day. The full bleed used with the image is designed to give readers a sense of being on the board themselves. inside the gigantic curl. Design by Regina Frank / SDA Creative, USA

SPACING TYPE

Type is spaced both vertically and horizontally. Vertical spacing, referred to as "leading," is the space between each line of type and is measured in points from the baseline of one line of type to the baseline of the preceding line. Increasing the leading can sometimes help to improve legibility.

Horizontal spacing is referred to as "kerning" or "tracking." Type is spaced in proportion to each character, using units as small as one-thousandth of an em (that is, the em of the type size in use). Designers of the best digital typefaces program special adjustments to the spacing of difficult pairs of characters such as AV, Te, ll, and li into their fonts. This information forms part of the font metrics and is applied automatically when type is set. Some page layout programs allow the graphic designer to modify these pairs, but this is something recommended only for experienced typographers who have good reasons for doing so.

Space can be added or subtracted between a range of characters (for example across several words or lines) by tracking. Word spacing can be similarly adjusted. The space between individual pairs of letters can be kerned (increased or decreased) to make them sit more comfortably together.

Colors

Air Freshener

Agency / Wink Client / Sky Wash Detial and Lube Date / Summer 2000 Art Direction, Design / Erik Torstensson Photography / Sesse Lind Icons / 500 GLS

Typeface

Neue Helvetica 35

> Neue Helvetica 55

Letterhead

Service Menu

Icons

Posters

Thank You Card

Complimentary Wash Card

based in Atlanta—illustrates how a whole range of coordinated graphics can be developed by cleverly picking up on key elements of the logo. Design by Wink Design, USA **THE DESIGN PROCESS** Design is normally carried out in response to a need and inevitably involves a certain amount of planning. The parameters may not always be clear in the first instance, since clients can have difficulty in pinpointing their exact requirements. Graphic designers are normally employed to bring their individual creative ability and practical understanding to solving a particular problem.

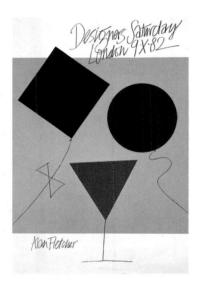

Acquiring an insight into the clients' businesses is an important part of informing the creative process. This can often be done simply by listening to and learning from clients, who usually know their own businesses intimately. Sometimes a client may be convinced that a particular medium or context is the best way to promote a product or service but, after careful analysis of the brief by the designer, an entirely different medium or approach may emerge as more suited to the actual, rather than the perceived, needs of the client.

The designer needs to make a reasonably accurate assessment of the size and complexity of the job and level of budget allocation. It is, for instance, unwise to embark on a corporate identity design without first agreeing which specific elements are going to need design consideration. Is it a logo or letterhead, or will there also be a requirement to look at packaging, vehicle livery, and uniforms, a signage system, website, and design standards manual? Even a small-scale design can involve unexpected work, such as having to include,

Above: This poster formed part of an in-store campaign for a department store that aimed to move away from clichés and express the real spirit of Mother's Day—a lie-in or a half-hour to herself will mean more than just tokens of appreciation.

Design by Williams Murray Hamm, UK

Above left: The idea for this classic poster grew out of the designer setting his own parameters in response to a wide open brief for Designer's Saturday in London. The event combined business and fun as the inventive and witty transformation of the primary shapes suggests.

Design by Alan Fletcher, UK/USA

or rework a highly complicated diagram. Preliminary inquiries have to be made as to the feasibility and timescale of any reprographic and production processes from the completion of digital artwork before a realistic timetable can be worked out and agreed with the client. These initial planning stages are all essential to the design process. The only real drawback to digital design is that it allows designers to explore endless variations of ideas and colorways in a process where time is usually at a premium and decisions have to be made quickly.

When it comes to the creative element of the design process, there is little doubt that paper, pencil, and digital software can work well in partnership. Paper and pencil are valuable basic tools for the digital graphic designer—much creative inspiration can come from doodling and note-making both on- and off-screen. Whichever starting point you use, your creative approach should always be informed by the brief. Basic guidelines for possible approaches can be set up by identifying from within the brief the answers to seven simple questions. This exercise will also help you to clarify your intentions for the design.

The questions are:

What - is the message to be communicated?

- is the reason for the brief?
- is the problem to be solved?

Why - does the client want to communicate the message?

Where – is the message going to communicate, and under what conditions?

Who - is the intended audience or market?

Working out and evaluating the answers to these questions should give you a springboard for idea generation that will help you maintain a reasoned link between the brief and even the most lateral approaches. One or more key words, images, or points should emerge from the analysis. These can be used as the basis of short but intensive visual brainstorming sessions on paper or screen to help start ideas and associations flowing.

Drawing need not be restricted to paper for these sessions; many designers find working with a digital tablet creates a natural progression from hand to screen. But, whichever method you use, the value of drawing as a tool for visual thinking and exploration is important to recognize. Thinking through drawing focuses the mind and, as it rarely produces "finished" or resolved ideas, its flexible immediacy can suggest alternative routes for exploration, allowing for "happy discoveries" along the way. For this reason, put down every response that comes to mind, whether or not the relevance is immediately clear—often, it is not! Wit and humor can also play an important part in graphic communication, and they often make for entertaining, informative, and memorable designs.

When working in a three-dimensional field, any initial two-dimensional creative thinking can be developed through the making process with small-scale maquettes and mock-ups or by using a three-dimensional modeling program.

Drawn or doodled ideas, whether on paper or screen, should be stored, and those with potential should be researched and developed further without imposing too many constraints. Although ideas are generated by the creative intellect, they normally need some form of reference to underpin them, since the imagination cannot always be relied on for accuracy. Access to the Internet is extremely useful for this purpose—the World Wide Web offers a vast storehouse of knowledge and visual references that can both inform and

Above left: This masculine indentity was designed for the re-launch of "Nutters," the London clothiers founded by maverick tailor, Tommy Nutter, in 1969. Nutters's trademark look was created through dramatic and humorous twists on classic English style.

Design by Bryn Jones, UK

Above: This double-layered book jacket features an outer layer printed on heavyweight tracing paper, designed to play with the book's theme visually and to physically involve the reader as the book is opened.

Design by Chronicle Books, USA

stimulate the design-making process. Digital image libraries offer downloading facilities, and it is possible to download royalty-free images. Ideas should always be thoroughly explored until they are fully resolved, and all research should be kept as it can sometimes conjure up different ideas worth following.

When an idea seems right, the designer should assess how it can be realistically applied to all the components of the job. Decisions as to choice and use of type, images, and color then need to be made. If you do not have the typeface you feel is suitable, font manufacturers have many browsable websites where it may be possible to find a face that fits your particular requirements. To assess colors and make choices, alternative colorways can be set up and viewed in most graphic art software packages. Images and graphics may either be supplied by the client or may need to be commissioned by the designer. They in turn may also help to generate ideas and influence the final design (see Image Selection and Image Creation).

Above: A page of ideas, notes, visual thinking, and thought exploration—an essential part of the design process, helping to generate and develop ideas as well as clarify intentions. Finding a "story" that will lend itself to visual interpretation is often a challenge to the designer. For this report for Cadence Design Systems, the aim was to

conceptually show the unique role of the company and the irony that difficult situations in a complex industry create growth opportunities. In the completed report, the headline and velour cover inventively encapsulate the aim with the images reflecting the global and everyday use of Cadence technology. Design by Cahan & Associates, USA

Below: Initial ideas sheet for sculptural light towers designed to define and frame entrances to the new scheme for Principe Pio, one of Madrid's main railroad station and metro interchanges. The design combines ideas of movement, destination, and connection with angled signage elements that further enhance the idea of dynamic movement. Bold color reflects the modernity and elegance of the space. Design development and refinement for presentation visuals were done in Illustrator 9.0. Rendering effects were applied in PhotoShop 6. Design by RTKL, UK

Most client's will have computing setups that allow you to communicate by email and to send visuals in a digitally viewable form. The graphic designer should be in a position to make PDF files, which can be viewed on any computer, and should also have a commonly used compression program. Once initial ideas have been approved or modifications agreed, the detailed design for each and every component of the job can be finalized before work can be prepared for production.

Every production process demands varying amounts of execution from the designer, but it will inevitably involve a digital file being prepared in a graphic arts program. The designer's file may be used directly to drive a printing device or a process with little or no intervention from the printer or anyone else. This raises two very important points. First, the content of your digital files must be correct in every aspect, with type and image information appropriately supplied. Second, it is extremely valuable to develop a good working relationship with your supplier, and ensure that there is a clear indication and understanding of responsibilities. Never assume that everything created digitally is going to be perfect—it is absolutely essential to have proofs for all print work, regardless of how small or big the job may be. Never rely on output from your studio printer being identical to that of the printer's or bureau's device.

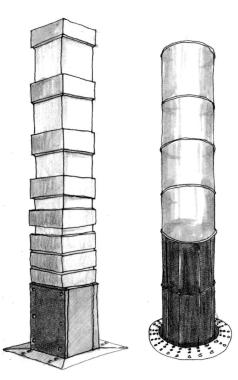

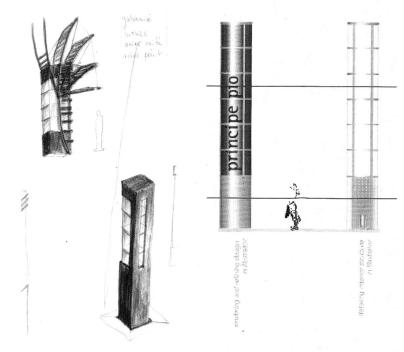

Left: Advertisement for Audley shoemakers. The concept for this intriguing ad cleverly plays on the idea of the two sides of the brain—emotional and rational—to parallel the company's philosophy.

Design by Lippa Pearce, UK

Below: Although display type set vertically is economical in one way, it puts added reading strain on the eye as it is forced to jump unnaturally downwards, from letter to letter.

E R T HORIZONTAL

LEGIBILITY VERSUS READABILITY

Continuous text needs special attention, since it contains large amounts of detailed information that needs to be easily understood. Readability is concerned with the speed and ease with which the reader can assimilate and retain information printed on the page or screen. Although individual components (letters) may be legible, this does not automatically mean that reading is easy. Readers perceive words not simply as sequences of letters, but as groups of letters and words. These letter and word groupings facilitate speedy recognition as the eye scans the text. Anything that contributes to the breaking up or the slowing down of this scanning process makes for harder and more tiring reading. For example, exaggerated tracking (character and word spacing) will disrupt the normal shape of words (recognizable letter groupings) causing strain to the eye and brain.

Character and word recognition are more easily achieved with upper- and lowercase letters, since they create a greater range of word-icon shapes and individuality than uppercase alone. Capital letters all appear to occupy equal spaces when set in a line of text, so the words they form are more difficult to discern at a normal reading speed. The relative weight of type can also affect legibility. Medium weights are easiest to read because of the visual balance between the counter-shapes and letter strokes. Extreme weights of both light and bold type are more difficult and tiring to read as the contrast between the letter strokes and counter-shapes is distracting.

\ \ \

A L

Modernism. as we have known it. has served as the aesthetic, spiritual and moral conscience of our time. It embodies h essentially democratic idea of the creative artist as the

Modernism, as we have known it, has served as the aesthetic, spiritual and moral conscience of our time. It embodies the essentially democratic idea of the creative artist as the inventor of a personal style, a unique vision of the world.

Modernism, as we have known it, has served as the aesthetic, spiritual and moral conscience of our time. It embodies the essentially democratic idea of the creative artist as the inventor of a personal style, a unique vision of the world.

Modernism, as we have known it, has served as the aesthetic, spiritual and moral conscience of our time. It embodies the essentially democratic idea of the creative artist as the inventor of a personal style, a unique vision of the world.

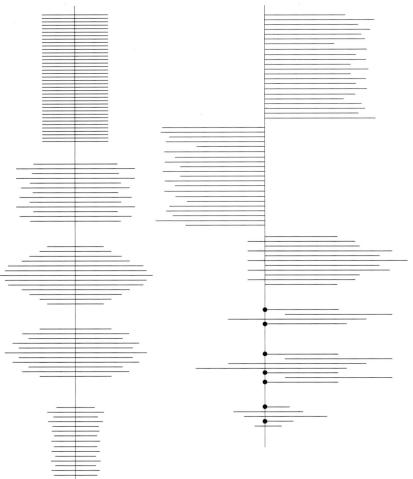

The style of text setting—justified, flush left or right, centered, or asymmetrictogether with line length, also has an effect on the readability of text. In reading any length of text, the eye is generally more comfortable in returning to a straight left-hand edge. However, small groupings of text can usually be read in most of the setting styles. Justified setting (text that is aligned at both sides) is not suitable for very small blocks of text where ugly word spacing will occur. Justification can also sometimes create difficulties with hyphenation and word spacing in longer, continuous text unless this is carefully controlled. Hyphenation at line ends can sometimes create an unnecessarily "spotty" look and should be avoided where possible.

Line length also affects how text is read. If lines of text are too long, the eye has difficulty in returning to the start of the next line. Conversely, if lines of text are too narrowly set, the eye is made to progress too quickly from line to line and may skip lines, interrupting the flow of comprehension.

Left: Digital technology allows almost limitless possibilities with text setting styles. However, when working with continuous text, even in small amounts, it can be helpful to establish an axis to give the design structure. These diagrams show a range of variations than can be useful.

Below: Lowercase letters have individual key characteristics that tend to be in the top half of the letterform. These characteristics are more important to letter and word recognition than those in the bottom half. This is particularly noticeable in serif typefaces where the tops of letters are more easily identifiable. In sans serif designs, there can be greater similarity between the top halves of letters

Design by Brian Coe, UK

Although these disturbances will have little effect over a few lines, they will tire the eye over large amounts of text. As a rough guide to line length, an average line of text in the English language reads comfortably with approximately sixty-three to sixty-five characters (counting word spaces as characters).

Digital technology enables both display and text type to be very flexibly set into shapes. Running text around images is also easily done. However, in working with either, care has to be taken to maintain coherent, readable text by controlling each individual line break.

Display type is normally restricted to a few words and presents fewer problems to the reader due to its size, weight, and dominant position in the design area or on the page. The designer should, however, look carefully at the spaces between characters and words in larger type sizes. Pairs of letters may need individual kerning to aid readability. Where several words are involved, one or more word spaces may need to be optically balanced—adjusted by kerning or tracking—to counteract the effects produced by the shapes of the last and first letters of the words on either side, which may be exaggerated at display sizes.

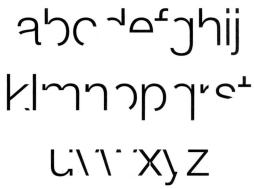

Top left: Setting justified type to an overly narrow measure throws up exaggerated letter spacing to fill the measure and makes for difficult and tiring reading.

Left: A comparison of overly long and readable line lengths.

Bottom left: Tight tracking makes an interesting but illegible typographic pattern. Loose tracking weakens the horizontal character of lines of type and so slows and hinders reading.

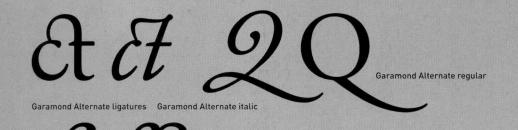

Upper and lower case SMALL CAPITALS

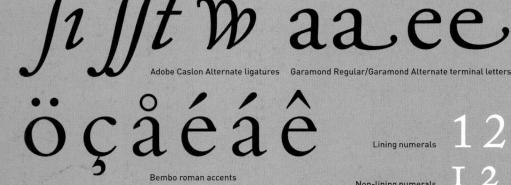

EXTENDED OR EXPERT SETS

Many digital typefaces have extensive ranges of characters well in excess of the basic set of letters, numerals, punctuation marks, and symbols included as standard in most fonts. Some font formats allow such additional characters to be included within a single font file; these fonts are referred to as having extended character sets. More commonly, additional characters for a typeface design are supplied as a separate font, known as an expert set. In either case, the serious typographer is provided with a range of alternate and supplementary letterforms that share the inherent form and structure of the basic typeface.

One example of an alternate character is the swash character, a decorative version of a letter with an exaggerated sweeping entrance or exit stroke that may even extend beyond the normal width of the normal character (i.e., the stroke overlaps the preceding or following character). Many swash characters are meant to add a flourish to either the start or the end of a word, so there can be more than one version of any individual letter. Capitals are common, but some designs include swash initial, terminal, and even medial lowercase letters (see above).

Nonlining (or old style) numerals make for more fluent reading than lining numerals and can be useful for softening large quantities of numerical information, particularly when set in the body of text. Expert sets may also include alternative small capitals, which are generally matched to the typeface's x-height and weight, unlike reduced-size capitals.

Above left: Expert font set showing the range of alternative characters available. Most expert sets include "old style" or nonaligning numerals in which some numerals rise above and below the x-height and baselines. This style of numeral works well within text because it is less disruptive to the visual continuation than aligned numerals. They can also be softer to read in tabular form.

Above: This page from a brochure for Entec creates a precise yet complex typographic "sound image," which reflects the nature of the product: high-fidelity speakers. The three-dimensional, broad-ranging nature of sound is suggested through strong contrast in size, weight, color, and type style, and semi-abstraction of parts of the letterforms. Design by Mauk Design, USA

LAYOUT The design area or page format and margins are the basic components of layout, which—like everything else in the design process—should always be informed by the content of the job and the creative approach. How and where the end product is to be used or viewed must be taken into consideration in deciding a suitable size and format.

Size and format can range from pocket to wall-size, in both two and three dimensions. When designing for the Web or multimedia, where the overall maximum area is predetermined, consideration of the page proportions should still be given.

In almost every design context, the graphic designer will need to set up an appropriate page or design area structure (see above). This is normally done in a page-layout program, and it initially involves making a series of interrelated design decisions: width of the top, foot, and side margins (essentially there for handling purposes and for leading the eye), the number of columns for text and image organization, and where appropriate, the number of pages or surfaces that may be involved. Once these

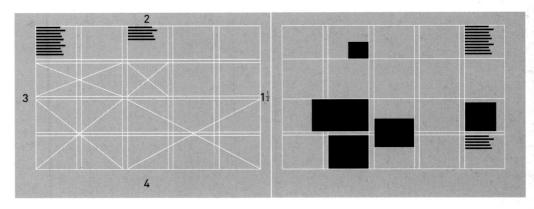

Above left: Structuring the design area across a series of pages or surfaces so as to give maximum flexibility without losing continuity is important to holding the viewer's attention. This can easily be achieved using master pages.

Above: Margin proportions will vary depending on the design context as in the diagram above, but as a guideline, the foot margin is normally double the head margin and the foredge margin double the width of the back margin.

decisions have been made, the page structure can be set up as single or facing pages in templates (or master pages in desktop publishing programs) to allow automatic repetition of the original structure across numerous pages.

Multipage surface design benefits from adding a further underpinning structure or grid to the basic page. This is done by subdividing the basic page structure into sets and subsets of equal vertical column widths. The greater the number of divisions or columns, the greater the flexibility. The modularity that is created can be used invisibly to structure the relationship of quite disparate elements, with some running across several or all of the columns. If the complexity of the job requires additional underpinning, a horizontal grid can be constructed in a similar way. A grid system can be particularly useful in helping to keep a sense of continuity across a range of different pages, sizes, scales, or formats. Corporate identities, exhibitions, advertising campaigns, and multimedia can all benefit from the controlling influence of a grid system.

Diagonal layouts can be very powerful but need to be kept simple because they may hinder the reader if too many elements are involved.

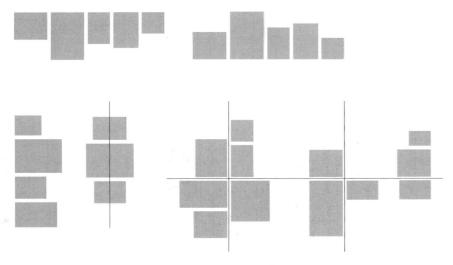

Left: Most graphic design work involves a number of different sized and proportioned elements that have to be coordinated within a given area. This diagram shows "hanging," "sitting," vertical, and centered alignments together with combined horizontal and vertical axes around which different clusters of elements can be grouped cohesively.

DOCUMENT SIGNPOSTING Most graphic design includes working with some element of text or copy. Most copy needs ordered presentation, so before any design work starts the designer should work through it to establish some basic organization or hierarchy.

Breaking the copy down into digestible passages, if only by white space, will automatically pace the reader. Controlling the space between elements will determine the reading sequence. Hierarchical conventions will direct and signpost the reader through, for example, a book, via the title page, the contents page, the page numbers (folios), chapter headings, subheadings, paragraphs, and footnotes.

Designing a website will often involve developing an ordered, functional, and user-friendly navigation process to take the viewer through the various pages. In advertising, the hierarchy of information may be as simple as a main heading and strapline, while an instruction manual may contain many layers of information. Developing a visual hierarchy will order information and make it easily accessible. The exercise will normally include typeface and style together with varying levels of emphasis for other elements through the use of size, weight, color, and disposition. Even the structuring of the basic paragraph needs many decisions about detailing (see diagram).

Bullet points (circular, square, or triangular) and selected dingbats (for example, Wingdings) can be used to highlight and draw attention to listings, instructions, or blocks of text, but the level of emphasis should be compatible with the rest of the text and overall context. The size, weight, or color of bullets and dingbats should complement, rather than

Column width La puerta con dos casas es lo permanente, inacesible. Esta Type face casa de alforja se encuentra en el territorio de los acontecimientos simultáneos. Dos espacios que se aman, que se besan, pour una puerta que no se sabe si separa o une. Aquí todo tiene la suficente claridad y la deliciosa Indents oscuridad de la armoniá. No nos sabemos dentro hasta que unos pasos más allá de la primera puerta, nos encontramos Alignments fuera del edificio; nunca sabemos qué es demasiado. Todo recuerdo de este viaje será el instante en que abandonamos esa sensación Type size de recogimiento, memoria irrecuperable de un espacio inmenso, inmensamento La puerta con dos casas es lo permanente, inacesible. Esta Type style casa de alforja se encuentra en el territorio de los Leading acontecimientos simultáneos. Dos espacios que se aman, Inter paragraph spacing AQUÍ TODO TIENE la suficente claridad y la deliciosa Case oscuridad de la armoniá. No nos sabemos dentro hasta que unos pasos más allá de la primera puerta, Tracking fuera del edificio; nunca sabemos qué

Below: Where it is essential that the viewer reads the design in a particular sequence, subtle grouping through the use of white space that is one and a half to two times the spacing between the individual elements in a group will naturally guide the eye through the grouping sequentially. When elements are butted up to each other, the eye will read the surface as an entity in itself.

compete with, the other elements in the design, and should direct the reader to and through the points in a relevant sequence.

Frames and rules are devices that can help to isolate, contain, formalize, contrast, and draw attention to text, image, or area. The weight, style, and color of the line used to make a frame will control the level and intensity of focus, but the design and proportion of the frame should be integrated with the main context. Framed text or other elements often appear within a main body of text, but they should still be capable of being read independently. To achieve this, the framed text needs to be set to a narrower width than the main text to allow for the thickness of the frame and a reasonable space

Below: Size, type style, icon, disposition, and typographic devices are combined to visually pinpoint key locations in the wayfinding system for the American Museum of Natural History in New York. Clarity in the design is essential in preventing visitors from getting lost in the huge building.

Design by Lance Wyman, USA

Right: Examples of conventions used to make sense of copy and so guide the reader through documents.

HEADINGS
Chapters
Sections
Major topic
headings
Subheads
Sub subheads

CAPTIONING Illustrations Photographs Charts Diagrams Tables

QUOTATIONS

Speech

Extracts

NUMBERING
Pages
Paragraphs
Footnotes
Cross referencing

INDEXING
Index
Table of contents
Glossaries
Appendices
Biblographies

PUNCTUATION

Pace Sense

between it and the text. Surrounding white space can suggest a frame (as with margins on a page) through the placing of single element within a large area. Decorative frames should be used sparingly; they can easily distract attention from the content.

Desktop publishing programs make a distinction between rules that can be placed before or after paragraphs and underlining, which is a feature of the type style (character underlining or word underlining).

Typographic rules have considerable potential in their own right as design elements and need not be restricted to being used in conjunction with paragraphs. They can direct and arrest the eye, physically divide areas or separate elements, pace the viewer, and be a facilitating device in leading the eye along the horizontal, vertical, or diagonal direction. When placed above, below, or to the side of an element, a rule has an anchoring effect on it. The level of focus and emphasis created in this way can be accentuated or diminished by modifying the relative size, color, texture, or weight of either the rule or the element. If different weights of rule are used in the same design area, they should be distinctly contrasting—if they are too similar in weight, they may look like a mistake or be indistinguishable from each other. Whichever type of frame or weight of rule is used, it is generally better to keep the scheme simple.

Above right: The impenetrable nature of the Berlin Wall is graphically conveyed in this exhibition display through the use of heavy typographic rules carrying tightly contained, reversed out type. Design by Ruedi Bauer and Pippo Lionni, Germany/France

Right top: A contrasting rule will anchor text to it. This device can be repeated within a design with different column widths to give an overall structure. A further rule placed after space below text or images will help to contain them.

Right middle: Within a design that uses marginal headings or two different column widths, a combination of vertical fine and bold rules can help to determine the reading hierarchy.

Right bottom: Rules can be a useful device for both separating and coordinating different elements within a design.

IMAGE SELECTION The client may provide the designer with a set of images that are integral to a particular job, which leaves the designer with no say in the content or design of the image and little say in the selection. However, the designer does have control over how the images are used and, when selecting from a range of existing images, he or she should ensure that the selection "tells the story" appropriately.

Right: The paintings used in this
Corporate Membership Program
for the National Gallery in London
were all selected from the gallery's
vast collection of new and old
works. The repeated use of strip
images plays on the title and
human nature—the reader's desire
to see more.
Design by Agenda, UK

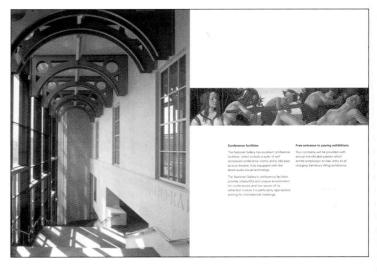

Above: Strong images and a bold message were used in this Maxygen annual report to illustrate how the company's new technology, molecular breeding—

which imitates the natural process of classical breeding to achieve desired genetic characteristics—is not worlds away from farming. Design by Cahan & Associates, USA Initial impact may be of prime importance, but drawing the viewer in through secondary and tertiary levels of interest should also be considered. There are, however, some occasions when it is better to invest in a completely new set of images. The designer can then advise on them or be involved in selecting them or commissioning them from a photographer or illustrator. As coordinator of all the elements in a design and manager of the process, the designer has a responsibility to prepare a focused brief outlining the aims, purpose, format, and context of the image-making. This should be agreed with the client and photographer or illustrator, and supplemented with detailed instructions concerning appropriate file formats and resolution values (see Image Creation).

Every aspect of an image should contribute in some degree to the overall message and mood of the design. Images may clarify, contrast, enhance, and partner text or other elements, but they should never be used as gratuitous "addons." Scaling and cropping images and deciding on a presentation method (color, black and white, duotone, cutout, or squared-up) need considerable care and attention, and should also bear a direct relevance to the overall design. Judicious cropping can substantially affect the visual impact and balance of the image itself, as well as influencing the message and other design elements.

Below: The nature of the high-tech company Geron, which develops treatments for age-related diseases, is humanized in this annual report companion design with its dramatically contrasting images and scales captioned with the subjects' small handwritten text. It is an approach with which readers can easily identify.

Design by Cahan & Associates, USA

Bottom: In this book spread the image is used to inform the typography in which the horizontal lines and color are picked out and continued through onto the facing page.

WEAT BOES GETTING OLD MEAN TO YOU?

I willing about my dies as real likely me. If I'll drive them them they I hope they'll

When you bend down you don't get up as fast. Take one day

Chapter 8: THE END of the RAINBOW

J. A. Bauer Pottery Co., Los Angeles Plainware mixing bowls (left) c. 1730.

Meyers Pollery, Vernon
California Rainbow mixing
bowls (center). c. 1935.
Japan. Cactus salt and pepper
shakers, unmarked. c. 1930s.
Meyers Pollery, Vernon
California Pandous law bould.

California Rainbow low bowls (right), unmarked, c. 1935. California Rainbow cosserole (lower center). J. A. Bauer Pottery Ca., Las Angeles

Cyclinder vase (foregraund

If ever a Golden Age was misnamed, it was California Pottery's. Except for some gilt trim from Sascha Brastoff, the treasures of that period are of little intrinsic value. They're just some molded earth sealed with a few nonprecious minerals. Although pottery is currently enjoying a collector/decorator revival, the worth of these once insignificant objects is best measured in terms of the pleasure they give to those who use, collect, or simply admire them. The fact that after all this time they are being used, collected and remade confirms their relevance to the way we live now.

For years collectors had been baffled: despite their best efforts they had been unable to learn anything about the creator of the pottery signed "Barbara Willis" that some of them prized. Then, in 1995, a woman in her seventies wearing a straw hat over bright red hair pointed to a vase at a Los Angeles flea market and said: "That's mine. I'm Barbara Willis. I made that." It turned out that Ms. Willis had closed her North Hollywood pottery in 1958 and was living happily in Malibu. After her "discovery" she began producing again, hand-thrown pieces this time, but in the same signature combination of intense glazes and exposed

DESIGNING WITH COLOR Color is the element that brings an added, almost magical dimension to visual communication. It reflects the everyday world and human experience, giving the designer a strong common language with which to express mood, emotion, and significance.

The digital graphic designer has an almost limitless color palette with which to work and evoke specific responses in the viewer. Color can be used as appeal, inspiration, entertainment, a focus, or an identifying marker.

Color is always relative and never works in isolation. The viewer responds to color within a context and in association with other colors and graphic elements. Environmental and lighting conditions affect the way color is perceived, which is a particular consideration when choosing colors for packaging, signage, and exhibitions.

Color can be used as a means of identification and coding, as in pie and bar charts, where a range of different elements of equal importance need to be identified. In such contexts, care should be taken to mix colors (hues) of similar tones (brightness) and intensity (saturation) to avoid giving undue emphasis to any one element. In a situation where it is necessary to create levels of relative importance, a change in color intensity or brightness or both can be used as a hierarchical device.

Combining complementary colors (true opposites on the color wheel) will set up a natural vibrancy if a sense of excitement and energy is needed. To use color emotively, it is essential to have an understanding of the design subject matter and the audience to which it is directed, so that color choice can be appropriately related. Colors can be considered as warm or

cool, soft or hard, light or dark, passive or active, all of which characteristics can be used individually or in association with each other. Mood is greatly affected by color temperature.

Color association forms an important part of color language in all areas of graphic design. This can be seen in the way that greens are used for freshness, blues and whites for hygiene, red for danger, and purple for richness. There are many examples of color combinations that are associated with politics, nationality, sports, religion, or cultural and social conventions. The designer has to be aware of all of them, in order to avoid creating confused messages. For example, red and green are recognized across the world as symbolizing "stop" and "go."

It is impossible to provide a set of rules for particular harmonious color

Far left: Color has been used to great effect in this initial lively sketch for the final, dynamic jazz poster. A simple, brilliant color "sings" from a rich, dark background evoking the mood and rhythm of the music.

Design by Niklaus Troxler, Switzerland

Left: This inventive annual report for the Linear Technology
Corporation is made up of two contrasting books—"Digital" and "Linear"—packaged in this bright sleeve. The "Digital" book is monochrome and only contains indecipherable streaming ASCII code. The "Linear" book dramatically makes the point that "digital means nothing without linear" through pages of brilliant digital color and succinct, accessible black text on pure white. Design by Cahan & Associates, USA

Left: Color coding in diagrammatic maps ensures a clarity of communication and quick recognition that can be flexibly applied to related graphics and signage.

Design by MetaDesign, Germany

PASSION FEAR COWARDICE

EMBARRASSMENT TEMPER DEPRESSION

Below: The distinctive color choice and minimalist packaging design for Apollo Lager deliberately breaks away from traditional beer packaging to coolly reflect the product name and the associated space travel theme in a memorable, understated way.

Design by Cahan & Associates, USA

Above: Color and meaning varies widely according to different cultures. For example in much of Asia white is associated with death while in the West it is associated with purity. These associations and differences can be useful in making unusual connections or changing perceptions depending on the design context.

Design by Alan Fletcher, UK/USA

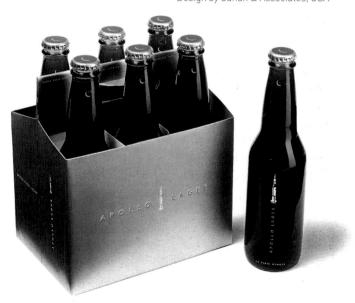

Left: The combination of green background and fluorescent ink used to print the tiny numbers on the June page of this Olivetti calendar, was so dazzling that the Italian printer wore sunglasses while working with the job! The powerful color combination that suggests red flowers in a green field is primary and the information secondary. This emphasis is used to bring feel of summer into the office environment.

Design by Alan Fletcher, UK/USA

TYPE AND COLOR

All the uses of color to express mood, emotion, or significance can be equally well applied to type. Color may be used to modify the way in which type works: bold type can be softened, hierarchies can be developed without recourse to change of size or weight, text can be enlivened, and typographic emphasis can be subtly enhanced.

When designing with colored type on a colored background, the designer must consider the choice of color combination carefully in order to ensure legibility. In general, type and background need to be significantly contrasting. Dark type on a pale

combinations, since these change according to different environments, fashions, and culture. The designer may consider setting up disharmonies as a way of creating shock or provocation, which may be a perfectly legitimate way of communicating a message.

Graphic art software provides tools for selecting and mixing colors in a variety of models. These give the designer unprecedented control over color creation and usage (see Color). The hue, saturation, and brightness (HSB) model is particularly useful because it enables the creation either of different hues of the same brightness and intensity or of varying intensities or brightnesses of the same hue.

Designers should be aware that their color perception can be affected if they set strong background colors for their monitors. Large areas of color and poor lighting in the working environment will have a similar effect on perception. It is advisable, therefore, to set the monitor to a neutral gray when working intensively with color, and to paint design studios in neutral colors.

Right: These unusual curved vertical signs for a drycleaning and laundromat business mimic laundry drying on a line. The freely drawn imagery combines with crisp type and fresh colors for this "new concept in clean clothes"—the idea being that doing the laundry should be more fun than a chore. The colors are carried through the clean lines of the interior and branded merchandise. Design by Ashdown Wood Design, Australia

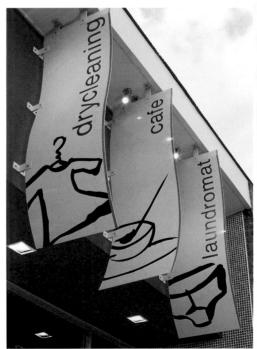

Left: Color and type reflect the "straight-talking" policy of TKB Solicitors, enlivening and humanizing the traditional, rather formal, perception of the legal profession.

Design by The Partners, UK

Left: Black was an unusual but distinctive choice for a coordinating element in the new, Suma supermarket identity in Barcelona. Together with special lighting, it is used as a means of focusing the eye on the many different colors of their merchandise. The graphics on these staff aprons show color used as coding for fish, meat, and vegetables.

Design by Suma, Spain

background, rather than on a white background, will result in less glare (particularly with screen-based designs, for example, on Web pages). Type and backgrounds of equal brightness (tone) will reduce legibility considerably. Color can be used with type to create a sense of progression and recession, to enhance spatial quality, and to suggest depth and perspective. The reading pace and sequence of text and display type can be further controlled through the use of color.

Setting type in dark colors may be unsuccessful if the letters have a small surface area with which to carry color; the result may appear to be a poor version of black. Type, particularly text type, has little surface area compared to the background surface on which it appears, so dark-colored type generally appears darker and light-colored type generally appears lighter. A heavier weight of type can be used to compensate for this phenomenon.

Interestingly, the millions of easily accessible digital colors have also brought a revived energy to the use of black and white that should not be underestimated.

Right: Subject areas are grouped together into discrete gallery displays in the Tate Modern, London. Each is identified in the plan (or on the website) by a unique color used in both the titles and floor plan, facilitating visit planning and wayfinding through the vast building.

Design by Halmes Wood, UK

SURFACE DESIGN

02.01

The roots of graphic design lie in our desire to communicate information—more especially by the arrangement of type and pictures on a printed page. Although the development of digital technology has made the possibilities virtually limitless, graphic design and print remain inextricably linked.

Graphic design for the medium of print embraces an extensive and varied range of products. These include promotional applications such as brochures, leaflets, flyers, direct mail, catalogs, and posters. Business communication tools include stationery, newsletters, training manuals, reports or menus. The publishing industry, producing magazines, books, and newspapers, is still one of the largest sectors employing graphic designers.

With ever-increasing market and client pressure to create eye-catching, innovative ways of presenting printed information, there are jobs that call for more specialized print processes. The use of materials other than paper—plastic, metal, or even fabric—is also becoming more prevalent.

The processes that take the concept to the printed product affect many design decisions made at concept stage. The choice of paper or other media, or the size of the print run, will dictate not only the type of print technology used but also the way the production files are created, including the appropriate choice of type and the size of the halftone dot.

The computer has shaped not only conceptual design, by encouraging freedom of layout and the breaking of typographic conventions, but also the linear process of transferring the design from screen to printed page. The traditional boundaries of the design-for-print process have been blurred. The designer equipped with a PC, or more commonly an Apple Macintosh, linked to a desktop scanner, a color output device, and a modem can take conceptual ideas through to press, although the final stage is still invariably an analog process.

There is a huge range of software available to realize this workflow. It is now possible for the designer to prepare the digital files required to make printing plates directly, virtually eliminating any intermediate reproduction stages.

PART 02. SURFACE DESIGN

CHAPTER ONE

DESIGN FOR PRINT

Left: Visual identity for Yosho.com.
The design utilizes a series of stripes printed as "spot" colors.
The colors were chosen to acurately translate into four-color process tints when incorporated into other printed elements, such as a brochure that contains photographic imagery.

Design by Segura, USA

Far left: Effective use of color, type, and imagery for the cover of *Frieze* magazine. The choice of color for for large, flat areas is very important as some hues are less intense when printed as process separations rather than specific PANTONE inks.

Design by Harry Crumb, UK

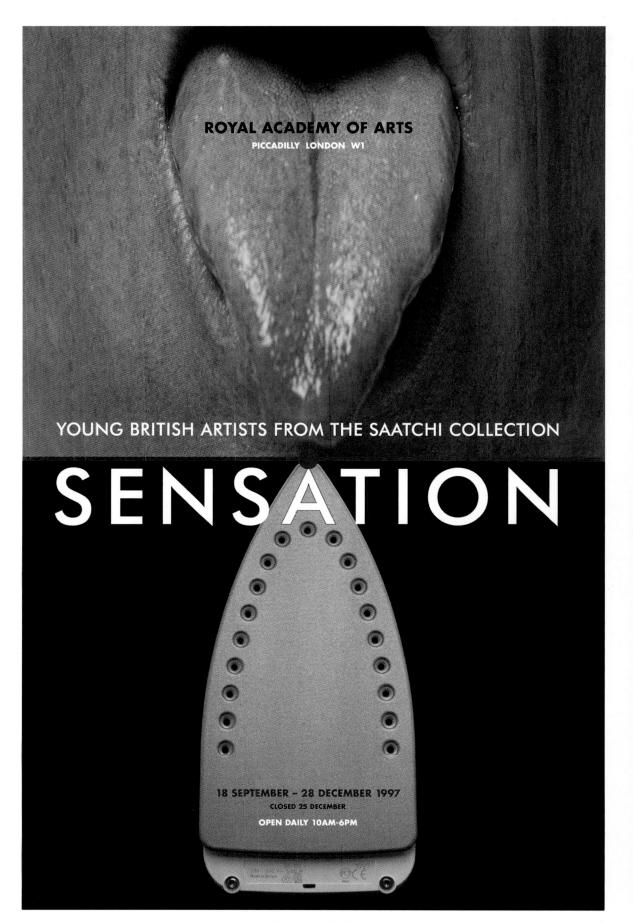

Right: Cleverly chosen imagery creates a powerful visual pun in this poster for an exhibition of British contemporary art.

Design by Why Not Associates, UK

THE SOFTWARE Over the past few years, there have been significant developments in software dedicated to both design and production, providing more streamlined digitally driven systems that take design directly to print. As a result, the definition of "publishing" has been greatly extended.

DESKTOP PUBLISHING (DTP)

Desktop publishing (DTP) software has evolved from the fundamentals of word processing into fully fledged design tools, streamlining the creation of very accurate "artwork" in which all text and pictures can be infinitely manipulated, and simplifying the construction and management of long documents. Text can be imported and then styled to the designer's requirements. There are virtually limitless attributes that can be applied in addition to the font style and weight. H&Js (hyphenation and justification), horizontal and vertical scaling, leading, kerning, and tracking can all be finely tuned.

Although there are far more Windows PCs than there are Apple Macintoshes, the design world is still dominated by the Mac. Because of this, almost all of the most important applications are available in both Macintosh and Windows formats, although if you're serious about design, you should use a Mac. The only exceptions are if you need to work with specific specialist tools such as CAD (computer aided drawing), where some of the key software is made for Windows only.

The key players in the DTP software market—QuarkXPress (regarded as the professional industry standard) and Adobe PageMaker (both vector-based applications, see page 212)—led the boom in desktop publishing in the late 1980s. These two old rivals have been joined by InDesign, Adobe's latest, advanced, desktop publishing software, aimed at both designers and prepress professionals. This benefits from excellent typographic controls and full "drag-and-drop" support, where graphic elements can be dragged into layouts directly from other applications.

Common to these DTP applications is the use of frames. Picture and text frames can have their exact position defined on the page (aided by the use of snap-to guides) and can be preformatted with type, paragraph, or run-around specifications, allowing the designer to lay out documents with fixed structures that are independent of content.

Frame tools include rectangle, circle, and polygon shapes. To make a frame, you simply draw the shape on screen using the text or picture tool chosen from the toolbox. Using

text frames also means that text can be placed inside virtually any shape and be justified. Picture frames can be given a run-around value to control the flow of text around an image. Frames can be layered, locked, stepped, and repeated by designated increments, or placed on master pages. They can also be converted to multiple text columns. Text frames can be linked, allowing text to flow automatically through the document.

Flexibility is further enhanced by the use of layers, which until recently have only been associated with graphics programs.

Layers can be on or off, locked or unlocked, and in view or out of view. They can also be exported and printed independently. Multiple-document layers are useful in a number of instances. For example, you may need to create several versions of your document using different languages, or you may need to add notes and comments to a document for

Normal

Opposite and this page: The three most commonly used page layout programs utilize similar toolboxes and on-screen dialog boxes to modify elements on the page and show accurate measurements.

PageMaker (far left) QuarkXPress (above and left), and InDesign (right)

Paragraph Attributes Formats Tabs Rules ☐ Drop Caps Left Indent: 0 mm Character Count: First Line: 0 mm Line Count 3 Right Indent: 0 mm ☐ Keep Lines Together 13 pt O All Lines in ¶ 0 mm Space Before: O Start: 2 End: 2 Space After: 0 mm Alignment: Left \$ ☐ Keep with Next ¶ H&1: Tight none | ☑ Lock to Baseline Grid Language Internati... \$ Apply Cancel OK for Web pages, while higher-resolution images could be placed on another for print.

New color technologies that, only a few years ago, were the preserve of the high-end prepress market have been brought to the desktop. The latest DTP software now makes it easy for the designer to produce digital documents that have a high degree of color fidelity and accuracy, making color publishing less expensive and more accurate for desktop prepress systems. Colors can be set up as spot colors or

production and prepress purposes. You could also use the layers

purposes. Low-resolution images could be placed on one layer

feature to develop documents for both online and print

DTP software now has built-in abilities to draw freeform shapes with Bézier tools although, in common with other graphic disciplines, designing for print still makes extensive use of vector-based drawing applications such as Illustrator and FreeHand. The designer also needs to be conversant with Photoshop for image manipulation and for correcting color, resolution, and file type.

specials, using a recognized PANTONE or Focoltone

number, or can be converted to four-color process.

When it comes to sending the final job to the next stage of production, DTP software has a "Collect for Output"

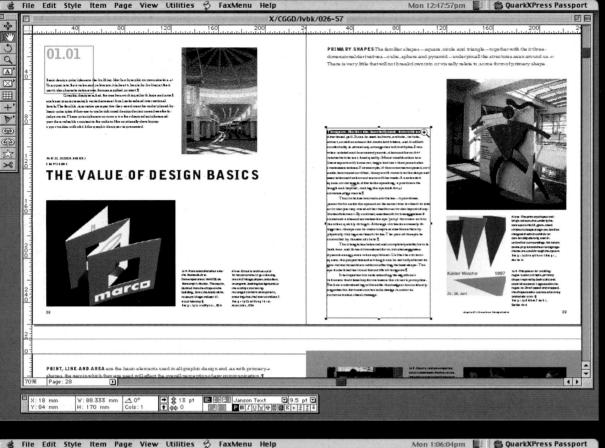

Left: A typical QuarkXPress desktop showing an activated text box. The box can be resized using the six "handles" and the position accurately adjusted in the measurements dialog box situated at the bottom left of the window.

Left: The floating palettes in action The document layout indicates the current page. By clicking in a text or picture box, and then making a selection from the colors palette, any element on the page can be color modified—individual letters, words, blocks of text, rules, or ever the boxes themselves. Note the use of the master page guides (in blue) and the individual positioning guides (in green).

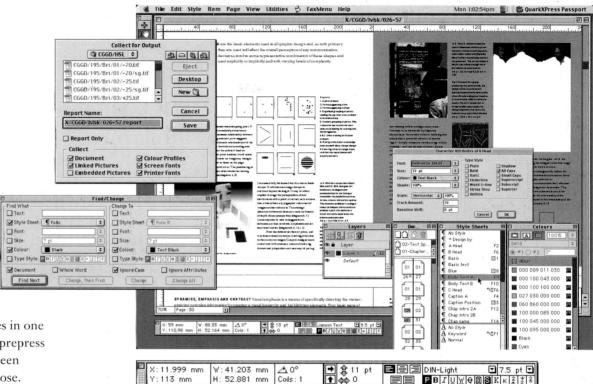

facility that places all required files in one folder. A number of independent prepress "collection" programs have also been specifically designed for this purpose. PreFlight Pro, for example, simplifies job preparation by not only collecting but also itemizing all files necessary to process the job correctly. Designers muct comply with font copyright when sending files to printers.

PRODUCTIVITY FUNCTIONS

Design productivity and document consistency have been greatly improved in DTP applications through features such as style sheets and master pages. Paragraph and character style sheets can be created to expedite the styling of text. Headings, subheads, introduction text, body text, and captions can all be assigned a style sheet and accompanying keyboard shortcut. If a font or style subsequently needs to be changed, the change can be made globally simply by amending the relevant style sheet. In some software, character styles can be applied to text within paragraphs without affecting the overall paragraph style.

Production can be further streamlined by using master pages, which might contain text, picture boxes, and grids arranged with the help of precise vertical and horizontal guides. Some applications feature multiple master pages, allowing several layouts to be managed within the one Above: Some of Quark's productivity features: The style sheet setup dialog boxes can be used to record individual text styles once the designer is satisfied with the layout. These can be appended to any other document. The find/change feature can change individual words, punctuation, font, and size throughout the document with a single click.

The collect for output feature places all required files (except fonts) into one allocated folder in order to send them to the printer or output house. The measurements bar shows all the attributes of the selected box.

document. Pages can be set up singly or in "facing" spreads, depending on the type of document, with automatic control of page numbers. Style sheets, colors, and hyphenation values can be selectively appended from one document to another, which is useful in magazine production when spreads with similar design attributes need to be created individually. Text alignment can be standardized by "locking" text to the baseline grid, which is particularly useful for long documents and book design.

Although each new version of DTP software seems to incorporate more and more specialized and sophisticated tasks, many third-party "plug-ins" or "extensions" are available to increase productivity further by automating specialist tasks. For example, printer's sections can be created automatically, entire pages or groups of elements can be scaled, and text can be treated with effects such as drop shadows. It becomes almost possible to perform every drawing, image, or prepress function within one application.

OPI AND FPO

Open Press Interface is an electronic imaging workflow standard that makes the on-screen design process quicker and the "live" files smaller. Images are prescanned and the designer is supplied with low-resolution positional guides, known as FPOs (for position only), to prepare the layout. Use of "low-res" images speeds up scrolling, screen rewriting, and rough proofing. The high-resolution versions are substituted before running film or plates by the OPI system.

SCREEN TO PROOF 1 Once the creative process is complete and both the designer and the client are satisfied with the design, the more practical side of production takes over. Preparing the page layouts for trouble-free output is essential.

PREPRESS

Much printing still involves producing film separations of each color to prepare printing plates, so it is likely that the designer will need to use the services of a bureau or the printer's own reprographic department. Although desktop scanning devices have greatly improved in quality, specialists continue to offer a higher-quality scanning service, using high-resolution scanners. Even if the workflow is totally digital, they can sometimes handle the conversion of files to Acrobat PDF format (see page 70).

It is important to have a good working relationship with your chosen bureau: you will need to discuss problems openly and know exactly what they expect from your files. The bureau will be able to advise on how to prepare the final file composition to speed up production, keep costs to a minimum, and make sure that the end result will print without mishap. If color or images "bleed" off the page, for example, the bleed specifications (usually 1/16 to 1/2 inch) need to be agreed with the printer and set up accordingly in the document, to ensure that any irregularity in guillotine register does not result in an unprinted gap at the edge of the page.

One of the most common problems when passing a job over to a bureau is the compatibility of fonts. Never use the type style functions in your layout software to artificially italicize or embolden fonts, as the RIP (see page 69) may not recognize them. Use PostScript fonts, and, when the job is sent, include a comprehensive list of fonts itemizing the various weights and styles. To output a file to film correctly, the bureau must have fonts identical with those used in the document, not just some that appear to have the same name. Strictly speaking, you should not send the fonts with the file, because this constitutes a copyright infringement: the bureau will need to have its own licensed copies (see Font Copyright, page 186). A possible way around this is to send PDF files with the fonts "embedded." However, without the font on its system, the bureau will be unable to make last-minute text corrections.

Above: A high-resolution drum scanner is a big investment.

Machines like this need a high throughput of work to be cost effective and so remain in the domain of the bureau.

Below: When two screens are superimposed and are not quite aligned the result can be an unsightly moiré pattern.

The bureau can manage other issues the designer may not wish, or necessarily need, to be involved with. Trapping is the function of overprinting edges of color areas to compensate for poor registration on the printing press. Colors or black can be set to overprint or "knock out" showing the color behind it, and special inks may require special treatment for trapping. Even if you have set trapping preferences in QuarkXPress, the imagesetting RIPs may override them. Again, the printer will advise the bureau on the best trapping method for the intended press. The percentage spread of a dot of ink when printed on a particular paper is known as dot gain. To correct for this, the printer will supply values that enable the bureau to adjust the dot size of the output film. To avoid the unwanted moiré pattern or "screen clash" sometimes apparent on a color halftone, the bureau will need to assign certain unique angles to the halftone screen dots.

Right: Imposition for a typical sixteen-page section. Eight pages are printed on one side, the paper is then turned and printed again on the other side.

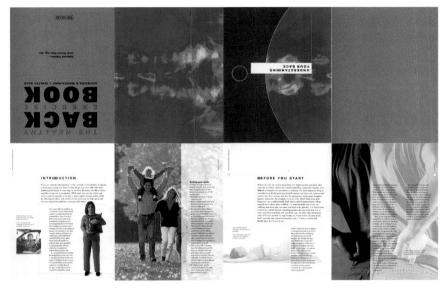

IMPOSITION

A document of more than two pages will normally be viewed on screen as a series of double-page spreads. When a multipage document is printed, however, the pages will be arranged on a larger sheet to be cut and folded into one or more sections. A page has two sides: a single fold creates four sides; fold again and you have eight sides; and so on. Printers' sections are, therefore, made up of multiples of four. The most common section size is sixteen pages, with eight pages printed on each side, although large, Web-offset litho presses can print sixteen pages each side. The planning of the pagination is called imposition.

Imposition will normally be carried out by the bureau, before running the film, or by the printer prior to platemaking. The designer should be aware of the most

Above: One side of a section ready to be trimmed, folded, and assembled, the result will be sixteen consecutive pages. The imposition is generally left for the repro house, bureau, or printer.

economical use of paper, and plan the page count accordingly. The best way to be certain of the structure of a long document is to draw a flat plan, a miniature page plan indicating the content and position of each numbered page in the section.

If the design of the spread incorporates an image that crosses over the gutter, it should be remembered that the two halves will be separated into two different areas of the larger printed section. When finally bound, they may well misalign or color variation may be apparent.

If the document has fewer than sixteen pages, both sides of the section can be put on the same plate. In this method, known as "work-and-turn," all the pages are printed on one large sheet, which is then turned over and run through the press again. After the sheet is cut in two, the two identical piles of short sections can be folded and trimmed, reducing the press time by half and creating less wastage.

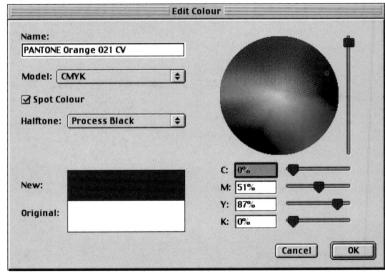

COLOR MANAGEMENT

Whether you use four-color process or spot colors, the final file should contain only the colors you want to print. Delete all unused colors (using the color-editing menu in the DTP software) to avoid the creation of more plates than intended. If the design uses spot colors, ensure they adhere to the naming conventions of the ink libraries, such as PANTONE, in all the applications that went into the creation of the document.

If you use PANTONE colors in process printing, the PANTONE must be converted to CMYK separations prior to film output to avoid the extra cost of five or six color printing. If you define a PANTONE color to allow separations, the software will use a look-up table to create the substitute recommended percentages of the four process colors to produce the closest equivalent CMYK color. Certain PANTONE colors cannot be reproduced accurately by the four-color process. To avoid any surprises during

Below: For four-color process printing, the color bar is used by printers to assess the performance of the press, giving information such as dot gain. Printed away from the image, it is later trimmed off.

Above and left: QuarkXPress offers comprehensive color management. Conversion can be made from one of the proprietary spot color system palettes to CMYK, ready for four-color print output. A floating on-screen dialog box shows the selected color at a glance.

production, it is a good idea to check when you make color selections. Pantone Inc. produces color swatch books that show how the process versions compare to the true color.

Transmitted light from computer monitors produces more vibrant or intence colors than can be printed, making some color matching unpredictable. A safer method of improving the predictability of the printed colors is to use a color management system such as ColorSync in your DTP and graphic programs. This provides input, display, and output device profiles and will be recognized by both the color proofing device and the printer's press and so help preserve consistency.

When printing a solid black, a denser color can be achieved either by printing the black twice, known as "double hitting," or by first printing a tint, or "shiner" color such as cyan (see Color).

RIPS

Most page layouts, supplied either as a DTP document or as a PDF, are output to an imagesetter through a Raster Image Processor or RIP (pronounced "rip"). This device changes the outlines of the type and drawings from PostScript (the standard language used by computers to communicate with printers or imagesetters) into a bitmap (an array of dots) that the imagesetter can print out. RIPs are essentially dedicated computers with vast amounts of RAM linked directly to the imagesetter. The RIP will also process all the screening of halftones.

It would be very time-consuming to do all the "ripping" on the designer's computer. In a faster version of the process, only the text and nonscanned vector graphics are sent to the RIP, along with low-resolution, position-and-crop guide files for the high-resolution images, which are then replaced. This process is known as Automatic Picture Replacement (APR). Late binding is a term used to describe last-minute changes made within PostScript files while they are in the RIP, such as adding trapping and imposition information.

Files that are "RIP friendly" will be processed faster, keeping reprographic charges to a minimum. For instance, it is best to optimize layouts for imagesetting by using Photoshop to prepare bitmaps of the correct finished size and orientation, rather than scaling and rotating bitmaps in your DTP software.

Imagesetters can now handle most file formats, but the format of any included images will affect the speed of the imagesetting process. The best format will depend on the bureau's equipment, but will usually be EPS (encapsulated PostScript) or TIFF. JPEG, a "lossy" format used in online and multimedia design, should be avoided in documents destined for print. It is worth remembering that a compressed TIFF file will take longer to output than an uncompressed version and so may be less economical. If you intend to include a mixture of high-resolution bureau scans and some created in-house, then check to find out the minimum and maximum resolutions

Below: The designer's computer can act as the front end to the system at the repro house. Flat artwork and transparencies are sent to the repro house where high-and low-resolution scans are made. The low-res scans are returned to the designer, who places them in the document. They are substituted later by the high-res versions prior to running film or plates.

required for the particular job. Attention should also be paid to the width of lines or rules, whether drawn in a vector illustration or in a DTP document. Hairlines, of 0.25pt or less, will RIP to film but may break up or even disappear when on press, as may very fine tints of color.

DELIVERING THE GOODS

The designer must decide on the most productive and cost-effective way to deliver the job to the bureau or printer. If either is located nearby, manual delivery on disk (CD, DVD, Jaz, or Zip) may be a less expensive option. For more distant output locations, ISDN, ADSL (high-speed telephone connection), or a dedicated prepress delivery service such as Wham! Net can be used.

To speed the transmission process, the files should be compressed into the smallest possible package. A number of compression utilities are available, the most common being those that write the zip format (not to be confused with Zip disks) and Aladdin's Stuffit. These utilities allow single files or folders containing all the relevant files to be compressed to approximately half their actual size, resulting in half the transmission time.

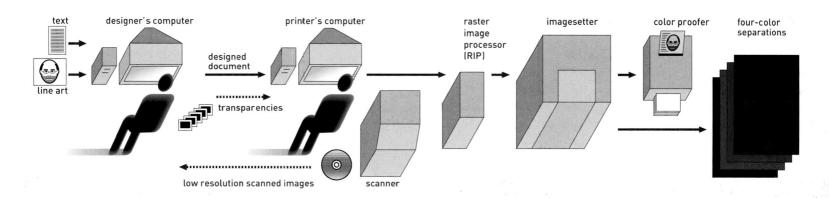

SCREEN TO PROOF 2 Adobe introduced the PDF (Portable Document Format) as a universal file type for transmitting and printing business documents. It is now the standard format for distributing cross-platform manuals, technical drawings, marketing information, and proofs. PDF has been heralded as the key to the future of prepress, eliminating film, plates, and repro bureaus.

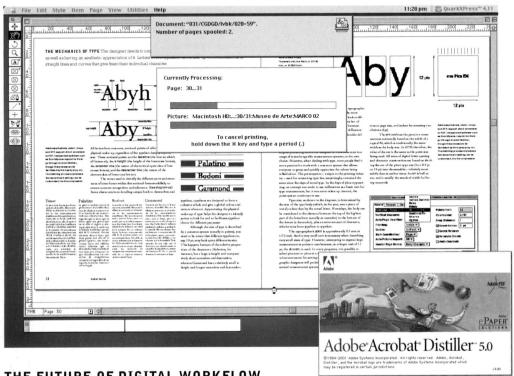

THE FUTURE OF DIGITAL WORKFLOW

PDF is a secondary file format, created from other files. Instead of sending separate page layout, font, and image files to the filmsetter, designers are able to use all these files to create a single PDF document file. These files are small enough to be transmitted on-line and can be output to any proofing device and eventually run on any printing press.

However, there are hazards that currently inhibit this perfect scenario. It is easy, for example, to let unconverted RGB images slip through to the final file, resulting in a mono image when the printer RIPs the file. Designers may neglect to embed all the necessary fonts, and the options for automatically converting images to CMYK can also produce unpredictable results. Image compression options are inflexible and images placed at inadequate resolution may not be detected. Trapping is not handled at all. As with DTP files, it is a good idea to run a "preflight" check on PDF files such as Enfocus's PitStop.

In an attempt to avoid PDF pitfalls—and to maintain their foothold in the prepress industry—many repro houses are encouraging designers to supply them with native files,

Above: Adobe applications, vector, image, and DTP, support direct conversion to PDF. Independent software such as QuarkXPress requires the file to go through Acrobat Distiller, although this process can be facilitated by thirdparty plug-ins. The distilling process takes only a few seconds and settings—the file compression, for example, or the color output format-can be customized.

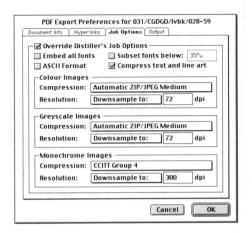

which they, in turn, output to PDF instead of film. This would seem to negate the benefit of using the format, but it does bring certain cost benefits. For example, "soft" proofs (viewed on screen) supplied in PDF format vastly speed up the production process (although traditional checking of film is still regarded as the only fail-safe method), and plates are run directly from the file, removing labor-intensive film make-up. For publishers producing weeklies or products requiring a fast turnaround, this can provide a competitive edge.

Ultimately, an industry-wide adoption of the PDF format would seem to benefit everyone. Repro houses could dispense with costly imagesetters while still offering highresolution scanning and final composition. Printers could accept jobs directly from designers as well as bureaus.

Currently the process is not quite the hoped-for simple, universal solution to prepress needs, but it is getting there.

PROOFING Only the designer knows how he or she expects the final printed product to look. The proof is the last opportunity to check for text, alignment, and color errors, and it is ultimately the designer's responsibility to clear it.

Probably the most widely used prepress proofing is done photographically using plastic laminate systems such as Matchprint or Cromalin—often called dry proofs. Colored powders or precoated sheets matching the process colors are exposed using filters and subsequently laminated together onto white paper.

It is important to remember that prepress or dry proofs are only an approximation of the finished result, although they usually give an adequate guide to the color balance. The only true method of seeing the final job, albeit the most costly, is to run a wet proof on a flatbed proofing press on the correct stock. Wet proofing usually includes a set of "progressives" (see below).

Do not be afraid to question the color reproduction if you are not satisfied. It is far better to correct at proof stage, because although limited color adjustments can be made on press, they tend to be less localized and will affect the balance of a larger area than may be desired.

For a single color, film is usually proofed as a positive dyeline or diazo print, known as an ozalid, brownline, blueprint, or blue. Halftone images are proofed either all together as a "scatter proof" or correctly positioned as "page proofs." Full-color page proofs can be output digitally from the designer's file as laser, inkjet, dye-sublimation, or thermaltransfer prints. There are many affordable color output devices on the market, but choose carefully. For serious proofing it is important to have proper PostScript-based printing. Most personal inkjet printers do not include PostScript, which means prints from QuarkXPress and Adobe InDesign will not match the final result. Fortunately, additional PostScript RIP software can remedy this.

Proofing systems compared (**** = excellent *** = good ** = average * = poor)

System	speed	quality	cost
Matchprint	*	***	\$\$\$\$
Cromalin	*	****	\$\$\$\$
Iris	**	**	\$\$\$\$
Inkjet	***	**	\$\$
Wet proof	***	****	\$\$\$
Ozalid	***	*	\$
Digital	***	****	\$\$\$

THE PRINTING PROCESS 1 The halftone plays a fundamental role in the printing process. To understand it, the designer specializing in print must first grasp the basic principles of color separation and screening technology.

COLOR AND THE HALFTONE

Whether you use spot color or CMYK process color in your design depends entirely on the job. Spot color will generally give better specific color matching and can result in brighter, more vibrant flat colors, but CMYK is the preferred process for photographic reproduction. Sometimes adding a spot color to a CMYK job is necessary, but this means additional printing impressions, which in turn will drive the printing costs up (see Color).

There are two forms of primary color; the red, yellow, and blue we all learned about in school, and the red, green, and blue of all computer and television displays, referred to as RGB. RGB is color created by combining light (hence, additive color), while all forms of print rely on reflection from pigment (subtractive color). A modified form of the red, yellow, and blue primary color setmagenta, vellow, and cyan—is used for most forms of color printing. Because the three colors do not actually form a true black when mixed together, black is used as the fourth ink to increase contrast and add depth. C, M, and Y are used as printers' inks to produce fullcolor work, and are known as the process colors. Black is referred to as the key (K), so the system is known as CMYK.

When artwork, a photographic print, or a transparency is scanned, a beam of light is used to pick up the three color components in a series of horizontal lines. The split beams are digitized and a laser writes the dots of the screened separations to paper, film, or disk.

Brighter, more stable colors can be achieved by using a technique called GCR (gray component replacement). With GCR, the black replaces the gray areas created in shadows by the process-color mix. It is then possible to run the process colors at different densities to increase color saturation without creating a "muddy" shadow.

A less widely used, but more sophisticated system known as Hexachrome, uses six colors, adding vivid orange and green to a tuned CMYK spectrum. This method produces an excellent quality of color reproduction, with subtle variations and greater range, but requires a specialized printing press, though Hexachrome is now starting to be used in desktop printers.

Prior to printing, the "continuous tone" images that result from scanning need to be screened to convert them to halftone dots. Digital imagesetters can write halftone screens of almost any shape, although the square dot is commonly used in four-color process separations. The fineness or frequency of the screen is measured in lpi or dpi—lines or dots per inch (per centimeter in Europe), and the optimum frequency is determined by the paper stock and the type of printing press. Coarse, soft material such as newspaper will use a coarse screen, such as 55 or 65lpi, to compensate for the spread of ink and prevent the dots from merging, while a good-quality art paper would use a 170lpi screen.

Below: The color halftone screens must be applied at different angles to prevent unwanted moiré patterns. Black is rotated to 45 degrees since this is the easiest on the eye; 90 degrees is the most difficult to guarantee, so this is reserved for the yellow; cyan and magenta are rotated at approximately 105 degrees and 75 degrees. Black-and-white photographs are normally converted to a monochrome (single-color) grayscale, but a designer may sometimes prefer to increase the tonal range of a monochrome image by printing in two or three inks as a duotone or tritone. The conversion can easily be performed in Photoshop by superimposing a contrasting black halftone over a single-color halftone made from the highlights and midtones of the same image. This effectively adds depth to what may otherwise be a flat image, while also adding a colored tint.

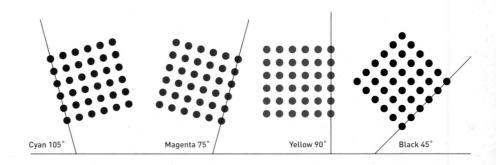

Above: An image separated for our-cclor process printing and inlarged (by approximately x 300,000) creates a "rosette" pattern clearly showing the angles of the individual color screens.

Right: An enlargement of a conventional mono halftone mage reveals the dot pattern. A regular array of different-sized lots arranged according to the creen and screen angle being used. Smaller dots represent the ighter tones.

THE PRINTING PROCESS 2 The design-to-print workflow can now be executed totally digitally. However, the final step—the printing press—is still predominantly analog. This is also the stage over which the graphic designer has least influence. Knowing how the finished product will look and feel is an essential part of the design process, so the designer must have a basic knowledge of the various printing techniques available to achieve the desired result.

LITHOGRAPHY

Originally devised more than 200 years ago, lithography is by far the most common form of printing today. Its success is based on a simple principle: oil and water do not mix.

In offset lithography the image is printed from a rubber-coated roller (blanket) to which the ink is transferred from the plate. The image is first created on a printing plate either photographically or by using a CTP (computer-to-plate) digital system. (CTP systems are not yet the standard, but this method is set to dominate within the next few years.) When the photopolymer resin coating of the plate is exposed to ultraviolet light under a process camera, exposed areas are hardened. The unexposed areas are subsequently washed off during processing. Gum arabic is then applied to the surface to make the nonimage areas water-receptive and grease-repellent (ink-repellent). Plates can either be negative or positive working. Negative-working plates are much less expensive and are generally used for single-color work. The same chemistry applies to negative-working plates but in reverse: it is the exposed areas that become unstable, leaving the unexposed areas to print.

The thin metal, plastic, or paper plate is then wrapped around the plate cylinder of the press. As the cylinder rotates, it makes contact with rollers wet with water or a similar dampening solution and rollers conveying ink. The dampening solution prevents ink from adhering to the nonprinting areas of the plate. The inked image areas are then transferred to a rubber-covered blanket cylinder, finally offsetting the image onto the paper as it passes between the blanket and impression cylinders.

The latest litho presses can be connected directly to the digital output source, eliminating both film and the platemaking stage, making the press another link in the digital chain, though at present this system is only economical for shorter runs. There are also some uniquely digital problems that may occur, such as ghosting and mottling.

Lithography is well suited to the four-color printing process, since larger presses can print the four colors consecutively in a single pass. In fact, modern commercial litho presses can print up to eight colors. Smaller presses are sheetfed, but longer print runs such as books and magazines are offset onto paper fed from large rolls on a so-called web press.

The size of the halftone screen and the surface of the paper stock will determine the density of ink required in the litho process. Uncoated paper is more absorbent and will soak up more ink; to compensate for this, the dot size can be reduced in film production. Positive-working plates produce less dot gain and are generally preferred for web-offset magazine printing.

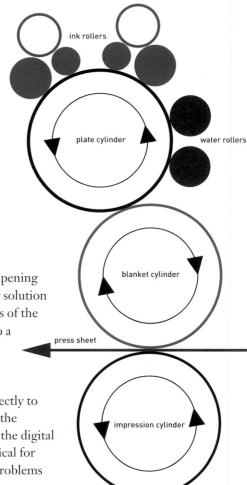

Above: Thick, viscous printing ink is forced through a system of rollers, making it semiliquid. A thin layer is distributed over the plate. A fountain solution moistens the plate's nonimage areas so that ink adheres only to the image areas. The plate cylinder revolves into contact with the blanket cylinder, depositing an inked, reversed image. Paper passes between the blanket and impression cylinders, offsetting a right-reading image.

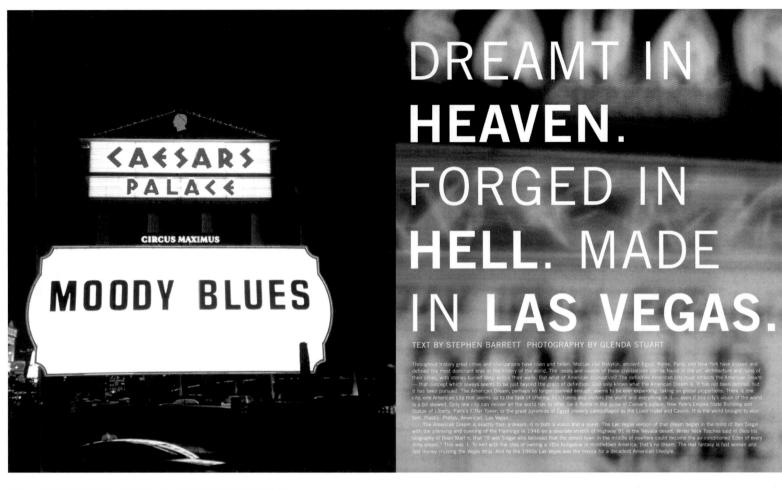

Left and below: In a typical weboffset system, the paper is printed on both sides in one pass. A web press consists of up to eight consecutive units like this, one for each color.

Above: A spread from the Canadian magazine Coupe, printed in fourcolor process on a web-offset press. Magazines are commonly printed in sixteen-page sections. Color can be adjusted on the press electronically by increasing or decreasing the deposit of any of the four process inks to sections of the printing plates. However, once on press, localized color changes to individual images is not possible.

Design by The Bang, Canada

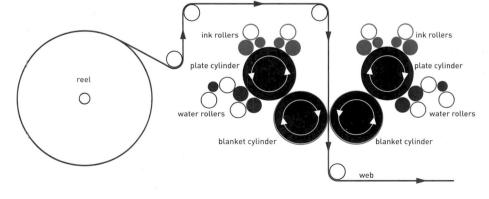

THE PRINTING PROCESS 3 The print industry is not limited to lithography, and the designer may choose to employ another printing process, perhaps one capable of printing on a wider variety of materials to create more interesting, tactile effects.

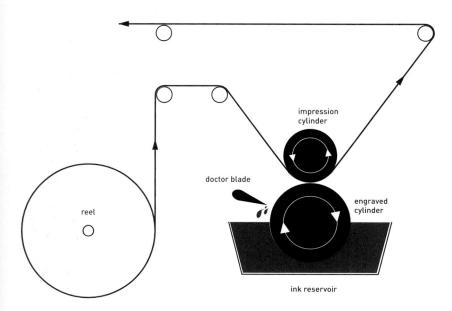

GRAVURE

Possibly the biggest rival to web-offset is gravure. This process is used to print everything from postage stamps and banknotes to wallpaper and wrapping paper. Gravure is a recent adaptation of the ancient etching method of producing print with tone. Gravure presses print from "cells" of different depths cut into the surface of the cylinder, deeper cells holding and subsequently depositing more ink, rendering a darker image. As the ink from neighboring cells tends to merge, this produces an almost screenless image.

Like offset litho, gravure can be printed onto a web of paper. The process is digitally prepared—diamond styli in the engraving heads that cut the printing cells are fed digital information directly from the prepress source. An engraved cylinder revolves in a reservoir of thin, solvent-based ink, flooding the surface. A flexible steel blade (the "doctor blade") wipes the cylinder clean as it revolves, leaving ink only in the image areas. Finally, a rubber-covered impression cylinder presses the paper onto the engraved surface.

The drawback with gravure is type, which appears less sharp than in lithography.

Above: A typical gravure press is web-fed. The engraved gravure cylinder rotates through an ink reservoir, and the surplus ink is wiped from the surface by a "doctor" blade. The printed image is made by pressure between the plate cylinder and the impression cylinder.

Below: On a letterpress press the paper is placed face down on an inked block, or "forme." Pressure is applied by screw or lever.

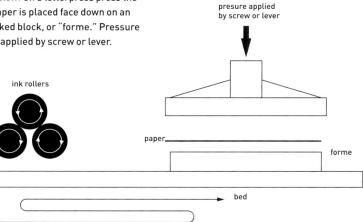

LETTERPRESS

Once the most popular printing process, letterpress is now only used for specialized jobs or limited-edition (short-run) books. The use of hot-metal typesetting really survives only to produce a proof that can then be scanned and printed by offset litho to reproduce the traditional effect.

Letterpress machines have largely been converted to or replaced by flexography, in which the metal type trays of letterpress are replaced by a flexible rubber or polymer plate. Generally used by the packaging industry, flexographic (or "flexo") presses are similar to gravure, using a series of rotating cylinders to collect ink from a reservoir and transfer it onto a web-fed printing material via plate and impression cylinders. Flexo presses can print on materials unsuitable for offset litho, such as cardboard, plastic bags, or wax paper.

Right: O by Federico d'Orazio. This plastic "book" can be unfolded and blownup into a human sized inflatable mattress. Text and graphics are screenprinted onto the plastic.

Design by Federico d'Orazio, Italy/Netherlands

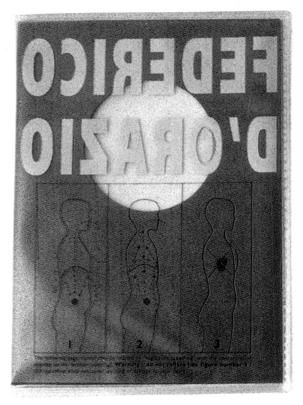

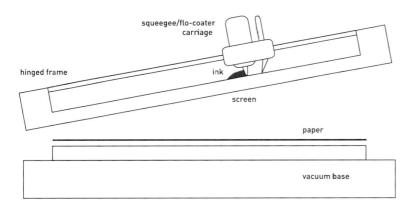

SCREENPRINTING

Often associated with poster and art print reproduction, the silkscreen or screenprinting process gets its name from what was originally a stretched silk cloth used to hold a stencil. This versatile printing process can produce thick, opaque deposits of ink in brilliant colors, and can be used to print on virtually any material, including shop windows and the sides of vans, or even curved or uneven surfaces such as bottles, T-shirts, and printed circuit boards.

Above: A common hand-operated screenprinting press. The rubber-bladed squeegee is pulled over the surface of the screen, forcing the ink through the mesh onto the paper or material held in position on a vacuum bed.

Modern screens are made from a fine polyester mesh, stretched on a metal or wooden frame. A simple line stencil is cut using a digitally controlled pen plotter that manipulates a knife. More complex stencils and halftones can be made using a film positive as in lithography. The screen is coated on both sides with a light-sensitive polymer emulsion and exposed through the film with ultraviolet light, after which the image areas are washed away with water. The screen is mounted on the press and a rubber-edged squeegee forces the ink through the mesh, passing only through the "open" image areas. Though fine screens are available, screenprinting is not recommended for close registration or work involving very small type sizes.

DIGITAL PRINTING

Digital presses are increasing in popularity for economic short-run, full-color work. Running at high speeds of up to 2,000 copies an hour, these presses can create a different image on every sheet of paper if necessary (see page 13, DPICT magazine cover), allowing considerable scope for printing personalized documents from, for example, mailing databases. The absence of prepress processes and materials, such as film and platemaking, makes short-run work as economical as high-volume printing.

FINISHING Once the job has been printed, there is one final stage before delivering the finished product. This is entirely mechanical, which may involve trimming, folding, collating, or binding, and must be considered early in the design process because it will affect the way the document is constructed and therefore the production budget.

Finishing can also include print-related operations such as diestamping, embossing, varnishing, and laminating.

Die-stamping and embossing use a metal die (engraved by a digitally controlled machine tool) to "stamp" or press a relief image into paper or board. The image can be impressed with or without ink, to create subtle effects. Frequently seen on paperback book jackets, a metal foil can be combined with the raised impression, using a heated die. Die-cutting physically cuts out sections of the paper. Digitally controlled laser diecutting is used to cut fine detail such as company logos in business stationery.

There are a number of ways to protect the printed page and make it scuff-resistant. Varnishes can be printed on the litho press to give varying degrees of gloss or matt finish. To add extra strength, a film lamination, again in matt or gloss,

Above: Some of the varied ways of folding. Left to right: Single fold four-page sheet. Accordion eight-page fold, gatefold eight-page fold, rollover eight-page fold.

can be glued to the stock under pressure through a heated roller. Interesting design effects can be created by mixing spot areas of gloss and matt varnishes or by adding a varnish after the lamination is applied.

FOLDING AND BINDING

Once the print finishes have been applied, the stock is ready to be folded. Folding is accomplished using a buckle, knife, or combination folding machine. There is no limit to the number of folds employed, and interesting visual effects can be created by using a single sheet designed to fold into several smaller sections. After folding, multipage jobs have to be gathered, bundled, and collated (put in order), prior to binding and guillotining. Other operations that may need to be considered are perforating or tipping-in (adding a single page to a multipage publication).

Left: Folding, binding and trimming in progress. Folded and collated "signatures" move along a conveyor of saddles in the shape of inverted "V"s. Wire staples are inserted along the fold of the spine. The three remaining edges are then trimmed by a series of guillotine blades prior to packing.

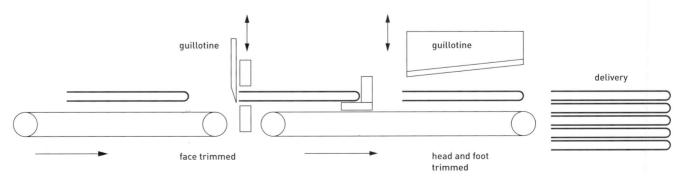

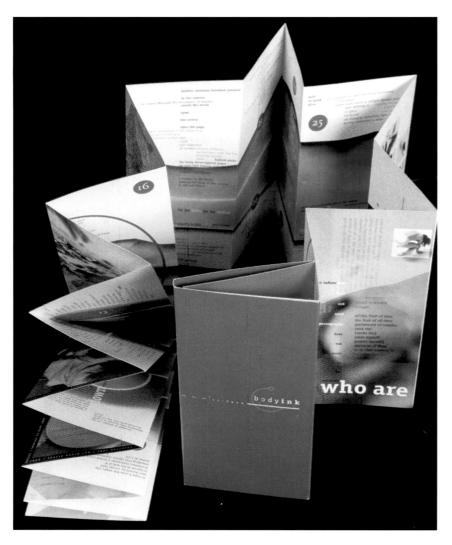

Right: Perfect binding. The sections are collated and the spines then trimmed off. The edges are roughened and glue is applied to attatch the wraparound covers.

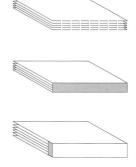

Binding may be performed by several methods. Booklets, and magazines up to a maximum of 96 pages, are commonly bound by saddle-stitching (stapling) or perfect binding. Unsewn binding is known as perfect binding: the gathered and collated sections are placed in the binding machine, spine down, and the edge is roughened and an adhesive applied. The cover is folded, scored, and wrapped around the pages. The adhesive is cured by heat and the pages are trimmed. The designer must remember that in perfect-bound books with many pages, text and pictures may disappear into the gutter because the spine on these books is less flexible than sewn titles and some fold is lost in trimming.

Case-bound or hardback books have a cover made separately. The page sections are sewn through the spine with thread and gathered together to form a "book-block." The cover and book-block are assembled with tipped-in endpapers, usually of a heavier stock. Finally a separate "dust" jacket is wrapped around the cased book.

Above: Multifolded concertina brochure commissioned by Photo '98: Year of Photography and Electronic image.

Design by Eg.G, UK

Right: Promotional brochure for "The Lightbox" property development. By using a plastic cover and ring-binding mechanism, this brochure could be economically updated by inserting or removing pages as the project progressed. Design by Foundation, UK

Above: Kenneth Grange design identity. A monochromatic twodimensional logo has been given a three-dimensional quality with thoughtful use of embossing. Design by Lippa Pearce Design, UK

Right: Case-bound books are assembled with a "book block" made up of sewn sections or "signatures," endpapers and a heavy board cover or "case."

CHOOSING PAPER The choice of paper is the foundation of a successful print job. The designer must consider carefully what the finished item is trying to achieve and select a stock that will not only convey the right message but also fit within the print budget.

A huge range of papers and boards is available, machine-made, handmade, and recycled. For some jobs, the type of paper will be determined by the method of printing employed. Offset litho presses require papers with good surface strength and dimensional stability, preferably with a low water content. The finish is a less important factor, since offset ink will adhere both to glossy coated and to matt uncoated surfaces. For gravure, the paper must be smooth but absorbent enough to collect the ink.

The paper must fit the brief for the job, and the finish should also be appropriate to the content. If you are looking for good-quality color halftone reproduction, a coated stock (made with mineral fillers to create a very smooth surface) would normally be used, although some very fine uncoated papers can now boast excellent color quality. The weight of paper is classified by the weight in pounds of a ream of sheets (500 sheets) cut to a designated size. Outside the Unites States the basic unit is grams per square meter (gsm or gm²). The impact of a prestigious catalog could be increased by using 150 or 200 gsm paper. Generally heavier papers or artboards are thicker than light ones, but the density and type of fiber will have an effect on thickness (bulk). Glossy art paper can sometimes feel thinner than an uncoated stock of the

same weight, so it may be necessary to increase the weight when choosing a gloss finish. If a brochure needs to be mailed, the weight of the stock will affect the cost of the postage. Be careful of ink showing through from the reverse side of some lightweight papers.

Budget may also limit the choice of paper. Your design might look wonderful printed on a specialist or handmade stock, but the cost might well be beyond the reach of the print budget. When deciding on the size and format in the early stages of the design, take into account the size of paper the job will print on, so that costly wastage can be avoided.

Paper is manufactured in standard sizes that reflect the size of the most commonly used printing presses. If possible, the document or section should be designed to fit one of the standard sizes, without creating too much wastage. Remember to consult the printer and allow for any bleeds and for sufficient free "gripper" edge as required by the press. The brief might call for a special finish, such as varnish or lamination, in which case the printer will give advice as to the best stock to use. Do not overspecify: it is not necessary to use a gloss stock if you are adding a gloss varnish. Types of binding may be influenced by direction of grain (the way the fibers lie) so prior consultation is important.

The printer will often be able to supply designers with sample books produced by paper merchants and mills showing all the weights and finishes of their branded stock. It is a good idea to build a library of sample books, some are inspirational works of design in their own right.

Right: Paper sample books such as this one for Monadnock Paper will usually include all the weights and colors available from a manufacturer and extend to such items as envelopes if they are available.

Design by Pollard & Van der Water Golden, USA

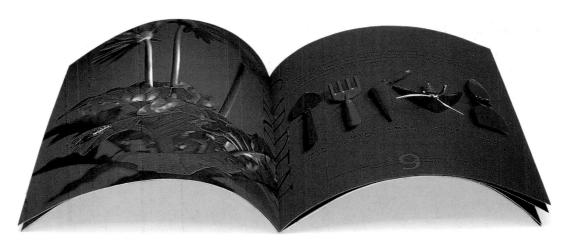

Above: Paper sample books can be interesting design projects in their own right. Modo Paper Mills Inc., USA strives to stimulate its target audience—the designers who will specify their product—with strong, colorful photographic imagery and unusual binding.

Design by SEA, UK

Right: Rolland Motif Paper promotional calendar. Innovative use of print techniques, dye cutting, and binding, cleverly demonstrate the versatility of the paper samples.

Design by Époxy, Canada

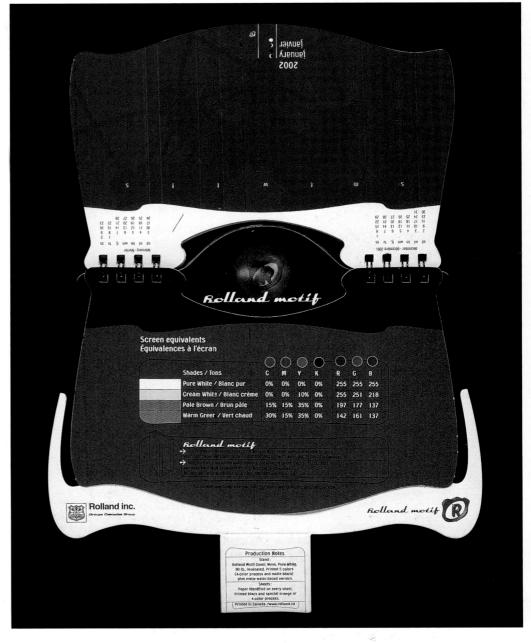

02.01 CASE HISTORY

LIVING IN THE CITY

An exhibition to display the results of an international architectural competition, which was organized by the Architecture Foundation in London to promote the regeneration of derelict inner city sites, and develop innovative models of future urban accommodation. The exhibition was held at the Design Museum in London.

The Architecture Foundation and the Design Museum required a number of printed graphic elements to both promote the exhibition and explain the architectural concepts proposed by the winning entries.

The designer was briefed to produce the exhibition graphics accompanied by a promotional poster, advertising, and various invitations to openings and private views. The initial brief also included a catalog. However, as the results of the competition arrived from the international architectural practices, it became apparent that a more substantial publication would be required, and a book was proposed.

Although the exhibition was funded through sponsorship supplied by business and charitable trusts, the budget was limited, precluding the use of a photographer or expensive production methods. The graphic and exhibition designers worked closely to ensure the graphic elements would compliment both the display stands and the exhibits. An architectural sheet-plastic material was employed to create the stands themselves, and it was decided to use this theme as a basis for the graphic imagery.

The material is translucent and lightly color tinted. Cost and practicality ruled out the use of the actual material as an innovative binding concept. Instead, the designer used a digital camera to create close-up images of the material, using light and reflection for architectural effect. To add a further level of transparency, the book was covered with a tracing paper wrap simply printed in one color. The tracing element was also bound into the publication to create section divisions.

It was deemed part of the designer's brief to liaise with the architects wordwide to collect the illustrative content of the book. These included digital photographs of architectural models, drawings, and three-dimensional renderings. As the time-scale was critical, electronic transmission had to be employed to collate these elements from all points of the globe. The images were supplied in a number of different formats, file types, and resolutions. Most were compressed as JPEGs to speed transmission. All the images had to be resampled to

Below: Page layouts in progress in QuarkXPress. Text was imported from emailed word processing documents. Pictures, emailed as compressed JPEGs, were converted to CMYK TIFFs prior to positioning on the page.

TIFF or EPS format to create 300dpi CMYK files suitable for printing. Text was supplied as a digital word-processing file by email and run into the page layouts. The pages were designed entirely on screen and first stage proofs created as PDF files. A set of hard-copy page proofs were also supplied to the client to ensure the "feel" was balanced and the weights of type sympathetic to the design.

After final corrections were taken in, the digital files were sent on disk to the lithographic printer based in Belgium. The printer ran the files to plate and supplied page proofs so the designer could check there were no file errors or incompatabilities that might cause poor-quality imagery, or font conflicts.

This page: Some of the elements that made up the printed material designed to promote the exhibition: invitation, poster, and book, with a spread depicting architectural concepts from one of the winning practices.

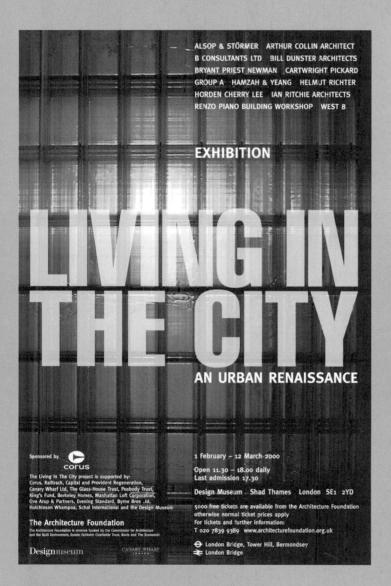

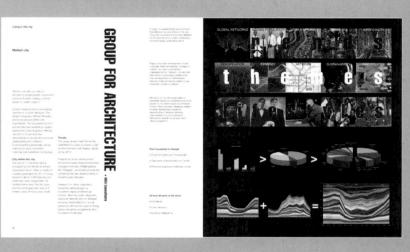

02.02

The practices of advertising corporate identity, and branding cut across other sections in this book, yet the profession of advertising has a distinct character that connects it closely with corporate identity and branding but sets it apart from other forms of visual and commercial practice. This

section therefore looks at advertising, branding, and corporate identity together. Although they used to be billed as separate practices that incorporated graphic expertise, the three aspects became more interconnected, as multimedia agencies, developed in the 1990s, were able to mix graphic and advertising skills and to take on entire promotional projects.

Essentially, advertising aims to produce a campaign—a strategic thought voiced in different ways, to surprise, delight, and inform people. Like advertising, corporate identity aims to coordinate the interpretation of a product or service with a distinct visual or verbal "look," by which it can be recognized. Branding became prominent in the

1990s with the rise of multinational companies that wanted to extend their promotions outside the normal territories of conventional advertising. Before any other quality, all three areas require ideas to be expressed with absolute clarity.

THE SIGNIFICANCE OF ADVERTISING IN CONSUMER SOCIETY

In each area, graphic design skills are essential. Branding and corporate identity require typographers to craft letterforms and distinguish brand character, and computerskilled graphic designers to coordinate the connections between all graphic elements, format material for printers (on disk and over the Internet), and define rules that govern the graphic's application to different media. In advertising, a graphic designer's sense of organization is essential in order to ensure the flow of information and consistency of treatment. Word-based advertisements depend on skilled and sensitive typography. Most significantly, establishing a brand and developing its corporate identity in an advertising campaign demands graphics expertise,

PART 02. SURFACE DESIGN

CHAPTER TWO

DESIGN FOR ADVERTISING

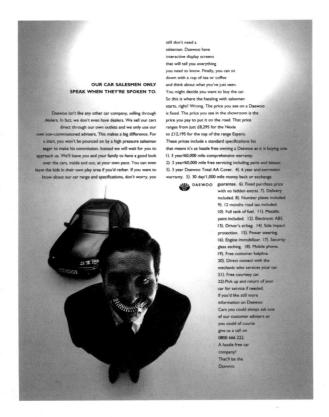

Left: This ad relies on a tight relationship between the art direction and copy. The organization of props, color density, and picture space has been carefully arranged with the shape and weight of the text. Note the distinct visual style and placement of brand name and logo. These reinforce the brand name and visual identity.

Design by Duckworth Finn Grubb Waters, UK Opposite above: This Coke campaign drew on the brand's famous marque, effectively reminding the viewer of its established familiarity and uniqueness. The art direction drew on the brand's pre-existing archival imagery, which plays to the strengths of digital image manipulation (scanning, reediting, segmenting, and enhancing).

Design by McCann Erickson, UK

Opposite below: In its location a billboard has to be striking, quickly understood, and easy to associate with the product or brand. The layout therefore must be clearly organized while the message must be punchy and succinct.

Design by Rainey Kelly, UK

Life tastes good

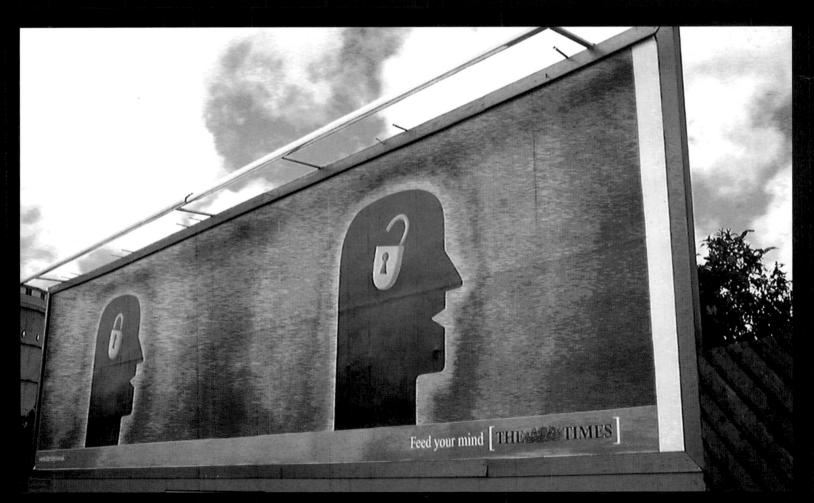

SPECIALIST PEOPLE Within the setup of a media advertising agency, there is usually a creative team that shapes the campaign and feeds ideas to graphic designers and typographers. Designers are usually called when ideas need to be presented at pitches, at review stages, and for final artwork. The precise nature of campaign development varies between agencies but one would expect to find the following elements.

CREATIVES

The creative department is made up of art directors, who construct the artwork, and copywriters, who determine the use and wording of copy. Both are answerable to creative directors, who control the overall direction of campaigns with financial and planning directors. Art directors and copywriters often work as a team, an approach that emerged from Madison Avenue in the 1960s. All three creative jobs require graphic design training, and it is with the creative department—usually called "the creatives"—that graphic designers, typographers, and brand-design specialists work most closely.

The input required from graphic designers centers on turning rough ideas in the form of scamps (see page 95) into finished digital artwork that brings together all elements—type, image, and corporate branding. Images can be developed digitally and sent via email. Graphic designers need to ensure that the campaign appears consistent with the other applications of branding and corporate identity.

FACILITATORS

The media campaign is usually connected to, and coordinated with, other areas of brand-building, such as price promotions and more targeted direct advertising. This is usually negotiated with the client's own marketing department and the project management team, which consists of the creative director along with planners, who translate the client's needs into the creatives' brief, and account handlers, who control the finances of a campaign. In all aspects of advertising freelance work, graphic designers are likely to come into contact with facilitators (often called "suits"), who employ typographers, illustrators, animators, computergraphic layout specialists, and production specialists on a project basis. Graphic designers are also likely to come into contact with project time-planners (called "traffic"); their job is to ensure that deadlines are met. Media-space buyers negotiate with billboard site owners, press, and other media owners to organize the placements of advertisements. In some

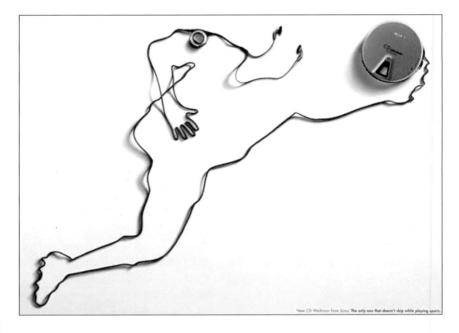

cases, specific advertising sites require designers to tailor their artwork at short notice in liaison with the media-space planning team.

Graphic expertise is usually introduced when the creative direction has been agreed, although the brief on which designers work tends to be established early in the process. Increasingly, because brandmarketing directors move jobs frequently, clients tend to employ their own third party, a "brand guardian," to oversee their product's long-term development. These people are concerned with all aspects of the brand's development, from campaign direction and corporate identity through to consistency in the development of product packaging. The lines of responsibility often interconnect, according to the variety of media used in an advertising campaign.

As in other fields of graphic design, work is nearly always produced on an Apple

Above: Art-direction-led advertisement. The product is clearly central to the artwork, preventing it from being confused with another brand, while the negative space emphasizes the simple arrangement. In the past the soccer player's crafted outline would have required a skilled modelmaker and photographic trickery. Today it is more cost-effective to simulate from a sketch model in either Photoshop or FreeHand.

Design by Tribal DDB, Spain

Bottom: This advertisement needed to include detailed product information, so bold art direction makes the text (headline and body copy) readable within a striking, stylized composition. The branding (top left) and product shot (bottom right) are strategically placed to ensure image and text connect with

the make and model. The illustration was specially commissioned, then scanned into the agency's ad format. The image was then produced in Photoshop, while the stylized copy was created in Adobe Illustrator.

Design by DDB, Singapore

Right: Copy-lead advertisement.
The justified copy is easy to read because of the liberal spacing between and around the text. The illustration provides the copy with a distinct visual point of reference, leading the eye into the text. Copy is often written straight into
FreeHand, therefore careful copy checking beyond electronic spellchecks is essential.
Design by Brook Street, UK

Macintosh. Work is increasingly moved between individuals and groups via ISDN and the Internet, so computer-skilled graphic designers have in recent years become integral to the advertising process. They are involved throughout the transition from the strategies (in the brief) to visualizing and development stages and through to the completed artwork ready for production.

In such a busy digital environment, the graphic designer must have a thorough grasp of file management and be conversant with file formats and compression techniques, in the interests of rapid and accurate communication. Producing prototypes is helped enormously by choosing the right software. Final print-quality presentation can be produced for client approval and "one-shot" or limited-edition giant posters can be produced on inkjet printers for trial marketing. On a smaller scale, photorealistic proposals for hoardings can be easily photo-montaged in Photoshop. Advertising and branding usually require designs in a wide variety of publications and formats. The ability of software to scale and reassemble design elements in different aspect ratios gives the graphic designer great flexibility and makes it easier to create adaptations.

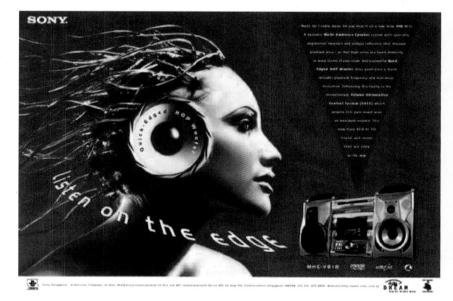

DESIGN CONSIDERATIONS Within advertising there are many different types of promotion, and agencies tend to specialize. The two most prominent are media advertising and direct advertising. Media agencies produce mass-exposure, high-publicity work through billboard, press, and commercial advertising, while direct advertising—often called one-to-one—is more closely geared to target markets and does not have the same audience reach.

MEDIA ADVERTISING

Billboards are usually produced for 48 or 96 sheet sites or single-sheet rectangular format (1 sheet = 15×30 inches). On a smaller scale, but in larger runs, 6-sheet and single-sheet poster campaigns are used to promote events rather than products. In both cases graphic designers liaise with advertising directors to make imagery and layout plans fit the format.

Press advertising ranges from double- and single-page spreads at one end of the market to column-width advertising at the cheaper end. Most advertisements require graphic judgement from an early stage. Factors such as typesetting, color, and organization of space are determined before photo-shoots and other production material are commissioned. Unlike brochure design, press design provides less choice over paper or format, and the brief stresses corporate qualities that need to be clear in the artwork.

Television commercials also require early graphic input. Illustrators are hired to sketch out storyboards from art directors' notes, which help the creative team to communicate precisely what they require from film directors. Because of the expense in hiring film crews, on-location storyboards are checked constantly to ensure that accurate footage is recorded, that the timing of sequences is met, and that recorded material fits precisely with the requirements of postproduction teams. Digital typographers and graphic designers are usually required to produce animated text sequences—added during postproduction editing—to link the film with the end frame. In most commercials the end connection between final product shot, branding, and strapline is the most crucial graphic element.

DIRECT ADVERTISING

The most common form of direct advertising is direct mail (DM), which uses postal services to reach selected potential or existing customers. Most DM specialists are graphic designers, because the work involves graphically presenting special offers, service schemes, brand magazines, and service information through the design of mailshots—flyers, brochures, and packaging. Databases and mail merge software simplify and facilitate the personalization of direct mailshots. The format and appearance of DM work are usually the remit of graphic designers, in negotiation with the client's marketing team. For bigger advertising pitches using DM, one-shot "interactive" self-liquidating promotions (SLPs) tend to be commissioned. These are specially designed limited-edition branded goods that connect to publicized special offers, and are usually developed from a media campaign. Point-of-sale promotion requires digitally skilled graphic designers to connect all areas of brand advertising and promotion work. Usually in stores and supermarkets, pointof-sale formats include freestanding boards, dump bins, banners, "wobblies" (plastic mobiles suspended from shelves), and "buzz stops" (vertical advertising hoardings between shelves). Digital graphic skills are particularly needed to scan and manipulate environments during concept development.

Right: Self-liquidating promotions (SLPs) are campaign extensions designed to add to a brand's promotional "hit." This megaphone slotted into a press, poster, and TV campaign for a soft drinks company picked up on the color and branding of the product while the SLP type, a megaphone, reinforced company's extravagant personality.

Design by Triangle Communications, UK

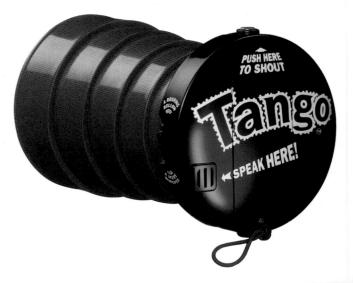

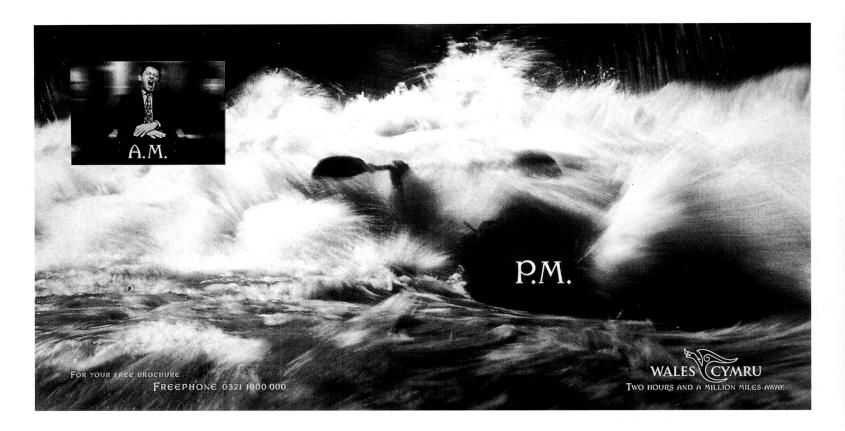

Top: This ad for the Welsh Tourist Board was designed for 48- and 96sheet billboards, which enabled the small inset image contained in the top left to contrast with the lessconstrained image representing the free open expanse of Wales. Design by Impact FCA!, UK Above: This press ad uses a visual pun as a lead into the body copy. Note that the text is separated from the image so that it does not impact on the image's clarity. The text also employs separate headings to make it appear less bulky. Design by Duckworth Finn Grubb Waters, UK

TOACHIEVE

DESIGN CONSIDERATIONS FOR MEDIA AND DIRECT ADVERTISING

- * An advertising campaign must have impact, relevance, and "connect" simply with the intended audience.
- ★ Advertising must not lose sight of its subject —the graphic content is essential in this.
- * Clarity—in print advertising 80 percent of the space usually conveys the idea, and 20 percent the additional information.
- * Analysis of the brief defines precisely what is required—the ideal is to reduce the proposition to a single sentence—and defines the types of skill required of a graphic designer.
- ★ The prominence of the logo or product shot must be considered, remembering that the purpose of the graphic input is to emphasize the advertised goods.
- ★ The brand characteristics must be systematically adhered to in terms of layout, tone, and treatment of the copy.

TOSHIBA

CORPORATE IDENTITY Corporate identity is the commercial face that represents a company, where branding is its commercial application. These terms often get confused because the word "brand" is the name given to a company's identity, while "branding" describes the marque by which a company, product, or service is recognized. Expressed simply, corporate identity is the creation of the brand, while branding is how it is then applied through all areas of communication.

The corporate identity has to represent the values by which a company should be known, but in recent years major brands have turned their products into subbrands; and consequently advertising activity has diversified. In modern communications agencies, the roles normally associated with branding and corporate identity tend increasingly to cross over.

The most common outlets for corporate identity include journals and in-store magazines, which are typically quarterly publications that show, through their editorial contents, how the company's products and services connect with the presumed lifestyles of consumers. Graphic design considerations include the creation and implementation of the brand's corporate rules regarding layout, and the organization of leader stories, "advertorials," and features in a visually stimulating manner.

Clear rules as to how the corporate identity will be used in different media have to be established. These typically range from stationery and advertising to digital applications. Appropriateness and consistency are key considerations. How changes affect the reading of the brand is a significant issue in the development of a corporate identity: does it still retain a connection with earlier brand associations?

Bigger brands have tended to develop and implement corporate identities through their own retail environments—most notably superbrands such as Nike and Disney Stores. Such total branding involves the bringing together of all visual aspects and the development of corporate signature styles to create a brand experience.

Corporate identity, therefore, requires background knowledge of the product's or firm's chief characteristics, the type of market in which the clients want to develop, and the nature of promotions to which they want to commit.

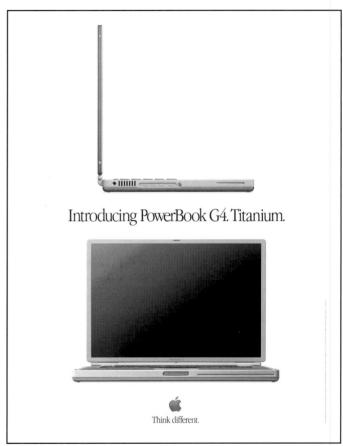

Above left: The Flash ads for internet search engine Ask Jeeves appeared on websites and search engines attracting a large number of "hits." With on-line ads a system of "hyperlinks" (sub-pages) need to be created, with a clear and consistent thread of corporate identity running through the pages.

Above: Most creative industries use Apple computers because their systems are geared to creating and manipulating digital images. From 2000 Apple made a virtue of this in their advertising. The shape of the Titanium powerbook became the advertising "hook," conveying a sense of stylish innovation and creative freedom as the unique selling proposition.

DESIGN CONSIDERATIONS FOR CORPORATE IDENTITY

Graphic consultants are typically involved in key stages of corporate identity work: primary research and recommendation, visualizing (through sketch work and digitally imaged scamps) image concepts, development and detail, and then implementation (digital type specifications and media appropriation). It is important for designers to be able to blend traditional and digital skills in order to get the right results in as little time as possible.

Corporate identities need to convey a sense of belonging, must be representative, and must be clear. Designers need to ensure that the placement of, and any appropriations to, a brand marque are consistent with core brand values. They should check to see what rules govern its usage. The visual dynamics of a corporate identity must be well measured in terms of appropriateness to market and consistency. This is absolutely essential to the inherent character of the product or firm it represents.

Having extracted key graphic qualities, the designer will need to consider the need for flexibility and assess how these qualities can be effectively reproduced at different scales and in different contexts.

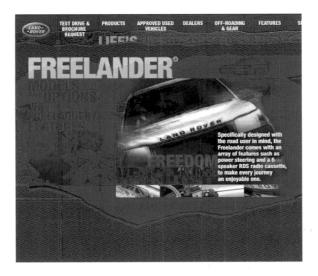

Above: Land Rover's direct mail has been credited with developing their existing customer base. Using data to target established and potential customers, the agency has developed a variety of promotional material that has coordinated usergroup outings, mailer posters, and small publications. Together it forges a bond between customers and the brand ethos. The range of paraphernalia is connected through strong corporate identity, which underpins the entire range of promotional work, including the Land Rover website (left).

Design by Craik Jones, UK

BRANDING Compared with corporate identity, branding is directly connected with raising awareness. It usually involves the development of a brand's identity within the everyday surroundings of its target market, using graphic techniques to ensure that the brand is associated with a particular space and mood. Branding therefore fits between direct advertising and corporate identity, because it commercializes the brand by applying the graphic identity to appropriate contexts.

Above: This limited-edition, business-to-business mailer treats a Tony Stone picture library image as police evidence. The team that designed this as part of the stock archive's rebranding had to develop the total package, linking separate

elements such as a flyer, poster, cover letter, and sealed bag. All elements were rendered in FreeHand and printed onto the different media.

The best-known aspect of branding is product placement, instigated by "marketers" who directly engage with graphic designers. The role of the designer is to apply the corporate graphic style to situations that, in most cases, require rethinking in terms of how an existing identity can be tailored.

Recently, branding has engaged a wider range of specialist graphic practices so that environments and products—from coasters and clocks to nightclubs and public spaces—have become vehicles for promotion. Photoshop is an ideal tool for producing mock-ups showing products and brands in different situations. However, final artwork will usually be produced to the desired specifications in FreeHand or Illustrator—vector-based files being more versatile for a variety of scales.

The objective of placement branding, called ambient or 360-degree advertising, is to engage customers the moment they are most likely to want the product, for instance, a drinks brand in a bar. Graphic designers are typically employed to restyle and appropriate graphic elements, taking into account how the branding will be understood in its given context. The development of typographical rules for on-line branding is essential, and usually involves collaboration between digital graphic designers, copywriters who shape the wording, and web designers who apply the corporate identity rules and graphic elements to suit the context.

Branding is also called on to extend direct advertising activity. Examples include branded booklets, collector cards, and correspondence, usually produced to promote product ranges and sent to existing clients to maintain customer dialog.

In recent years brands have developed their identity by diversifying into other markets. Brand stretching can simply involve a brand name being applied to another product, but more often it involves developing a brand through a new product range, for instance a drinks brand expanding into leisure clothing, where new product ranges are links to the brand's main area of operation.

In some instances clients have their own brand guardian, who ensures that the advertising strategy and other new ideas fit with the existing brand ethos and the company's other development plans.

Design by Tequila, UK

Right: Even in the design of the Porsche mug, the placement of the marque and copy are key design elements, as is the sourcing of a mug manufacturer with the appropriate surface finish, proportions, and details for Porsche's brand identity. Such qualities may be defined in a corporate identity specification manual.

Right: "The Smirnoff Experience"—a branded dance event—was a version of 360° advertising, where the landscape was dominated by a single brand. Such sponsorship strategies reinforce the association between a venue and a distinct brand or product. They are coordinated with a range of branded design material, including posters, environmental graphics, and self-liquidating promotions.

Design by KLP Euro RSCG, UK

Right: Initially produced as a brand extension of the fashion label Benetton, *Colors* magazine espouses many of the values associated with the brand's established global identity. The magazine added depth and kept the spirit of Benetton's brand ethos, which had been developed through earlier ad campaigns.

Design by Benetton Publishing, Italy

DESIGN CONSIDERATIONS FOR BRANDING

Graphic consultants are typically involved in three stages of branding development: primary research and recommendation, visualizing the brand in context, then working out implementation feasibility.

The role of graphic designers in branding involves consultation and recommendation more than redesign. Branding must graphically reflect, in situ, a company's aspirations in a wide variety of contexts, ensuring that the visual distinction of a brand is clearly evident and that its primary function is to condense key characteristics into a single "signature"—a visual typographic or graphic element. This will be the marque by which it is recognized.

With promotional work in mind, the branding should incorporate commercial hooks that suggest how the brand typography and graphic styling could be adapted. This may suggest to a brand's marketers or advertising creatives the key qualities that can be picked out as a selling proposition.

The context in which the brand is placed has to be clearly relevant and easy to associate. It is important, if it is to work effectively, that the branding cannot be misconstrued and that any brand extensions of the work must connect with the core ethos of the brand's other promotions.

02.02CASE HISTORY

DAEWOO MATIZ ADVERTISING CAMPAIGN 2001

The agency campaign team, led by their creative director, liaised with Daewoo's marketing director and team. The agency re-presented developed project work to the Daewoo team at interim presentations and final presentation stages.

The first stage of the process was to define the requirements of the brief and the type of finished outcome that was being sought. Agency planners and the creative director constructed a brief for the creative teams, based on consumer research and initial client meetings. The key quality picked out from the brief—the Matiz's maneuvrability in urban conditions—was translated into ideas through roughs and initial scamps.

It was agreed that the agency would develop press, poster, billboard, and selfliquidating promotional material. Such work often has to co-ordinate with other direct promotions, such as point-of-sale showroom displays. At this first development stage the campaign direction was reappraised, next stages were agreed, and a time scale was put in place. Daewoo's marketing director signed off the plan of progression for the next phase. The creative team for the job consisted of two graphic designers, a creative director, two creatives (sharing art direction and copywriting roles), and a planner. Scamps of the poster were developed from rough sketches, incorporating many of the corporate layout elements and logo. These were often collaged in FreeHand. Freelance graphic designers were briefed at the studio, and then they developed the work, corresponding via email and phone. A "book" of interim solutions was presented to the Daewoo team for approval.

Decisions were made within the agency on the most appropriate solutions to go forward to the final presentation of ideas. Three different versions for each promotion strategy were developed for the presentation, which were presented with detailed scamps. The creative director planned the presentation as a demonstration of how the work addressed the brief, met existing Daewoo objectives, and broke new ground. Some ideas were rejected at this last stage before the development of final artwork.

The winning concepts were then refined though scamps and mock-ups, with regular creative team development meetings. Having defined the direction of the final execution, graphic specialists worked on the typography and graphic arrangements for the poster and corresponding promotional material. Production technicians were contracted to work out feasibility and costings with account planners, then the agency's "space buyers" investigated relevant venues for the campaign duration. Final variants in design detail were presented to the rest of the creative team at an "internal crit," where graphic treatments were selected for detail design. Final mock-ups were produced for client approval using digital packages.

At the final client presentation, campaign work was presented to Daewoo's project team by the agency's creative and planning directors. The work was approved and signed off for production, pending minor graphic amendments. "Traffic planners" then co-ordinated final location shoots for the art direction, while typesetters were employed to coordinate the final copy arrangements. Space buyers signed up to poster and billboard sites while printers and manufacturers were contracted to produce the final printed artwork. Simultaneously, call centers were organized to deal with inquiries and coordinated promotion offers. Contractors were hired to install the posters.

All that remained to be done was to print and install the posters and launch the campaign.

DUCKWORTH FINN GRUBB WATERS

Great Pulteney Street, London ww 9n2. Telephone: (020) 7734 5888.

Fastinite: (020) 7734 5746. Email: diswikdiese com

BRIEF

What is this brand called? What is this campaign/ ad called?

What is this brand's DNA?

Who do we want to buy it?

Appened's who's looking to buy a new car who is fed up with the pressures of urban driving. Whether they're young or old, a businessman or a creative type, they will all share the same frustrations: congestion, lack of parking spaces and dismal public transport all make urban driving a nightmare.

The Daewoo Matiz is the perfect urban car, in fact its even won the 'Best City Car' Award to prove it. It's nippy enough to move though traffic, and small enough to slip into the smallest of parking spaces.

The Mhtiz has also won the 'Best Budget Car' and if you have to commute into work, might well work out annually, as not much more than the cost of your travelcard

Why should people buy this brand?

The award winning Matiz, designed to ease the pain of urban driving

The Daewoo Matiz is small and nippy enough to be the ultimate in urban driving, and it comesat an affordable price: that's why its won the Best City Car and the Best Budget Car awards

Requirement Appearance Date Budget Guidelines

Signatures Date Internal Present Creative Team(s)

Plan/ Acc.

Traffic Job Number

> Buckworth, Fire, Guide, Waterskinsted engineered in England our Resistence Office, as Great Fultures; Singst, up

Left The agency brief, developed from client meetings

Belcw left: Initial sketches, produced as rough visuals, which are used for in-house discussions and development meetings only. Below right: Final presentation scamp, where text and image elements were assembled in Photoshop.

Bottom: The completed poster.
The final version was produced as a Photoshop document, and was transferred to Adobe Illustrator format for print production.

Duckworth Finn Grubb Waters, UK

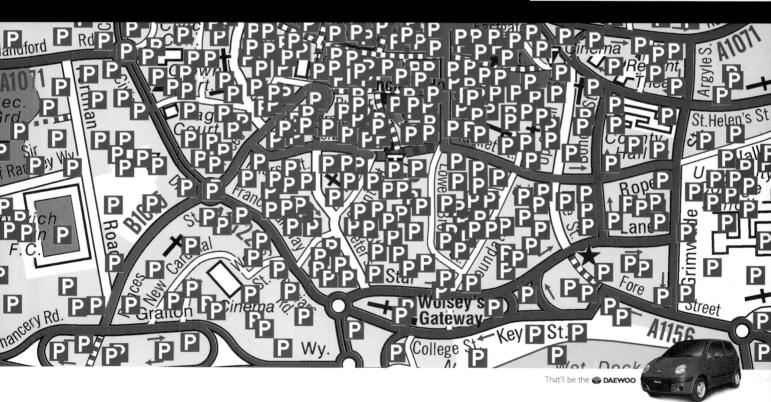

02.03

Every day, we come into contact with packaging of differing shape, size, and purpose, informing us of the merits, dangers, quality, or value of the products they contain. Some packs are designed to be discarded immediately after purchase, others are integral to the life of their contents. The graphic designer has to create compelling and attention-grabbing packaging items and take into account the legal requirements, trading rules, and environmental concerns that govern the industry. Packaging must function physically as well as being visually attractive and enticing.

The ability to visualize two-dimensional designs in the round—as provided, for example, by QuarkWrapture—is essential to the digital graphic designer who has to imagine the packaging in its made-up

form to determine how text or images will sit in relation to components such as folds, gluepoints, or lid mechanisms.

Preparing digital files of the complete pack design for production is the responsibility of the designer. To facilitate this, much of the software used in package design allows for manufacturing or cutter guides to be imported. These are used as templates for the graphic content of the pack.

Different pack shapes are continually being developed, which can be manufactured from an expanding range of materials. Polyethylene, high-grade plastics, acetates, and many other new materials have been added to the already extensive range available to the designer. These materials, each with their different textures and surfaces, provide both opportunities and challenges for surface application and production.

Branding is essential to packaging design and is much more complex than simply the application of a logo. Typography, shape, image, layout, choice of color, and tactile qualities all contribute to developing product identity.

Visuals on screen can be seductive so designers have to be careful not to be beguiled by the ease with which software allows them to create a packaging design. What is seen on screen will ultimately have to be

PART 02. SURFACE DESIGN CHAPTER THREE

DESIGN FOR PACKAGING

Left: To a consumer, this bag represents style and luxury, but strip away the cosmetic elements of the design and you are left with a simple paper bag. The design is no more practical, despite the extra cost in materials, but is now an effective marketing tool for the brand.

Design by Kenzo, France

translated into a physical, fully functional, three-dimensional product. It is important, therefore, to include mock-up construction as part of the design process.

Testing a package design by producing an accurate mock-up, well ahead of the full-scale production, and checking that the design itself and the surface graphics work together is essential. Once constructed, a package can dramatically change in appearance from the original design. Type, for example, may become distorted, cut-out windows may not align adequately enough to display the product, or, just simply, the overall design may have less impact off-screen. Keep printing out and test assembling work frequently. This can save you much embarassment when it is time to show ideas to your clients.

Above right: This award-winning cover for the Pet Shop Boys "Very" CD stood out in the competitive charts crowd by defying the traditional approach to packaging design. Taking advantage of alternative manufacturing techniques resulted in, not only a practical packaging solution, but an effective publicity device. The designer conveyed a message to the consumer of an individual and creative band, setting themselves apart from a crowded industry. Design by Pentagram, UK

Right: The plastic carrier bag was once an undesirable but very cheap device for carrying shopping home. With advances in printing technology, the colors, texture, and quality in production of this bag means it can now proudly be used to successfully represent a contemporary brand image.

Design by Paul Smith Ltd, UK

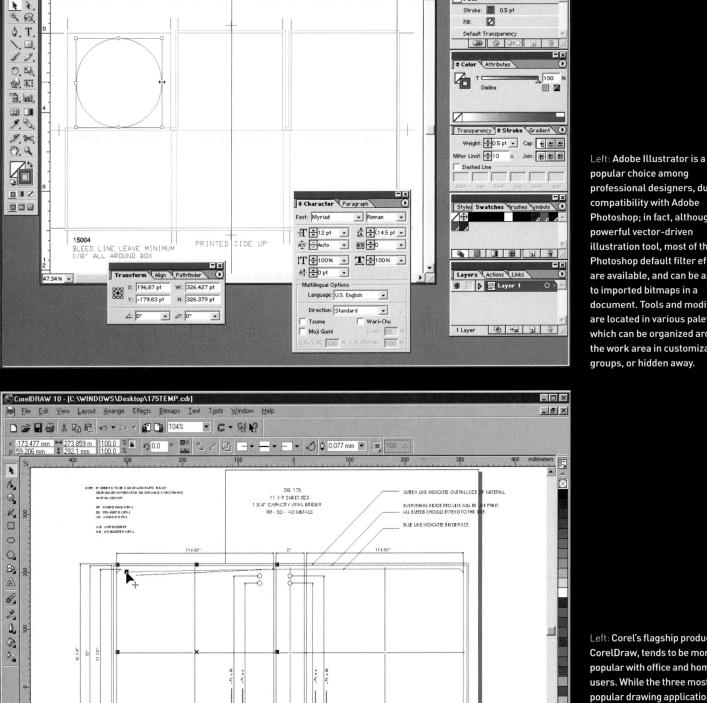

4 DX:-17.167 mm DY:6,059 mm Distance: 18.204 Angle: 160,560

(-301.943, 200.000) Click an object twice for rotating/skewing; dbl-clicking tool selects all objects. Shift-click multi-selects; Alt-click digs; Ctrl+click selects in a gr... 🐧 C 100 M:100 Y:13 K:0 0.077 mil

None

Adobe Illustrator

File Edit Object Type Select Filter Effect View Window Help

1 of 1 +) Page 1

🗟 cd_digipak_6-panel.ai @ 47.34% (CMYK/Preview)

popular choice among professional designers, due to its compatibility with Adobe Photoshop; in fact, although it is a powerful vector-driven illustration tool, most of the Photoshop default filter effects are available, and can be applied to imported bitmaps in a document. Tools and modifiers are located in various palettes, which can be organized around the work area in customizable groups, or hidden away.

Path

Left: Corel's flagship product, CorelDraw, tends to be more popular with office and home users. While the three most popular drawing applications do not differ much in price, the Draw package includes not only a vector-based drawing application, but a full version of Corel's bitmap editing application (Photo-Paint) and a handful of other useful tools for screen captures, texturing, tracing, and more.

DESIGN TOOLS Graphic designers normally have a good understanding of all the major graphic arts software, including three-dimensional modeling applications but, at minimum, should be fluent in at least one drawing program, when working with packaging.

Computer-generated artwork can be extremely accurate, allowing the designer to work to precise tolerances. This has consequent benefits for the manufacturing processes.

Designers often tend to favor one program over another for reasons of familiarity, but DTP programs—more suited to multipage work, are less frequently used for packaging design. However, artwork for manufacturer's cutting guides and templates can be imported and locked into these programs and graphic elements used as necessary. Dedicated drawing programs such as Illustrator, FreeHand, or sometimes CorelDraw are widely used since they have many functions that assist the design development process. Almost infinite scaleability and distortion controls, together with lockable layers and guides, give designers greater flexibility for experimentation and for previewing their creations at different stages.

The advantage of working with layers, which can be locked and/or hidden, allows numerous permutations and variations of a design to be made on screen without accidental deletion or movement of key elements.

Repetitive transformations, "click and drag" duplication, and knife tools are just some of the highly productive features of drawing programs. As with DTP programs, other graphic elements—including photographic images, text, and manufacturer's guides—can be imported. Bitmap editing programs are used extensively for modifying and preparing images for packaging design.

An interesting feature of "object-oriented" drawing programs is the facility that allows the user to assign different output halftone resolutions to individual elements, thus allowing a high degree of control over differing graphic components when printed onto different surfaces.

Files exchanged between different computer platforms can produce incompatabilities so it is advisable to check on this before committing files to the final production stage.

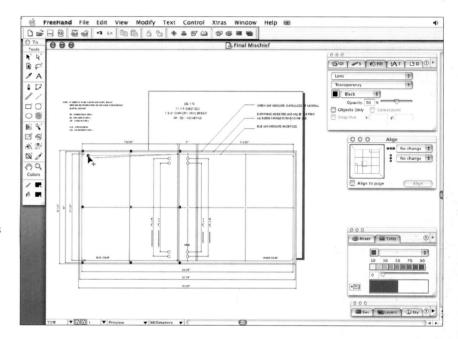

Generating digital artwork and transmitting it to clients and manufacturers, by high-speed telephone lines, has greatly reduced the time span between concept and production, but this advantage can only be maintained by accurate file preparation and platform compatibility.

Above: Macromedia FreeHand is the main competitor to Illustrator and is very similar with the exception of some minor differences in the way tools are sorted and implemented. Panels and Inspectors are used to display tools and options. Support for documents with multiple pages, the Perspective Grid, and powerful type handling tools including support for hanging punctuation are some standout features.

MATERIALS Products of most shapes, sizes, and weights generally need some form of packaging. This must be suited to the individual product to ensure adequate protection as well as ease of opening and good customer appeal.

One aspect of packaging design that cannot be dealt with by computer software is the choice of the right material. The substrate's behavior when folded, bent, stamped, molded, or blown is crucial to how the final product will look. This is simply something you have to learn from experience and by making or commissioning mock-ups.

Paper and cardboard are widely used in the packaging industry. They are relatively inexpensive and have a versatility that makes for simple and quick processing. Additionally, they are materials that designers can also use easily for constructing presentation mockups. Embossing, creasing, cutting, folding, slitting, gluing, and the printing of inks, varnishes, and other finishes are all straightforward processes suitable for use with paper and cardboard.

Recycled cardboard is used for many forms of packaging. This lowers unit costs and also carries the added bonus of being "environmentally friendly," a quality that is exploited by manufacturers of "wholesome" or "green" products. Inexpensive card can be treated with a range of coatings to enhance its performance. Water- and oil-resistant laminates, for instance, can be applied for effective food packaging or other moisture-producing goods. Card is often coated purely to resist marking that can occur from frequent handling.

Other materials are regularly used in conjunction with card packaging to provide strength or to give extra visibility of the product. Acetate windows, for example, can be glued into position over an area that has been die-cut from the card sheet.

Intricate or fluid shapes cannot be easily constructed from card so many of these designs are produced by using plastics and films. Injection molding, in which melted plastic is forced into a mold, is widely used, though setup costs can be high and only large production runs bring the unit cost down to acceptable levels. A popular type of plastic for packaging is PET (polyethylene terephtalate), which is easy to shape and is good looking.

Plastics use numerous chemicals in their manufacture and do not degrade quickly, making them difficult to use for products that in themselves are considered environmentally friendly. Designers need to be aware that materials can "speak" to the audience as clearly as graphic imagery does.

Glass, once a popular packaging material, has seen a decline in use. It is more temperamental than plastics, such as PET, shatters easily, and cannot withstand extreme temperatures. However, its transparency, molding capabilities, and self-coloring, together with its suitability for frosting and engraving, give it a tactile and aesthetic appeal, appropriate for giving products an unusually luxurious feel.

Metal, as a packaging material, accommodates extremes in packaging price points. At the lower end of the market it is used in great volume for canned foods, aerosols, and oil containers. It is also used for luxury goods, such as gift-set cans printed with interesting graphics—making them collectable once the contents have been used. Metal is also suitable for recycling because it is easy to melt down and re-form. However, there are fewer shape options from which to chose since most tin production is based on two or more pieces being welded together.

This page: Different food types demands various packing solutions, depending on the nature of their contents. The breakfast cereal (below) needs to be sealed in an airtight container to avoid spoiling. Heat sealing, plastic zip sealers, and foil packing help the longevity of the product. Eggs (below, far right) have always been awkward to package. This effective solution is created from one sheet of card, making it easier to manufacture as opposed to more common molded designs used today.

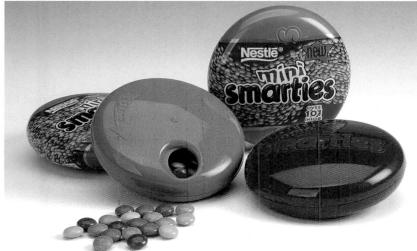

A simple cardboard tube used to be the only pack to buy Smarties in.
But market forces demand interesting and novel approaches to retailing and so this toylike pack was created for Mini Smarties—exactly the same product but an exercise in alternative formats.

The glass bottle for Coca-Cola (top, middle), however, has remained a favorite, indeed a classic design. Essentially unchanged since 1915, the shape is a registered trademark and proves that innovation in packaging is not always the best approach. The coffee pack (top, right) makes use of foil wrapping and vacuum packing to retain freshness.

All materials have their own unique qualities and behavioral properties. A lot of packaging incorporates several materials that have to combine successfully. It is a good idea for designers to take the time to familiarize themselves with the manufacturing capabilities and performance of each of the materials they intend to use.

Understanding the purpose and function of a package design is of prime importance to the graphic designer. The major consideration for large, bulky items such as, for example, computers, microwave ovens, and washing machines, is ensuring the packaging provides adequate protection and has prominent instructions for lifting and storage. In a retail environment large items are usually displayed unpacked, suggesting that compelling marketing graphics play a subordinate role in these instances. Despite this, there are manufacturers that use every opportunity to advertise their products and recognize that even large cardboard boxes offer a chance to promote the qualities of the product within.

KEY KNOWLEDGE So diverse are materials and methods of packaging that designers are constantly having to up-date their technical knowledge in terms of production, digital software upgrades, and new applications designed to facilitate and expand conceptual work and the creation of digital artwork.

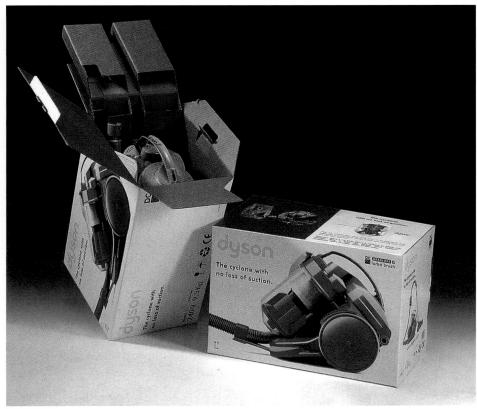

Above: Packaging for large domestic appliances usually makes use of basic corrugated cardboard with a single color application of type and virtually no coated finishes. Here the experience of buying an innovatively designed product such as this is enhanced by the pack design. The four-color image on coated stock, the intricate and environmentally friendly card inserts both point to attention to detail and encourage consumer confidence in the product.

Design by SCA Packaging, UK

Right: "Squeezable" bottles formed from flexible plastics are less expensive than metal or glass alternatives and are more convenient for the consumer. This innovative tube incorporates a small silicone valve that self-closes immediately after use. The graphics are printed on a soft, flexible, transparent sleeve that is then shrink-wrapped around the tube.

Design by Fuji Seal Europe, UK

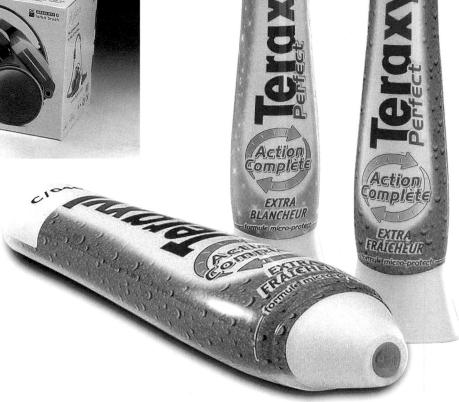

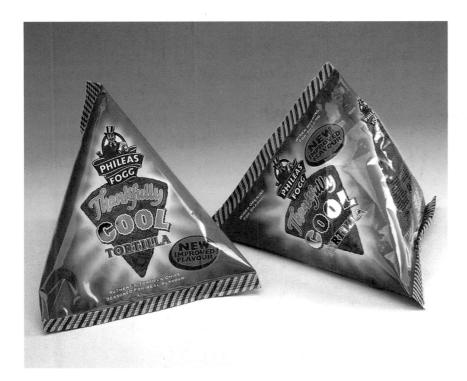

Cutter guides are used frequently in the manufacture of card packaging. Printing card packaging is usually done by offset lithography and the steps taken by the graphic designer to create graphic files for reproduction are similar to those for any general design for a print job (see Print section). However, once the sheet is printed, it will then be cut, creased, and perforated in order to form a three-dimensional pack. The printed graphic work has to fit accurately within the physical shape to be cut in order to display as intended. For this reason, cutter guides are supplied to designers (usually as EPS files) from which to work. These guides accurately show where the cuts, folds, and creases will be made, thus providing an accurate template to show the designer where to place the surface graphics.

Cutting and creasing equipment runs at high speeds so they can have plus and minus tolerances and specific "bleed" allowances that have to be taken into account when graphic artwork files are prepared.

Different materials and packaging shapes may require a number of alternative methods of printing and/or have properties that might affect the overall design. For example, corrugated card has a coarse surface that, if uncoated, soaks up ink and the fluting on the reverse side acts as a cushion, making printing flat areas or delicate halftone work difficult.

Flexographic printing (see page 105) is used to print onto rounded or curved surfaces, as on dishwashing liquid bottles, although precise registration of colors is difficult to achieve. Fine text and hairlines also tend to suffer, breaking up and distorting as a matter of course. Transparent stickers are

Above: Packaging of tortillas never took any interesting forms until the Phileas Fogg Tortilla pack was created. Creating this eye-catching design required the commitment of the client and the technical know-how of the designer and manufacturer. Design by Lawson Mardon Packaging, UK

Above right: Square cartons of juice used to be a challenge to open without spillage. Plastic screw top pourers have now been incorporated into the pack, improving the customers' experience of the product.

increasingly being used as a more accurate alternative with assured, high-quality, printed results—but at an increased cost.

Most metal packaging design is printed as flat sheets, which are subsequently pressed or stamped into the required shape or component.

Unit cost is critical in the packaging industry. Print runs are usually very high compared to general publishing work. The number of colors, glue points, and separate processes in a pack design affect the production costs, so the designer's ingenuity and creative skills will often be exercised to the full when working with low-level budgets. The safety of packaging must be considered carefully and can impose significant restrictions on design. Packaging must prevent toxic or sharp objects from being accessible to children or piercing the pack and all food products must have tamper-proof devices such as protective films, ring pulls, and pressure buttons on jar lids, incorporated into the pack design. Additionally, adequate warning or directional texts (also in braille) have to be prominently displayed on packaging that contains any form of hazardous product.

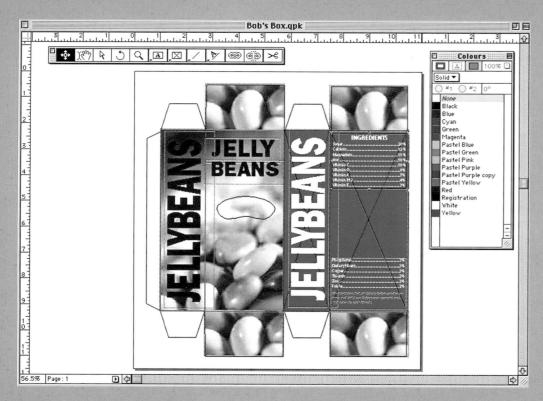

Left: Visualizing a pack's design, before committing to paper or card mock-ups, is made easier with computer software. Virtually all the tools in QuarkWrapture are identical to those in XPress, making the surface design simple and straightforward. When exported as a QuickTime movie, the finished pack may be viewed folding itself up from flat to the assembled piece and then viewed from any angle.

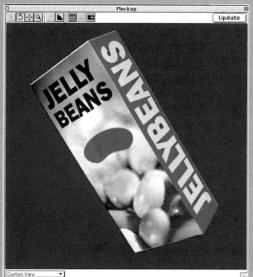

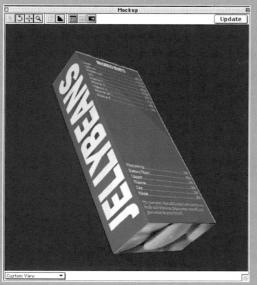

INFORMATION REQUIREMENTS

Pack designs need to communicate information about their contents as well as persuade the consumer to make a purchase. There are a considerable number of elements that have to be incorporated into a pack design—some seemingly excessive but usually necessary for safety reasons or legal requirements. Bar codes, ingredients (vital to those with allergies and important to those counting calories), instructions for preparation, use, or assembly, warnings, sell-by dates (overprinted separately), technical data, and promotional advice, all have to be taken

into consideration and accommodated within the design. Additionally some of these elements, such as barcodes, are fixed in terms of size, position, and color, and these cannot be ignored or visually relegated simply because they might degrade the look of the pack design.

The graphic designer should also consider that most packaging is normally first seen as a collection—row upon row of the same product identically packaged. A stylish design with powerful impact viewed in isolation, either on screen or as a physical mock-up pack, may look less successful in a general display context and viewed from a variety of heights, distances, and angles. Using a three-dimensional modeling program or dedicated packaging software, such as QuarkWrapture, in order to see realistic three-dimensional renderings of multiple packs from a variety of viewpoints is useful for this purpose. Wrapture also allows the pack to be seen in the round as a QuickTime movie. Image manipulation programs, such as Photoshop, enable the designer to montage pack designs into instore photographs and view them in context alongside competitors' products.

PLANNING AND PRODUCTION Packaging briefs are usually more comprehensive than those for other areas of graphic design. In large retail organizations, the brief is usually drawn up by senior buyers after consultation with the manufacturer's marketing department. Marketing departments and manufacturers themselves may also commission designers directly. The product is often already in existence and the target consumer, retail outlets, and a unit price for the packaging (as a proportion of the selling price) are already known.

Designers need to obtain as much of this information as possible and also consider potential modification and application of the design to future range extensions or different consumer markets.

Unit costs will determine the number of colors and construction methods that can be used, but inventively simplifying one aspect of a design allows elaboration of another.

If the product in question can be accommodated in a standard pack design, the creative process can begin using the relevant templates from the manufacturer immediately. If the pack has to be custom-made, it is likely that the designer will need to confer with specialists. These may be in-house cardboard engineers or specialist moldmakers, die-stampers, and packaging manufacturers. Glues, inks, materials, and assembly techniques are so varied that collaboration and research is strongly recommended.

Below: Cardboard engineering plays an important role in the design of protective cartons for fragile products such as this Wedgwood china. Die-cut corrugated board inserts fit both the box and lid to hold individually shaped items securely. Inserts can be stamped and creased from a single sheet, or cut and slotted together for extra strength.

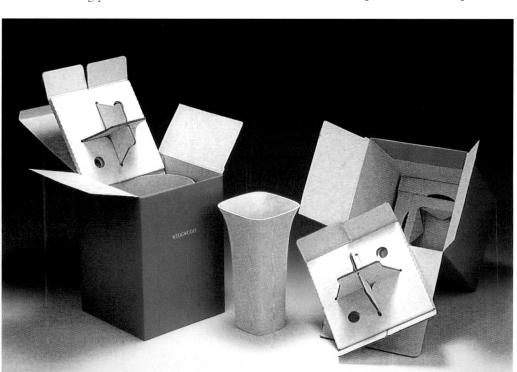

Designs can be created on screen using a drawing program with images imported from bitmap imaging software although, ideally, a dedicated packaging program with constructional and three-dimensional viewing facilities, should be used. This can be followed by a physical mock-up for client approval although the quality of three-dimensional packaging programs may sometimes obviate this need. PDF files (see PDF files—Print section) can be sent directly to client marketing managers who can return them to the designer annotated with comments and any necessary amendments.

Final digital files should be prepared with great attention being paid to dimensional accuracy and color specification before being sent to the production contractor. This may be a printing company with access to specialist cutting and finishing processes or a specialist packaging manufacturer with printing capabilities. The designer's files are used to make printing plates or stereos for final printing.

Color proofs should always be obtained and checked for color fidelity and hand-cut samples made up to check for constructional weaknesses or inaccuracies.

There should be close contact between designer and the production team throughout the production period. At the final stage, the client must approve and sign off the proofs and made-up packs.

02.03 CASE HISTORY

MISCHIEF—PULL ALONG TOY

John Lewis Partnership's brief was to design packaging for a range of "own brand" wooden, preschool toys, to compete against well-established brands was given to the designer. The client wished to avoid brash and garish designs associated with cheaper, plastic toy packaging. The packaging was to accurately represent a higher-quality product with a potentially long lifespan.

The products were aimed at children aged between twelve months and three years. However, as the purchase would be made by an adult, the packaging had to appeal to their perception of quality and value for the money. It was thought important to allow access through the packaging, to the toys inside, so that potential customers could feel the texture and quality of the wood used. This need for accessibility involved cutting a panel from the main pack, which could weaken the overall package structure, so minimum guidelines were drawn up to ensure optimum strength and durability.

A packaging engineer was commissioned to develop the structure of the packs for this range, taking into account the client's requests for accessibility. To ensure the mock-ups created were accurate, a drawing program (Macromedia FreeHand) was used to produce scaled line drawings of each toy. This provided accurate information to help the engineer create precise dimensions for each of the proposed packs.

After evaluating the full range of toys to be marketed, the engineer designed a range of ten boxes to accommodate a total of twenty products. The number of boxes could have been further rationalized by constructing a range of more evenly sized boxes, however, this ran the risk of criticism of "overpackaging" because the customer could be left feeling cheated after finding a small toy in an oversized box.

The packaging engineer then tailored each pack to individual requirements for securing each toy within the outer pack. Simple but effective strengthening techniques, including double-folded handles, were designed to ensure the product could be carried safely. Problems, such as ripping at stress points could occur during handling if such details were overlooked. The intention was to have as few tie or glue

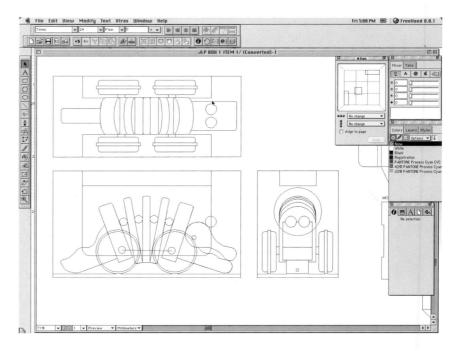

Above: The packaging engineer supplied these scaled drawings of the product to establish how much space is required by each item. An outline of a possible box shape is placed around each item to determine the minimum number of boxes capable of packaging the entire range.

Above right: The mock-up helped to illustrate the validity of a box shape to the client's manufacturer. This starting point answers initial questions such as cost or shelf area required. Once approved the progression to further mock-ups and the final design can continue.

points as possible to help reduce costs. This was achieved by creating supports and grooves within the cardboard to enable the pack to be created efficiently from one piece. Minor adjustments were easily made, redrawn, and quickly represented using the drawing program. Finished, physical mockups were then constructed.

The design of the packaging structure was subsequently passed to the graphic designer, who created surface graphics in the same drawing program, developing three options for a client presentation.

The selected design used a rich, earthy terra-cotta color to represent both the toy's natural origins and quality. The color had a traditional quality that contrasted well with the strong, lowercase Gill Sans typeface that was used. Cutter guides were supplied via email to the graphic designer and were transferred to layers in FreeHand. Other layers were placed underneath for text, color panels, and logos to manage the origination of digital artwork efficiently.

Once the final artwork was approved, the files were sent via email to suppliers in Korea, Thailand, and Taiwan for manufacture. Printer's proofs were received and color corrections to match those of the client-approved mock-ups were requested before the job was finally approved for production.

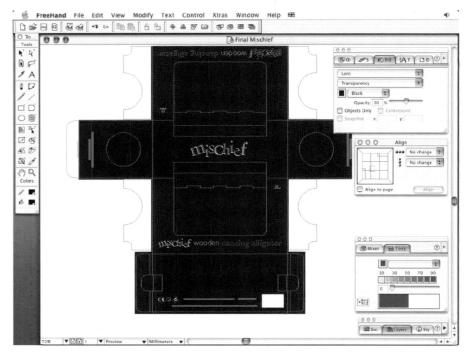

Below: The final printed product with an insert structure holding the product in place during transit and on the shelf. Sales of this range have been very successful with a like for like increase of 54 percent within two months of being launched.

Above: The final artwork is ready to email to the various Far Eastern countries who will produce the packaging. Finishing details such as age warnings, bar code spaces, and color specifications are checked and signed off by the client. Die-cutting details such as the circular window were incorporated not only to add interest to the pack, but to enable the customer to see and feel the product more readily. This was a request made at the briefing stage.

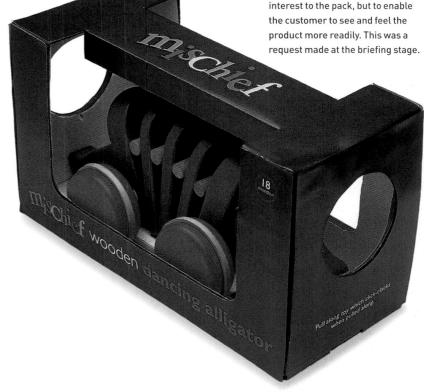

02.04

Even hanging a small sign outside the local corner store will need some thought. Will it be seen from the end of the street? What will it look like at night? How can it be cleaned? Will it need planning permission? Larger sign projects are even more involved. An ordered mind is needed to pull the complex threads of a signage system together.

Anyone who has ever taken a wrong turn, got lost, and asked for directions from a passerby will know how confusing verbal directions can be. As the Chinese proverb goes, "one hundred tellings are not as good as one seeing."

This is the reason we have signs; to help us travel independently. Signs distil information to the absolute minimum, they speak to you just at the right moment, they keep us moving. Seeing one good sign is better than a whole crowd of helpful locals.

Signs are often considered as merely two-dimensional directional aids—as arrows on posts or lists fixed to walls. A lot of this type of signing surrounds us: construction sites use basic, temporary signs; hospitals need rigorously functional signs; and department stores rely on floor-by-floor directories to list each sales area. These are all good, conventional signs, with each serving different, but important, roles.

But there are many opportunities to branch out into three dimensions, where signs can become an integral part of a company's identity and embody the spirit of their brand. On a larger scale, signs can also be landmarks or even advertisements. If the purpose of a sign is to help you identify your destination, then sculptures or even an icon such as the Statue of Liberty can also act as a sign. After all, the statue unmistakably proclaims "America" even without carrying the name. So signing can take many different forms. While conventional signs quietly go about their business directing you from point A, there are many other ways of announcing your arrival at point B.

PART 02. SURFACE DESIGN CHAPTER FOUR

DESIGN FOR SIGNAGE

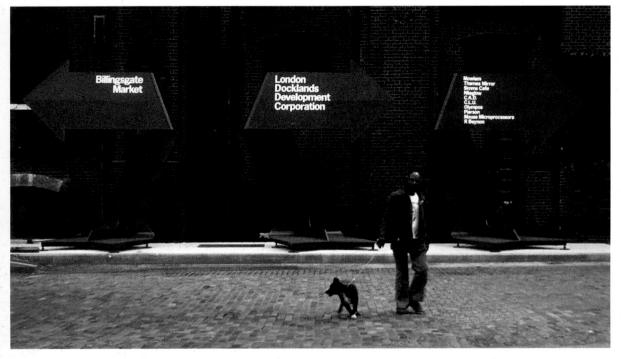

Left: These directional arrows are large-scale sculptures, each weighing two tons and reaching nearly eighteen feet high. With landmarks this size the designers believe that it would take an idiot to get lost.

Design by Pentagram, UK

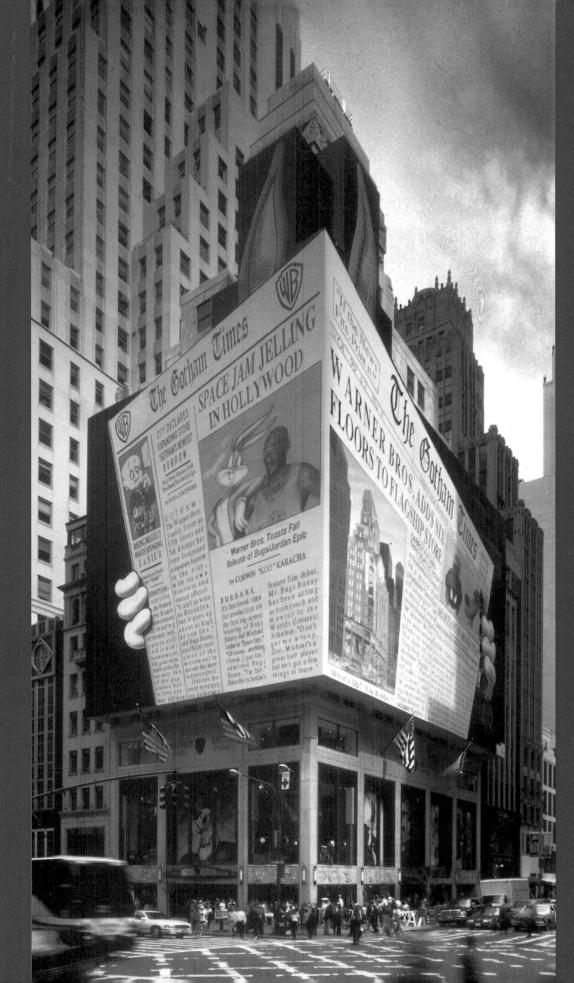

Right: How large can you get? This sign just can't be missed—it not only signs Warner Bros flagship New York store but it also keeps you up to date with the latest company successes. Cleverly, the sign is presented by one of the company's most important assets, Bugs Bunny. A perfect mix of information and brand experience. Design by The Partners, USA

GRAPHIC DESIGN AND SIGNAGE DESIGN The graphic designer draws together creative expression and analytical problem solving. Sign design demands that the analytical problem solving must come first, in order to inform creative expression appropriately.

Designers have to consider that many who momentarily glance at their signs will be on their way to somewhere else, wrapped up in their own worlds, engrossed in the exhibition they've come to see, finding their way to the train, or simply on the way to the restrooms. In this sense, sign design can be a straightforward occupation, merely guiding a fellow human being from one place to another without fuss or bother. That is when signs really work in the real world. However, to be able to achieve this functionality together with style, panache, and wit is the designer's creative challenge.

Sign design is a distinct area of graphic design in that signs take longer to plan, develop, make, and install than many other graphic design projects, with perhaps the exception of permanent exhibition projects (see Exhibition and Display). They are also around for a lot longer, making mistakes painfully lasting for the client (and the designer) involved. Signage is a design area that can be very rewarding for the graphic designer in that it can make a significant contribution to a visitor's experience of a building or space.

Left: Tall, thin monoliths made of frosted polycarbonate sleeves allow ambient light through and make the dark type stand out in a crowded retail environment. Vinyl cut lettering is applied to the hollow inner surface. This can be peeled off and updated when the store layout is changed.

Design by North Design, UK

Below: This museum orientation map uses silk screen printing and vinyl frosting on the reverse side of a large sheet of glass. When secured with heavy-duty stainless steel fixings it seems to float away from the wall.

Design by Atelier, UK

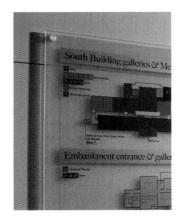

DIGITAL TOOLS FOR SIGN DESIGN

Although sign design demands a different approach to many other areas of design, the tools a signage designer needs can be found in virtually any properly equipped design studio. Signage design requires strong type and graphics, so the key digital tools of this trade are either FreeHand or Illustrator—used for design, graphics production, and typesettingand a good range of typefaces. QuarkXPress is sometimes used, but it isn't really useful as a true drawing tool. Photoshop can be invaluable for creating mock-ups of signs montaged into photographs, but is generally not that useful for actual artwork production. Similarly, three-dimensional modeling and CAD tools can be an asset for creating more effective presentations of work and might be used extensively by architects involved in the project, but aren't used for core design and production tasks.

Many signs are produced using cutvinyl lettering and shapes. These are produced on vinyl-cutter machines, most of which can work happily with vector-based EPS graphic files exported from any professional drawing program. However, some less-common production tools, such as computer-controlled milling machinery for cutting and routing metal or wood items, may require other file formats. DXF is likely to be the format required in these cases. This format is more commonly used by CAD software, but FreeHand and Illustrator can export two-dimensional DXF graphics when required. Note that type may need to be

Right: This sign system for the Bristol Legible City Project was built of component parts that could also be used for street furniture and bus shelters. Made from stainless steel supports and vitreous enamel panels, in the street scene these kindred elements provide a coherence and sense of identity for the city.

Design by MetaDesign, UK

converted to editable shapes first to preserve the desired look and feel, and plan with the machinery operators to make some test runs before committing to a production schedule.

Silkscreen printing is a very common print process, and lends itself to the reproduction of strong line artwork with flat colors. It is ideal for signs that have to withstand temperature and weather extremes, and exposure to public abuse. For more temporary uses large-format digital printing is becoming increasingly popular. Digital printers can handle complex imagery with graduated tones and vignetting. These graphic techniques are very difficult to achieve using more traditional sign production processes. It is very cost-effective for short run and one-shot signs and posters, but the drawback is the fragility of the medium. Results are easily damaged, and in particular are prone to fading even when protected by lamination or encapsulation. More lightfast inks are being developed to address this problem, but be careful when considering this production method for anything but temporary signs.

Below left: British Airports
Authority, London VIP lounge,
internal signs. In keeping with the
calm atmosphere of a VIP lounge,
these signs were treated like
pieces of art, made from embossed
leather, simply framed and hung
like works of art. They present a
contemporary British feel to
business travelers on a stopover
between flights.

Design by Pentagram, UK

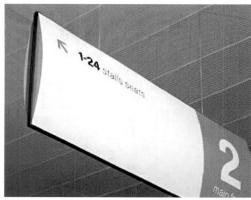

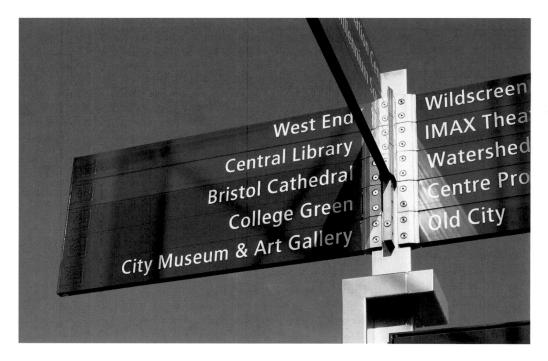

SPECIALIST PROCESSES NEEDED FOR SIGNS

The environment in which signs are placed and the roles they must take on will influence their physical construction and form. Only then does the designer have a surface on which to consider graphic elements.

The signs shown on these and following pages have all been influenced by their environment. They differ in a range of ways: visually, in the use of materials, and in manufacturing processes. Specialist processes for sign-making are almost limitless as the lifespan of signs lends itself to a wide range of durable materials including metal, glass, plastic, wood, stone, slate, woven fabric, and even leather (see Exhibition and Display). Lettering and images can be screen printed, inkjet printed, etched, cut out, routed, carved, or molded. Methods of fixing can be as varied as any other architectural construction and it is this rich variety of materials, formats, and fixtures that makes sign design such an interesting area in which to be involved. Virtually all the image-making processes, whether for creating film for silk screen printing or for driving a router to carve into wood, can be driven by designer-generated digital files, either directly or indirectly.

Left: These signs for a listed 1950s theater are simple elliptical "blades" with a period typeface screen printed onto powder-coated trays. They are finished with stained hardwood trim.

Design by CDT, UK

Right: A freestanding museum sign that can be removed when the space is needed for functions. The clear information is presented at eye level downward, allowing for wheelchair users to read the information in comfort.

Design by Atelier, UK

POSITIONING

The designer's family of sign types (see page 120, The Design Process) will need to develop from the environment in which they are to be placed. So a typical sign family may comprise a free-standing structure, a wall-mounted or hanging sign, a statutory sign, and perhaps one or two individual variations for particularly tricky areas. Working with this family of sign types, a walk through the site (physically, electronically, or mentally) is needed to establish the earliest points at which a visitor needs to see each aspect of information.

Highway signs are a good illustration of this principle. Users are usually traveling at great speeds so these signs are provided well before an exit—allowing time to get into the correct lane, slow down, and prepare for exiting. Placing signs ahead of the exit means that drivers remain calm, make no sudden movements, and are able to get to where they want to go with relative ease. The same principles apply to all signs even at the comparatively gentle pace of walking through the foyer of an exhibition hall or strolling through a park. Repetition of information is not a problem. Remember, visitors often enter environments from many different directions and the repetition of information will help nurture trust in the sign system.

Naturally, signs need to be positioned where they can be seen. The ideal is to locate signs so that information is presented just above normal eye level for general ease of reading, which will also accommodate wheelchair users. Tactile signs should be appropriately located for the partially sighted, which may be in addition to the general sign system. However, the concentration of visitors in that particular area should always be considered. If signs are to be located in crowded areas there may be no other option but to place the signs higher so they can be read by everyone at all times, even though this may be at a distance.

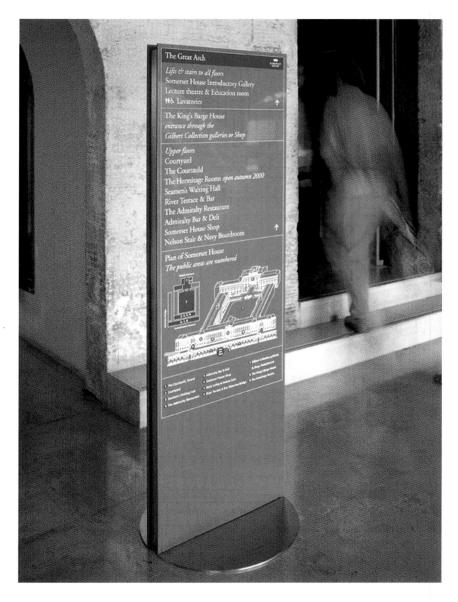

Right: Whether above a freeway or in a hallway the principles of signage positioning remain the same. In the 1970s French designer Jean Widmer worked with a team of specialists to examine the legibility and positioning of freeway signs. One of his recommendations was to position exit signs at 2km and 1.5km (1.25m and 1m) ahead of the slip road as well as on it.

Lighting is a factor to consider when positioning a sign. What looks good on a screen presentation, doesn't always work in situ with the harsh glare from sunlight hitting a reflective sign surface. This glare may become a dark shadow later in the day, with the sign disappearing altogether at night if not illuminated. Avoid reflective materials, keep to matt finishes, and ensure that signs are properly illuminated.

IMPLEMENTATION

Digital artwork can be prepared using a standard drawing application. Sign manufacturers may use their own specialist software for certain processes, so the designer's digital files will need to provide accurate information regarding type, spacing, and typeface. In some instances it may only be necessary to produce "master" artwork for a typical sign from each member of the sign family to serve as a control model. From these control models prototypes can be made and in turn used as the final controls for the complete system. A visit to the factory to check manufacture and fine detail is worthwhile since errors can be difficult to rectify at a later stage.

Sign manufacturers will usually be contracted to install the signs and during this crucial stage it is worth making daily visits to the site. On completion there will be a walkaround tour with the client to pick up on outstanding issues. Identifying these issues is known as "snagging."

Once the project is complete it is important that the client receives "as built" records for future maintenance. Meticulous filing, data back up, and recording of the design drawings during the development of the project can be transformed into a handover manual comprising instructions on maintenance, repair, and updating. This should also include all the final sign schedules, their positions set against floorplan journey routes, technical drawings, and fixing instructions.

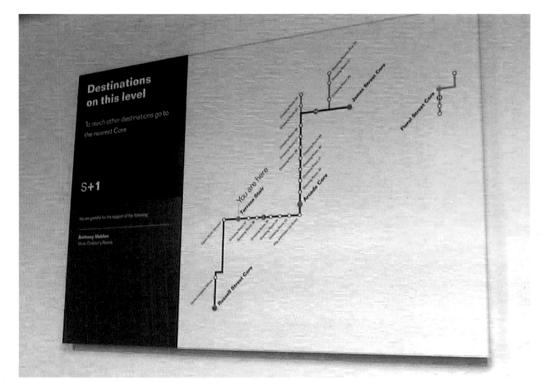

Above: The Royal Opera House, London, backstage sign. This sign has and integrated tray into which slots a digitally printed route map of the "back-of-house" area. With constantly changing accommodation in this part of the building it was essential that the signs could be updated by the client themselves. Digital maps held on system provide an inexepensive cheap and simple self-maintenance solution.

Design by CDT, UK

MAINTENANCE

Good sign systems should last for many years since they are generally serious capital investments. Designers have to rely heavily on the professional expertise of sign manufacturers for advice on the practicalities of appropriate materials, paint finishes, fixing solutions, and other production processes.

It is important to convince the client that materials and build quality should never be cost driven—skimping on a second protective paint coating, initially to save on production costs, may result in rapid fading from the sun's ultraviolet rays after a few years. It is more expensive to replace a whole sign system earlier than normal than it is to prepare more robust signs to begin with.

Vandal-proofing is an important factor in sign design. Signs should be strong enough to support physical abuse and their surfaces may have to withstand "tagging" with spray paint and marker pens. Signs are a magnet for vandals so surfaces must be easy to clean and signs should be designed to enable quick replacement of component parts.

Such components need to be simple enough to order and to install—ideally by the client's own maintenance teams. This is where the "as built" handover documentation becomes essential to the client. All final design solutions should detail each component part and provide ordering and fitting instructions. Overall control is important to many clients, since their site activities may change in line with their business. Signs therefore, may need to be frequently amended, taken down, or added to by the clients themselves.

PLANNING AND PRODUCTION On large signing projects it is essential to become involved as early as possible. This involvement helps the designer understand an architect's vision for a building or space and should influence the final signage solutions. It also provides the opportunity to integrate signs into the fabric of a site, thereby reducing the number of signs needed to be applied to wall surfaces.

DESIGN TEAM

If the project is a large one, there will be a number of parties involved. First is the client, who should outline the extent of the project and provide any corporate guidelines that may be applicable. Second is the architect, who should provide the brief on the thinking behind their design, the purpose of each space, and the materials to be used. The architect will be closely shadowed by a construction manager and a quantity surveyor who will supply delivery schedules, budgets, and liaise with other contractors on the designer's behalf. Additionally, there will be a selection of interested parties, including local planning authorities, fire and safety officers, access groups, and possibly heritage organizations. And don't forget the users—they will need to be consulted, for instance, through focus groups.

RESEARCH

The designer should start by studying the site plans thoroughly—not forgetting all the external approaches. Signs should be seen by the users before they arrive on site. The design team members should then be consulted individually and sounded out for their concerns for the project.

A site visit by the designer is important particularly for observing how people move through the space. If the environment is not yet built, designers should visualize themselves as visitors and walk their way through the plans. Journey routes and all possible destinations should be mapped. This process will indicate the points with the greatest number of intersections and decision-making points for visitors. These points are key sign positions. Lists of all the information a visitor may need to know at these points should be made. In preparing these lists it will be found that some are quite short, others long. The amount of information a sign has to carry and its position should dictate its physical form. For example, an extensive list of information might result in a large freestanding sign, while small amounts of information may necessitate a small, wall-fixed, or perhaps suspended sign. By examining the site, a family of signs will emerge. It is best to

keep the family numbers to a minimum; as numerous sign variations will not only be more costly in manufacturing and future maintenance but also potentially confusing for the user.

THE DESIGN PROCESS

When the site has been fully researched, the designer should begin by designing a representative example of each member of the sign family. This can be achieved using most page layout or drawing programs. These initial concepts should then be presented to the project team. It is best to make paper prints at full scale and stick them onto walls in situ if possible. Only then will the project team understand the full impact of the concepts.

After client approval, the graphic designer will prepare a design specification for each sign type. Talking directly with the sign manufacturer is vital at this point. It will help with any necessary design refinement for production and costing, and the manufacturers should be willing to prepare early prototypes.

Below: Typical floorplan with journey routes and sign points identified. Each sign point will be numbered and a sign schedule prepared (see opposite).

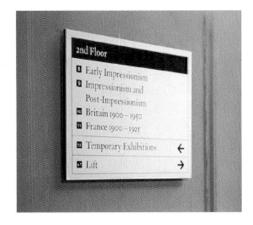

Below: An extract from a sign schedule showing sign identification number, sign type, what it has to carry, how it is to be fixed, and how many needed.

Right: An extract from a sign specification tender package showing the level of detail needed for a prototype.

Left: A finished sign from the same project.
Design by Atelier, UK

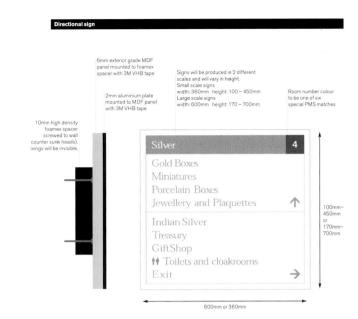

Mid basement

number	area	code	legend	Fixing/Construction	quantity
1	В	Direct	Silver + Gilt/Gold Boxes Micro Mosaics	screened or vinyls on glass wall/wall mounted	1
2	4	Room	Room 4	wall mounted	4
3	4	Info	lift access details/In event of fire do not use lift	wall mounted	1
4	4	Direct	Room 4 – Silver	wall mounted	1
			Gold Boxes/Miniatures/Porcelain Boxes/Jewellery + Plaquettes Indian Silver/Treasury/Shop/Toilets/Exit		
5	С	Direct	Micro Mosaics/Jewellery + Plaquettes	screened or vinyls on glass wall/wall mounted	1
			Indian Silver/Treasury/Toilets/Shop/Exit		2 2
6	5	Room	Room 5	wall mounted	1
7	5	Info	Research room	wall mounted/door mounted	1
			about Research room appointments		

It is important for the graphic designer to be fully involved in the preparation of prototypes, the tender documents, and in reviewing the tender submissions. In cost-driven projects, designers often find themselves being the sole champion for quality. Accepting the lowest tender for a sign system can be a false economy as quality may suffer, resulting in a higher incidence of damage, repair, or replacement. A close working relationship between the designer and the sign manufacturer is essential if the preparation of artwork is to be trouble-free.

DEVELOPING A HIERARCHY OF INFORMATION

Who will be the main users of the signs and what information should they carry at what point? The information should be ordered according to its level of importance. For example, in a building such as a performance venue the main users will be audience members. First they will want to know where the box office is in order to pick up their tickets, then where the auditorium is, which side of the auditorium to enter to get to their seat, and how much time they have before they have to take their seat. They may want refreshments and to sit down while they wait, or they may want to locate the restrooms.

Understanding the user's requirements, helps the designer organize the placing of elements on a sign and determines the level of emphasis. By taking on the role of a member of the audience, the designer will probably arrive at the following hierarchy: box office, auditorium, seat numbers, clock, cafe, and restroom. Obviously the box office is a key source of information and will be in large type along with directions to the auditorium. The clock needs to be nearby and easily readable from the sign point. Seat numbers are another level of detail and can be smaller. Facilities such as the cafe and restrooms can be indicated using pictograms. Thus, an information hierarchy emerges directly from identifying the needs of the user.

02.04 CASE HISTORY

THE ROYAL NATIONAL THEATRE

The extensive refurbishment of the Royal National Theatre, London, introduced more facilities and new entrances to the building. It had been a common complaint that visitors found it difficult to find their way around and so the new sign scheme was an important part of the refurbishment. CDT Design was commissioned to develop a new signage system.

STAGE 1

A number of problems were faced. The structure itself is a protected building, is multi-leveled, and has many entrances on many floors. To make things even more confusing, where traditionally theaters have just one main auditorium, the Royal National Theatre has three.

To win planning consent for a new sign system in a listed building there has to be an improvement on the existing signs, in sympathy with the architectural features of the building. The whole site was carefully studied, noting the raw shuttered finish to the concrete, the chamfered corners, and the recessed holes in the walls left when the tie bars holding the shuttering together were removed after the concrete had hardened. These details affected the form and detailing of the final sign solution. This was composed of modular slats with chamfered edges, which when stacked together echoed the wall shuttering. The signs wrapped themselves around columns, which also had chamfered corners. As an interesting finishing detail some signs had subtle recessed holes that matched the tie bar holes in the walls. The building was built on a 45- and 90-degree grid, with all the walls, supporting columns, and even the floor tiles conforming to the grid. This determined the choice of Ehrhardt as a suitable typeface—with bracketed serifs set at 45- and 90-degree angles, it echoed the spirit of the building.

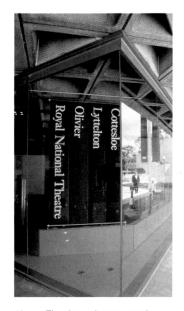

Above: The three theaters at the RNT are clearly identified and the color associations are established well before a visitor enters the building. Here, the signs act as both a draw to the main box office from the outside and serve as a sun blind for the box office staff on the inside.

STAGE 2

Making sense of the building required more analytical thinking. While each theater had its own catering facilities there had previously been instances where visitors took preperformance refreshments in the wrong bars and then found themselves trying to enter the wrong theater for the wrong performance! After studying the floor plan, the whole theater was divided into zones to ensure that every sign within each theater area was prefixed with the theater name, and then color coded to each zone. This color coding was adopted by the architects during the interior refit. Wall coverings and furniture were selected to match the zoning system.

The multilevel nature of the building meant every entrance had to have a complete directory of facilities available at each theater and (particularly important for latecomers), directions for getting directly to each theater quickly. With its imposing concrete, steel detailing, and dark tiled floors the RNT is quite a monotone building, so the signs introduced "spots" of color acting as a trail to each theater.

STAGE 3

With the introduction of new entrances and new facilities, the way in which visitors used the building was going to change. Schedules of information were compiled that listed every possible visitor requirement for key points around the entire building. The information listed dictated the type, size, position, and fixing for every individual sign. In the early stages many of the signs were designed then printed out full size and pasted on the walls in situ. Three-dimensional prototypes were also tested in the same way, this time in conjunction with the lighting designers who tested the readability during day and evening light conditions. Some fixing tests were also carried out to accommodate the irregularities of the wall surface. These early prototypes acted as control samples against which the complete sign package was checked for quality during production and installation.

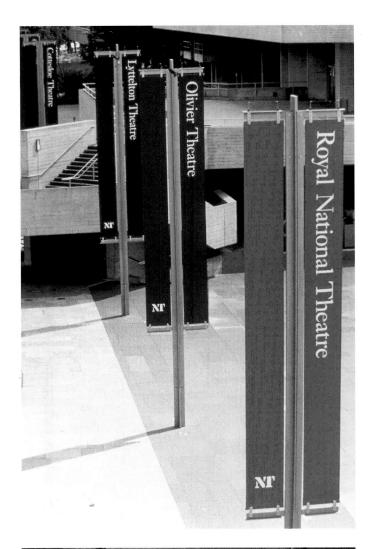

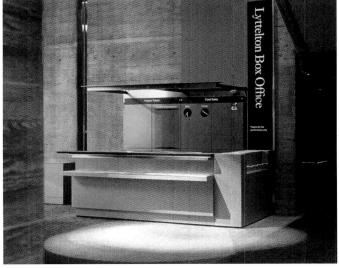

Above: To avoid any confusion, all facilities relating to a particular theater were prefixed with its name.

Top: Large external banners were designed to be seen from the other side of the Thames River and from the bridge nearby.

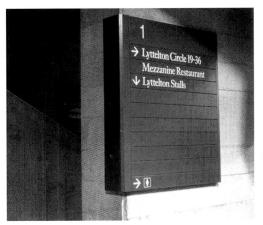

Left: The main internal signs wrap around supporting walls to avoid being hidden from other angles.

Below: Visitors are greeted by large directory panels detailing all facilities available at each theater, each of which has a color zone.

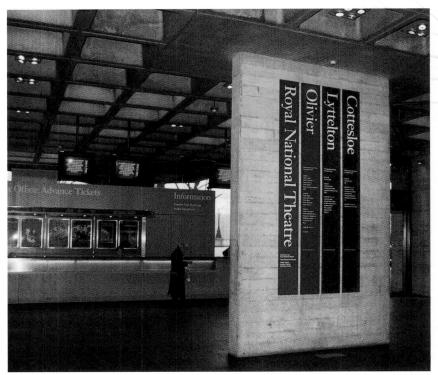

Early design work was produced in QuarkXPress and the final artwork was prepared using Adobe Illustrator so the manufacturers had outline paths for printing purposes. The signs themselves were manufactured from extruded aluminum, sprayed with several protective paint layers, and the type and pictograms were screen printed on top. All fixing screws holding the signs together and onto the wall were concealed for security reasons.

This entire signing project took a little over two years to complete from early concepts to the final installation. All of the work—schedules, flow routes, tender package, engineering drawings, final typographic proofs, and fixing details—was then compiled into one "as built" handover document for RNT's maintenance department.

02.05

Graphic designers working on exhibitions face the challenge of creating a thematic design for viewing in large spaces at a human scale and in a variety of different dimensions. They must be able to think three-dimensionally, often having to visualize the exhibition space from architectural drawings

and consider the general themes, atmosphere, tone, and messages that need to be communicated to the audience.

The overall visual identity, the display panels, and the accompanying publicity material—the two-dimensional aspects of an exhibition—are the main responsibility of the graphic designer. Digital technology makes for imaginative and flexible design and production, and also allows for easy sharing and exchanging of files by email or ISDN—a great

advantage in exhibition design, which can involve designers from many different disciplines working together toward a common goal.

The three-dimensional aspect of exhibition design is produced by specialized exhibition designers, who may have had architectural or interior-design training but can equally come from a variety of backgrounds. Having spatial awareness, developing themes with a narrative, interpreting subject matter effectively, working closely with the graphic designer, communicating to the target audience, and producing detailed working drawings (on AutoCAD) for contractors are all paramount to the exhibition designer.

It is generally not necessary for the graphic designer to be familiar with either AutoCAD drafting packages or Form Z (software that creates walk-through vistas), although both are integral components of the exhibition design process. It is also useful for members of the design team to exchange and understand each other's digital files. Graphic designers working on exhibitions normally produce flat artwork for panels using vector-based software, such as Adobe Illustrator, FreeHand, PageMaker, and QuarkXPress, which allow for radical change in scale without loss of quality. Images scanned or created in Photoshop can be imported into all these programs together with text from word-processing software.

PART 02. SURFACE DESIGN CHAPTER FIVE

DESIGN FOR EXHIBITION

Above: Pearling and fishing in the Arabian Gulf, from the National Museum of Dubai's Underwater Gallery. The underwater effect is achieved using reflections and floating glass panels. Clear and full-strength images are mounted onto glass, and projected gobos and water images complete the picture. Design by Event Communications, UK

Left: The entrance to the Fondation Folon exhibition in Brussels, a permanent exhibition on the work of the artist Jean Michel Folon. Euroculture, the designers, has perfectly captured the poetic, dreamlike qualities of the artist's work in the design of the exhibition space, which starts off by allowing the visitor to enter through a giant book, which slowly opens as the visitor moves past the admission desk.

Design by Euroculture, Belgium

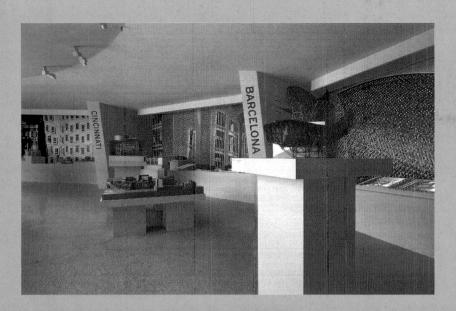

Far left: Guggenheim Museum exhibtion on the work of the architect Frank Gehry. Gehry's drawings, enlarged and printed onto the walls, show his fascination with capturing a sense of motion. To produce this effect, the artwork was printed onto the maximum width of paper available (virtually any length is possible, but widths are dependent upon the size of the roll of paper the printer takes), mounted onto MDF, and heat sealed or wrapped for installation. Alternatively, laser cut vinyl can be applied to painted walls, and again heat sealed if it is in danger of being damaged.

Design by Guggenheim Museum, USA

Below: Legacy—Testament to those who survived, Flanders Fields exhibition, Leper, Belgium. This memorial exhibition makes use of war-damaged sculpture rescued from Ypres cathedral, set against an etched glass panel depicting the names of survivors. Specially commissioned images of other memorials are placed behind in the form of large photoprints mounted onto Foamex. The low lighting helps to convey the somber atmosphere.

Design by Event Communications, UK

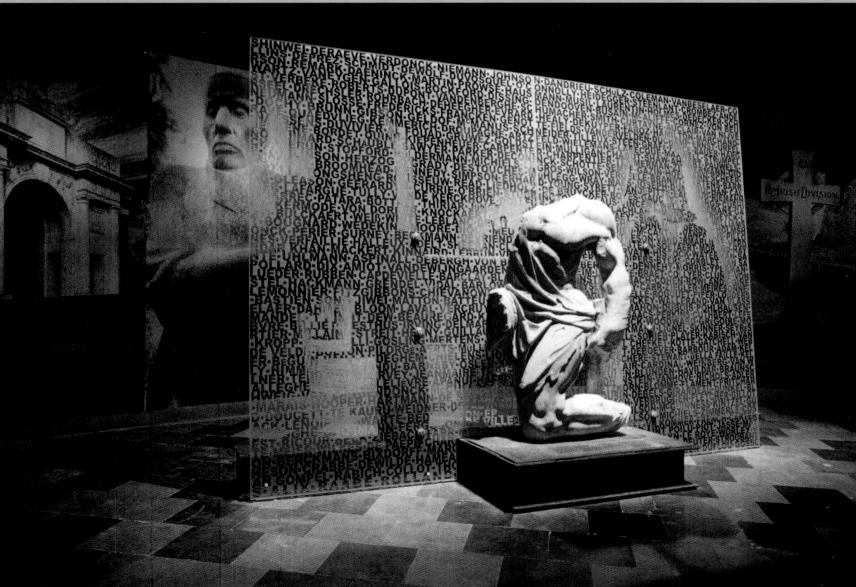

THE NATURE OF EXHIBITION DESIGN Exhibitions vary widely in their nature and complexity, and so can assume a variety of shapes, sizes, and forms. However, conveying the message appropriately is key to every situation, whether the context is a simple panel system or a full-blown major exhibition.

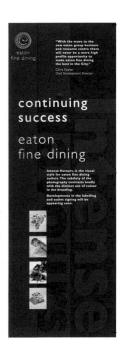

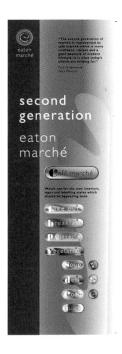

EXHIBITION OPTIONS

The simplest cost-effective way to communicate a message to an exhibition audience is to use portable panel systems. These can take the form of multiple, flat-panel, and fascia configurations, pop-up, telescopic wire-framed structures, or pull-up, single canvas panels. These modular exhibition systems allow simple, digital graphic panels to be economically produced on a wide range of materials, including paper, PVC, gauze, cotton, and canvas. Graphics designed for these systems need to be durable and light. This type of exhibition or display is used wherever portability is an important consideration.

Shell schemes are a cost-effective solution to exhibiting at trade shows. Supplied by the venue organizers, they consist of standardized basic units that feature power and lighting, and onto which individual company fascia and wall panels can be attached. They often form an integral part of the overall trade show personality.

Above: Visuals of large graphic panels used for The Eaton Group's Five Year Business Plan—4th Year, Management Briefing. The final digital prints were mounted onto 10mm Foamex and heat-wrapped for durability. JPEGs and EPS files of design work produced for the company's advertising campaigns, brochures, and signing are brought together in a series of three six-foot-high graphic panels.

Design by Perks Willis Design, UK

Alternatives to shell schemes consist of three-dimensional designs built by specialist contractors and are consequently much more expensive.

Custom-made exhibitions are usually complex, high-budget design concepts built for a specified time span ranging from a two- to four-week-long trade show to a temporary year-long exhibition or permanent museum gallery. These exhibitions are built to a design created by a specialist exhibition designer and, whether long or short term, are built to last for only a designated period. The graphic designer's role involves designing and overseeing the production of the exhibition identity and related design publicity material, often in the form of oversized, digitally printed banners and introductory vinyl cutout lettering. It is the responsibility of the designer to specify the correct materials for mounting, sealing, and finishing graphic panels. The durability of materials used is dictated by the size of the budget and is directly proportionate to the life span of the exhibition.

Permanent exhibitions may have a lifespan of ten years, sometimes more, and tend to be located in museums or galleries. The planning stage of such exhibitions can spread over several years. Large budgets and maintenance programs are necessary to keep them in pristine condition, and to support areas within the exhibition that have to be reworked due to changes in science or popular thinking. The designer's role, however, normally ends when the completed design is "handed over" to the client.

Educational exhibitions, which may be long or short term, are concerned with

Below: Screen grab showing the use of Form Z software, as used in the Arte Povera exhibition in Tate Modern, London. Once the process of feeding in dimensions, thicknesses, and other data has been completed, it is possible to produce vistas of gallery spaces from many different angles and get a very accurate impression of the intended design scheme.

Design by Philip Miles Graphic Design, UK

communicating complex concepts in an effective and inspirational way. Subject specialists liaise with educationalists and designers to ensure that teaching points can be clearly interpreted by the audience. Interactive devices, although expensive, can significantly enhance these key teaching points, encouraging audience participation, and adding greatly to the educational experience.

In situations where a custom-made exhibition needs to travel, a whole new set of criteria has to be taken into account in the design approach. Durability, packing, weight, and possible language issues need to be addressed, particularly if the exhibition is touring abroad, and a successful traveling exhibition will, wherever possible, make inventive use of panel stands as packing cases. The graphic designer normally designs accompanying touring manuals, giving clear instructions on installation and dismantling.

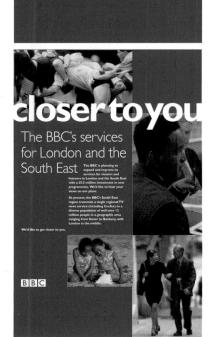

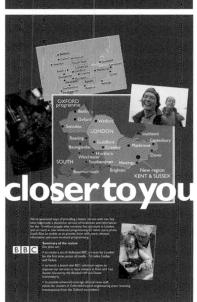

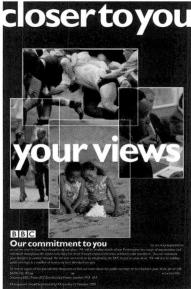

Left: Visuals showing a set of panels designed to fit into a traveling modular system for use in the BBC's public consultation on proposed changes to regional services in London and southeastern England. A simple, eye-catching design, this had to be instantly accessible using stock photography, striking colors, and simplified maps.

Design by Perks Willis Design, UK

Below: Oversized display banner, Times Square, New York, Banners can now be printed onto an extensive variety of materials, in huge sizes, sometimes covering whole sides of buildings. In Times Square, waterproof banners such as these provide an alternative to neon, LCD, and lenticular displays.

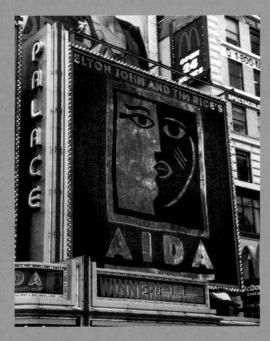

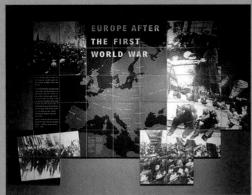

Left: Detail of multimedia wall in the Finney Gallery, National Museum of Football, Preston, in northern England. The wall is formed through a complex lavering of information, which has produced a "reportage" style integration of film, sound, lighting, objects, photography, and text. Many different materials have been used to create this exhibit-wood fiberboard, glass, galvanized steel, and plywood, together with threedimensional lettering, floor lightboxes, and object cases wrapped in supergraphics, all interspersed with monitors and speakers. These are all mounted on a steel support frame. Design by Land Design Studios and The Chase, UK

Above left: Multilayered map showing the social order of Europe after WWI, screenprinted in three colors and fired onto ceramic tiles.

Above right: Lettering, Holocaust Exhibition, Imperial War Museum. The font is Bell Centennial, produced in 1/4-inch-thick fret-cut mild steel. It is constrained by welds of steel. The steel wall outlines the aims of the exhibition, and also functions as a projection screen for war film footage. Design by DEGW, UK

EXHIBITION GRAPHICS PROCESSES Digital technology has radically changed the labor-intensive and limited production of exhibition graphics. This once depended on photo enlargements and photo techniques as the core origination media. Designers can now be much more ambitious. As technology develops, the creation of digital artwork and digital production becomes a more comprehensive and integrated procedure.

The extensive capabilities of giant ink-jet (or bubble-jet) printers allow for artwork files to be run out at virtually any size and on a variety of substrates. Transparencies are scanned to produce high-resolution digital files, and the designer combines these with text and other images. Retouching and manipulating images in Photoshop allows total freedom. Areas of interest or special significance can be highlighted or played down by modifying color and contrast.

Laser-cut type output from digitized artwork allows for great flexibility—virtually any design can be converted into a path for the laser-cutting program. Matt and gloss vinyls are available in a wide choice of colors, and self-adhesive, frosted films can be used to give the illusion of sandblasting onto clear surfaces. Raised type can also be laser-cut using polystyrene or metallic finishes—almost anything is possible. Spacers mounted between wall and lettering can create the illusion of depth and shadow. Different surfaces can be built up to provide a three-dimensional finish.

Silkscreen printing (see page 115) panels and graphic surfaces is a far more labor-intensive, high-budget process than producing prints digitally. It does, however, produce a sharp image in beautifully flat, hard, and durable inks that can be matched to the PANTONE system, unlike digital output, which can only simulate PANTONE colors with varying results. Silkscreening also makes it possible to print directly onto glossy, curved surfaces. The use of "tough inks" eliminates the need for protective sealing, and allows matt and gloss finishes to be mixed.

Below: Designs for metal gobos, From The Beginning, Natural History Museum, London. Lasers are used to cut intricate designs from metal disks. When installed into a projector system, colored lights can be shone through, and the resulting image made to move through gallery spaces, giving another dimension to the exhibition design.

Design by Exhibition Plus and Perks Willis Design, UK

MULTIMEDIA EXHIBITIONS

The use of multimedia adds an exciting dimension to exhibition design and provides almost limitless opportunities to feed the designer's imagination. Multimedia productions can be projected onto panels or played either on freestanding monitors or on screens set into part of the exhibition structure.

Lenticular panels, created from a high-tech photographic process, provide a low-tech form of animation by a simple flip from vertical to horizontal.

Touch screens can be incorporated into the design to show animated or interactive programs, or both, giving viewers more in-depth information about a specific subject and increasing the direct involvement of the audience in the process. Specialized interactive designers can transform a concept into a fully functioning, moving machine that works electronically, mechanically, or manually, but the graphic design element of each of these exhibition components is still the responsibility of the graphic designer.

Lighting and lighting techniques are another important part of exhibition design. Gobos—small metal or glass disks with either cut or printed designs—are a versatile way of making lights move either slowly, or in dramatic shooting movements. Specialized companies produce these items, however, the designer should bear in mind that a projector is needed to use them. Colored gels can be added to produce different colorways. Gobos are a very good way of reinforcing areas or themes (or even exits) in exhibitions and can be projected onto floors, ceilings, and walls or thrown along galleries.

DESIGN CONSIDERATIONS The graphic designer is responsible for providing visuals and digital artwork for all the graphic panels, labels, and interactive exhibit components throughout the exhibition. These are produced at a convenient scale that is compatible with the size of the panels.

Viewing ergonomics are particularly important, and it is essential to produce a full-size mock-up of a typical panel before spending time developing a design too far. This enables you to check the effectiveness of size and height of titles, text, and captions. Lighting conditions also need to be taken into account; they can radically affect legibility. As a general guide, unless you are designing for very young children, the average eye-level should be set at 5 feet with the majority of the text not falling much below hip-height.

The spacing and arrangement of panels should facilitate overall understanding of the subject matter. Visitor flow and avoidance of bottlenecks is usually the responsibility of the specialized three-dimensional designer, but the graphic designer also needs to be aware of these aspects in considering the arrangement of information.

The design of the exhibition identity, including a versatile logo and a related family of associated elements, is of prime importance since it has to carry the visitor through the entire exhibition. Where the brief is to design an exhibition for an organization that has its own distinct and well-structured corporate identity, the implementation of the scheme needs to be faithful and accurate in every rendition—a detailed manual may be available from the company for guidance on this.

- 1. Partitioning the space creates an orderly flow of visitors around centrally placed exhibits.
- 2. Dividing the space into smaller manageable areas aids comprehension and allows the subject matter to be broken down into logical units.

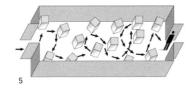

- 3. Regimented positioning of exhibits, allowing random circulation.
- 4. Regimented positioning of exhibits with regimented circulation.
- 5. Random positioning of exhibits allowing random circulation.
 The solution you choose should be dictated by the subject matter.

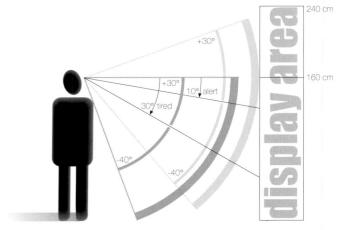

Above: Ergonomic data showing natural viewing heights and angles, and areas of optimum visibility. The upper segment of the display should be viewed from about 6 feet away to successfully scan the

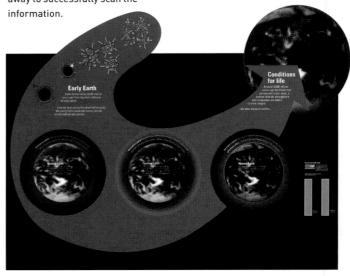

Above: From The Beginning, The Natural History Museum, London—an exhibition about the last 600 million years of Earth's history. This visual is from "Early Earth," a huge exhibit with a large laminate arrow, and doors that vistors can open. The laminate arrow was silkscreened, and the outside of the doors made from digitally

produced artwork illustrating the cooling earth. The doors had a heavy-duty coating for maximum durability to withstand extensive handling. Inside the doors were a few simple exhibits behind glass with backlit Duratrans.

Design by Exhibition Plus and Perks Willis Design, UK **PLANNING AND PRODUCTION** Planning an exhibition can be a lengthy process. Budgets must be finalized, research completed, locations found, and cost effectiveness checked before the design team is appointed. In practice this means that the graphic designer has to be flexible enough to work with restricted budgets and accommodate (or tactfully challenge) preconceived ideas.

The graphic designer's initial role is to formulate the overall design concepts and produce preliminary designs for key panels and related elements for client approval. The style of typography, illustration, and photography, and the processes needed to realize them, must be clearly identified. Illustrators, photographers, and picture researchers have to be commissioned as well as any other experts, including lighting designers or multimedia specialists.

Once a writer has supplied a cohesive script for the exhibition, the specialized three-dimensional designer produces detailed plans and elevations. The graphic designer, in turn, has to produce a comprehensive panel specification document to enable contractors to see and understand the full extent of the job. Estimates are then sought to ensure that the intended scheme is feasible within the allocated budget, and the project goes out to tender. When budgetary requirements are met and contractors appointed, design production can begin. The graphic designer then produces digital printouts of single flatpanel designs and views of key sections of the exhibition, using a combination of graphic arts software to realistically simulate the three-dimensional environment. Because colors vary dramatically from screen to printer, and from the desktop to the press, constant monitoring is essential to ensure consistency. In order to minimize expensive mistakes, individual components of each exhibit are turned into artwork that needs to be approved and signed off by the client before it is sent away for production.

A graphics issue sheet should be designed to tie in with the specification document, to detail and track each component of the artwork. This sheet should accompany every piece of artwork, together with annotated color visuals, TIFF and EPS files, fonts, etc. Unlike other areas of graphic

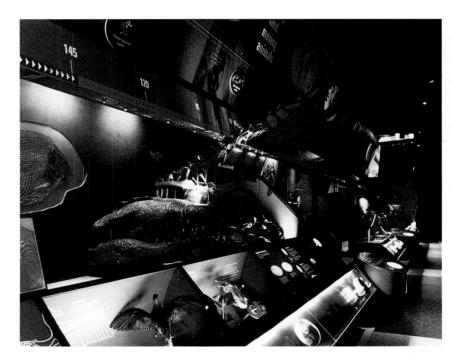

Above: From The Beginning, The Natural History Museum, London. This photograph shows a view down the gallery featuring a giant mural with a timed sequence of different fluorescent light effects. An etched stainless steel timeline runs the length of the gallery, introducing the arrival of different creatures to the planet, and a second layer of smaller exhibits and models runs above this in a run of showcases. tracing the development of life on earth in more detailed form. Larger exhibits stand behind, and vinyl wall graphics complete the picture.

Design by Exhibition Plus and Perks Willis Design, UK design, the exhibition graphic designer may well be providing artwork to a number of different contractors (in different digital formats) for a range of different specialized components, including multimedia, animation, or video editing.

Before panel artwork is mounted and sealed to its substrate, a visit with the client to the photographic contractor for the final approval should be planned. Delivery to the site can take place when the finished design is mounted and sealed, but panels will need to be checked again for possible damage, on site, prior to installation.

02.05 CASE HISTORY

RHYTHMS OF LIFE

The exhibition involved a large team of three-dimensional designers, graphic designers, illustrators, model-makers, video producers, interactive exhibit designers, lighting designers, building contractors, photographic contractors, picture researchers, and a composer, all working with London's Natural History Museum's in-house writer and project manager.

Initially, the specialized three-dimensional design company, Exhibition Plus, worked with the in-house team, developing ideas and extending the brief. Only then did Perks Willis Design (PWD) start work on the overall graphic scheme and identity. Because "Rhythms of Life" was to be a traveling exhibition, Exhibition Plus designed flexible structures in bamboo and timber (to illustrate slow and fast growth) and kitelike graphics encapsulated with a matt finish that could be replaced inexpensively when the exhibition was translated for touring. It could also be easily dismantled and packed into large oil-cans, which served as some of the bases for the graphic panels and exhibits.

The exhibition was aimed at families with young children. It had to be clear, bright, fun, and animated, and flexible enough to be reproduced in several European languages. PWD's first job was to try to capture the essence of what the Natural History Museum was trying to achieve—to communicate how humans and animals are affected by rhythms around them, primarily day and night, and the seasons—and then produce some key exhibits. Early influences were Keith Haring, The Beano comic, and Hergé's Tin Tin—cartoon-like images with lots of natural movement. The color scheme consisted of seasonal leaf colors, sunshine yellow, midnight blue, and rich red. Starting with a set of rhythmic symbols of falling leaves, suns, moons, and beating hearts, these naturally led on to the exhibition identity.

Above: Banner showing the exhibition identity and use of related corporate elements. The image needed to be vibrant, appealing to children, and above all seen as having "street cred." This banner shows the use of the composite elements of the logo that were used as a background image.

After producing an initial graphic panel, a full-sized mock-up was made to ascertain legibility, contrast (in varying lighting conditions), reading heights, and distances. Illustrators were then commissioned to work on the kite-shaped graphic panels, with a brief to produce amusing and whimsical images for children aged six to twelve with added "street cred." The final panels were to have a mix of photography and illustration.

As an opening piece, large-scale cutout themed figures of a "clock boy," tree, and dog were designed to reinforce the concept of time. These were produced as digital prints, mounted onto MDF and then finished with a heavy-duty sealant. Type panels were applied as overmounts. Interactive devices were designed, and specifications given to PWD to design graphics for the component parts.

After extensive tendering processes had taken place, PWD started to produce artwork for the exhibition. Transparencies and line illustrations were scanned to produce "paths" that could be colored up in Adobe Illustrator. Most of the exhibition was designed in Adobe Illustrator, with Photoshop used for re-touching and superimposition.

Left: Designs for glass gobos, used to send images shooting up and down the gallery. Glass gobos, although not as durable as the metal variety, allow for more flexible use of colors. These gobo images formed moving markers for various sections of the exhibition.

Right: Artwork for kite-shaped graphic panels.
The original artwork was produced traditionally using ink on lineboard. This was then scanned, and turned into Adobe Illustrator paths that had color added to them.
illustrations by Debbie Cook and Colin Mier

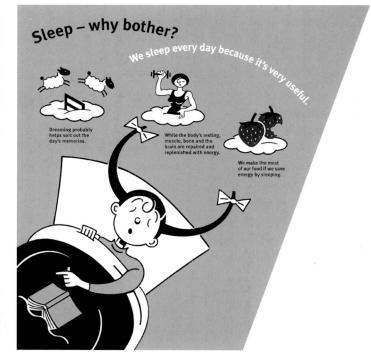

Above and right: The mattlaminated kite-shaped graphics and side banners were fixed to the bamboo poles using colored ties. Interactive exhibits were attached to thick horizontal poles arranged around oil cans or trestle units. Colored vinyl symbols were applied to the lower surfaces to further enhance the themes.

Artwork was then sent to the exhibition contractor, who produced high-resolution digital prints onto paper, encapsulated them with a matt finish, and finished them with eyelets so that they could be attached to the bamboo frames. The interactive devices also used digital prints and, where necessary, were finished with a heavy-duty seal. Artwork was also produced for converting into gobos. Elements from the logo, leaves (below), suns, moons, and hearts were all used to highlight different areas of the exhibition. Baggage labels and clipboards with additional information and facts were applied to the bamboo and other surfaces to provide low-cost interactive devices.

Below right: Detail of small half life-size lenticular panel, which flips between open and closed eyes, using a stock photographic image with illustrated overlay. [This small panel was mounted onto a metronome arm.] Lenticular panels provide simple low-tech animation, and can either flip from left to right, or top to bottom, depending on the effect required. More complicated lenticular panels can have several images incorporated within them.

SEREEN DESIGN

03.01

The impact of the Internet revolution on our lives is undisputed. The growth of websites is increasing at an unprecedented rate, and the challenge for the graphic designer to apply traditional design practices in this digital environment is an exciting and sometimes daunting one.

In the early days of the Internet, Web page construction was a relatively simple process. There was only one browser for viewing pages, and the constraints of the medium meant that the placement of small images in relation to text was the only consideration. Today, the role of the Web designer has expanded considerably. New technology and improved functionality on the Web has meant that designers can now employ animation, sound, and movies and ever more complex graphic image formats to enhance the user's experience. With software such as Macromedia Flash or Adobe Live Motion, for example, dynamic, highly interactive Web content becomes a design reality. The Web designer has to take stock of emerging technologies and strike a balance between applying proven design principles and technology-driven possibilities. The gap between the early programmers of the Internet revolution and the pure designer has narrowed to the point where the two are now inextricably linked.

In the early 1990s it would have been hard to imagine that we could access so much information through a personal computer, but today we are presented with billions of pages of information through the Web. It is in this arena that designers can make their mark, using the powerful tools at their disposal to create successful designs and solutions that communicate to a universal audience.

The range of websites, on which designers might be called to work, is as varied as the Web itself, ranging from educational, cultural, and nonprofit-making organizations to commercial and financial ventures. Rebranding of existing corporate identities forms a major proportion of Web design work and many companies who entered the "cyber marketplace" early are conscious that their initial Web presence is outdated and in need of a fresh look. New technologies are being introduced that add greater functionality and scope for e-commerce, all of which need an effective visual interface. The graphic designer can find challenging and varied prospects within the world of Internet design.

PART 03. SCREEN DESIGN

DESIGN FOR THE INTERNET

Above: www.egomedia.com
Ego Media is an interactive design
group based in New York. First
impressions are everything in the
interactive design and their website
makes extensive use of Macromedia's
Flash to enhance the prospective
customer's experience.
Design by Ego Media, USA

DIGITAL TOOLS FOR INTERNET DESIGN

Internet design is done with a mixture of general-purpose design tools and software made specifically for Web work. Key website layout programs include Macromedia Dreamweaver, Adobe GoLive, Microsoft FrontPage, NetObject Fusion, and SoftPress Freeway. Dreamweaver and GoLive are both powerful code editor tools, with Dreamweaver in particular favored by site editors and programmers, while Freeway (Macintosh only) is more suited to serious design tasks.

Graphic content is best produced using Photoshop, as well as Macromedia Fireworks, a Web-specific graphics production tool. Flash media content is best produced using Macromedia Flash or Adobe LiveMotion, while QuickTime content is made with anything from Apple iMovie through to Adobe Premier. FreeHand and Illustrator are also used for producing graphics for Web use.

Producing page and site mock-ups is an important part of Web design. Photoshop has been quite popular for this task, but it must be said that while this makes exporting graphics convenient, it isn't a good layout tool compared with the Web-oriented Freeway or even QuarkXPress.

Left: www.foldersgalore.com
Coming up with a site map will help
designers develop a logical
website structure. Site maps are
often included as a navigational
tool for users. This site map uses
multiple rollovers to mark the text
labels as users point at the
appropriate page icons.
Design by Biggles, UK

Above: www.yugop.com
Yugo Nakamura applies a rich
design aesthetic to all aspects
of his site. The level of Flash
programming required to create
such complex interactive tableaus
is very advanced—a successful
blend of technical know-how and
visual craft.

Design by Yugo Nakamura, Japan

Left: www.dennisinteractive.com
Dennis Interactive has long been an
innovative company in the field of
interactive design. Their Internet
portfolio reveals a varied and
challenging client base—
testament to their flexibility and
versatility in producing on-line
work without becoming narrowed
to a specific "look and feel," which
can be the fate of many a designconscious enterprise.

WHAT IS THE INTERNET? The Internet is a global telephone network connecting computers all over the world, transporting information in digital form. The idea of a network that could share information over great distances with ease was conceived in the United States in the 1960s as a military communications application. By the early 1990s the first computer code of the World Wide Web was devised—an "illustrated" version of the Internet allowing the transportation of pages, images, and video using a relatively simple, editable code.

THE GRAPHIC DESIGNER'S ROLE ON THE WEB

As with designing for print publications, the graphic designer's role is to produce an appropriate visual structure for Web pages. The fundamentals of design—the use of layout, color, type, and imagery—remain the same, but clearly there is a lot more to Web design than this.

Understanding the possibilities and limitations of Web design is vital. Interactivity, where the page contents can respond to the user's actions in some way, is highly important, as is nonlinear navigation, where multiple links between pages allow users to pick what they see.

A grasp of the core graphic design software packages is as useful here as in any area of digital design. It is also very helpful to have some knowledge of the many ancilliary packages on offer for Web design work, and to be comfortable with managing the myriad file formats involved in this field. You'll also need to learn at least one of the key website design tools to some extent. How far you take this depends on whether you plan to deliver mock-ups and guidelines to teams of code writers, make the complete site yourself, or strike some balance between the two. But you do need to understand the principles of the Web in order to design effectively. Being a successful Web designer means being a bit of a jack-of-all-trades—but you'll also need to remain a master of design skills at the same time or you'll become just another visual Web technician.

BYTES & BITS—HOW THE INTERNET WORKS

Essentially all digital information can be reduced to basic binary code—ones and zeros, or the "on" and "off" state of an electrical signal. Any content, text, or images delivered via the Internet must be digitized or encoded into "bits" at high speeds. In reality, the speed at which individuals can receive information is governed by the quality of their Internet connections via a modem linked to a telephone line or fiber optic cable. The Internet Service Provider (ISP) provides the link between the individual computer and the World Wide Web, supplying a dial-up telephone number that enables two-way

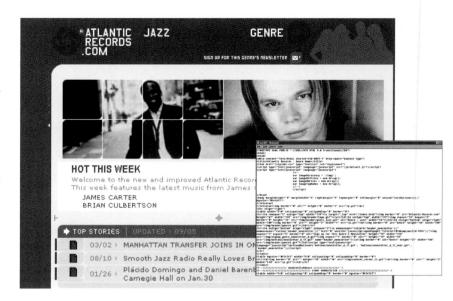

Above: www.atlantic-records.com
All websites, no matter how diverse
their content and appearance, are
underpinned by HTML. Browsers
will allow the viewer to inspect the
code, thus rendering the designer's
layout and structure transparent to
the code-savvy reader. Although
HTML provides the basic layer upon
which content is built, other
proprietary codes such as
Macromedia's Flash are used for
applications, which are not revealed
in the source window (shown inset).

transmission of email and access to the Internet. Other services are often offered such as website hosting, e-commerce, and technical support.

Fiber optics and satellites, which work at the speed of light, can support the rapid transfer of data but "old" telephone network technology, often utilized at the first and last stages of transmission, is the cause of the characteristic delay in receiving Web pages over landlines.

Web pages are drawn on the screen from information encoded using HTML (Hyper Text Mark-up Language). Web page browsers provide the software interface for decoding HTML and rendering the intended visual content on the screen.

The term "Internet" should not be confused with "Intranet," which is a closed and exclusive network for individual organizations for the use of their employees only, to send and receive data either locally or globally.

Left: When you first set up your computer, you will be prompted to sign up for an Internet Service Provider (ISP) to provide access to the Internet. On the Apple platform the "Internet Setup Assistant" will guide you through the process; you can choose an ISP based in the country you reside in, or alternatively you can manually enter settings, such as dial-up number and password, from your existing account.

Below: www.google.com
The World Wide Web is a vast and rapidly growing storehouse of information, news, and data.
Search engines go some way to cataloging this information and are an essential on-line tool to master.

Right: www.apple.com
Websites that are too reliant on
HTML text for their content may
load quickly but are susceptible to
browser preference changes by the
user, which can cause the text to
enlarge by up to 300 percent! This
distorts the page view wildly. Apple
has constructed its corporate site
using predominantly graphic
content, which is immune to such
preferences shifts by the user.

BROWSERS Internet browsers are exactly what they say they are—a means to "browse" the World Wide Web, not unlike browsing the pages of a magazine or book. The phrase "surfing the Web" is often applied to this activity, and "browser" is a generic term for the many software applications available for Web surfing.

Although most people think of a Web browser as the means by which they connect to the Internet, it is in fact just a tool used for reading and displaying files found on computers that are themselves connected to the Web. Connecting to the Internet is like connecting to the world's largest computer network. Once "on-line" the browser is free to search for a sepecific Web page. This will be either the browser's default "home" page or a specific address that the browser has received in some other way.

When a browser is given a particular address (URL), it sends a request to the machine identified in the address, and obtains a Web page by way of reply. It then displays the page according to the HTML formatting instructions found in the document. When the browser finds references to graphics or other "rich media" content, it returns to the remote computer and requests those items. The results of all this are shown, to the best of the program's ability, within a browser window.

THE HIDDEN CODE

Web pages can contain a variety of different items, but it is text that forms the majority of the information. HTML-formatted text is certainly not the most flexible or exciting form of typesetting a designer could wish for; the choices of style, fonts, leading, and kerning control, for example, are limited at best, and all but nonexistent for most of the time. There are other options a digital

designer could choose, such as bitmap graphic images of text, but these are best suited to headline work rather than setting paragraphs of body text.

While browsers can convert formatted text and graphics without help, they require additional software in order to cope with other media such as QuickTime video or Flash animations. This extra help is provided via Web browser "plug-ins"—add-on software that extends the browser's capabilities. Plug-ins are either provided as part of the standard browser package, or can be found on magazine cover CDs or downloaded from software manufacturers' websites. Most are free because manufacturers want their plug-in software to become as widely used as possible, in turn encouraging Web designers to use their commercial software. Popular plug-ins include Flash (for interactive animated content), RealPlayer (for video and audio), and QuickTime (for a variety of video and audio content).

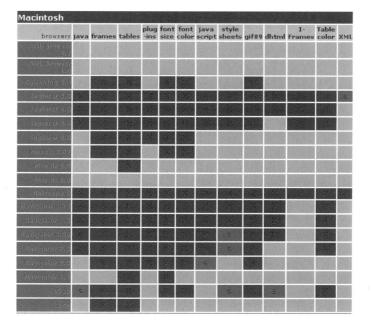

Above: The two main players in the Internet browser war. Each successive update that is released leapfrogs the rival's capabilities, which is an aid to the consumer who benefits from greater usability and performance but often at the expense of stability and reliability. Many popular plug-ins are not preinstalled on these browsers because their manufacturers do not want to offer a competitor's range of products and services. This monopolistic stance inhibits the market growth of new products in many people's view.

Left: www.webmonkey.com
Web Monkey provides a vital
resource for Web developers and
designers. Industry enthusiasts
who are keen to promote an openaccess approach to Web design
maintain this free service. The site
offers useful statistics on common
Web design problems, such as
which versions of browsers
support what versions of plug-ins.

This page: All browsers employ an identical method of locating websites by prompting the user to manually input a website address. Then, hitting the Return key will prompt the browser to locate the address on the World Wide Web automatically. Netscape has the minor share of the market and has to work hard to produce revisions of its interface to retain customer loyalty. New browser revisions may offer different interface styles, yet the real test on their improved performance is their ability to accommodate the latest advances in code types and plug-in types.

Right: Microsoft's Internet Explorer is bundled free with virtually every new PC sold. IE and Netscape's Navigator are bundled with every new Apple Mac. Other browsers, such as Opera, are not free but they can provide a more refined performance.

MODERN BROWSERS

The first Web browsers were in fact very basic tools, handling basic text-formatting options and simple graphics. Today's browsers are much more capable. The market is currently dominated by two main players, Microsoft's Internet Explorer and Netscape's Navigator, although there are a few other browsers vying for attention, Opera and iCab in particular. Each browser has its own interface characteristics, and although their functionality is fundamentally the same, Web pages will need testing on target platforms before the site goes public.

Browsers are constantly being upgraded to accommodate improvements and changes in technology and coding. This can be problematic for the Web designer; different tricks may need to be developed in order to keep control over the way pages behave across different browser versions. Although this is an onerous task, it is vitally important to ensure that the maximum intended audience of a website is reached and that the site's design integrity is upheld.

useit.com: Jakob Nielsen's Website

Permanent Content

Alerthov

....

<u>First Rule of Usability? Don't Listen to Users</u> (August 5)
To design an easy-to-use interface, pay attention to what users do, not what they say. Self-reported claims are unreliable, as are user speculabloss about future behavior.

Tapline Blues: What's the Site About? (July 22) Helping Users Find Physical Locations (July 8)

All Alerthox columns from 1995 to 2001

Reports

Locator usability 11 design guardines to help customers find physical locations How to design the PR section of your site to optimize usability for journalists 2.5 design to the property of the first communication of the communication of

Web Usability Book

Designing Web Usability: The Practice of Simplicity

Extence Free review; "should," be read by any executive with responsibility for managing online operation."

#RAMM*(THE PRINCE): The most important look on web publishing yet to appear & "well researched, sensible, and
right on target, 1...] impressively contacts and complementary."

Conference

MOINE

New book: My design guidelines for e-commerce user experience are now available in full-color printing and hardcover binding. All guidelines are based on findings from detailed usability studies or white year. On the distance of the printing from the studies of the studies of

The online same for the movie "A.L." is a great example of smoorative use of the networked nature of the Web to create a new metha form. Unfortunately, this specific game suffers from being overly difficult This makes the game extring for a small number (2000) of hard-cores, but is a hum-off for the rest of an Housever, if well be eminently possible to create other forms of networked scewinger humb bat allow for multiple levels of difficulty and introductions.

rchive of news items

Recent Interviews

Credit State e Ballerin. The pass with the mouse is king July 21.

Constity of the specimene or y. The first Least 1. Improving the Online Experience (July 2).

Constitution of the specimene or y. The first Least 1. Improving the Online Experience (July 1).

Solven Vellay Passer: Juny 21.

State of Least Young Least 1.

Computer world. **Gree Young Sin. Keep Youn Least (About 18 by greeting 10) has of Computerworld. **Gree Young Sin. Keep Youn Least (About 18 by greeting 10) has of Concept (About 18 by greeting 10).

State 1.

Sta

20) Jung World Don't slavishly multie Amazon, Web expert save somite Timer. Usebility guin philosophiase on Web subjects Somite Timer. Web Web The Amazon from one who knows if New York Timer. Companie Siles Seem to Skimp on the Facts. New York Timer. Companie Siles Seem to Skimp on the Facts.

ull list of interviews

outh tochnah arener los angeles california

SOUND OFF

phoneic by shawn strul

NEWS

COLD PACIFIC STORM HITS COCHRAN AVENUE, HUNDREDS OF WET DOGS.
POWER CRISIS PREVENTED OPERATION OF HAIR ORVERS.
WET PAVEMENT CAUSED FATAL FALL.

ENTER

GRATUITOUS ANIMATIONS, MEANINGLESS CONTENT TYPOGRAPHIC, TESTED BY APES, APPROVED BY MANYEYS

SOMETIMES WE DO SOME WORK

MAYRE SOME PRESS WILL HELP

PREVIOUS VERSIONS ONE :: TWO :: THREE

WORK STUFF

EMAIL

THE CHALLENGE FOR THE PRINT DESIGNER There are some fundamental differences between design for print and design for the Web. All Web publishing is intended to be viewed on screen. This means the "end-user" will determine the precise output of the design by the particular setup or preferences they may choose for their computer. The challenge for the Web designer is to adapt and learn to make the best of this environment.

Unlike the print designer, the Web designer has to cope with his or her work being seen in different viewing tools and on different screens, and even with different text sizes. The most common factors that affect the way a page is seen are monitor resolution and browser window size, Web browser preference settings, and display differences between Macintoshes and PCs. (Remember that although most designers work on Macs, over 90 percent of Web surfers use a PC.)

In Web design, unless steps are taken to lock things down, everything in a layout can move. Some Web designers do their best to take control over this, locking elements down as much as possible in order to preserve the design's intended appearance. Others try to produce pages that take this issue into account, retaining a measure of the intended appearance ("degrading gracefully") as items shift in the browser's window. This form of design, sometimes called fluid or liquid design, can ensure layouts fit browser windows regardless of window size, but it does impose aesthetic constraints on the designer.

The most common orientation of print design, whether a book, a magazine, or an annual report, is portrait. However, computer monitors are landscape-oriented devices, so many existing print designs don't directly translate into good Web page designs. Pages that are too tall to be seen all at once can be scrolled, but this is a poor answer to the design problem. Good design, careful planning, and a structured page-navigation system are all an asset. Fluid page design techniques can also be a strong asset, where it suits the desired design structure.

To work effectively, a Web designer should understand the needs and limitations of his or her work's intended audience, not just the possibilities.

DESIGN DECISIONS

Some designers prefer to adhere to basic standards that make their work accessible to as many users as possible no matter which browser version or platform is used. This precludes use of the latest technologies and plug-ins, as earlier versions of browsers, for instance, are unable to take advantage of their enhanced features.

Another school of thought is that designers should produce only for the current versions of browsers, thereby taking advantage of the latest developments such as Cascading Style Sheets (see page 149) and XML code. The rationale here is that browsers are free and easy to upgrade and to deny advances in technology is to hamper innovation in design even if this risks losing a small percentage of the intended audience.

A solution to the issues of older browser performance, and one that has already been alluded to, is to offer the endusers a choice when they first log onto a site: either a version with cutting-edge technology, or a "non-Flash" or "no frames" standard HTML alternative. This requires more work and planning but will be accessible to a wider audience.

MONITOR RESOLUTION The variable nature of how a Web page is displayed on an end-user's computer can be particularly vexing for a designer. One of the most hotly debated aspects of this is the problem of varying monitor resolutions. A page that holds together well on the designer's screen may completely break on another.

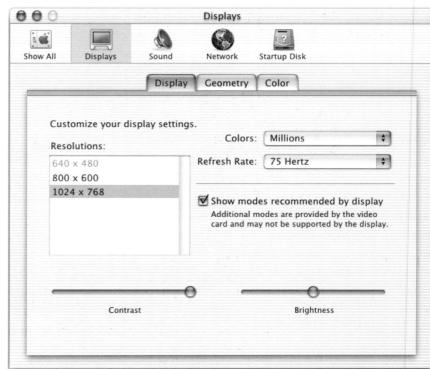

HOW TO DESIGN FOR VARIABLES

Part of the problem of variable display lies with the technical aspects of type handling between Macintosh and Windowsbased computers. Windows uses a different relative point size for text scaling, 96 pixels per inch (ppi) rather than the Macintosh standard of 72ppi, with the result that text formatted in certain ways will look 30 percent larger compared with surrounding graphic items when viewed in Windows-based browsers. Monitor resolution is the total number of pixels displayed on the screen—this is why Web page measurements are calculated in pixels not inches or centimeters. The greater number of pixels held on a screen the higher the detail because more visual information can be displayed. This factor alone is crucial in deciding on the optimum size for images and text for a Web page.

Early monitors could only display 640 x 480 pixels on a 15-inch screen. Today monitors are capable of displaying varying resolutions depending on the video card installed on

the system. This is why it is vital to design pages that either fit into a minimum size or flex to accommodate varying sizes. The majority of computer users today have 17-inch screens set to 800 x 600 pixels, or laptops with 1,024 x 768 pixel displays. Identifying the intended audience and their predicted computer setup is essential to ensure successful scaling of Web pages. The most common mistake made by designers is to produce pages that are too large for the majority of computer screens—often a designer will work on a 21-inch or larger monitor, giving a false impression of scale and resolution quality.

Deciding on the predicted monitor size and resolution is the first step followed by calculating the actual screen space where the

Above left: The user can rearrange the space where a Web page is actually displayed by adjusting the parameters built into modern browsers and changing monitor resolutions. Even a simple act such as resizing a window can radically alter the "live space" view of a page. Designers have to equip themselves with all the relevant information that is needed to produce a design that will hold up on the audience's system under these conditions.

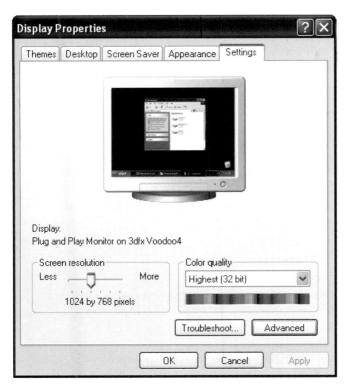

Below: The Apple Macintosh operating system has always encouraged the user to become acquainted with the inner workings of the computer system. Changing monitor resolution and color depth is just one example. Programs like Macromedia Dreamweaver assist the Web designer in foreseeing these operating system parameter shifts, which will affect the layout.

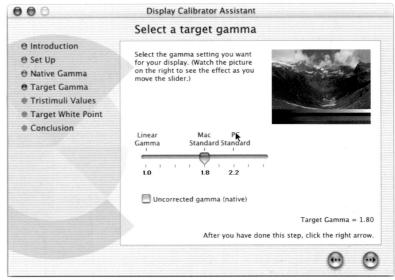

Opposite right and above: Both Macintosh and Windows operating systems allow the altering of monitor resolutions (Apple Menu \rightarrow Control Panels \rightarrow Monitors on Macintosh OS 9.x and Right Click (on desktop) \rightarrow Properties \rightarrow Settings on Windows 98). This is particularly useful for designers who need to be aware of variable end-user monitor settings that can throw a Web page layout completely out of sync with the designer's original intentions.

Web page will be displayed. Browsers occupy a proportion of the monitor window with their varied menu options of tabs and side bars—as do operating systems with their onscreen menus. The area where the Web page will actually be displayed is often referred to as the "live space," which (unsurprisingly) is another flexible element in the design environment. For example, the latest version of Internet Explorer for Mac has no less than five collapsible panels, each increasing or decreasing the viewable live space area. One normally assumes that the majority of endusers will be content to leave the default panel settings untouched.

There are published charts that specify live space dimensions for browser versions, operating systems, and screen resolutions.

These are invaluable to the designer for ascertaining the best all-round page dimensions to use.

It is also possible to create pages that scale according to the width of the browser window. This is particularly useful in situations where the viewer is using a smaller (not maximized) browser window, regardless of the screen resolution. This method involves a careful page layout in an invisible HTML table set to a width of 100 percent. All of the graphic and text elements within the table are contained within the table and strategically positioned to the right, center, or left of the screen. As the browser window is scaled—or as the page is viewed at various monitor sizes and resolutions—the layout elements "re-flow" to fit the width of the page, usually to a minimum of 640 pixels wide.

FILE SIZES No matter how stunning a website design may be, if it takes too long to download (and anything much over ten seconds is too long), then it cannot be counted a success. Until broadband cable Internet connections become universal, the Web designer must design for the user with a 56k modem and a copper phoneline designed for the comparatively low demands of voice transmission. In practice this means getting the most out of small files.

IS YOUR WEB PAGE SLIM ENOUGH?

Usability and efficiency are the currency of popular websites, therefore page download time is critical. The speed at which a page is displayed in a browser window is directly related to its file size. The drive to minimize the total file size of a given page is fanatically pursued by Web designers.

A fast-loading page will greatly enhance the first impression of a visited site and hopefully attract the viewer back for repeated visits. Other factors—such as the speed of the modem connection, available bandwidth, and the efficiency of the connected server—will influence the download time. The way in which a page is rendered by a browser follows Western style text formatting by reading the page from left to right, top to bottom. As content is revealed in this progressive manner it is important to understand how different media affect the overall display sequence. Images, for example, will be displayed at a slower pace than HTML text. To gain an understanding of page file sizes it is useful to outline how data is measured.

File size is calculated in bytes, a byte is eight bits, 1,024 bytes is a kilobyte, or 1K. Bandwidth is measured in bits per second, 1,000 bits is a kilobit, and the capability of modems is expressed in kilobytes per second. The fastest a modem can manage in reality is approximately 4 kilobytes a second (a 56K modem refers to kilobits, not kilobytes). The published data rate of a modem is always the maximum so in practice a 56K modem will connect at somewhere between 38K and 44K depending on the quality of the

Below: On Macintosh and Windows operating systems it is possible to get an exact indication of file size directly from the desktop (for Apple, click the file icon once -> Apple Key + I, for Windows, click the icon once -> right click on the mouse -> Properties). This is invaluable when preparing content for a website. Macromedia Dreamweaver will perform a similar function when media is first imported into the application to use in a Web page layout.

telephone line connection. A more realistic guide is that a file containing a letter-proportioned page with average text coverage will measure approximately 6K, and will take 2 seconds to download on a 56K modem.

So what size should your Web page ideally be? Some maintain that an entire page should not exceed 20K in total. This is, of course, often highly impractical, as unavoidable graphics such as corporate logos or the need to use high-quality images will easily push the total size over that threshold. A more realistic guide is 50K, which should take approximately 15 to 20 seconds to download on an average connection. However, this does require some deft planning and tight compression ratios for any included graphics. The real test is assessing the amount of time the intended audience might be prepared to wait.

Text file sizes are the smallest, followed by graphics, with video, sound, Flash, and Shockwave in the rear. Flash and Shockwave do have their own built-in, preloading capability, which can hold the viewer's attention while the remainder of the content is downloading. Likewise, progressive JPEG and interlaced GIF images will load almost instantly and achieve full clarity in stages.

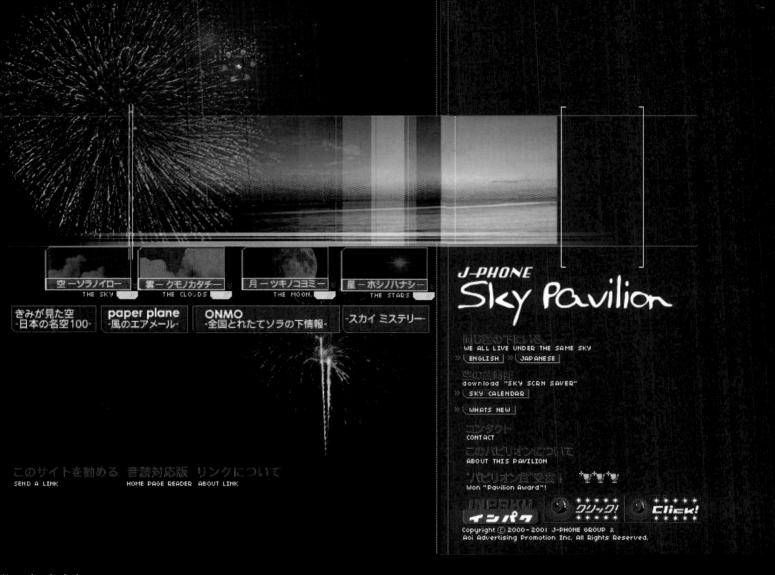

Above: inpaku.j-phone.com
This site uses a clever combination
of optimized GIF and JPEG image
files to give the appearance of a
"full" page. Slabs of Web-safe
background color underpinning
carefully positioned superimposed
images can produce a graphically
impressive site that does not betray
the necessity of fast-loading files.

An approximate guide to various Internet connection devices and their data processing:

Connection	is rated at	typical throughput	to be safe
14.4 modem	14.4 Kbits/sec	1.2 Kbytes/sec	1 Kbytes/sec
28.8 modem	28.8 Kbits/sec	2.4 Kbytes/sec	1.8 Kbytes/sed
33.6 modem	33.6 Kbits/sec	3 Kbytes/sec	2 Kbytes/sec
56K modem	53 Kbits/sec	4 Kbytes/sec	3 Kbytes/sec
Single ISDN	64 Kbits/sec	6 Kbytes/sec	5 Kbytes/sec
Dual ISDN	128 Kbits/sec	12 Kbytes/sec	10 Kbytes/sec
Cable modem/ADSL	512 Kbits/sec	40 Kbytes/sec	20 Kbytes/sec

COLOR AND TYPOGRAPHY Print-based designers making the switch to Web design must be aware of various differences and limitations involved in file output. One major difference is the expanded, yet unpredictable, RGB color space; another is the typographical limitations of HTML and Web browsers.

WEB COLOR

For those familiar with designing for print, the Web environment offers some new concepts and practices in using color. In general, the Web designer has to think of color in a very technical manner. Traditional rules involving CMYK and PANTONE colors do not apply.

Most computer monitors today display millions of colors by mixing red, green, and blue light, as a television does. The light viewed is "transmissive" (projected from the screen) and not reflected, as in CMYK colors printed on a physical page (see Color). Browsers have their own built-in color rendering systems, which can sometimes alter a color unexpectedly on monitors set to 256 colors. Colors on a Web page that are not part of any graphic (pictures or backgrounds, for example) are specifically identified in the HTML code, which raises some restrictions on

Right: It is vital for the designer to use color effectively on the Web and respect its limitations and characteristics. Adobe Photoshop 6 has included the option to select Web-only colors from the Color Picker to make this task easier. This will ensure compatibility with browsers and consistency of color rendering when a page is published.

Below: Mundi Design's Web Color Theory, one of the many resources available to help Web designers comprehend the sometimes confusing nature of screen-only color. The on-line resource provides an interactive "handson" approach with which the designer can experiment with various color schemes.

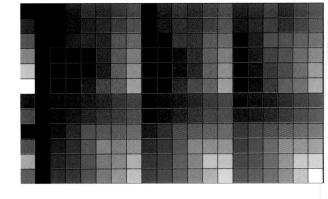

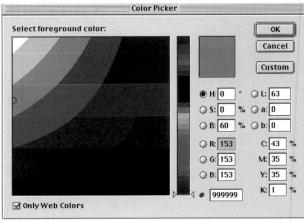

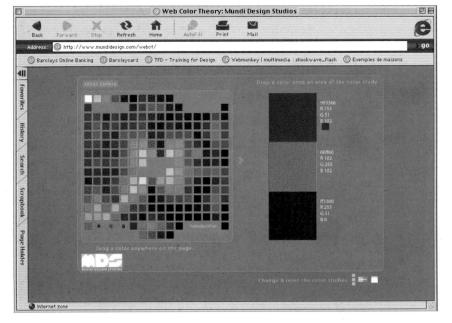

color use. The final consideration is that the default Windows and Macintosh 8-bit system palettes (a uniform sampling of 256 RGB colors used to display system-level operations) display a slightly different set of colors. The Macintosh system palette is actually the closest to how browsers render color, which is useful for Macintosh Web designers.

The redeeming factor in the confusion of RGB color presentations is the use of a Web-safe palette. The Web-safe palette consists of 216 colors made up from the Macintosh and Windows system palettes, which all browsers are able to render accurately. If the designer uses the Web palette, consistency is assured across both platforms.

When saving images in the GIF or PNG-8 formats the Indexed color mode is used; it is limited to any combination of 256 colors or less, and as such it can support any of these

Arial Helyetica san-serif Times New Roman, Times, serif (+3 size) Courier New, Courier, mono Verdana, Arial, Helvetica, san-serif

smaller color palettes. It is also worth noting, however, that many (if not most) current computer systems in use are capable of 16-bit color or higher, which enables browsers to display a much larger range of color and virtually eliminates Web-safe color limitations.

WEB TYPE

HTML is a proficient tool for coding and sending basic formatting instructions to different computers. Its original purpose was to place the ultimate control of presentation of the information in the hands of the enduser. This simplicity and lack of precise control means good typographic detailing is difficult to achieve. Designers do not like the lack of typographic control available using HTML, but it is the fundamental standard of Web page design. In the most basic form of HTML there are only three types of fonts available: proportional serif (Times New Roman on Windows, or Times on MacOS), generally used for body copy; proportional sans-serif (Arial on Windows, or Helvetica on MacOS), often used for headings and large type; and fixed-width (Courier), best for columns and tables. These are considered the default Web fonts because they are the only ones that are guaranteed to be installed on virtually all systems; the use of typefaces not installed on a given system will cause that text to be displayed using one of the default fonts.

New font development coupled with widespread free font downloads has enabled Above: The array of available fonts for print publishing is vast; the choice in Web publishing is not. The elements of compromise and forethought need to be deftly applied to a project to attain a good level of typographic style. Web designers can access a number of on-line resources, such as Microsoft's True Type Font Utility, to aid better type use in a constrictive area of Web publishing.

Below: General font attributes can be altered in all WYSIWYG editors, although testing or previewing the page in a browser is crucial to ascertain its published appearance. To make certain of a font's behavior, the only failsafe method is to upload the page to a server and view it on a number of operating systems and browser types.

designers to use a greater variety of type styles; for example, Microsoft's Verdana—developed specifically for use on the Web—is enjoying widespread popularity as one of the best sans-serif fonts for Web use on both platforms. In addition, CSS (Cascading Style Sheets), and certain browser plug-ins enable designers to refine the way type is displayed in specific browsers.

The formatting options used to set the text sizes can be crucial to the way things appear on different browsers and computers. The basic formatting controls work on some of the oldest browsers, not to mention screen readers for blind users. However, these don't solve the issue of the way Windows scales fonts, with 12-point text displaying closer to 16 points. To solve this, and to provide greater formatting control, more sophisticated formatting instructions can be used. CSS, for example, embeds a set of instructions in the page, including rudimentary letter spacing and leading control. Writing CSS coding yourself is not easy, but fortunately most serious Web design tools make CSS style creation pretty simple. Dreamweaver is tuned for this kind of work, and some software

makes it as simple as ordinary text formatting.

The final option is to create graphic images of text. This technique, while usually not suitable for large blocks of text, is ideal for preserving exact typographic detail for headlines and similar elements. Do this with tools such as Photoshop, FreeHand, Illustrator, and Fireworks.

WEB GRAPHICS Designers face a new set of constraints when working with graphic images on the Web. Images sent over a network and viewed on screen have to be low-resolution—monitor resolution 72ppi. They must also be small files if they are to be viable Web page elements. Currently there are two dominant graphic file formats on the Web, JPEG and GIF, with a third contender, PNG, attempting to find popularity with Web developers.

Web graphics are compressed versions of original picture files. The production methods employed to create graphics are similar to print in so far as images are created or sourced, drawn, or scanned, manipulated, and then saved for publishing. It is the RGB image mode, resolution, and output stage that are uniquely different. If a Web designer remembers that everything happens on the screen, it is easier to develop a more proficient working practice.

To create effective Web graphics a certain amount of image information must be sacrificed in order to create file sizes small enough for Internet delivery. A loss of sharpness or subtle detail compared to high-resolution print scans is natural. The relatively crude 72 pixel per inch resolution of Web-ready graphics combined with the lossy compression methods impose limits that Web designers just have to accept.

Production of Web-ready images is generally done in Photoshop ImageReady, Fireworks, or PaintShop Pro, and all provide some form of image preview to find the right trade-off between high compression with lowered quality and low compression with large file size. Below: The importance of experimenting with file format compression settings cannot be overstated for Web graphics. Even the basic rules can be misleading depending on the specific nature of the graphic being used. A good practice for the Web designer is to always keep the original prepared graphic. Then, export a range of compressed files to view comparatively within the most popular browsers, ideally also over a number of monitor types.

GRAPHIC FILE FORMATS

GIF (Graphic Interchange Format) is the veteran of the Web, being the first file format to be supported by Web browsers. It remains the most popular graphic format on the Web today. GIF files index color information within a maximum 8-bit palette (akin to older monitors), which gives them 256 colors from which to choose. Compression is achieved by rationalizing rows of pixels with similar colors, making it most suitable for graphics with flat areas of color, such as text and logos.

JPEG (Joint Photographic Experts Group) files contain 24-bit color information (6.7 million colors). They use a different, lossy, compression method, where some image information is discarded rather than rationalized as with GIFs. A sliding scale is used to choose the level of image compression. With medium or high settings

Original image

JPEG

GIF

150

part 03. screen design

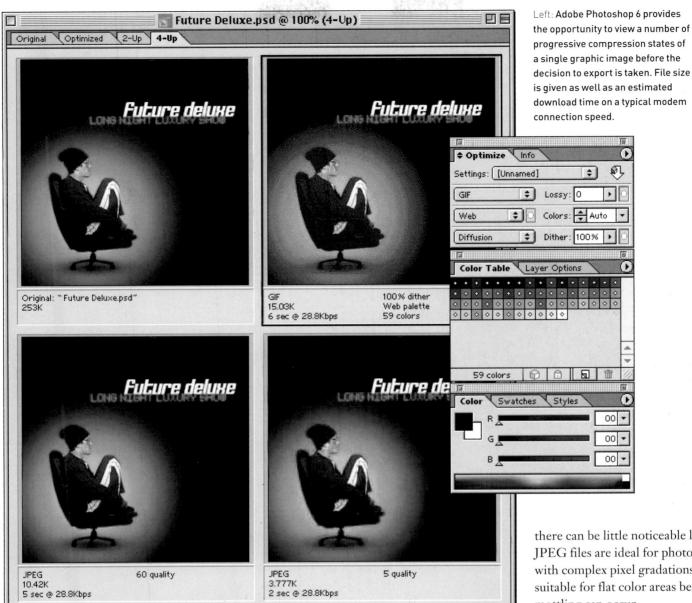

100% ▼ 15.03K / 6 sec @ 28.8Kb... ▼

smooth tonal changes, so better compression and cleaner final results can be achieved by blurring anything in the image that isn't part of the central focus. Here a JPEG image has been reduced in size to minimize download time. The resulting pixelation can be disguised by applying a gaussian blur from the filter→blur menu. This gives an overall smoother, though softer appearance.

Left: JPEG images work best with

there can be little noticeable loss in quality. JPEG files are ideal for photographic images with complex pixel gradations, but are not suitable for flat color areas because unwanted mottling can occur.

1

PNG (Portable Network Graphics) is an adaptable format allowing "lossless" compression with 8-bit indexed and 24-bit true color, but it is finding it hard to dislodge the dominance of the other two.

A golden rule in Web design is never to scale or otherwise edit images once they've been converted to Web-ready format. It is always best to keep your original source files and go back to those if scaling or other significant changes have to be made. JPEG files in particular should never be edited and resaved; each time this is done the JPEG compression process destroys a bit more image information.

HTML HTML code is the framework of the Internet upon which the visual interface hangs. It sits behind every Web page, giving instructions to the browser on where to place images, render text, and manage assorted media. It is the foundational building block on which all Web development has been built. Its principal function of "hyper linking" (the ability to link between pages and addresses on the Internet) remains one of the most potent tools on the Web today.

HTML TAGS

HTML is composed of sets of nested instructions, called "tags," that hold formatting and layout information pertinent to the page, such as font styles and background color. These special instructions are not themselves displayed in the browser window, but affect things that are. For designers not used to looking at a page of HTML code it can appear rather daunting. On closer inspection, however, the code, while sometimes rather convoluted in structure, is actually quite logical.

The master tag is the HTML tag, the opening <HTML> tag and the closing </HTML> tag. These encapsulate everything on the page, like the front and back covers of a book. The contents of the page sit within this tag in various nested groups. At the top of the page is the <HEAD> and </HEAD> tag pair, which hold items describing the page. This includes the page title, copyright information, and keywords intended for some of the Internet's search engine indexing tools. (Keywords for search engines can help get sites into the listings of search engines, so when people search for related items the sites you design are among those offered. But with many millions of pages available and the fact that some search engines actually ignore keyword lists, this does not always work miracles.)

HTML KNOWLEDGE

Designers need to understand HTML to a reasonable degree in order to work with specialists such as database programmers, even if they will never actually hand-craft a page themselves. The HTML files that browsers read are simply ordinary text files, so you can edit them and create new pages from scratch using nothing more than SimpleText or TextEdit. Building Web pages by hand using text editors used to be the only option available, and many experienced Web programmers still use this approach. Fortunately, today's professional visual Web design tools are easily good enough to produce work to the level of the best hand coders without the designer having to key a tag at all. So while it is important to understand the structure and principles of HTML, don't believe the myth that you are not a Web designer until you can type everything in by hand.

HTML is a language that is continually growing, with new tags added from time to time. Browser revisions accommodate (and sometimes drive) these changes, for example, supporting JavaScript (an embedded control language for making Web browsers perform complex functions) and CSS, which engenders structured control over layout and type.

Above: It is a very handy skill to be able to look at a page of HTML code and "decode" it—although not essential for the designer using a WYSIWYG program. Often unused tags are left in the code when using applications like Dreamweaver. This can sometimes produce unwanted disruptions to a given page. To know and edit the basic tags in HTML is both time-saving and professional.

WYSIWYG There is a huge number of Web design or authoring tools from which to choose. At the professional level "WYSIWYG" ("What You See Is What You Get") software, such as Macromedia's Dreamweaver or Adobe's GoLive, offer a desktop publishing—style work environment favored by designers. With precision tools for layout, image placement, and text editing, these packages are ideal for print designers wishing to enter Web publishing.

PROFESSIONAL AUTHORING TOOLS

The consumer market for Web design is catered for by lowend software that provides basic formatting options but lacks the flexibility and control offered by the professional tools. Consumer-orientated software can provide a useful introduction for the general user, but designers will imediately feel frustrated by their limited abilities.

Professional website design tools, often called WYSIWYG (What You See Is What You Get) tools, are the best for designers, because they offer methods of working that approximate DTP-software behavior with reasonable success. With these tools the designer arranges the elements on the page and the software writes the code required to re-create the layout in a Web browser. Dreamweaver and GoLive prefer everything apart from text to be prepared for the Web beforehand, and can provide "smart links" with Fireworks or Photoshop ImageReady for image optimizing. Freeway can work with DTP formats such as TIFF and EPS graphics as well as JPEGs and GIFs, creating and optimizing Web graphics along with the page code.

Above: Freeway's approach to layout is based on traditional DTP behavior, scaling graphics, and styling text on the page. Guides can be dragged onto pages manually or set up as regular design grid structures.

Left: Adobe GoLive's basic layout structure is based on placing grid objects on the page, and design elements within the grids. It has extensive options for handling QuickTime movie contents, and a timeline editor for managing page-level animations.

Graphics are usually prepared for use in an image editor such as Photoshop. Site mock-ups can be done in a number of different applications, but designer, developer, and programmer specialization—as well as the increasing complexity of Web design applications and Web programming—has led to teams with split designer/programmer workflows using Photoshop as a layout tool. Most Web design applications such as Dreamweaver and GoLive are still very designer- and programmer-friendly, enabling designers to maintain control over more of the production process, or vice versa. Still, many designers prefer creating layouts with layout or graphics tools, such as QuarkXPress or FreeHand, or using a Web DTP tool such as Freeway, so as to avoid having to work with programming code entirely.

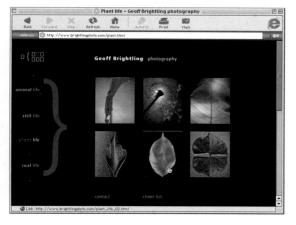

WYSIWYG

Entire sites can be constructed and edited with WYSIWYG tools; hyperlinks can be made and tested, interactive forms, buttons, and rollovers created, and pages uploaded to the hosting Internet Service Provider. Flash and Shockwave files can be included as elements on a page, but often they are used to create stand-alone pages or sets of pages. They both use a traditional, time line format for creating animation with the capability to script links to other pages, movies, Internet addresses, or for sending mail. The advantage of using Flash and Shockwave for Web design is that they can be treated as "embedded" files, or objects, within HTML. This means that they cannot be altered when displayed in a browser, assuring design fidelity. Flash, in particular, is favored by Web designers for this fact alone.

SHOCKWAVE

Shockwave is the Internet export format of Director, Macromedia's CD-ROM authoring software. It is used extensively for on-line gaming because of its powerful Lingo scripting language, which facilitates interactivity. Shockwave can contain sound, animation, graphics, and three-dimensional components. However, it is far more complex to work with than Flash, which offers many of the same features.

FLASH

Flash is Macromedia's Web animation tool; it is used for simple animated logos as well as creating entire sites with navigation structures. Flash uses vector technology, similar to Illustrator and FreeHand, which is ideal for the Web because of the small file sizes and scalable qualities characteristic of vector files. It compresses sound using the Web's standard MP3 format, contributing to efficient download times. The Flash plug-in is found already installed in millions of the world's modern Web browsers. However, this doesn't mean that all these browsers will have the latest version of the plug-in or haven't had it disabled for some reason. It is good practice not to design sites that require Flash unless you're confident that enough of your target market will have a recent version installed.

Above left: www.trafficthemovie.com This Flash dominated site to promote the movie, "Traffic," presents the visitor with a sequence of visual puzzles to solve before the next stage of the site can be accessed. "Traffic" entertains while drawing on the viewer's intuitive abilities.

Left: www.brightlingphoto.com
This site uses carefully prepared
photographs, subtle rollovers, and
a simplified iconic representation
of the user's place in the site. The
result is understated elegance
and a site that is extremely easy
to navigate.

Design by Biggles, UK

Left: www.fray.com/hope/thecity/
Web pages can be displayed
as multiple frames within a
single window. Many Web
designers try to avoid this
technique, but this site shows
how this can be put to excellent
creative use. Black-and-white
photography and graphic
typography helps to make this
site a particularly powerful
interactive experience.
Design by Powazek

Design by Powazek
Productions, USA

Left: www.fray.com/hope/2000/ Sometimes the best Web designs are the simplest, at least as far as the final result is concerned. This Web page uses sliced graphics and overlaid text to produce a strong, creative impact. Design by Powazek

Productions, USA

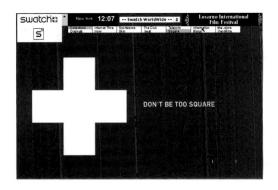

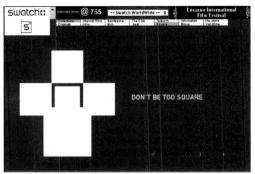

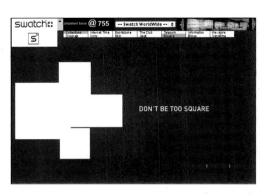

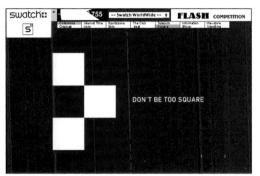

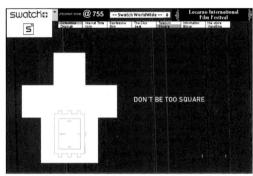

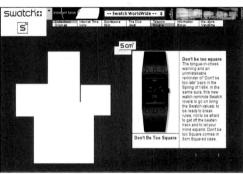

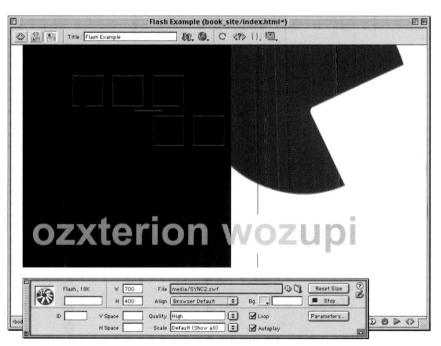

Left: Specific attributes of Flash can be manipulated within Dreamweaver, not on an authoring level, but on the control of playback properties.

Above: www.swatch.com
This site for the Swiss watch
makes full use of Flash animation
to involve and entertain the visitor.

Above right: The Flash interface is difficult to find your way around at first, although Flash 5 is much closer to the standard of DTP application interfaces. It has the advantage of integrating well with Dreamweaver, giving the designer the chance to play the Flash movie directly within the editing area.

Right: Freeway is a viable alternative to Dreamweaver, particularly for the Macintosh platform. It has great versatility and flexibility compared to many of its rivals.

INTERACTIVITY To interact with a computer is the fundamental principle of communication in the digital world. Almost without exception every type of content on the screen requires some level of user interaction. Websites are designed exclusively for this purpose—to encourage the visitor to explore and access areas of the site that offer up information. Web designers have to understand the concepts of interaction fully in order to use them appropriately.

CREATING HYPERLINKS

Interactivity is a key element of any website, making the design dynamic and encouraging the user to stay and look around. The simplest form of interaction is clickable hypertext links. These provide links to other pages via clickable text items. Visually, graphic buttons and image maps are a more sophisticated form of link, but the technical aspect of the link is produced in exactly the same way.

The process of producing links varies slightly from one website layout tool to another, but the principle is the same. The examples shown above demonstrate creating hyperlinked text using Dreamweaver, and creating a graphic link using Freeway. In Dreamweaver the process begins by selecting a word or piece of text on the page. Click in the "Link" field in the "Properties" palette, and type a complete URL or pick one of your other pages from the pop-up menu. When the page is tested in a Web browser the linked text will take the user to the specified page when clicked. The process in Freeway is very similar. It begins by selecting, in this case, a graphic on the page. Then press on the globe icon at the bottom of the window and pick one of the pages in your site, or select "Other" and type the URL into the URL field in the "Hyperlink" window. Preview the result in a Web browser and the graphic will take the user to the linked page when clicked.

Above left: The principle of text hyperlinking can be applied to any graphic element on a page as well. It is always important to check for broken links when publishing a site. Trying to navigate your way around a site with over a thousand links can be a very arduous task! Most WYSIWYG applications offer a fast and efficient method to check the integrity of all links with a page as well as an entire site.

Above: Mapping the links from a page can be a tedious business, but with complex sites it can be vital to keep track of your overall site navigation structure. Look for site and link mapping features in your Web design tool in order to keep on top of this when handling large projects.

ROLLOVER BUTTONS AND IMAGE MAPS

Rollover buttons are used to make graphic link items more interesting visually and to provide feedback to the user so he or she knows an item is definitely a clickable link. Rollovers use a second graphic, which is shown in place of the first when the user points the cursor at the item, and are most commonly used to simulate a button that either lights up, appears to depress, or display some other form of detail change. They are produced using JavaScript instructions, which are placed in the HTML along with the image references in order to create the image-swapping behavior.

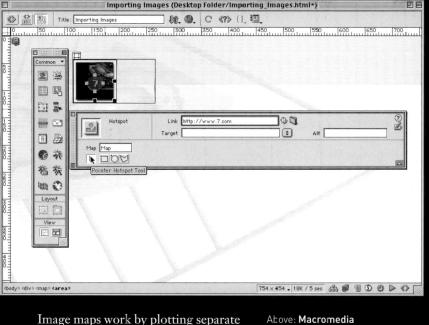

to a separate URL. This creates "hot spots" within the graphic that take the user to different destinations when clicked. The graphic itself is an ordinary image file, and the map coordinates, which plot out the hot spot areas, listed within the HTML code. Image maps allow a very visual design method and don't demand that the designers slice their images up into multiple parts to create each graphic link. There are two forms of image map: client-side and the more unusual serverside. Client-side image maps hold everything to do with the map, including all the URLs,

within the HTML page code. Server-side image maps send custom messages to a remote Web server that passes back the final

destination URLs.

areas of a larger image and linking each area

"hot-spot" tools into the Properties window. This makes for very easy hyperlinking editing when working with images on a page. Hotspots can be linked to invisible elements on an HTML page ("Anchors") and separate pages contained within a Frameset. This can be advantageous for producing quick side menus—when clicked, these change the content in the rest of the Web page.

Dreamweaver 4 incorporates the

text, set in Verdana.
Linked Text: This text is
hyperlinked and bold; hyperlinks
are set to dark red on this page.
Visited Link: This text is
hyperlinked and bold, but has
already been visited; visited links
are set to brown on this page.

Below: Four possible states of a

Plain Text: This is plain black HTML

clickable hypertext link.

clicked.
Active Link (CSS): Using Cascading
Style Sheets, this link is made to
turn orange when clicked;
however, this can also be done in
plain HTML.

Below: Graphic buttons and image

way as hypertext links but they do

offer the designer infinite scope

for creativity.

maps work in exactly the same

Hover (CSS): Using Cascading Style

Sheets, this link has been given a

bright red to indicate that it can be

Hover state. When the mouse

pointer hovers over it, it turns

JAVA AND JAVASCRIPT Java and JavaScript are two distinctive coding languages used to add interactivity to Web pages. Java is an object-oriented "full" programming language like that can be used to create complete applications. The Web manifestation of Java is in the form of Java Applets—independent, mini-executable programs placed on a page, like an image. JavaScript is a client-sided scripting language that allows the creation of rollover effects, the opening of pop-up windows, and many other interactive page functions.

JavaScript and Java are actually two entirely different things. JavaScript is a text-based scripting language that is used to make specific instructions for browsers. These are placed into regular Web pages alongside the HTML code and are read and acted on as required. Web designers frequently use JavaScript without even realizing it as part of rollover effects and similar Web tricks.

Java on the other hand is a complete programming language used to make self-contained miniature applications, or Applets, which can be embedded into Web pages, but are actually very much separate from the browser. The major browsers support Java Applets but unfortunately they can be unreliable in handling them. Applets provide an array of functions from games to numerical computations. For designers they are useful for text effects, scrolling marquees, and flashing text to name just a few. They are practical for sites

Above: Just like regular TV, Apple's QuickTime TV offers the viewer the choice to switch between channels and view different programs or content on-line. In reality, bandwidth difficulties make this a somewhat less-than-smooth affair. A good ISDN line will permit this to operate more effectively.

that require fast response from user input because they compute on-the-fly using the host computer's processing power. Designers who are not programming conversant can download pre-prepared Java Applets from sites such as http://javaboutique.internet.com and place them directly on the page.

JavaScript is written directly into the HTML code. It is generally very stable, as long as it is well written. It can perform rollovers, randomly display content on a page, and load content into new browser windows, as well as a host of other functions. Designers do not have to learn programming to use the basic JavaScript functions as the main website design packages will generate the code.

SOUNDS AND MOVIES

Sound and movies (video) on the Web are commonplace, but handling these weighty files can be a testing experience for the designer. Both formats require specialist applications to prepare them for publishing, and a good bandwidth connection to allow uninterrupted playback or fast download to the client computer.

SOUND FORMATS AND CHARACTERISTICS

The most commonly used formats for audio and video Web publishing are MP3, QuickTime, and RealAudio. These formats all use forms of "streaming" technologies that allow playback to begin without having a complete file downloaded, thus presenting a continuous stream and avoiding a lengthy download. Sound quality is determined by file size so CD-quality sound is not best suited to the Web. Sound files are often compressed to reduce download time, thus sacrificing the full tonal range of the original file. Speech is acceptable at 11kHz sampling rate, while music is better at 22kHz, both in mono. Flash uses sound very efficiently.

Below left: Undoubtedly the most widely used multimedia player application, Window's Media Player started out as a very basic utility, finding its legs on the Windows 95 platform. It has evolved into a powerful, automatically upgradable suite of tools, and its latest version, designed for Windows XP, allows for extensive visual customization.

Below: The Apple QuickTime interface is a strong competitor to the Window's Media Player. It is regarded as being very stable on both platforms and will handle a broad range of media. The familiar controls of treble, balance, bass, and volume are built into the interface control panel for manual adjustment.

VIDEO FORMATS AND CHARACTERISTICS

The QuickTime platform (".mov" file extension) operates on both Macs and PCs while the Windows Media Player (".avi" file extension) only works with the Windows operating system. Characteristics are similar to sound in that large file sizes give better quality. RealVideo is a common cross-platform format on the Web, although a plug-in is required on the end-user's side and a dedicated RealMedia server is needed to host the video. Some form of streaming, plus a relatively low frame rate (such as 12fps) and small window size (perhaps 160 x 120 pixels) is the only solution to delivering video smoothly.

Left: Banner ad design is a key part of design for the Internet. Creating an eye-catching banner that entices the viewer to click, yet fits into the typical banner graphic dimensions and can be compressed to a high degree is quite an art.

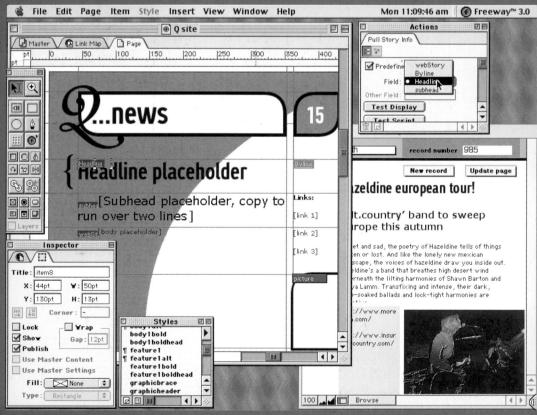

Left: Designing templates for database-driven publishing is a key part of commercial Web design. The trick is to make a layout that works both technically—fitting the contents from the database without breaking—and creatively.

DEVELOPING A WEB DESIGN STRATEGY Web design has become an industry in its own right with its own unique workflow, structures, and ethics. Digital designers have had to develop strategies that work and operate in this field. Websites are not just marketing tools for the corporate world, they are focal points that enable businesses to stay at the cutting edge in highly competitive markets.

Traditional designers will be pleased to know that it is a good practice to start website designs with paper. After all, we read screens more slowly than paper, and even today's software isn't as quick and flexible as pencil-and-paper sketches. It is often best to visualize ideas and work out navigational structures and site maps on paper before going to the computer. To design the navigation of a site is a creative process in its own right involving considerable planning, and, with complex sites, teamwork.

Set yourself a clear brief with well-defined objectives that can be articulated to the client (quite often clients are not familiar with the nature of Web media). Build in a time scale; this will help to deter clients from adding more content as the job progresses, which is often very tempting with the "openness" of this particular medium.

When moving onto the computer, don't be diverted from your original plans. Keeping an eye on the overall project is vital, although inspiration for a job often comes from stopping and moving off the screen for a moment to regain objectivity. Web pages contain many ingredients that can quickly evolve from the original conception. To help design the layout, create a grid based on a maximum character count taking into consideration the intended platform (remember text can become oversized in some browsers unless formatted in specific ways). Consider the number of graphics you are using and assess their file size and download times. If you are using other applications such as Flash, set your parameters to be compatible with placement on a page. Remember that a Flash movie will take considerably longer to design and create than the page on which it will eventually reside.

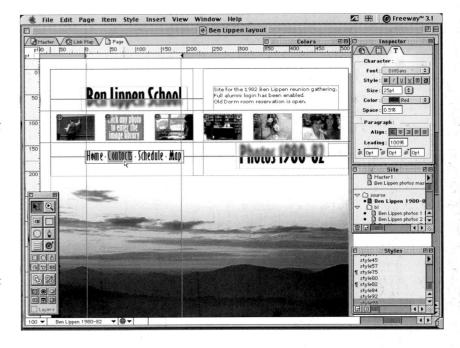

An overriding factor in your design strategy is an understanding of the audience's computer capabilities. Designers usually work on powerful, well-equipped computers. It is easy to overlook this and produce a design that is too unwieldy for the average user. Also take into account browser versions and the age of the computers that the user may have. This will always affect the design approach. Don't include sound if the intended audience is unlikely to have a sound card in its computer.

The more attractive and popular a site becomes the more likely it is that download times will increase the frustration of the users. Successful Web designs are those that strike a balance between form and function.

Above: Freeway's approach to layout is based on traditional DTP behavior, scaling graphics, and styling text on the page. Guides can be dragged onto pages manually or set up as a regular design grid structure.

PLANNING AND PRODUCTION The planning and production of Web design are different from those for traditional desktop publishing. The technical and developing aspects of the medium should always be capitalized on but never allowed to override the design concept.

A diverse range of roles are needed to design and produce a successful, large-scale website. These could include graphic designer, market researcher, project manager, programmer, production manager, picture editor, sound production manager or video editor. This covers such a broad set of skills that no individual is likely to have them all, so in practice, freelance designers will sub-contract work to other specialists for specific tasks. Sub-contracting can be expensive so it is important to be aware of the scope of the project and adjust the overall design fees accordingly. For example, when a site requires a lot of expensive CGI scripting for e-commerce or on-line booking, this could form the major financial part of the job, with the design costs being relatively modest.

A fundamental planning consideration is deciding whether a site is linear or non-linear in its navigation structure. More than likely it will be the latter, in which case a legible '3D' site map should be created, clearly indicating all the possible linking routes for the user to explore. Refer to this often during the production process to avoid becoming confused when tying pages and sections together.

It is advisable to mock up key pages in graphics tools, such as Photoshop or Fireworks, and get them approved by the

Below: www.tate.org.uk
The value of a clear and simple
layout can never be overestimated.
Keeping an eye on the actual
problem and giving the audience
something accessible is a prime
objective in Web design.
Information should be easily
retrievable without too many layers
of navigation to wade through. The
alphabet is one of the oldest ways
of organising information and is
still one of the best as seen in this
page from the Tate Gallery website.
Design by Nykris Digital Design, UK

client before moving over to your website design package. Or, if your package is sufficiently DTP-like you can move straight to it from paper sketches.

Dreamweaver and GoLive do not allow for magnification of page elements or enlarged views of graphics, so you'll need to inspect and test the quality of all the graphic content in an image editor prior to importing.

Testing is absolutely critical and should not be compromised in any way. A designer is advised to use both a Macintosh and a PC for this purpose, although using Virtual PC on a Mac is a perfectly acceptable solution. Remember that graphics on a PC will appear a little darker than on a Mac, and HTML text can appear larger in Windows. It can be useful to set up a private testing folder on a remote Web server so the client can monitor progress and view 'live' pages. Testing work without first uploading to a remote server gives a false impression of download times. Remember to build in enough time for exhaustive testing and keep the client updated as things progress.

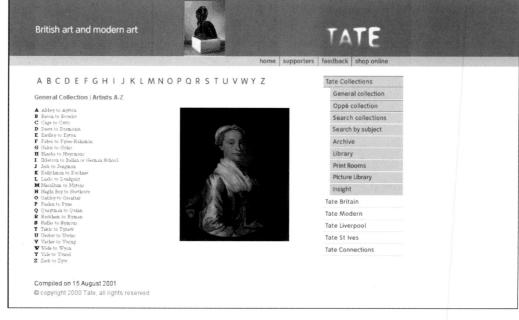

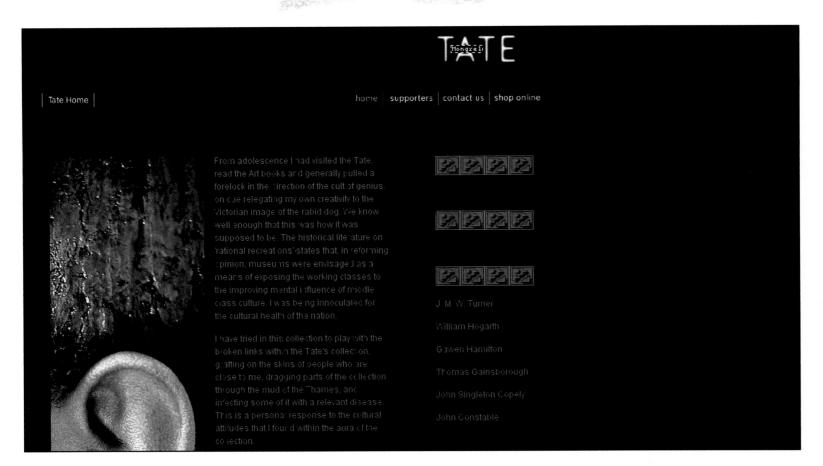

Above: www.tate.org.uk/webart/mongrel/collections/
The right balance of image and text can provide the best platform to invite prospective viewers into a site—and then keep them there with consistency of layout throughout! Navigation bars and menus come in all sorts of shapes and sizes. Whatever your choice, beta-test it on those unfamiliar with your way of working.

Design by Nykris Digital Design, UK

Right: www.core-design.com
Flash is not reliant on HTML to reveal
its content. As long as the right plugin is installed on the browser Flash
will play "within itself." This is why
many designers favor Flash as text
size and layout proportions are not
adversely affected by browser
preferences. This games
development company makes great
use of Flash to give the visitor an
impressive dynamic experience.
Design by Core Design, UK

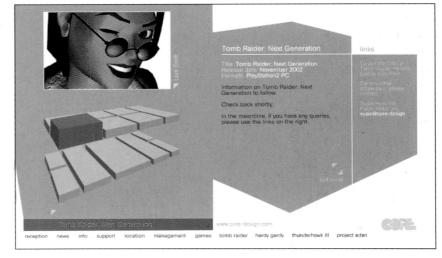

1. Pages	max 25k file size (inc graphics), max 795 x 500 pixel area		
2. Text	minimum size 3 (12 pixel cap)		
3. Graphics	convert all graphics to RGB. Titles as transparent GIFs,		
	all other graphics as JPEGs max size 16k		
4. Background	common to all pages		
5. Hyperlinks	to email—check to URLs—check and update		
6. Browsers	compatible with V.4.x and up/		
	P.C. and Mac/(alternative text only?)		
7. Test	test all links on both platforms		

Left: A simple checklist is always useful before a project gets under way. Web projects can quickly mushroom out of their intended scope if careful planning is not adhered to. Paper plans are invaluable to refer back to when the screen becomes too cluttered or overfamiliar. A disproportionate amount of time can be wasted at this stage of production if all the thinking is done on screen.

03.01 CASE HISTORY

WENDY CAULES CERAMICS

Wendy Caules is a ceramicis who lives and works in the UK. Headprecious Design was commissioned to produce a website that would provide a showcase for her work as well as a contact point for customers. The emphasis was on simplicity of layout in order to allow the work itself to breathe and stand out. The client specifically requested that the navigation should be

"straightforward" yet "intuitive."

The website would comprise a homepage with links to pages with samples of work, a live email contact, and a curriculum vitae page. Within the sample pages it was suggested that a QTVR (QuickTime Virtual Reality) movie could be used to show a 360-degree view of an individual piece.

THE FIRST STAGES

After the brief was agreed and the launch date set (to coincide with an exhibition of the artist's work) the next stage was to capture images of the work. Most examples of the work tended to be in 35mm transparency format, which is not ideal for high-quality reproduction. It was, therefore, decided that Headprecious Design would photograph the work using a digital camera to obtain a suitable format for Web publishing. An extra day was added to the schedule for photographing the work in a studio. The resulting images were used as a starting point for the initial design ideas and mock-ups. Samples of four

This page: QuickTime Virtual Reality was used to offer a 360-degree view of a ceramics piece, accessed via a pop-up window from the main portfolio page. Relying on the intended audience's recognition of visual symbols as navigational devices (buttons) relieved the need for a large amount of HTML text to be included in the site.

different design concepts were presented, each incorporating the photographic images with varied options for type, layout, and navigation structures. The artist chose a design that had a bold, clear "look and feel" with a dominant photographic element, large-scale type heading, and three visual (nontext) navigation buttons. The background graphic on the homepage was chosen to run throughout the site to help maintain consistency. It was agreed that the only section that would use HTML text would be the curriculum vitae page.

The background image was constructed in Photoshop using a technique that maintained the image quality but allowed for a small file size, allowing a shorter download time. The technique employed a screen of alternating 50 percent transparent horizontal white lines, two pixels apart placed over a subdued montage of photographed ceramics pieces scaled to a "live space" area measuring 800 x 466 pixels.

OPTIMIZING THE SITE

To achieve a smooth screen rendering, the homepage graphic was spliced into three vertical sections, measuring 22, 35, and 10K respectively. Although this still constituted a large file, each image would download progressively and simultaneously, presenting a fluid screen draw. To ensure visual content would be present on the screen immediately, low-resolution, gray-scale versions of the three large graphics were created to render quickly followed by the full-color versions overlaying them as they downloaded. The same technique was applied to all the images on the work sample pages.

Buttons were made as rollovers, incorporating simple graphic symbols to indicate their function in the rollover state, with small-scale images of ceramic pieces indicating the Above: By slicing the main graphic on the homepage, a relatively large-scale image could be employed to create visual presence. As well as the design considerations, an equally important aspect of the project was to ensure successful indexing for search engines. The timescale involved for this should not underestimated, and correct meta-tagging on the homepage itself is the first step. Pointing search engines at the site can be a lengthy process.

static state. The buttons were subsequently placed in layers on top of the main graphic and scaled to match precisely.

THE FINAL RESULT

The entire homepage measured 97K, resulting in an approximate download time of 25 to 30 seconds. This was within the acceptable timeframe for the intended specialist audience group. The brief, to create a highly visual site with detailed graphics while at the same time maintaining a fluid rendering of pages, was achieved.

03.02

Multimedia, also known as hypermedia, is the broad term that encompasses any communication medium that combines the use of sound, graphics, moving image, video, and animation. It generally involves some form of interactivity, which distinguishes it from simple video productions. It is fast

which distinguishes it from simple video productions. It is fast becoming integral to our daily lives, with the advent of new iTV, WAP cell phones, touch-screen information kiosks, Internet enabled pay-phones, DVD, CD-ROM, and sophisticated TV graphics. Designers are increasingly involved with the continuing growth of interactive technology.

The CD-ROM, once hailed as the replacement for the printed book, was one of the first vehicles for interactive, "multimedia" products for the mass market. Traditional publishing houses ventured into this medium with reworkings of existing texts with little success. It became

obvious that reading on screen was not about to replace the convenience of the book. DVD (digital versatile disk) has secured more of a market identity largely due to its focus on entertainment and music industry. DVD is a rich medium that provides high-quality playback of video and music with many other features such as user interaction and editing as standard.

The most noticeable form of multimedia is television graphics (advertising, trailers, title sequences, and weather charts), produced using digital technology but mainly delivered by analog transmission. (This will be totally superseded by digital transmission.) Since television covers many areas of information and entertainment, it gives the digital graphic designer a wide range of creative opportunities and by its transitory nature also encourages experimentation and innovation. Design has flourished in the area of information screens and kiosks found in banks, airports, museums, in-store points, stations, and public spaces. Unlike their hard-copy counterparts, information kiosks can be easily updated, and hold large amounts of information. Moving images and animation add to their interest and entertain the veiwer.

Artists have adopted multimedia as a viable medium for selfexpression, from on-site exhibition installations to Internet delivery. The internationally acclaimed video artist, Bill Viola, has a long respected

PART 03. SCREEN DESIGN CHAPTER TWO

DESIGN FOR MULTIMEDIA

Right: Touch-screen information kiosks, such as this example from the National Portrait Gallery in London, can offer a plentiful choice of media for the viewer. Illustrations, graphics, and video can be rendered quickly and efficiently with dedicated hardware. The constraints for the multimedia designer are far fewer in number than they are for those in Web publishing.

Design by Cognitive Applications, UK

"tradition" of embracing new media and technology in his work. The Web artist, Earminski, exploits the full power of sound and animation to present his idiosyncratic view of popular dulture using Macromedia's Shockwave.

We exist in an environment where our senses are constantly hombarded with sounds words, and images. Designers, artists, and developers are responsible for the many forms of information and entertainment that we experience. Designers have to reset their working parameters constantly to keep abreast of new developments, techniques, and applications. Multimedia designers may well be musicians, line artists, film- and video makers, writers, or editors. However, digital graphic designers inci that their visual language together with their experience in managing words and images provides them with an excellent basis for multimedia work.

designer is free to create a highquality sensor vexperience using dynamic video and audio. Lacys high-resolution moving images such as this are impossible to transmit over the Internat, yet will not tax the hige data-carrying capabilities of a DVD disk.

THE DIFFERENCES BETWEEN MULTIMEDIA AND WEB DESIGN Much of the technology used to create multimedia projects is similar to that used to create Web pages, but there is one major difference. Multimedia work is not constrained by the limitations of the Internet.

Unlike the Internet, in which the allimportant download time is reliant on the unpredictable speed of the modem, multimedia, whether it is a CD-ROM or touch-screen museum installation, is powered by the computer's own internal processor. The advantages of this are clear. First, the viewer sees "real time" playing on screen, and second, far larger file sizes are permissible and therefore a greater range and quality of content and media is available. The obvious benefit involves the use of video and sound, both of which are memory and diskspace hungry. A DVD can deliver full stereo, surround sound, and uncompressed-quality audio and video, which would be impossible to deliver over the Web. The use of fullscreen animation, a wider choice of fonts and complex graphics, are all additional choices for the multimedia designer.

WHAT IS "REAL TIME PLAYING"?

Real time playing should be qualified: the speed at which data can be read from a CD-ROM or straight from the computer's hard drive depends on the processing power and internal architecture of the machine and the speed of the CD/DVD reader. Top-end machines utilize very fast hard drives and large amounts of RAM (on-the-fly processing) to render multimedia on-screen smoothly. Lower-end "pro-sumer" machines offer a reduced capability. There is always a delay in the transfer of the information held on a compact disc. Video playback from a

CD is usually set at 12 frames per second as opposed to a much higher rate for dedicated video players. This is because the CD-ROM drive cannot read the frames fast enough to present a fluid picture, hence the characteristic jerky motion. This does present a dilemma for the multimedia designer, although the speed of CD-ROM drives is improving. Content optimized for the very latest CD-ROM drives will not work properly on those machines with older, slower drives. This issue is not dissimilar to the problems of browser age and compatibility faced by Web designers. However, the constant renewal and advance of computer-processing power offers greater choice for multimedia developers, both professional and amateur. Editing full-screen, broadcastquality video on a "home" computer is now possible with the advent of Apple's Final Cut Pro software and digital, videoready G4 computers.

THE END-USER

Where the multimedia work is to be delivered will determine the quality and size of the product. A dedicated custom setup, such as a museum installation, will provide opportunities for maximum quality, while a consumer CD-ROM may be produced to suit the most popular home computers. Multimedia is often delivered over a closed network using a powerful central computer to send the work to smaller, satellite machines. This is much more efficient than using the Internet and is most often used in Intranet systems for company data, training workshops, in-store information points, and similar restricted environments.

Multimedia products offer a broader, richer, and more expanded range of outcomes than Web products, which by their very nature are anchored to the current constraints of the Internet. Interactive television, although in its infancy and burdened by low screen resolution, provides a particularly exciting prospect for multimedia designers.

Above: A DVD disc looks identical to a CD-ROM disc, but its capacity to hold data is many times greater. The latest computers available to the consumer market come equipped with DVD-ROM. This allows vast amounts of hard-drive hungry data, such as raw video footage, to be archived effectively for later retrieval.

This video was created within a corporate identity campaign for a technology infrastructure company. The video incorporated digital video, still photography sequences, three-dimensional modeled elements, and graphics animated and edited in Adobe After Effects. The video conveyed the seamless transparency of technology between the everyday user and behind-thescenes networking systems.

Design by Inter Stitch, USA

This page: Tomato Interactive has produced some visually stunning and exciting multimedia work over the past five years. By combining live concert footage, as seen here with Underworld's "Everything Everything" DVD, with graphic imagery and inset video, the audience is presented with a multi-layered aural and visual experience.

Design by Tomato Interactive, UK

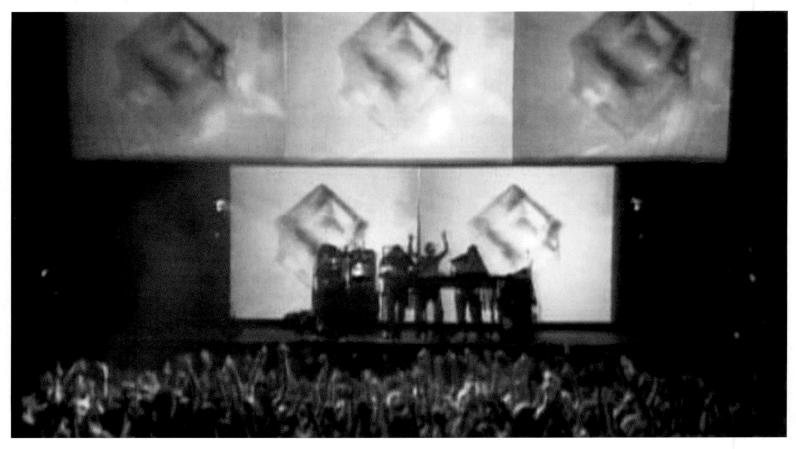

THE DESIGN PROCESS The multimedia design process is by definition diverse and the designer has to adopt many roles. Working through ideas and concepts on paper is useful, and defining the project parameters is essential. Many multimedia prototypes are very complex with the integration of sound, moving image, video, and graphics presenting the designer with a formidable challenge.

Almost without exception, multimedia models are nonlinear, that is, they present an interface to the user that is composed of multiple choice options and paths to select. A well-designed navigation structure will significantly improve the enjoyment and accessibility of a piece of work. Good navigation design is an artform in itself and certainly should not be undervalued. The problems associated with user boredom, characteristic of Web publishing, are not so prevalent in multimedia work. It is assumed that a potential audience will be more focused and, as the medium delivers a quicker response to user interaction, not need to wait as long for screen content. This distinctive quality of CD-ROM multimedia products should be balanced against the fact that they are less easy to update than Web pages.

HIGH EXPECTATIONS

Client expectation can present problems for the designer. The nature of multimedia allows for a rich and varied content, but the time and cost in preparing this content can be significant. So how does a designer positively engage the client while at the same time highlighting the potential pitfalls and limitations of the medium? Clients who are not fully conversant with the scope of the medium often anticipate an "all singing, all dancing" product. One solution is to present a scaled range of product levels, offering the necessary graphics, navigation structure, and production methods necessary to complete the work to a satisfactory standard for a lower budget. A menu of additional options, such as more video, larger-format video, and more animation

and sound can then be offered. The onus is then on clients to balance their expectations with project budgets. Providing a demonstration of a range of options will be very helpful in this process.

If a designer is part of a large organization with access to many technical resources, many of these issues are moreeasily solved. The "internal" client may well be aware of the possibilities and options available from the start. For the freelance designer there is a more challenging task, because all the resources will have to be independently sourced. This is why many multimedia designers build up contact lists of programmers, video editors, and sound designers to call upon. This aspect alone encourages an interdependent approach to multimedia design processes. Designers can increase their skills and expertise by working in a "design community," sharing their knowledge and learning from others. This makes for a very exciting and challenging career shift for many designers switching from traditional print and publishing backgrounds.

AUTHORING APPLICATIONS AND THEIR ROLES In the professional market, Macromedia Director, a multimedia authoring software package, is the dominant player. It allows the designer to manipulate sound, graphics, moving image, and video directly in the editing environment without the need for further plug-ins. Director uses Lingo, its own powerful scripting language, for complex "behind-the-scenes" programming actions that provide a rich resource for user interaction.

DIRECTOR

Director uses a metaphor of a theater production for its authoring environment, comprising a "stage," "cast members," and a "score." For designers, this is an excellent format because it demystifies what could potentially be a rather complex workspace. The screen functions as a stage on which the designer can directly place cast members from a database of elements (graphics, sound, video, etc.). The cast is then orchestrated within the score (a multilayered traditional animation timeline) to animate frame by frame. Cast members become "sprites" when they are placed on the stage, leaving their original files untouched in the cast database. Sprites are clones of their parent cast members and can be modified on the stage without increasing the file size of the finished movie. They can be animated, resized, made transparent, and scripted to perform and respond to user interaction using Lingo. Finished productions can be made into stand-alone cross-platform applications using a "projector," which does not need the Director software to run. Projectors launch the authored Director movies, which can be set to fill the entire monitor screen, obscuring the desktop, to deliver a professional presentation.

If used effectively, Director can provide a complete digital production solution for multimedia CD-ROM, DVD, and touch-screen installations. In terms of Web publishing, Director has found favor with many on-line games developers, who exploit its option to export projects as Shockwave movies. Macromedia has actively encouraged a growing Web community of third-party developers who test, share, and expand the capability of Director. They, in turn, have helped it to become extremely versatile for integration with other formats such as Adobe's PDF, Apple's QuickTime, and HTML. For example, a CD-ROM production could include a "live link" to a website or have the option to open and view PDF files while the Director movie is running on the user's computer in the background.

AFTER EFFECTS

Adobe's After Effects has become the industry standard package for producing broadcast-quality composite digital video productions. It is an amalgamation of Premier and Photoshop. Graphics, sound, music, and video can be imported and then edited to create a layered composition that can be exported in any number of popular file formats (QuickTime, Windows Media Player) or exported directly to a professional video postproduction system such as Avid's Media 100. After Effects can utilize a range of Photoshop filters to apply effects and transitions over a time period. This software is frequently used to create title sequences for TV and multimedia presentations. Although mainly noninteractive, it can be exported for Web publishing and include some user interaction elements.

In the multimedia market there is a range of proprietary animation and three-dimensional software, such as Cambridge Animation System's "Animo" and Avid's "Softimage," used in the entertainment, video, and film industry. They are exclusively designed for high-end animation, editing, and production. Companies like Industrial Light & Magic have set new standards in three-dimensional character animation and digital special effects.

Left: Adobe After Effects gives the multimedia designer scope to combine sound, video, type, and static imagery into a single timebased movie. The published movie can be used for professional broadcast applications, video, or as an element in CD-ROM and DVD productions. After Effects, simply put, is Photoshop with a time line and sound added.

Above: Macromedia Fireworks is a Web-specific image editor with some animation features included. It does a pretty good job of animated GIF production, but it isn't in the same league as Flash or Director when it comes to interactivity and serious animations.

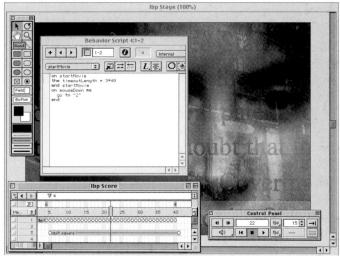

Left: This is the Macromedia
Director authoring environment
showing the main windows used to
create and edit a movie. Ideally, two
monitors or one large one is best
suited to display the multiple
windows necessary to author a
project. The interface is fairly
intuitive and can be used to produce
successful productions without the
need to write Lingo scripts.

Above: Director gives the author many prepared Lingo scripts to use in a movie, making life easier for the hesitant scripting author. The Behavior window offers drop-down menus to select the most commonly applied scripts in well-organized subcategories. Scripts can be used to control playback characteristics, memory use, sound, visual effects, and user interaction.

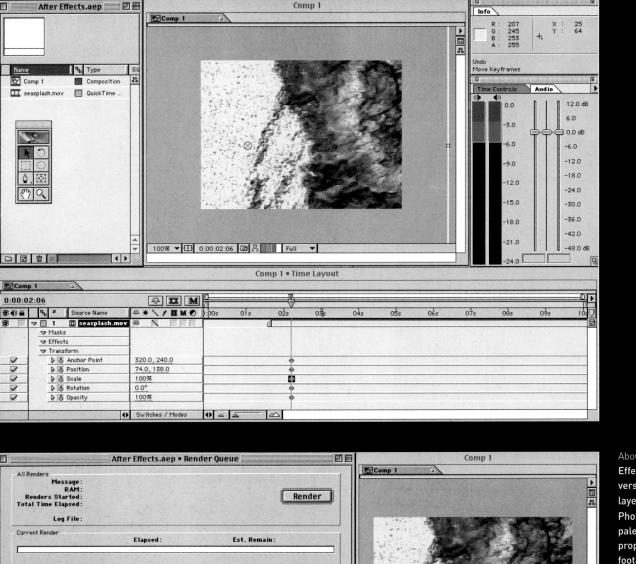

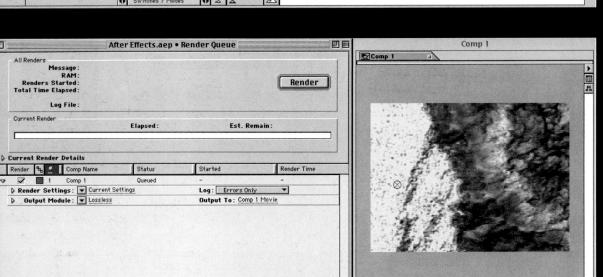

100% ▼ 1 0:00:02:06 ② A Full

Above and left: Adobe's After Effects is essentially an animated version of Photoshop. It allows layers to be imported from Photoshop and retains familiar palette features and tool properties. Sound, imported video footage, and graphic stills can be composited together into a smooth, exported QuickTime movie, which can then be integrated into a multimedia

production on CD-ROM or DVD.

PLANNING AND PRODUCTION In many respects multimedia planning and production is closer to desktop publishing than it is to Web publishing. There are fewer constraints than in Web design; the outcome can be produced, manufactured, and published to exacting, high standards without the loss of control associated with Internet delivery.

Above: a screen from a promotional CD-ROM for Voyages Jules Verne Travel. The repurposing of existing promotional or advertising material, supplied by a company, can be effectively implemented into a multimedia production. Posters, photographs and video can be re-edited with Adobe Photoshop and Premier to sit within a new production. Design by Phil Taylor and Phil

Jackson, UK

Despite this extra control over design, development and production costs can be great, with the problems of rising costs to cover additional sound, video, and animation. Invariably, multimedia projects are large undertakings with many unseen issues unfolding during the production and authoring stages. It is essential to establish a fixed price for the initial design and concept stage and then build in a tiered fee structure to cover production costs dictated by any revised expectations or supplementary requirements of the client. Subcontracting is common with multimedia projects and should be thoroughly researched and planned. For example, using advanced Lingo scripting in Director will often require out-sourced programming expertise, even for the experienced Director user.

Some CD-ROM productions can be too big to fit on a single disk. If a client expects a large amount of high-quality stereo sound and full-screen video for the product, this may push the project over the maximum 700Mb capacity of a compact disc. Somewhere content has to be trimmed down for the whole project to fit on the disc. Graphics and text do not usually present a problem for the designer owing to their (relatively) small file size so most "compression of content" must be made to sound and video.

Fortunately DVD products have a much larger capacity and can accommodate rich media content, making them ideal for a broader design scope.

"TEST TEST TEST!"

Testing is absolutely vital for multimedia productions. Web publishing has its challenges, with varying ages of browser versions and monitor resolutions, but multimedia has all these and more! A typical CD-ROM will have to function on computers with different specifications of hardware, on varying revisions of operating system software, and be compatible with applications oftware and third-party applications. When a client wants to include video, a choice between QuickTime or AVI format has to be made.

QuickTime will play seamlessly on a Macintosh (and in some respects is a more stable format than AVI files), but will not play by default on Windows. Although the QuickTime software is readily available and easy to install on a Windows machine, clients are often sceptical about the ability of the intended audience to install such software. Testing strategies have to be assembled and implemented for every aspect of a project to ensure maximum compatibility and usability. Compromises may have to be made, a situation all too familiar to Web designers.

Cross-platform compatibility is one of the most sought-after goals in multimedia. Although the Apple Macintosh market is small in comparison to that of PCs, clients may wish to reach as wide an audience as possible by including a Mac version in their planning. Professional developers often have a testing room set aside with a range of older machines of varying specifications to test a product for flaws and conflicts.

03.02 CASE HISTORY

WOODWARD PORTRAIT EXPLORER NATIONAL PORTRAIT GALLERY, LONDON

The Woodward Portrait Explorer is a permanent touch-screen installation designed by Cognitive Applications, based in the UK and the US. The Portrait Explorer system extends the approach of the acclaimed Micro Gallery guide in the National Gallery, in London.

The installation functions primarily as an informative guide for visitors to the gallery, with insights into thousands of works of art in the collection, video interviews with artists, and many other interactive features.

Designing a multimedia system for public use, such as in a gallery, requires careful planning and execution. Typically an interface design will employ visual metaphors as navigational icons. Presenting a "human" interface is critical to the useability of the multimedia system. With Web design the interface has to exist within the constraints of browser configurations and limitations, and can be altered by the end-user. Touch-screen installations run directly from a hard drive or CD and so permit greater control for the developer. This requires the application of considered and tested design concepts. For example, if the design calls for finger/touch interaction to activate a cursor instead of a mouse, larger buttons will be needed on the screen. The familiar metaphor of "push-buttons" with drop shadows may seem outmoded in today's computer-driven design, but in an established, traditional gallery setting they may be critical in ensuring that the system is accessible and user-friendly to a wider public.

Rory Mathews, Design Director at Cognitive Applications, UK, considered three important questions before designing the museum installation:

- * What is the subject matter?
- * What environment will the system be seen in?
- * What are the aims of the system?

The most fundamental question concerning the Portrait Explorer system was, "What, in essence, is an art gallery about?" The answer to this was, "To provide an environment in which to present works of art, and to allow the opportunity for the visitor to expand his or her knowledge through exposure and education." The system would need to accommodate a wide range of people and not exclude anyone within the "typical visitor" profile, which does not really exist in a large, openaccess public space. An interactive multimedia system would need to be in tune with this environment and aligned to these aims. The Portrait Explorer system was designed to offer a refined interface that achieved these aims through an exhaustive reappraisal of the objectives during the design process.

THE MAIN SUCCESFUL CHARACTERISTICS OF THE SYSTEM

- * The system has its own visual identity, but complements the character of the museum and its collection.
- ★ The system's graphic design, interface design, and technology—like good book typography—are designed to be virtually transparent to the ordinary user.
- * The design does not compromise the integrity of the works of art by gratuitous use of animation or image manipulation.
- ★ The design will always be complementary and subordinate to the works of art discussed in the system.
- * Because the system is designed without modish design or technological gimmicks, it will not become dated quickly.

A visitor to the National Portrait Gallery can enrich his or her experience greatly through interacting with the Portrait Explorer system. Through the considered use of animation, video, and image manipulation, Cognitive Applications have built a successful, interactive experience.

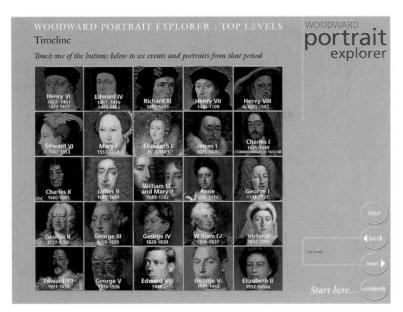

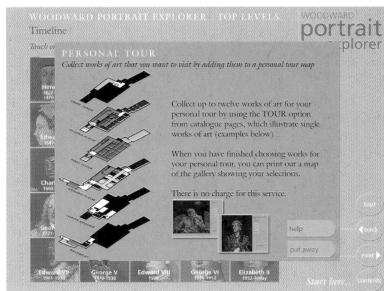

Above and below: These screen shots demonstrate the careful planning that is necessary to produce a project such as the Woodward Portrait Explorer. The aim of any ambitious site-specific multimedia installation is to

complement the museum's collection and enrich the visitor's experience. This site succeeded in this by offering a varied mix of educational, informative, and entertaining stimuli with which the viewer can interact.

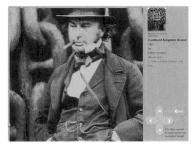

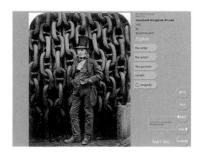

03.03

Computer and video game graphics have come a long way since "Pong." Visually, the 1972 gaming pioneer made do with two white rectangular "bats" and a square white "ball," or a plain black background. Created in the days before microprocessors, its graphics were hardwired by an engineer.

Today, however, game development is a global creative industry employing tens of thousands of writers, musicians, game designers, and artists. User-friendly professional tools have enabled non-engineers to create the vast amount of visual content required for a state-of-the-art title, in high-resolution color—using many of the same techniques as conventional non-interactive graphic designers and fine artists.

Game development is a highly team-orientated industry. In total, between 13 and 40 people will work closely together during the 14-month to two-year period that will see a game grow from concept to final production. Typically, a team will be split evenly between the three departments of art, programming, and game design, with a single producer in overall charge.

Each individual department within the team will function as a tightly knit unit, with individuals assigned their own areas of focus or specialization.

A single artist famed in a different field—comic-book art, for example, or film design—is very occasionally brought in to a game project as a "star" attraction, and will probably contribute his or her work independently of the development team; but it is extremely rare to see one person given any sort of headline credit for a game, especially on the art side.

There are some basic technical specializations within most game development art departments—but it is important for any artist to be flexible, and to at least have an understanding of the other elements that together make up the finished graphics. Broadly, there are four areas of game art: conceptual, two-dimensional, three-dimensional, and animation. Conceptual artwork will be sketched in the earliest stages of a game's development to establish the basic look of characters or environments and, in detail, to storyboard ingame sequences or cinematic style "cutscenes."

PART 03. SCREEN DESIGN

CHAPTER THREE

DESIGN FOR GAMES

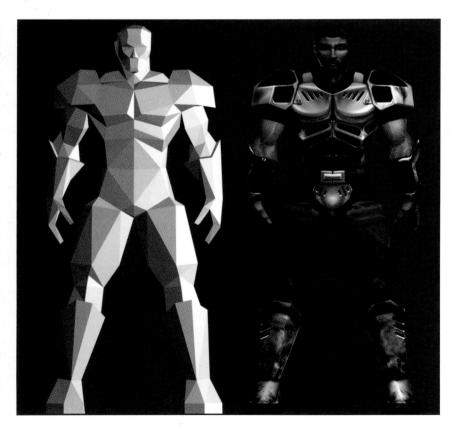

Left and above: Three-dimensional game environments and graphic objects are typically constructed from polygon mesh frames to which two-dimensional "skins" are applied. The frames are kept relatively simple in order that a typical player's computer is able to

animate them in a naturalistic way. Of course, the demand for more and more impressive graphics is one of the main driving forces behind the everincreasing processing speed of consumer computers.

Design by Shane Caudle, USA

Bolow Myst III

Games revelopment is a field in which unrestricted imagination and digital fachinology can come together. While it is true that most games or aphics are rather

computate, titles such as the bugely popular Myst series have proved that there is a demand for computer games with a high degree of artistry.

Question by Presto Studius.

Pinished two-dimensional work is required for the creation of on-screen display elements (stores, meters) transators, and idons) or menu-based interfere screens. Very recently Flash has become a visible cross-platform development environment for this kink of "front end" work. Generally though, two-dimensional images are created and manipulation in a graphics editing backage such as Actore Photostop. This is certainly the tool most ortain used for the creation of the fundamental building blocks of contemporary game graphics, rwd-damensional textures, which valide overtaid onto this polygons in the game's three dimensional-rendered world.

Although there are a small number of popular modern titles that don't create a fully three-dubensional game space, they are very much in the numerity Hardware advances over the past seven or eight years have resulted in the normalization of this cace-revolutionary approach.

Technical challenges still abound, however, and althree-concensional artist has to work structly within the
confines established by the game "engine" written by the
program aing feam. This will determine, for example, how
many individual polygons can be used to build any particular
character or object, without affecting the game's performance

The most prevalent professional tooks for threedimensional and ammation work are Discreet's 3DS tudio. Max and Alias (Wavetront's Maya, Using either of these packages, artists have total modelling control over every detail of the landscapes, architecture, objects and characters which populate today's interactive three-dimensional worlds—Jotally immersive "virtual realities" uridinamed of by those first "Pong" players a few short decades ago.

			catapult6	
Chassis	Weapons	Armor	Firepower:	Maximum Tonnage:
Type:			Armor: Speed: Heat Efficiency:	Current Tonnage: 65.00 Available Tonnage:
Camouflage: 04-OpsOliveDi	rab	,	Chassis Tech Type:	
Components: Beagle Acti Light Ampli Jump Jets AMS	ve Probe (BAF fication	Ton: 1.0 1.0 4.0	Acceleration (Meters/Sec.): 9.22 Deceleration (Meters/Sec.): 13.83	
Heat Sinks: Top Speed (KPI Engine Upgrade		5 6 5.0	Torso Twist Speed (Degrees/Sec.):	
	chtsb. When t ration will be d		Comstar Information Network	RESTORE
7-7				CLOSE

Players must visit this complex interface before the main game can begin. If could have been boring by the agressive font and bigoding lighting work to build excitement.

the world's best-setting timeses dimensional modeling software backage. It is used by a wife variety of users. If on game developers and fitting in degigners at times currently available on the Macintoshiplatticm.

perhaps the industry standard software for games development, and is also widely used to the field of film and produced teleprocess. The program's power, speed, and flexibility, however, are reflected in a very heftyprocetag.

TYPE COLOR IMAGE

04.01

Type is one of the graphic designer's core tools. With attention to detail, the designer can use type to communicate appropriately, to suggest mood and character, and to contribute to page or surface layout dynamics. However, type does need to be handled with care and understanding.

Designers should not only have an appreciation of the aesthetic values of type (see Design Basics), but also know how type is stored, controlled, and output digitally. All these have a direct bearing on how type is printed and displayed on screen.

A typeface is an alphabet (along with numerals and punctuation) considered as a designed or aesthetic visual entity. A font is the collection of characters that is held in one file. One font may contain the alphabet in upper- and lowercase, with related numerals and punctuation, while an additional font (with the same typeface name) may contain old style numerals, small capital letters, alternate swash characters and an extensive range of ligatures and foreign accents. These additional fonts are often called 'expert sets'. If special characters normally contained in an expert set are included in the basic font, that font may be described as having an extended character set.

Font-related issues have probably been the cause of most design-to-print headaches, and the following short explanation is intended to help designers avoid them.

PART 04. TYPE/COLOR/IMAGE CHAPTER ONE

TYPE

áéèüöçôåñ

Above: These are some of the most common accents used in Latin languages. Most can be found by depressing the Option key while typing a character. For example, to obtain an acute accent over an e (é), hold down Option and type e, let go of Option and type e again.

Left: Every character in a font is decribed by a set of vectors (its outline description). It is this information that monitors and printers draw upon in order to display and print type respectively.

国 GillSan
河 GillSanBol
国 GillSanBolCon
国 GillSanBollta
酒 GillSanCon
酒 GillSanExtBol
国 GillSanIta
酒 GillSanLig
国 GillSanLigIta
国 GillSanUltBol
河 GillSanUltBolCon

Left: Purchased fonts are often supplied in folders. Fixed size (or bitmap) fonts are contained within a folder called a "suitcase." On a Mac the suitcases and corresponding PostScript files need to be stored loose in the system's own font folder in order for them to be accessible.

Below: Key Caps is a desktop accessory found under the Apple Menu that displays a keyboard layout. By depressing Shift, Option, or Shift/Option a further three sets of characters are revealed. There are up to four characters held under each key. A useful piece of software called Keyfinder will display the entire character set available and indicate what key or combination of keys are required.

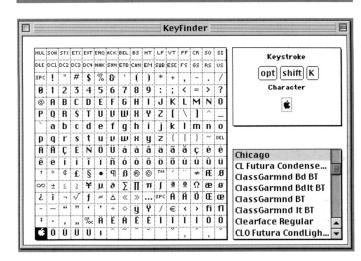

BITMAPS AND VECTORS

Letterform information is stored digitally in both bitmap and vector forms. Bitmap data provides adequate information for screen display at a fixed size but gives a "pixelated" appearance when scaled up. Vector (outline) descriptions of each character provide better information from which to print. Because vectors are straight lines and curves recorded in a font as mathematical formula, the resulting shapes, when filled with pixels, improve the quality of the scaling.

Monitors cannot be relied on to show fine typographic detailing, so character shape and spacing intended for a printed job may not be accurately represented on screen. This is less of a problem for screen presentations, since other monitors will display your work in a similar way. PC and Macintosh monitors can, however, vary quite markedly in their display (see Web Design and Multimedia).

POSTSCRIPT TYPE 1 FONTS

PostScript is Adobe's page description software that, among other functions, instructs the printing device to produce letterforms and graphics to a high degree of accuracy at any required size. Documents containing this outline information for printing are called PostScript files. Fonts containing this outline information are called PostScript fonts, and there are two kinds, of which Type 1 is by far the most common. PostScript fonts consist of two parts: a bitmap file for screen display and an outline file, which is the PostScript description of character shapes. The operating system can use bitmap information to draw characters on screen and the PostScript font file for downloading to the printer. A separate PostScript font file is required for each style in a typeface, e.g., regular (plain), italic, bold, bold italic.

chapter 01. type

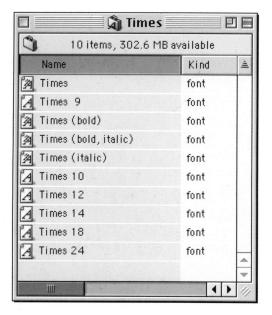

Left: This open folder shows
TrueType files for Times together
with fixed-size fonts. TrueType
fonts are recognizable by three
varying sized capital "A"s on the
icon and these contain outline
information of the font for variable
scaling. The fixed-sized fonts (a
single capital "A" on the icon)
provide bitmap information
needed to draw just that one size
accurately and, under about 18pt,
it looks better on screen than
scaled fonts.

The latest editions of the Windows operating system as well as Mac OS X have built-in rasterizers that pick up the outline (vector) information from the font file and create better looking, more accurate letterforms on screen. Older editions of Windows and the Macintosh operating system need to have Adobe Type Manager (ATM) installed to do the same job. Both operating systems must have at least one size of bitmap font installed to enable them to work and also to display the fonts in program menus.

Below: ATM (Adobe Type Manager) is a desktop feature that utilizes PostScript file information (outlines) in order to render characters accurately on screen. ATM Deluxe also acts as a font management utility enabling users to temporarily bring fonts into the system and remove them when necessary. With the advent of new operating systems ATM will not be required.

Bottom: Some pairs of characters, when spaced out uniformly, do not always sit comfortably together. Kerning is the adjustment of the space between adjacent characters to optimize their appearence.

Quark's Edit Kerning Table permits changes to default kerning values—a task not to be undertaken lightly.

TRUETYPE

TrueType fonts have become very popular, despite the apparent domination of Type 1 fonts in the design field. TrueType fonts combine vector and outline fonts, which allows them to be infinitely and accurately scaled. A TrueType rasterizer is built into both Macintosh and Windows operating systems to provide information for both screen drawing and print output. TrueType fonts are held in a single file (a suitcase on the Macintosh) that can contain sufficient information for constructing regular, regular italic, bold, and bold italic versions of the same typeface.

MULTIPLE MASTER FONTS

Multiple Masters are Type 1 fonts developed by Adobe. Unlike ordinary fonts, Multiple Master fonts contain several outlines that represent either end of variables on a design axis such as weight, width, style, or optical size (from fine print to display). The designer is able to create custom fonts by choosing points between the extremes using the Font Creator utility, built into ATM for Windows, or as a stand-alone application on the Macintosh. Multiple Master fonts may have axes for weight, width, style, or optical size—or (in theory) all four. Potentially, they allow for great flexibility of character shape without the problems of distortion, but are rather uncommon.

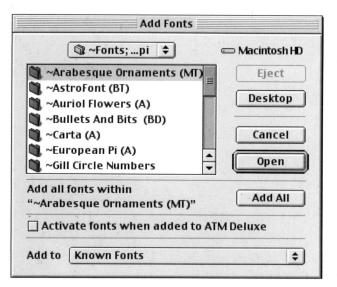

WHICH FONT FORMAT TO USE

There is no problem in mixing TrueType font and Type 1 fonts within the same design. It is a good idea, to avoid confusion, to make sure you don't have fonts of the same name in the different formats.

When using Type 1 fonts, be sure that there is an outline font available to download to the printer and check that no fonts are missing.

On the Macintosh, True Type fonts and the bitmaps for Type 1 fonts are kept in "suitcases" in the fonts folder. PostScript files for the printer are kept loose in the font folder and can have various icons according to the font vendor. On a Windows operating system, True Type and PostScript files are kept in separate folders. Alternative locations are possible if you use a font manager such as Suitcase.

FONT METRICS

Font metrics are a component of all fonts. They are measurements that govern spacing, kerning, and hinting, and contain the font's kerning tables. They are only used by some software and are generally not required to display or print fonts.

FONT PROBLEMS

Many font problems are unwittingly self-inflicted, but a little organization and care should keep most designers out of trouble. Understanding font icons can help a lot; examples are shown in the illustration.

One of the most common problems is type that looks horribly jagged on screen. This happens when the relevant PostScript file is missing from your system and needs to be reloaded. It also happens when ATM is switched off. If type prints out incorrectly, the PostScript file for a style of font may be

What you see on screen may not be what you get from the printer if you select the bold, italic, and bold italic versions of a PostScript font from style menu (such as italicized Bodoni Regular) rather than from the font menu (for example, Bodoni Italic). If a TrueType file contains regular (plain), bold, regular italic, and bold italics, you can select these styles from font menus or by clicking on a floating palette.

Some fonts may not be listed alphabetically where you expect them in the font menu, for example. Bodoni Italic may be listed as "I Bodoni Italic." If this confuses you, you can use a utility such as Adobe Type Reunion or Adobe Type Manager to group fonts into typeface families.

If line endings and text flow change unexpectedly, you may have two similarly named versions of the same typeface.

Above left: Another feature of ATM is a window that previews chosen typefaces, showing their visual appearance in a variety of sizes and line settings (left).

Above: The open window of a font folder shows all the PostScript files that accompany the suitcase for the typeface Minion.

Almost certainly, they will have different spacing or kerning, causing the spacing to differ. It is advisable to keep just one version of a font to avoid mixing them up.

This problem can be exacerbated when your job goes to the output bureau or printers. A bureau or printer may assure you that it has a copy of your font, but you need to be sure that type is rendered using precisely the same outlines and metrics that your font has given you. Make sure to send a copy of your font to the bureau or printer, but remember that this is only legal if the bureau or printer also owns a license for that font (see Font Copyright). Above: Many type foundries and type libraries may be found on the Internet. Most sites contain useful information concerning the history of typefaces, their designers, and facilities to try typefaces out.

AGFA Monotype

If your bureau or printer tells you that a font is missing, especially one that you think you have not used, the problem most likely lies in a blank line or invisible character (including spaces and returns), all of which will have font and style settings applied to them. Make a final check of all these in the "Font Usage" dialog before you send the job, rather than wasting time supplying them later.

One way to avoid all such font problems is to supply files in the PDF format (see page 70) with the fonts "embedded."

FONT COPYRIGHT

Fonts are protected by copyright law. When you "buy" a font, it is in fact usually only the license to use it that you have acquired.

Typical single-user licenses allow one copy of a font to be installed on one computer. You may use the font to print directly to any output device (laser printer, inkjet printer, or imagesetter), since fonts are only temporarily uploaded during the process.

Type used on Web pages will display properly only if the person viewing the page has the required font installed on his or her system. However, copyright rules prevent fonts from being supplied or served with the pages. Software is available to allow only the characters you have used to be supplied to a Web page as vector-described glyphs. This will bring infinitely scalable, good-looking type to your website.

jaggies jaggies

Ab Ab

Antialiased type

Bitmap type

Above: Antialiasing, particularly at small sizes, helps to create a bettershaped letter as these enlargements show.

Above: Jaggies is the name given to to the crude pixelated rendering of type on screen that occurs when bitmap fonts are enlarged. Smooth results are obtained when outline information is made available through the use of TrueType fonts or PostScript fonts.

IMPROVING TYPE ON SCREEN FOR ON-LINE VIEWING

The best rendering of type is achieved through imagesetter output, since resolution is much higher than on screen. Resolution (the number of dots per inch) varies from one printer type to another. Inkjet and laser printers output at 300 to 600 dots per inch (dpi) or better, producing prints of the quality of a good photocopy, but imagesetters output at up to 3,000dpi, producing prints with crisp, sharp edges and very fine detail.

The quality of digital type on screen, however, is constrained by the resolution of the monitor. When a font outline is rasterized on screen, only the pixels that fall within the outline shape will normally be drawn. The relatively low resolution of monitors cannot display fine detail (less than one pixel), causing inconsistencies or loss in features such as serifs and stroke weights and badly formed letters and spaces. Small sizes of type display badly on screen. Since small sizes are those most commonly used for text meant for extended reading, this is unfortunate.

A technique known as hinting can be used to adjust the arrangement of pixels to take account of lost detail. When there are too few pixels to display a small letterform correctly, hinting instructions in the font file can be used to provide a better-looking letterform and maintain optically balanced spacing.

Though it is important for print designers to have a good preview of their work, the quality of screen display becomes all the more urgent for on-line viewing where the screen image is actually the finished product.

To counteract the disappearance of detail at small sizes, larger type is often used for on-line pages than would be appropriate for a comparable printed job. But this doesn't

really solve the problem. Improvements are constantly being made to give small type a smoother appearance and make it easier to read on screen. Antialiasing techniques, in particular, are now frequently used to improve the on-screen look of all sizes of type.

ANTIALIASING

Antialiasing is the strategic insertion of pixels of various shades around parts of the letterform to create an illusion of relative stroke bulk and smoothness—an exercise that works well by tricking the eye. Adobe products use antialiasing by default for displaying text on screen and Microsoft Windows software automatically smooths fonts above a certain size.

04.02

The appropriate and emotive use of color is integral to the competence of the digital graphic designer. In our consumer-led, information-rich, entertainment-orientated society, the designer must understand thoroughly both the nature of color and the way in which it works in order to use it effectively.

There are several reasons why the nature and the workings of color are important (see also Design Basics). First, when designing on screen with color (and when screen color is actually used in Web and multimedia projects), that color is transmitted directly from a white light source. However, when color is reproduced through the use of printing inks, the colors are not transmitted but reflected. Crucially, the range of colors that can be printed with inks is smaller than and different from the range that can be created from white light on a computer monitor. So the final digital file, particularly one used for print, must contain reliable information about color output.

 ${\tt PART~04.~TYPE/COLOR/IMAGE}$

CHAPTER TWO

COLOR

WHERE DOES COLOR COME FROM?

All color comes from pure, white light. Most of us have seen light passed through a glass prism and split into the colors of the spectrum. The colors seen from the prism are transmitted directly onto the retina and are not reflected from any surface. The computer monitor is a source of artificial white light and the colors seen on a monitor are also transmitted directly onto the retina.

Since all the data that constructs computer imagery is digital, monitors need a method whereby all the colors of the spectrum can be quickly simulated. The method used displays only the three primary colors that make up white light, in a grid of pixels. By using up to 256 different intensity levels of each of the primary colors to display each pixel, it is possible to arrive at a total of 6.7 million colors (256 x 256 x 256). The three primary colors used are red, green, and blue, known as RGB for short. If we created products only for screen viewing, what we need to understand about primary colors could stop there. However, most designers also produce design for print, so they have to simulate color through printing inks. Ink colors are perceived by the viewer through the reflection of light from the printed surface. The RGB primaries apply exclusively to transmitted light, and for reflected light we need a second set of three colors. These are cyan, magenta, and yellow, or CMY.

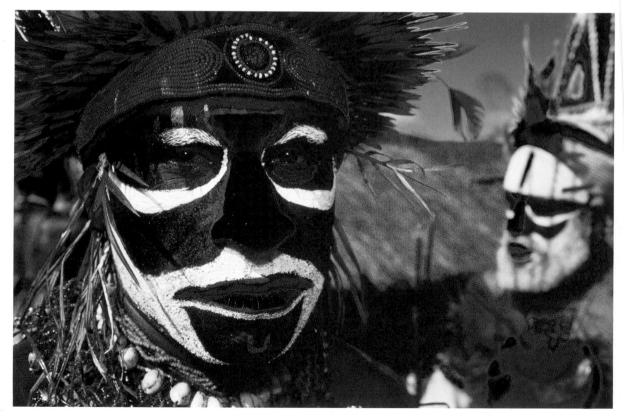

Right: The use of color for decoration, symbolism, and communication is an integral part of every human culture.

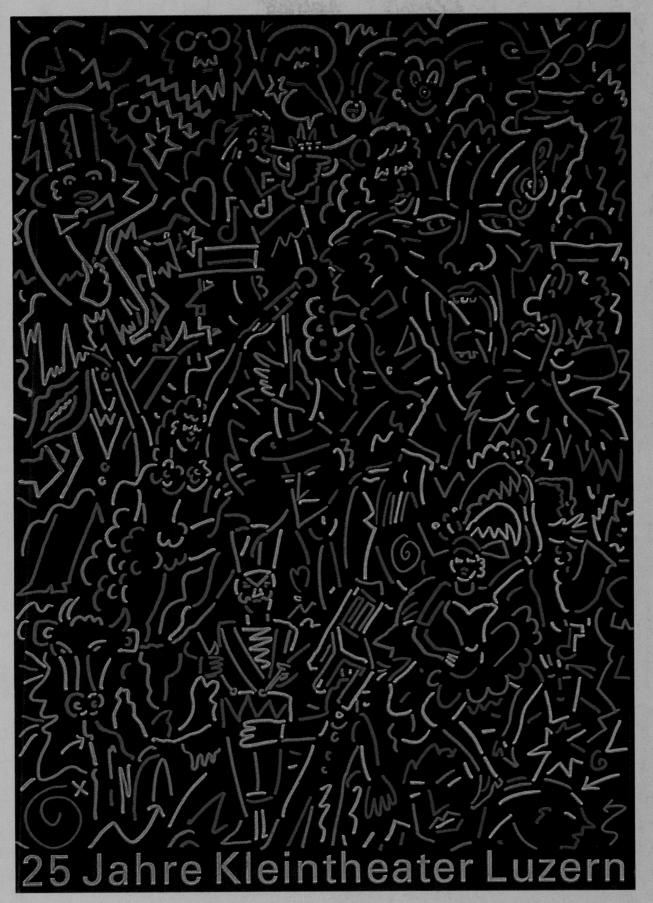

Left: This powerful poster shows how vibrant colors contribute to the verve of the subject matter and helps to delineate the composition. Design by Nicklaus Troxler, Switzerland

chapter 02. color

Additive color

This diagram represents red, green, and blue light falling onto a white surface. Yellow is formed when red and green overlap because there is additional light in that area. When all three colors overlap, we see white since all the components of white light are now present.

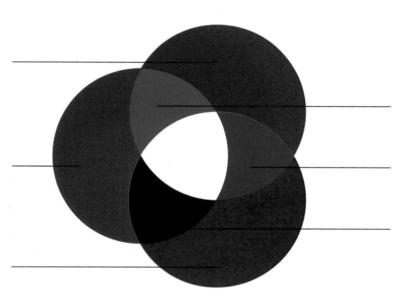

TRANSMITTED OR ADDITIVE COLOR

When one primary transmitted color is combined with another, more light is perceived than with one color alone. For this reason, red, green, and blue are referred to as the additive primary colors. All three colors add up to white. Thus, combining red light with green light, for instance, produces a color that starts to approach white light (in fact, yellow). Similarly, a combination of red and blue produces magenta, and a combination of blue and green produces cyan. It will be seen that each primary additive (or transmitted) color appears the way it does because each represents white light minus two primaries. So, for example, red is white light minus green and blue.

Subtractive color

Here, three primary subtractive colored inks have been printed onto paper. Each of these colors has one of the additive primaries subtracted so, where two overlap, two primary colors are subtracted, leaving only one of the primaries visible. Once all three subtractive colors overlap then all three components of white light are absorbed; no light escapes and black is perceived. In practice a small amount of light does get reflected and a true black is not achievable using only cyan, magenta, and yellow. To correct this printers use a fourth ink, black, to create deep shadow areas necessary for good color-image reproduction.

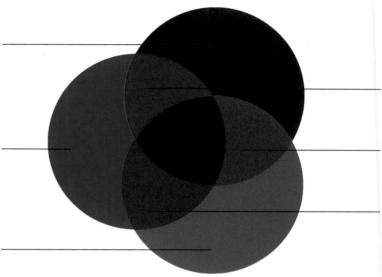

REFLECTED OR SUBTRACTIVE COLOR

In our material world, everything we see has a particular color because most matter absorbs white light (which we get, with varying degrees of purity, from sunlight and artificial light) to a greater or lesser extent. Black objects absorb all the white light that shines on them, while white objects reflect all the white light that hits them. What is generally understood to be an object's color is, in reality, only the reflection of certain amounts of the three primary colors. It is a combination of these that is perceived and interpreted as a particular color. For example, if an object appears red, it means that the material of which it is made is absorbing all the green and blue light, leaving only the red part of the spectrum to be reflected. Paints, inks, and all other kinds of coloring pigment behave in the same way, by subtracting (absorbing) a certain amount of light and reflecting the rest.

Since pigments subtract color from white light, it should be easy to see why red, green, and blue inks cannot be combined to mix colors for printing on white paper (which reflects the red, green, and blue that compose white light). Remembering that each primary additive color is white light minus two other primaries, it should be clear that mixing any

Right: Photoshop's Channels palette shows how an image is composed in RGB or CMYK mode. On the left are the four channels of CMYK, which appear very much like the proofs taken from each lithographic printing plate. The channels displaying RGB are instantly recognizable by the areas of black in each channel that represent the absence of light. Note that the top images in these palettes provide a preview of the combined channels.

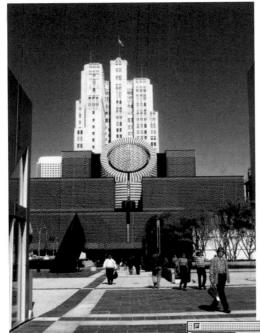

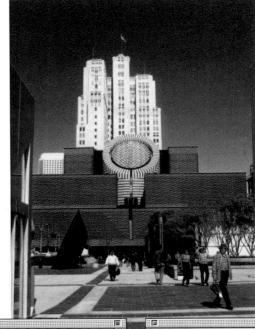

two primaries as pigments (making them part of the reflective surface rather than transmitted light) will result in all color being absorbed.

If the goal is to mix a wide range of printing colors from a small number of basic hues (say three), colors that absorb only one primary color must be identified. You will recall that the secondary colors—cyan, magenta, and yellow—are each achieved by absorbing (subtracting) just one primary color from white light. Similarly, mixing two secondary colors will absorb (subtract) two transmitted colors and leave the third. Thus, mixing cyan pigment with yellow pigment would produce green; mixing cyan with magenta would produce blue; and mixing magenta and yellow would produce red. All printing devices can therefore use cyan, magenta, and yellow as printing primary colors.

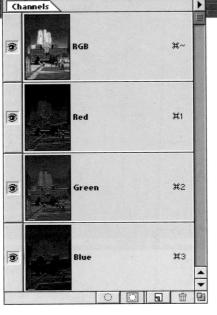

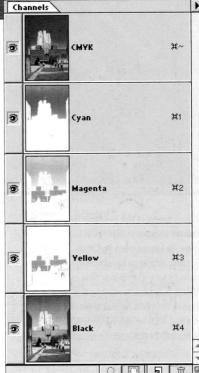

Light reflected

chapter 02. color

COLOR ATTRIBUTES Whether color is transmitted directly onto the retina or reflected from different pigments (including cyan, magenta, yellow, and black), it still consists of the three primaries—red, green, and blue. These primaries are the ingredients of different colors but all colors have three other attributes: hue, saturation, and brightness.

Above: The saturation level of the top picture is high (thus fully saturated) and the bottom picture is very low (desaturated). A fully saturated image contains maximum values of each color and can often produce an exaggerated, rather than accurate, representation.

Above: The brightness level of the top picture is optimum and the bottom picture is very high. Toward each extreme the contrast diminishes and thus the optimum brightness level of an image is that where the contrast is greatest.

Understanding the attributes of hue, saturation, and brightness (often referred to as HSB values) is essential to working with color successfully. They form the basis of color language and underpin dialogs between users of color throughout the graphic arts industry.

HUE

Hue is the easiest term to understand, since it is essentially interchangeable with the word "color." The colors of the spectrum are often displayed in a circle or color wheel, and we can use basic names to identify each main color: magenta, red, orange, yellow, green, blue, cyan, indigo, and violet. Many hundreds of names are possible for the colors in between. When we refer to a color as being "orange" we are identifying its hue. It doesn't matter, for instance, whether it is a vibrant, dull, or very dark orange: orange remains the common hue.

SATURATION

Saturation refers to the vibrancy and purity of a color. To understand saturation it is often helpful to look at its opposite, "desaturation." Since colors are made up from the three primary colors a total absence of light (i.e., no red, green, or blue) will lead us to perceive black. If there is equal, full-strength red, green, and blue, white is perceived (so it follows that white is, in fact, full color). As gray lies somewhere between black and white, so it is made up of equal amounts of less-than-total red, green, and blue. The three amounts of color are in perfect balance, and the result is described as a totally "desaturated" color. If we now, for example, gradually

increase the red element in our gray, while decreasing the blue and green in proportion, the gray will turn redder and eventually become a totally saturated, vibrant red. The nearer the amounts of red, green, and blue are to being equally balanced, the less saturated a color will appear. Conversely, the more difference there is in individual amounts of red, green, and blue, the greater is the saturation. Saturation levels can be described as the tendency of a color to move toward or away from being gray.

BRIGHTNESS

Brightness (sometimes referred to as lightness or tone) refers to how much light has been used to produce the color in question. Saturation or desaturation of a color depends on the ratios of red to green to blue but not necessarily the overall quantity of light used to create it. If a large amount of light is used to create a color (irrespective of the relative ratios of red, green, and blue) the color will be bright (or light). If little overall light is used, then the color is perceived as being dark.

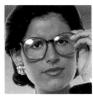

your screen.

COLOR MANAGEMENT

The accurate management of color from screen to printing press is complex and

difficult. Much work has gone into the

production of color "profiles," which are

colors accurately on screen while taking

software modules designed to simulate printed

account of known variables affecting hardware

and design programs. Color profiles are truly effective only if all programs and related

predictable color output is to make test prints

on the same printer that is used for the final piece of work from files generated on your

own workstation and look at them against

hardware are catered for and are regularly

calibrated. The best advice for achieving

Above: Understanding color is made simple when viewing Photoshop's color palette. In the examples on the left hue and brightness values have been kept the same and it is purely the change of saturation (indicated by the slider) that changes the color applied to the image.

The examples in the center have been modified purely by hue and those on the right by the value of brightness. Often hue, saturation, and brightness controls are used in conjunction with one another but to get a better understanding of what is happening it is useful to refer to and experiment with this palette,

using one slider at a time. This method of mixing colors (found in other graphics arts applications) is invaluable for mixing controlled ranges, or sets, of colors allowing the user to maintain some attributes of color while altering others.

chapter 02. color

04.03

Images created on the computer can range from a simple icon printed in one color to a multi-layered photographic montage using all the colors of the spectrum. Different types of image include diagrams, charts, grap is, maps, technical illustrations, logos, icons, symbols, photographs, collages, montages, and photomontages, any of which might be incorporated into a design to inform or entertain, or both.

Images are designed in different styles, both for aesthetic reasons as well to meet production limitations. They may be in black and white, grayscale, or full color, and may be produced as monotones or duotones. They may be square, rectangular, or geometrically shaped, or appear unbounded on the page or surface.

What images are, what they do, and how they are created are of considerable importance to the graphic designer. Imagemaking requires care, a rich visual language, a sense of purpose, and sensitivity to the way in which the outcome can affect the viewer.

Many graphic designers concerned with image-making are, or become, photographers and illustrators, with much of what they create being integral to their own designs. The graphic designer's motivation often springs from a client-generated brief, the parameters of which will often dictate the use of type and image.

WHERE TO OBTAIN IMAGES

Rich sources of copyright and copyright-free art are available on CD and the Internet, which, together with images generated by the designer, can provide a springboard for inventive, image-based design solutions. Collections of imagery can inspire the designer into developing, simplifying, or synthesizing them to support a project. This can often be detected in icon or logo design, where several visual references may have been modified and fused into a single graphic symbol.

PART 04. TYPE/COLOR/IMAGE CHAPTER THREE

IMAGE

Much of the time, however, the graphic designer is the creative manager of visual components and uses images created by illustrators and photographers. A balance has to be maintained between giving the illustrator or photographer creative freedom and ensuring that the commissioned work complements the project. Building a good working relationship and establishing a rapport with other artists is essential to professional working practice and to getting the right results.

The advent of digital control over images has almost immeasurably expanded the creative scope of illustrators and photographers. With accessible, powerful software for creating and manipulating images at their finger tips, digital graphic designers can produce a wide range of graphic effects to incorporate into existing or newly created images. Respect for the integrity of other image-making professionals is, of course, extremely important. It is not ethical either to alter another professionals' work or to manipulate it gratuitously. However, by agreement or in collaboration it is possible to modify the original dimensions, mood, and meaning of an image.

Opposite and above: Mood and atmosphere can be generated from creative image manipulation in a bitmap-editing application. Qualities of layering, transparency, and depth are obtained by the inventive use of Photshop functions.

Designed for *MacUser* magazine by Tom Hingston Studio, UK

chapter 03. image

UNDERSTANDING DIGITAL IMAGE-MAKING The development of software for easy and creative image-making continues in leaps and bounds. Just when the designer exhausts all the tools of one program, an updated version hits the market adding a plethora of new features.

As programs become feature-rich, they attempt to be all things to all people, and in doing so may mask the fact that the behavior of some aspects of image creation is not entirely compatible with others. It is easy to be overwhelmed by the multitude of features available, so it helps to have an appreciation of some of the underlying principles.

There are essentially two different types of image-making programs—painting (or image-manipulation) and drawing, also referred to as bitmap and vector (vector programs are sometimes also called "object-oriented" software). Bitmap images do not mix readily with vector images, but they can be made to integrate and work together.

Above: Libraries of images on CDs are popular and readily available. Usually images are scanned at varying resolutions to meet different requirements. For example, low-resolution scans provide economic file sizes for screen-based work; very high resolution is suitable for commercial print quality. Some CDs contain royalty-free images but the better images available are subject to a fee when used commercially. Be aware that altering an image digitally does not alter the laws of copyright.

Right: Bitmap images (above right) may be available in full-color or as "grayscales" printed in a single color. Images with no gradations between black and white are called line art, often refered to as "bitmap" images (below right). (Note: Bitmap is a generic term and strictly speaking can refer to any image composed of pixels.)

BITMAP PROGRAMS

The industry-standard bitmap program, used by digital graphic designers, photographers, Web designers, and the printing industry, is Adobe Photoshop. There are other bitmap programs used by artists and illustrators, such as Painter. CorelDraw also has a bitmap component called Corel PhotoPAINT, while Deneba Canvas combines drawing and bitmap editing fairly well.

Bitmap programs are used for creating single images and are not used for creating multipage documents. The principle on which the program works is that of a fine grid of pixels. Each pixel can be colored separately and the arrangement of these pixels produces the effect of an image. This method of image-making can be likened to taking a piece of finely divided graph paper and coloring each individual square with its own color. From a distance, the squares disappear and the overall impression of a complete image emerges. Because images are constructed purely with pixels, it is possible to use tools that modify them individually or as large groups. Because the program's tools can be made to

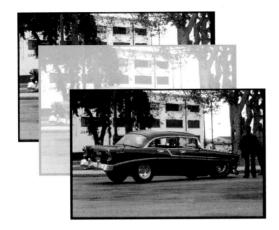

travel across these pixels to create color changes, the term "painting program" is often used. Tools with a variety of functions do, in effect, sweep across an image, altering the underlying pixels.

BITMAP ADVANTAGES

Bitmap software lends itself particularly well to photographic and other "continuous tone" images, such as paintings or illustrations. A photograph captures a realistic view of what we can see around us. In the environment hues and shades merge imperceptibly with each other in every direction. This "continuous tone" effect would be impossible to reproduce realistically using drawn shapes. Scanners read a photograph by recording color values at thousands or millions of points from side to side and from top to bottom. When these colors are displayed on the computer's monitor as pixels, they are too small to see individually but give the viewer an impression of continuously changing tones. Software tools can alter pixel values in a gradual way, so maintaining realism.

The amount of detail that can been seen in a scanned picture depends entirely on how many times per inch the scanner is made to record the color values. This figure is called the resolution. High resolution is obtained when pixel information is recorded at say 300 times per inch (300ppi); low resolution may record as few as 72 pixels per inch (72ppi).

grayscale images overprinted black onto a copy of the image, which has been printed in spot color to provide depth and interest. Generally the angle of screen for the black is set at zero and the angle of screen for the spot color is set at 45 degrees, which allows the color to be more visible. Digitization of the image allows for considerable control of the tonal range across the black and spot-color versions of the image.

Below: These images have been scanned at 300ppi, 150ppi, 72ppi, and 36ppi. The lower the scan resolution the less information captured and therefore a coarser image. In order to display these images the same size, on screen or in print, we have had to the enlarge or reduce the view.

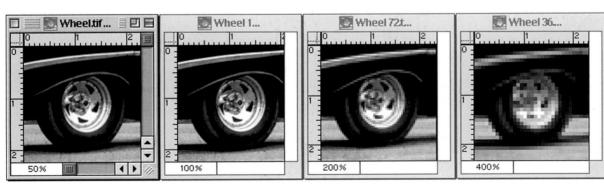

Above: The essence of a bitmap image is that shapes and images are made up entirely from the uniform arrangement of varying colored pixels. There is no underlying structure to describe this shape.

60

BITMAP DISADVANTAGES

Bitmap images have two disadvantages. First, in terms of digital storage, bitmap files are very memory-intensive. The values of every pixel that makes up the image must be identified and recorded digitally. This information can be compressed to some degree by using special compression techniques such as LZW or JPEG, but bitmap images are still enormous compared to text files. Second, because a bitmap image has no structure other than a sequence of pixels arranged in a grid, the only way to enlarge it is to make every pixel bigger. The viewer will soon lose the illusion of a smooth image and become aware of the individual colored squares. This "pixelation" makes the image appear coarse. The best way to remedy it is to rescan the image at a sufficiently high resolution to allow for the enlargement, but this is not always practical at a late stage in production.

Left: Even apparently rough-edged images can benefit from being created by vectors. Though this logo for Chronicle Books has been enlarged greatly from the same small-scale "Illustrator" file, it still maintains a sharp edge. This would have been impossible from a small-scale bitmap file.

Below: Bitmap applications provide photo-realism and are useful for applying graphics such as logos or advertising into real-life situations. Here a corporate identity has been digitally applied to a photo of a vehicle so the look can be tested before implementing the design.

VECTOR-BASED PROGRAMS

Vector-based programs describe the shape of an object as a series of strategically placed points connected by lines controlled by mathematical formulas—rather like a "join-thedots" picture with the added benefit that the connections between points can be precisely described as straight or curved lines. The line is called a path or a vector. Paths can have thickness (stroke) and color, and the shapes or objects they create can also be filled with a color, gradient, texture, and so forth. Each object can be moved around a page independently, which allows them to be arranged and rearranged, overlaying or underlying each other as appropriate. By altering the position of the points and the ways in which the paths connect them, the vectors and the resulting shapes they make can be reformulated.

Vectors are an ideal way of describing the outline shape of letterforms, and in fact printer font files are essentially a collection of outline vectors.

Above right: The fundamentals of "pen" tools, as they are absolutely

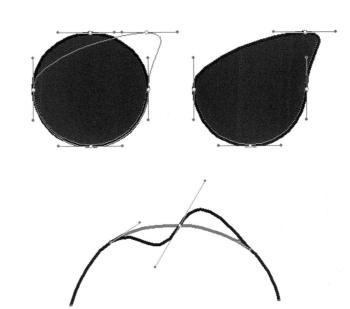

vector shapes are points joined by straight or curved lines controlled by either moving these points or adjusting the curves between them by means of curve levers. All drawing applications use this method of creating simple or complex paths and shapes. It is well worth taking the trouble to master how to use the "path" or essential in digital image creation.

Vector images allow for good-quality scaling both on screen and when output from a printer's RIP. When a vector image is resized, the mathematical formulas ensure that all the points and paths are repositioned so as to maintain their original relationships. Since coloring is simply the filling-in of a defined shape, the scaled shape is automatically refilled. Objects described by outline information are memory-efficient, since a relatively compact set of numbers can describe quite complex shapes and color fills. Vectors, however, cannot produce photorealistic images, since realism needs a constantly shifting description of tone and color that can only be carried out satisfactorily by the subtle changes in pixel color, achievable by bitmap techniques.

Above: Here, in a bitmap editing application (Photoshop) vectors are used purely as an aid for the user to create smooth shapes to which images may be selected, cropped, or painted. Once the vector has been used to carry out a function, the resulting images are recorded in bitmap form.

Right: FreeHand, as with other drawing applications, will create nonprinting guides from userdrawn shapes. This is very useful when setting up perpectives and/or plans.

VECTORS AND BITMAPS TOGETHER

Most major graphic arts programs can handle both vectors and bitmaps, although they represent different imaging technologies. However, one or the other technology generally dominates each program. For example, all page-layout and drawing programs are essentially vector-based, but they also have the ability to import bitmap pictures. The bitmap is usually contained within a placement holder, such as a "picture box," that may or may not have a visible frame. Vectored objects such as typographic elements, graphic shapes, rules, drawn logos, and technical illustrations may lie over or under imported images.

Unless it is appreciated that an image composed of a grid of pixels is fundamentally different from a vector image, whose component parts are described as outlines and filled shapes, much confusion may occur. The designer may be left wondering why certain tools and functions do not work for both kinds of image.

Page-layout programs such as QuarkXPress, Adobe PageMaker, and Adobe InDesign have features that allow for a certain amount of control over the imported bitmapped

Above: A cube drawn in a vector application (right) has been "rasterized" when opened in Photoshop (left). The process converts the vector image to a bitmap (pixel-based) image.

Above left: A series of circles of increasing size produced from a single bitmap file compared to those produced from a single vector file. It is not difficult to see which are which.

Below: Adobe Streamline is a useful application that can turn bitmap images into vector files. It places points and vectors to create outlines around significant bitmap areas of tone and/or color. The resultant outlines can then be filled with color using a drawing application like Illustrator.

images, including scale and shape changes, and the coloring of black-and-white or grayscale pictures. The features vary slightly from one program to another. Adobe Illustrator and Macromedia FreeHand, both of which are drawing programs, have the capability of modifying imported bitmapped images through various special-effect filters, and are also able to convert (rasterize) vector objects into bitmaps. Once rasterization has taken place, the vector information is lost and the result is simply a collection of pixels.

In contrast, Photoshop, a bitmap program, has some vector-based tools included to enable the user to make very accurate and smooth selections with the aid of paths. Additionally, text can be created using the outline (vector) information from the font files and still remain editable. In the end, however, vectors and editable text will need to be converted into bitmap before they can be properly integrated into the image.

Working in the opposite direction, Adobe Streamline is a useful program that can process bitmap images and produce outlines (vectors) where colors and tone change. The trace or auto-trace facility in some vectorbased software can be used in the same way, especially on selected areas.

Left: When images are imported to a layout or drawing document, it is usual for only low-resolution copies to be placed on the page as visual guides. When a printing device comes across a picture imported into a document, it searches for the orginal, highquality file. Seen here is Quark's Usage dialog box, which keeps track of where the originals of imported images are stored. One of the most common print "problems" is when designers forget to send their original good-quality scans together with their document files.

Right: Seen here is a vector (left) and bitmap (right) version of the same image. In order to maintain a similar quality of reproduction when enlarged to 200 percent the bitmap image must be rescanned at a much higher resolution than before. resulting in a much larger file size. By comparison, the same vector file may be used at any size without compromise to quality. Notice, though, how bitmap images create smooth transitions throughout all the subtle tonal changes while vector images shows welldefined, hard-edged, shapes.

Original Native Adobe

Illustrator file-2.6MB

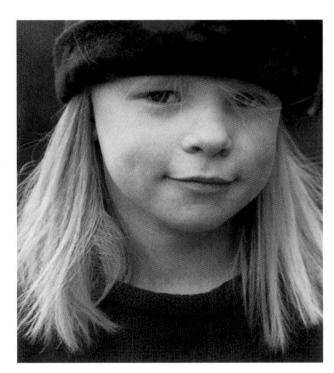

Native Adobe Photoshop file enlarged 200 percent—11.9MB

Original Native Adobe Photoshop file—3MB

chapter 03. image 203

SCANNING AND RESOLUTION To work successfully with bitmap pictures, the impact of several different but interrelated technologies must be considered. In planning graphic reproduction the intended result needs to be established before the appropriate preparatory steps can be decided upon. In other words it is usually advisable to start from the output end and work backward to the beginning.

SCANNING FOR PRINT

The Print section in Part II of this book explains how a printing plate must be made for each color in order to transfer the color-filtered components of the image onto paper. In four- or six-color process, the colored areas of an original image are analyzed for how much of each printing ink is required to simulate the color at any given point. Then the location of each required ink color is transferred to the appropriate plate as tiny, close-printing dots in a conversion procedure called halftoning. The dots in a full-color halftone vary in size according to how much of their ink color is required at a given spot, but even the biggest of dots is so small that it merges almost imperceptibly with the surrounding dots to create the illusion of a visually smooth change of color, tone, and intensity.

Imagesetters (output devices used to generate reproduction-quality copy for printing) have a device resolution of up to 3,000 dots per inch (dpi). For most printing work, halftone dots are required at a rate or output resolution of 150 halftone dots per inch. Dividing the imagesetter resolution by the output resolution, we find that a 3,000dpi imagesetter has 20 dots with which to construct the largest halftone dot required. Since these rates per inch are linear, the largest (100 percent) halftone dot would be 400 dots in area (20 dots square) and a 10 percent dot would be around 40 dots in area. That is more than ample to ensure fine reproduction.

The designer's file must obviously contain all the image detail to produce all the tiny halftone dots that represent how much ink falls where. In fully digital printing and direct-to-plate (DTP) imagesetting, the dots transferred to the plate come directly from the designer's file. More conventionally, there is an intermediate stage in which the imagesetter produces prepared photographic film, through which the plate's light-sensitive, emulsion-covered surface is then exposed to light. In this case, it is the film that comes directly from the designer's file.

In order to produce output at 150dpi (output resolution), the imagesetter must receive information at a minimum of 150 pixels per inch, or ppi (input resolution). If a picture file has been scanned at a lower resolution, there will be insufficient information to satisfy the imagesetter. In the absence of such information, it will make identically sized halftone dots until new information reaches it. For instance, if a file can only provide 50ppi (one-third of the necessary linear resolution), an imagesetter set to output at 150dpi must create three identical dots in a row both across and down. This results in a group of 9 identical dots that, when printed, will look like a little square to the naked eye. Worse, the whole image will be made up of these little squares. The way to avoid this is to scan at a high enough resolution to provide at least 150 unique pieces of information for the 150 demands made by the imagesetter.

That is the theory—but there is one small, added complication. Halftone dots are arranged at angles to each other, with a unique angle for each process color. The objective is to ensure that any pattern in the dots does not distract the human eye, so that the image appears smoother and more realistic. Since images are scanned horizontally and vertically rather than at an angle, and since imagesetters lay down the dots from left to right, the requirement to work at an angle increases the demand for accurate information across the inch. For this reason, it is recommend that images should be scanned at between one-and-a-half times and twice the intended output resolution.

There is much confusion about the terminology regarding resolution. Dpi, ppi, lpi-what's the difference? It is quite common for lay persons and professionals alike to use dpi (dots per inch) to decribe any type of resolution. Strictly speaking we use the term samples per inch (spi) when refering to scanned bitmaps but now mostly ppi is used. Pixels per inch (ppi) refers to monitor displays and dots per inch (dpi) refers to particles of ink, toner, or light that are used by printing devices to create images. Halftone dots, created from the smaller printer dots (dpi) are arranged in lines to form a mesh, or screen, and so halftone screens are expressed in lines per inch (lpi).

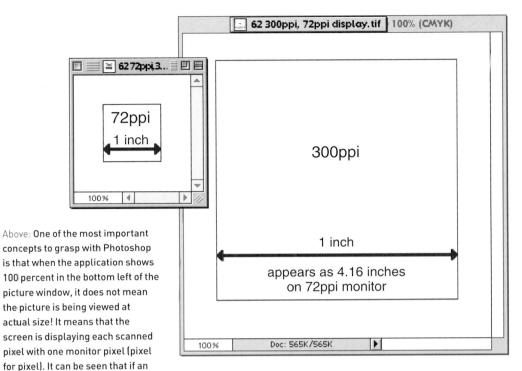

bigger-looking picture. It is not possible to mix pixel resolutions in the one image so when images of variable resolutions are copied and pasted, they will appear to shrink or expand in order to fit the pixel grid of the host image.

Right: The ideal resolution for print work is 300ppi (top). If the resolution is too low or the image is enlarged too much—thereby reducing the effective resolution—then unwanted pixelation occurs (center). If no halftone dots need to be created—as in line art images—one may scan at the maximum resolution of the output device, which could be as much as 3,000dpi. However a scan at 600ppi will normally be sufficient to obtain a visually sharp edge (bottom).

Left: When an area is enlarged on screen for a zoomed-in view, the application's software creates squares of identically colored pixels to give the illusion of enlargement. Pixels are still displayed at the rate of 72ppi but the illusion is that they have "grown." A similar effect is seen when an image scanned at low resolution is printed and there are not enough pixels per inch for every halftone dot required. So a few neighboring halftone dots will use the same information and therefore appear identical, vertically and horizontally. This results in visibly squares and the picture appearing "pixelated."

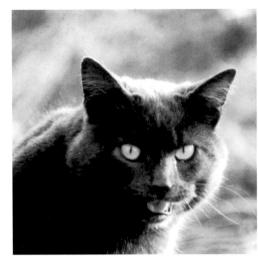

image is scanned at 72ppi (the

same resolution as the monitor,

which is fixed) then it will appear

scanned at, say, 300ppi, then the

monitor will require 4.16 inches to

the correct size. If an image is

show 300 pixels resulting in a

chapter 03. image 205

Above and right: Image size and resolution are interlinked. When an image is scanned it may be expressed in two ways. First, by how many pixels it measures horizontally and vertically. This need not dictate how big it will print, just how many bits of information record the picture. Second, we are able to give the picture a physical size so that when sent to a printer there is some reference as to how big the picture should be reproduced. Above left are two versions of a picture that has been scanned once—its pixel size is 148 pixels x 118 pixels. The top picture is described physically 1 x 1/4 inches at a resolution of 150ppi, while the lower picture is described 2 x 1½ inches at a resolution of 75ppi. This is very similar to looking at a mosaic on a wall close to or from a distancethe number of squares that make up the picture do not change, it is the viewing distance that makes the picture appear bigger or smaller and coarser or smoother respectively. In contrast the picture on the right has been given the same physical dimensions as the lower left but has been scanned at a far higher resolution (300ppi) so that the pixel size is 591 pixels x 472 pixels.

Most designers tend to err on the side of caution and stick to scanning at double the halftone rate. So, for most general commercial offset litho printing, pictures are scanned at 300ppi at the final output size. There will be no quality problems if a picture is scanned at higher resolution, but equally there will be no quality improvement. However, there will be an enormous increase in file size and processing time, which will slow all processes down.

If an image is to be printed in solid process color, requiring no halftone dots, it is known as line art. Theoretically, for the best results you could scan that image at 3,000ppi to match every imagesetter dot. However, this is impractical for file size reasons. For crisp results, line work should be scanned at 600ppi. Any extra quality obtained from scanning at much above this level of resolution is imperceptible.

The resolution of an image must be correct for the size at which it will be printed. It is no good scanning a picture at 300ppi and then enlarging it dramatically in a page-layout

program. Your original picture file will still contain the same information, but it will now be stretched two or three times beyond its original dimensions. This has the effect of substantially lowering the resolution relative to its new size. A small amount of scaling up or down may not result in print-quality problems, but it is always best to scan a picture at the correct resolution for the intended output size. Fortunately, most scanning software allows the user to set a resolution and a scaling ratio. The scanner then ensures that the picture is scanned so that the resolution is correct at the new image size.

When buying a scanner, it is important to ascertain the highest resolution actually achievable. Some manufacturers claim a very high output, but this is sometimes achieved by interpolation—the software recalculates its best actual result to add more pixels per inch. Although interpolation will smooth out an image, it will capture no more detail, so always judge by "optical" not "interpolated" resolution. Interpolation also takes place when an image or parts of it are rotated or transformed in some way. Sometimes, owing to looming deadlines or unavailability of the original image, a designer will need to increase a picture's resolution directly in the file. Photoshop can interpolate and increase the number of pixels in an image; if this proves necessary, the bicubic method should always be used for the best results.

FOR SCREEN PRODUCTS

Resolution issues for image use in Web pages or multimedia production are much more straightforward than for print, since the designer knows that the audience will be viewing images on a monitor not dissimilar to the one on which the design was created. There is a lot of confusion over the difference between Macintosh and Windows screen resolution. Text in Windows is drawn using a 96ppi model, but you can safely stick to 72ppi for your bitmap design work. The good news is that 72ppi images contain just 5184 pixels per square inch, less than one fifteenth of the size of a 300ppi file. This makes for quick transmission over the Internet.

FILE FORMATS FOR BITMAPPED IMAGES Digital images can be saved in a variety of file formats, each of which has its own unique way of storing information and of handling digital data. Choice of file format is important to the digital graphic designer, since the one selected will have a bearing on the efficiency and performance of the stored image.

PICT (Macintosh picture file) is the Macintosh operating system standard format for saving bitmap information. It cannot store CMYK information.

BMP (Windows bitmap) is the Windows operating system standard format for saving bitmap information. It cannot store CMYK information.

TIFF (Tagged Image File Format) is the most widely used file format for print. It can store bitmap (black and white), grayscale and color information (RGB, CMYK, or indexed color), and include masking information. Furthermore, TIFF files can be compressed without losing data. Most programs can read TIFF files. The Macintosh and the PC use different versions of the TIFF format, but both versions can be read by Photoshop and resaved for the platform required. Clipping paths cannot be saved in the TIFF format.

JPEG (Joint Photographic Experts Group) is favored for photographic images, especially on the Internet. It can offer high compression of file sizes, reducing them to a fraction of their original size. The drawback is the loss of information in the compression process: the greater the compression, the greater the loss. The user, who can make a trade-off between

Below: File formats may, in Photoshop, be selected from the Save or Save As menu. Some file formats, such as Pixar or Amiga, are for more specialized computing systems and for most users may be ignored. Often, some file formats are "grayed out" on the pop-up menu. This is because some file formats work only with RGB images and some only with CMYK images. When all of the file formats are "grayed out," except Photoshop format, this indicates that the picture contains layers that will have to be flattened before the image can be recorded in any other file format. Note: To create GIFs the Export menu (under File) needs to

be selected.

Photoshop

Amiga IFF

Photoshop 2.0

file size and quality, can control the amount of compression. Repeated compression and decompression will make the quality worse.

EPS (Encapsulated PostScript) is a PostScript image file with an encapsulated screen preview, most often produced by vector image programs. It may be resized or cropped but usually no alteration to the content can be made other than by the program in which it was created. Photoshop can open and save EPS files, and can also compress them to JPEG. If a clipping path (cutout instruction) has been created in Photoshop, saving in EPS format ensures that when the file is opened in another program, it can appear in the shape to which it was clipped. EPS files are also able to hold information about the appearance and output of duotones.

GIF (Graphics Interchange Format) is a format normally only used for Web work. It supports only 256 indexed colors. A useful feature is that, on saving, it is possible to select a color to appear as transparent for cutout effects.

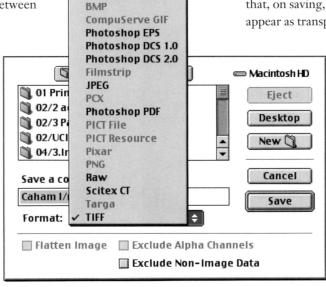

Far left: Picture files, when saved, have mini previews displayed in their relevant folder windows, which is useful for quick selection.

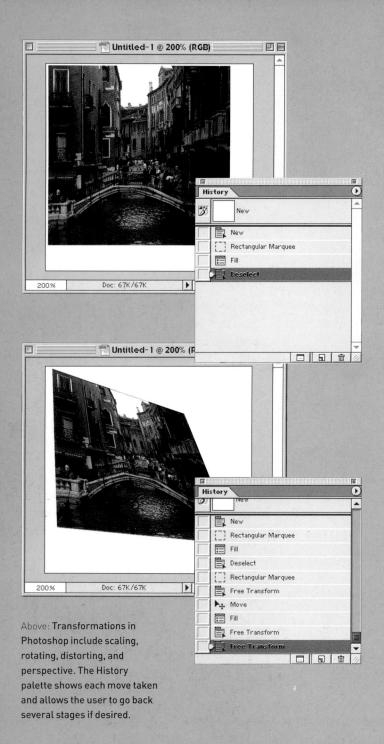

Right: The Curves control in
Photoshop provides a very
sensitive method of picture control
by allowing the alteration of pixel
brightness across all of the color
channels. Each channel may be
controlled separately, facilitating
the inrease or decrease of that
color in any part of the the image
between shadows, at one extreme,
and highlights at the other.

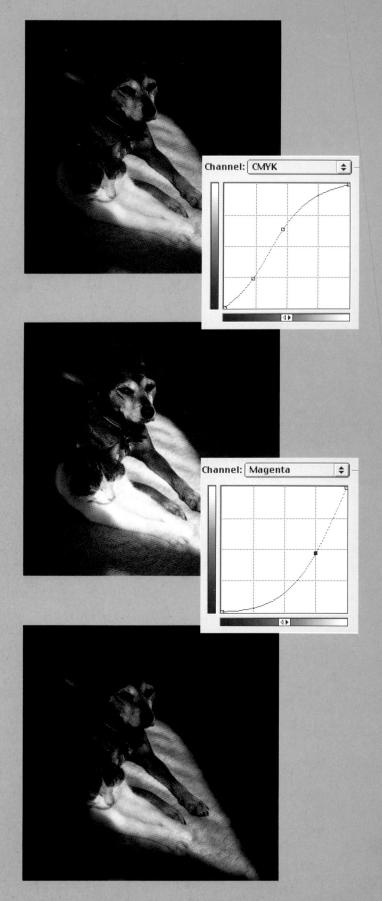

WORKING WITH BITMAP IMAGES IN PAINTING PROGRAMS Working on a bitmap image is much more flexible than working with the object-oriented, structured nature of vector shapes. Tools, generically termed "painting tools," can be drawn across a field of tiny pixels to alter them in various ways.

Whether you have selected the eraser, pencil tool, or airbrush, you are able to assign a "brush" size to it. This is measured in pixels (e.g., 1-pixel brush, 10-pixel brush, 35-pixel brush, and so on) to describe the area that brush will have effect on. Painting tools can also be assigned an opacity level to determine the strength of "painting" that the particular tool will have. A color selected from a range of sources may also be chosen for the tool in use.

Photoshop (the industry standard image manipulation program) has become an extremely powerful, and sometimes bewilderingly complex tool—yet, at its simplest, it is a number-crunching factory. The whole of an image comprises millions of regimented pixels, each with a 24-bit binary number dictating the color it represents. As painting tools are passed over these pixels, their numerical values are changed. To get a clearer idea of how this is achieved, it is useful to breakdown Photoshop's functions into basic operations. Then we shall look at transformations and other imagemanipulation features.

PAINTING WITH TOOLS

Images can be modified by using painting tools, either at full strength or with the opacity level turned down. Changes are carried out in a painterly fashion with the tools responding to hand and mouse control. The rubber-stamp tool is probably the most useful painting tool, allowing a point on an image to be selected and information to be copied from that point to the brush. The information is then used as the painting medium—a form of image-cloning.

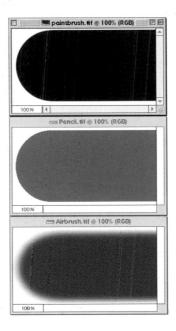

Above: The three fundamental painting tools of Photoshop—brush, pencil, and airbrush. Most significant is the default antialiasing of the brush and airbrush compared to the pencil. Antialiasing is a technique used by software to place intermediate pixels of lighter tone between one color and another to create an impression of smoothness. Antialiasing replicates the way the eye sees and helps create photorealistic imagery.

Right: Probably the most useful painting tool in all of Photoshop's armory, the rubber stamp tool (cloning tool) allows one part of an image to be painted across to another part. Combining subtlety of brush size and strength of opacity it is possible to eradicate unwanted material and replace it with other image-forming pixels. In the window to the right can be seen a circle, which is the rubber stamp brush, and the cross hair, which indicates the place from where the information is being copied.

GLOBAL PAINTING

Large areas, or selected areas of the image, may be filled using instructions from a pop-up menu. The same colors and opacities as used by the brushes are available.

SELECTING

If only an identified area within a picture is to be painted, a number of tools can be used to select and isolate the area required accurately. It can be done with rectangular, oval, or freehand tools, as well as a magic wand that selects areas of like color.

TRANSFORMATIONS

Photoshop menus allow for either the whole image or a selected part of it to be rotated, inverted, distorted, or inverted (colors reversed). Other transformations are also possible.

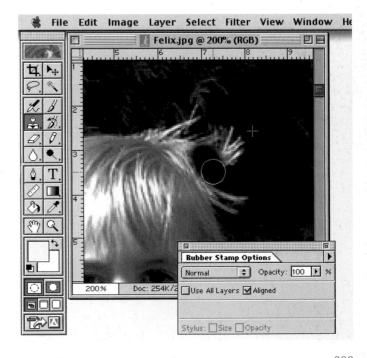

chapter 03. image 209

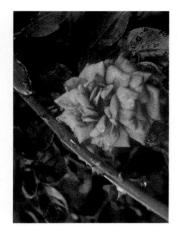

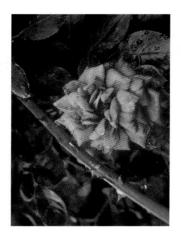

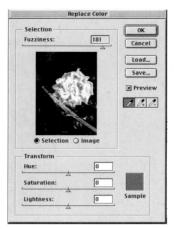

Left: The replace color function in Photoshop allows for change of hue, saturation, and lightness. The fuzziness control dictates the extent of area changed.

GLOBAL COLOR ADJUSTMENT

Global color adjustment allows the designer to modify either the entire image or a selected area for color balance, brightness, and contrast, saturation levels, color replacement, and general fine-tuning. The controls are available on a menu, and calculations are carried out and implemented throughout the selection according to the type of adjustment selected.

Right and below: Layer masks are used to control the amount of image on one layer being viewed. Seen here is a layer mask, attached to layer 1, which is controlling the amount of image appearing thus permitting some of the image in the background layer to show through.

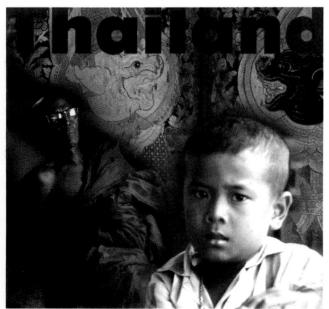

Below: The beauty of masks is that they can be saved and called up any time to select a particular area of an image. Furthermore, a mask can be added to and subtracted from, using any of the painting tools, brush sizes, and/or opacities, providing a highly detailed and subtle method of selecting areas for modification as and when required.

Original image

Quickmask

Mask applied

LAYERS

Layers exist to help the graphic designer create montage work as well as to facilitate making changes to a picture without damaging existing work. Photoshop's layer feature works just like putting a sheet of clear film over your image and painting onto it. The original image can be seen through the layer and, if you do not like what you have created on the layer, parts of it can be erased or thrown away. The important thing is that the original remains intact. Photoshop is cleverly able to apply varying opacities (and many other properties) to each layer to controllable degrees, giving the impression of images fusing into one another.

ALPHA CHANNELS AND MASKS

A color file has, by default, a channel dedicated to each primary color—red, green, and blue. In the case of CMYK files, there are four channels. Extra channels (alpha channels) are used for masking information. A mask can be thought of simply as a stencil, a tool that

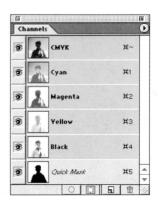

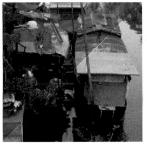

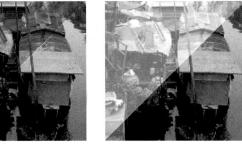

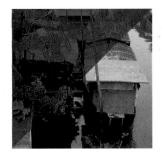

Above: Color modes are the way in which colors may be painted onto an image, taking into account the value of the pixels over which they are being painted. The color blue has been painted across half of the above pictures but the color "mode" selected has been changed for each. From left to right: Color, overlay, multiply, saturation, and luminosity. The last two are interesting in that only one attribute of blue is being used to change the picture, that is to say the pixels have been changed to match only the value of blue's saturation in one picture and only the value of blue's luminousity in the other.

prevents you from painting over a certain area. This is exactly what Photoshop masks do: you can create your own mask in an alpha channel and bring it into play to paint the shape created by the mask. If you have spent a considerable time in making a selection using some or all of the selection tools, it is usually worth using that selection to make and save a mask. If that selection is needed again, you only have to call up the mask. Masks that are saved with files can be used by layout programs to create cutout images.

WORKING WITH COLOR ATTRIBUTES AND COLOR MODES

In applying color using brushes or global fills, it is possible to paint with attributes of color rather than with the color itself. For instance, if a vibrant red is selected from the palette and a brush set to the color mode called "luminosity," the underlying pixels will not change to red when painting starts but will simply be altered to match the luminosity value of the red. Using the color mode menu allows the designer to color intelligently. If color is applied with the "color" mode selected, the underlying pixels will change color but the light and shade qualities will remain unchanged. There are many different color modes with which to paint, each one affecting the underlying pixels in its unique way.

FILTERS

Filters apply special effects to images or parts of images enabling many interesting and novel effects to be created quickly. Photoshop is supplied with many interesting standard filters, but dozens of other filters are available from third-party manufacturers, including EyeCandy and Kai's Power Tools.

Left: Just some of the many filters and effects available to modify images. Combinations of filters and the use of a filter several times over provide interesting and more extensive results. From top left clockwise-original picture, frosted glass, emboss, feather edges, wind blast, color halftone, pinch.

WORKING WITH DRAWING IMAGES IN VECTOR PROGRAMS The vectors used in drawing programs are called Bézier curves. All drawing programs handle Bézier curves in a similar fashion: a pen tool allows the user to set a series of points on the page, and these will automatically be joined by lines.

The shape of these lines is dictated by the way in which the pen is manipulated by dragging and clicking the mouse. Each point, when selected, will display one or two nonprinting "curve handles." A given point may be selected later and the handles manipulated to modify the curves. The points themselves can be repositioned to create revised shapes.

Drawing programs give the digital graphic designer many powerful tools with which to create complex shapes, to apply special effects, and to speed up many otherwise laborious tasks. Not all drawing programs offer identical tools, although most of them do share a core set of features. The menus and terminology employed may also differ, as may the graphical presentation of tools. For example, both Illustrator and FreeHand can convert type into points and vectors; the operation is called "Create Outlines" in Illustrator but "Convert to Paths" in FreeHand.

Left: Just a few ways of using type in a drawing program. The type may be converted to paths in order to make adjustments to the letterforms. The shape of type converted to paths may be used as a picture mask and drawn shapes (in this case type) may be rasterized into a bitmap image so that bitmap filters can be used. Of course, once an image has been rasterized it will no longer have any vector structure.

SOME OF THE FEATURES OFFERED BY DRAWING PROGRAMS

- * Typographic functions are comparable with those found in leading page-layout programs, so that all character and paragraph formatting and spacing can be applied, together with layout functions such as multiple columns and text flow.
- * Text can be converted to paths so that letterforms can be used in the same way as any other hand-drawn object.
- * Shapes may be stroked (given a colored outline), filled, cut, rotated, skewed, distorted, duplicated, mirrored, scaled, and added to. They may also be grouped, fused, cropped or used to crop others, used as a mask, used to contain a picture, and used to make patterns.
- ★ User-defined color palettes can be made up from RGB, CMYK, and HSB models as well as from color libraries such as PANTONE.
- * Many guides, grids, and views are available to support image construction. Views such as "artwork" mode show only points and paths, without color or fills, to help to clarify highly complex pictures and speed up screen rendering.
- ★ Layers can be used to build up images in coherent groupings. These may be locked against accidental deletion and may also be hidden while other layers are being worked on.
- * Numerous filters are available to create special alterations and effects with shapes or groups of shapes.
- * Shapes or groups of shapes can be rasterized, which enables them to be used with an imported bitmap image.
- * A range of bitmap-only filters may be applied to any imported bitmap or rasterized image.
- * Multiple blends may be used between two shapes to act as a morphing technique.
- * Space and align tools allow for swift arrangement of disparate elements.

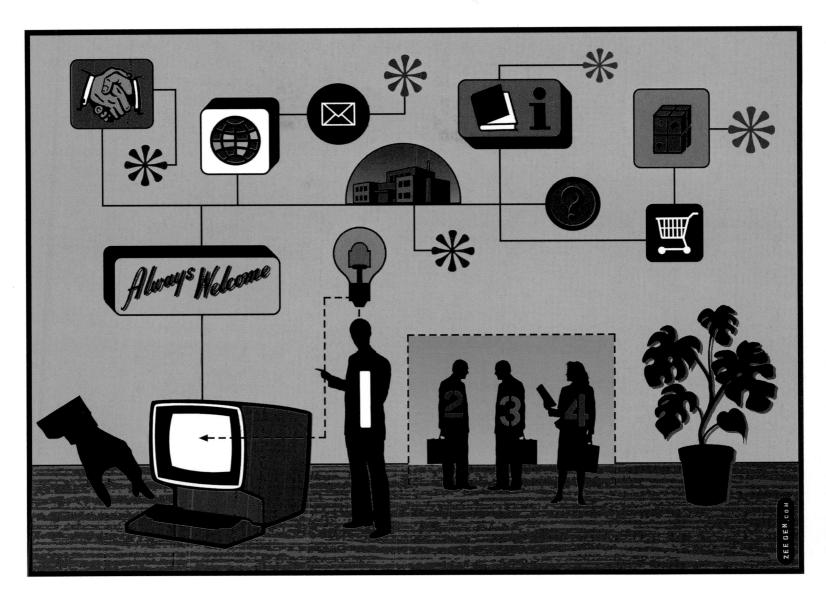

Page-layout applications are also vector-based, but generally have fewer drawing tools than dedicated drawing programs. All these features contain additional subfeatures. The powerful software that drives these programs demands determination to master some of the techniques.

In almost every case, your finished drawings should be saved in EPS format, since only the PostScript language is able to make sense of vector information and is capable of converting it for print. A few applications, notably Photoshop Freeway, FreeHand, and After Effects, can read Illustrator files directly, in some cases making better use of that format.

As with bitmap programs, the major vectorbased applications have many features for preparing artwork for further dedicated animation and Web authoring software. Above and right: Illustrator Lawrence Zeegen uses FreeHand to assemble and manipulate a combination of bitmap and drawn images. When displayed in "artwork" form it is easy to see the entire structure and layout of object-oriented components.

Design by Lawrence Zeegen, UK

chapter 03. image 213

GLOSSARY

animation The process of creating a moving image by rapidly moving from one still image to the next.

laborious process of drawing or painting each frame, animations are now created with specialist software (qv) that renders sequences in a variety of formats.

antialiasing The strategic insertion of pixels (qv) of various shades around parts of the letterform to create an illusion of relative stroke bulk and smoothness. Used by default in certain programs, for example Adobe products.

Apple Macintosh The brand name of Apple Computer's range of PCs (qv). The Macintosh (or "Mac") was the first personal computer to make use of the graphical user interface that had been pioneered by Xerox at the Palo Alto Research Center. The use of this interface provided the platform for the software (qv) applications that gave rise to desktop publishing, revolutionizing graphic design.

authoring tool Software (qv) for creating interactive presentations or Web sites. Such programs typically include text, drawing, painting, animation (qv), and audio features. These are combined with a scripting language that is used to determine how each element of the page or screen behaves—for example, it may be used to ensure that a movie is played when a certain button (qv) is pressed. bandwidth The measure of the speed at which information is passed between two points (for example, between two modems [av] or from memory to disk). The broader the bandwidth, the faster the data flow. Bandwidth is usually measured in cycles per second (hertz) or bits per second (bps). Bézier tools Vector-based (qv) drawing tools employed by many

drawing programs. A pen tool allows the user to place a series of points on the page; the points are then automatically joined by a line. The points may be moved or otherwise edited to create new shapes.

bitmap Strictly speaking, any text character or image that is composed of dots. A bitmap is a "map" of bits (qv) that correspond with the items-pixels (qv), for example—that are required to represent the image. "Bitmapped fonts" are composed of dots or pixels (as opposed to "outline fonts," which are composed of vectors (qv), and are often used to render PostScript (qv) Type I fonts onscreen (and thus are also known as "screen fonts"). To draw the character shapes accurately, the computer must have a bitmap installed for each character size; if this is not present, the character will take on a jagged appearance. TrueType (qv) fonts are outline fonts, and thus do not require bitmapped versions. The use of Adobe Type Manager also ensures that bitmapped fonts can be avoided. Similarly, bitmapped graphics are those that employ pixels rather than vectors, and these may also take on a jagged appearance when viewed at an enlarged size.

bit A contraction of "binary digit," the smallest unit of information that a computer can use. A bit may have one of two potential values: on or off, positive or negative, 1 or 0, something or nothing. Eight bits form a byte, the unit that is required to store an alphabet character.

bleed The margin outside the trimmed area of a sheet, which allows for tints, images, and other matter to print beyond the edge of the page. If sheets are printed without bleed, it is generally not

possible to print matter right up to the edge of the page.

body text The matter that forms the main text of a printed book, excluding captions (qv), headings (qv), page numbers, and so on.

brand guardian A person who is employed, usually by the client of a design or advertising agency, to ensure that the corporate brand identity of the client company is consistently presented.

broadband Telecommunications that employ a broad range of frequencies, enabling a faster rate of data flow.

browser An application that enables the user to view (or "browse") Web (qv) pages across the Internet (qv). The most widely used browsers are Netscape Navigator and Microsoft Internet Explorer. Version numbers are particularly important in the use of browsers, as they indicate the level of HTML (qv) that can be supported. button An interface control, usually in a dialog box, which is clicked by the user to designate, confirm, or cancel an action. Default buttons are usually emphasized by a heavy border and can be activated using the Return or Enter keys. CAD Acronym for "computer-aided

design." It may be used to refer to any design carried out using a computer, but is usually used for three-dimensional (qv) design, such as product design or architecture, in which software (qv) is used to control the entire process from concept to finished product.

caption Strictly speaking, a caption is a headline printed above an illustration, identifying the contents of the image. However, the word is now used to describe any descriptive text that accompanies illustrative matter.

CD-ROM Acronym for "compact disk, read-only memory." A CD

technology that was originally developed for the storage and distribution of digital data. Based on audio CD technology, CD-ROMs come in two formats: 74 minutes (650 megabytes of data) and 63 minutes (550 megabytes).

client-side image map An image map (qv) that holds everything to do with the map, including URL (qv)addresses, within HTML (qv) code. CMYK In four-color process (qv) printing, an abbreviation for cyan, magenta, yellow, and black (black being denoted by "K" for "key plate"). compression The technique of rearranging data so that it either occupies less space on disk, or transfers more quickly between devices or along communication lines. Different kinds of compression are used for different kinds of data: applications, for example, must not lose any data when compressed, whereas images and movies can tolerate a certain amount of data loss.

contrast The degree of difference between adjacent tones in an image (or computer monitor) from the lightest to the darkest. "High contrast" describes an image with light highlights and dark shadows but few shades in between, whereas a "low contrast" image is one with even tones and few dark areas or light highlights.

corporate identity A design or set of designs for use on corporate stationery, livery, etc.

CSS Abbreviation for "cascading style sheets." These allow the Web (qv) designer to exercise control over typography and layout in much the same way as an ordinary pagelayout program, enabling him or her to apply preset formats (qv) to paragraphs, individual page elements, or entire pages. Several style sheets can be applied to a single page, hence "cascading."

hardware device or software (qv)program that are determined at the time of manufacture. These settings remain in effect until the user changes them; such changes will be stored in a "preferences" file. Default settings are otherwise known as "factory" settings. display type Text that employs large-size fonts (qv)—usually 14pt or more—for headings (qv), or any matter that is intended to stand out or be highlighted on the page. Director Macromedia's CD-ROM (qv) authoring software (qv). download The transfer of data from a remote computer—such as an Internet (qv) server—to a PC (qv). dpi Abbreviation for "dots per inch." A unit of measurement used to represent the resolution (qv) of devices such as printers and image setters. The closer the dots (i.e., the higher the value), the better the quality. Typical values include 300dpi for a LaserWriter printer, and 2450dpi+ for an image setter. Dots per inch is sometimes erroneously used as a value when discussing monitors or images; the correct unit in these cases is ppi (pixels (qv) per inch).

default settings The settings of a

DVD Abbreviation for "digital versatile disk." A storage disk similar to a CD-ROM (qv), but distinguished by its greater capacity (up to 17.08 gigabytes).

embedded fonts Fonts [qv] that are fixed within files, meaning that the original font folder does not need to be provided in order for the file to be printed or set.

embossing Relief printing or stamping in which dies are used to impress a design into the surface or paper, leather, or cloth so that the letters or images are raised above the surface of the paper.

EPS Abbreviation for "encapsulated PostScript." A graphics file format

used primarily for storing objectoriented or vector (qv) graphics. An EPS file consists of two parts: PostScript (qv) code, which tells the printer how to print the image; and an onscreen preview, usually in JPEG (qv), TIFF (qv), or PICT format. film The material that provides the template for printing plates. A cellulose, acetate-based material, coated with light-sensitive emulsion so that images and text can be recorded photographically. finishing As the name implies, the final part of the print production process. It encompasses various processes, including collating, trimming, folding, binding, embossing (qv), laminating (qv), varnishing (qv), and so on. Fireworks A Web-specific graphics production tool by Macromedia. Flash Macromedia software (qv) for producing vector (qv) graphics and animations for Web (qv) presentations. Flash generates small files that are quick to download (av) and, being vectorbased, the graphics may be scaled to any dimension without an increase in file size.

font A complete set of type characters of the same size, style, and design.

format The size or orientation of a book or page.

four-color process Any printing process that reproduces full-color images that have been separated into three basic "process" colors—cyan, magenta, and yellow—with a fourth color, black, added for greater density. See also CMYK.
frames (1) Decorative designs or

frames (1) Decorative designs or rules surrounding items of matter on a page.

frames (2) On the Web (qv), a means of displaying more than one page at a time within the same window: the window is divided into separate areas, known as frames,

each one displaying a different page.

FreeHand Vector-based (qv) drawing software by Macromedia. **Freeway** A website layout program produced by SoftPress.

GIF Acronym for "graphic interchange format." A bitmapped (qv) graphics file format that compresses (qv) data without losing any, as opposed to JPEGs (qv), which tend to lose data.

gobos Small metal or glass disks with designs printed onto them or cut into them.

GoLive A website layout program produced by Adobe.

graphic A general term that is used to describe any illustration or drawn design. May also be used for a type design based on drawn letters. grid A template [qv]—usually showing such things as column widths, picture areas, and trim sizes—used to design publications with multiple pages, to ensure that the basic design remains consistent. hairline rule The thinnest line that is possible to print. It usually has a width of 0.25pt.

halftone (1) The technique of reproducing a continuous-tone image on a printing press by breaking it up into a pattern of equally spaced dots of varying sizes. The dot size determines tones and shades: the larger the dot, the darker the shade.

halftone (2) An image reproduced using the halftone process.

heading A title that appears at the top of a chapter, or at the beginning of a subdivision within the text.

hierarchy of information The technique of arranging information in a graded order, which establishes priorities and helps users to find what they want.

hinting In typography, information contained within outline fonts (qv) that modifies character shapes to

enhance them when they are displayed or printed at low resolutions (*qv*).

HSB Abbreviation for "hue, saturation, and brightness."

HTML Abbreviation for "hypertext mark-up language." A text-based page-description language used to format documents published on the Web [qv] and viewed on Web browsers.

hue Pure spectral color that distinguishes a color from other colors. For example, red is a different hue from blue. Light red and dark red may contain varying amounts of white and black, but they are the same hue.

hyperlink A contraction of "hypertext link," a link to other documents that is embedded within the original document. It may be underlined or highlighted in a different color. Clicking on a hyperlink will take the user to another document or website.

Illustrator Vector-based (qv) drawing software by Adobe.

image map An image that contains

embedded links to other documents or websites. These links are activated when the appropriate area of the image is clicked on.

ImageReady Software (qv) for the production of Web-ready images, produced by Adobe.

imposition The arrangement of pages in the sequence and position in which they will appear on the printed sheet, with appropriate margins for folding and trimming, before platemaking and printing.

InDesign Desktop publishing software (qv) produced by Adobe. inkjet printer A printing device that creates an image by spraying tiny jets of ink on to the paper surface at high speed.

ink A fluid comprising solvents and oils in which is suspended a finely ground pigment of plant dyes,

GLOSSARY

minerals or synthetic dyes, which provide color. There are many different types of ink for the various

Internet The entire collection of connected worldwide networks, including those used solely for the Web (qv).

Internet Explorer Web browsing software *lqvJ* from Microsoft. intranet A network of computers similar to the Internet *lqvJ*, but to which the general public does not have access. Mainly used by large corporations or governmental institutions

ISDN Abbreviation for "integrated services digital network." A telecommunications technology that transmits data on special digital lines rather than on old-fashioned analog lines, and is thus much faster.

ISP Abbreviation for "Internet (qv) service provider." Any organization that provides access to the Internet. Most ISPs also provide other services, such as email addresses. JavaScript Netscape's Java-like scripting language, which provides a simplified method of adding dynamic effects to Web (av) pages. JPEG Abbreviation for "Joint Photographic Experts Group." This International Standards Organization group defines compression standards for bitmapped (qv) color images, and it has given its name to a popular compressed (qv) file format. JPEG files are "lossy" (i.e., they lose data during compression), but they are suitable for graduated-tone images. kerning The adjustment of the space between adjacent type characters to optimize their appearance. Kerning should not be confused with tracking (qv), which involves the adjustment of space over a number of

lamination The application of transparent or colored, shiny, plastic films to printed matter to protect or enhance it.

layers In some applications, a level to which the user can consign an element of the design being worked on. Individual layers can be active (meaning that they can be worked on) or non-active.

layout The placement of various elements—text, headings (qv), images—on a printed page.

leading The spacing between lines of type.

Lingo A powerful scripting language contained within Macromedia's Director (qv) software (qv).

Mac OS The operating system used on Apple's "Macintosh" computers. master page In some applications, a template (qv) that includes attributes that will be common to all pages, such as the number of text columns, page numbers, and so on. Media Player The most widely used multimedia player application. Part of the Microsoft Windows suite.

modem Contraction of "modulator-demodulator." A device that converts digital data to analogue for transfer from one computer to another via standard telephone lines.

mounting The process of sticking artwork on to a thick piece of board, usually for display or presentation purposes.

MP3 Abbreviation for "MPEG audio layer 3." A compressed (qv) audio file format.

offset lithography A common bulk printing method involving the use of photographic plates.

PageMaker Vector-based (qv) page make-up software from Adobe.

PANTONE The proprietary trademark for Pantone's system of color standards, control, and quality requirements, in which each color

bears a description of its formulation (in percentages) for subsequent printing.

PC Abbreviation for "personal computer." The term is generally used to denote any computer that is IBM-compatible and runs the Windows (qv) operating system (as opposed to the Mac OS (qv), for example).

PDF Abbreviation for "portable document format." A cross-platform format that allows complex, multifeatured documents to be created, retaining all text and picture formatting, then viewed and printed on any computer with an appropriate "reader," particularly Adobe Acrobat Reader.

Photoshop Powerful, industrystandard image manipulation software from Adobe.

pictogram A simplified, pictorial symbol distilled to its salient features to represent an object or concept.

pixel Contraction of "picture element." The smallest component of a digitally generated image, such as a single dot of light on a computer monitor. In its most simple form, one pixel corresponds to a single bit [qv]: 0 = off, or white; 1 = on, or black. In color and grayscale images (or monitors), one pixel may correspond to several bits: an 8-bit pixel, for example, can be displayed in any of 256 colors (the total number of different configurations that can be achieved by eight 0s and 1s).

plug-in Software (qv), usually developed by a third party, that extends the capabilities of a program. Plug-ins are common in image editing and page layout software for such things as special effects filters. They are also common in Web (qv) browsers for playing such things as movies and audio files.

PNG Abbreviation for "portable network graphics." A file format for images used on the Web (qv) that provides 10 to 30 percent "lossless" compression (qv) (meaning that no data is lost, as opposed to JPEG (qv) files).

point The basic unit of Anglo-American type measurement: each inch is divided into 72 parts, and each part represents one point. PostScript Adobe's proprietary page description language for image output to laser printers and high-resolution (qv) image setters. pre-press Any or all of the reproduction processes that occur between design and printing, especially color separation. proof A prototype of a job, taken at various stages from laser printers, image setters, inked plates, screens, and so on, in order to check the progress, quality, and accuracy of the work.

QuarkWrapture Powerful graphic packaging application from Quark. **QuarkXPress** Industry standard page layout program.

QuickTime Apple Computer's software (qv) program and system extension, which enables computers running either Windows (qv) or the Mac OS (qv) to play digital movies and audio files, particularly over the Internet (qv) and in multimedia applications.

rasterization The method of displaying and creating images that is employed by computer monitors (and video screens). The screen image is made up from a pattern of several hundred parallel lines created by an electron beam that "rakes" the screen from top to bottom in about one-sixtieth of a second. An image is created by the varying intensity of the beam's brightness at different points. The speed at which the image or frame is created is the "refresh" rate.

adjacent characters.

Real Audio An audio-file player from Real Networks. Highly compressed (qv) for optimum playback performance.

reprographic Individual or short-

run or copying printing, typically

using photocopiers rather than commerical printing presses. resolution The degree of quality, definition, or clarity with which an image is scanned (qv) or displayed. The concept is used in connection with photographs, monitors, printers, and other output devices. RGB Abbreviation for "red, green, blue." The primary colors of the "additive" color model, used in video technology, and therefore in color monitors. Employed for Web (qv) and multimedia products that will not be printed using the traditional CMYK (qv) model.

traditional CMYK (qv) model.

RIP Acronym for "raster image process." The conversion of data that has been generated in a page-description language, such as PostScript (qv) (in other words, a page that has been put together by a designer), into a form that can be output by a high-resolution (qv) image setter for use in commercial printing.

rollover The rapid substitution of one or more images when a mouse pointer is rolled over the original image. Used for navigation buttons on Web (qv) pages.

rule A printed line.

sans serif The generic name for type designs that lack the small extensions or serifs (qv) at the ends of the main strokes of the letters. Sometimes called "lineal type." saturation The variation in color of the same tonal brightness from none (gray) through pastel shades (low saturation) to pure color with no gray (high or "full" saturation). scamp A preliminary drawing showing a proposed design. scan, scanner A scanner is an

electronic device that uses a sequentially moving light beam to convert artworks or photographs into digital forms (scans), so that they can be manipulated by a computer or be output to separated film. Some scanners are simple, flatbed, desktop models that are generally used for the positioning of pictures; others scanners are sophisticated devices ("drum scanners") that are used for high-quality reproductions.

serif The short counterstroke or finishing stroke at the end of the main stroke of a type character.

ShockWave A Macromedia technology used for making Director (qv) presentations that can be delivered across the Web (qv) and viewed with a browser (qv).

silkscreen printing 'A traditional method of printing in which ink (qv) is forced through a stencil fixed to a screen made of silk. Modern printers more commonly use a screen made of synthetic material ("screen printing").

software Specially written pieces of data, also called "programs," that make it possible for computers and computer-based machines ("hardware") to perform their tasks. spot colors A printing color that has been specifically mixed for the job, as opposed to the four-color process (qv) colors.

strapline A sub-heading that appears above the heading (qv) in a piece of text. Straplines are used to give extra information about the subject matter of text pieces.

streaming A method of

transmitting audio or video files, allowing them to be played continuously.

tagging Mark-up language formatting commands. A tag is switched on by placing a command inside angle brackets (<command>), and turned off by typing the same command again, with a forward slash before it (</command>).

template A document created with pre-positioned text and images, used as a basis for repeatedly creating other documents that follow the same format and style.

three-dimensional The effect of creating an illusion of depth on a page or monitor.

TIFF Acronym for "tagged image file format." A standard and popular graphics file format originally developed by Aldus (now merged with Adobe) and Microsoft. TIFFs are used for scanned (qv), highresolution (qv), bitmapped (qv) images, and for color separations. They can be used to transmit blackand-white, grayscale, or color images that have been generated on all the most popular platforms. touch screen A computer screen that responds to touch, sidestepping the need for a computer mouse. Large touch screens respond to finger touches, while small versions are usually navigated using a round-nibbed plastic pen ("stylus").

tracking The adjustment of space between characters in a selected piece of space. See also kerning. traffic In an advertising context, elements of client business that an agency is handling.

trapping The slight overlap of two colors to eliminate gaps that may occur between them during the normal fluctuations of registration during printing.

TrueType Apple Computer's digital font (qv) technology, developed as an alternative to PostScript (qv) and now used by both Apple and Microsoft for their respective operating systems. A single TrueType file is used for both printing and screen rendering, while PostScript fonts require two separate files for these functions.

type Originally used to refer to an individual text character cast in metal, but now used to refer to any letter, numeral, or ornament belonging to a typeface or font (qv). typography The art of type (qv) design and its arrangement on a designed page.

URL Acronym for "uniform resource locator." The unique address of any page on the Web (qv). A URL is usually composed of three elements: the protocol (such as "http"), the domain name, and the directory name.

varnish A liquid that dries to form a hard surface, which does not dissolve in water. Varnish is used in the manufacture of printing inks (qv) and as a surface protector for printed matter, especially covers. vector A miniature database that stores information about the magnitude and direction of a line or shape. Sometimes used to refer to the lines themselves.

Windows The PC (qv) operating system devised by Microsoft.
Windows uses a graphical user interface that is similar to the Mac OS (qv). In some circumstances
Windows can be run on a Macintosh (qv) computer, but the Mac OS cannot run on a PC that is designed to run Windows.

Web Also known as "World Wide Web" (WWW). The entire population of Web servers that are connected to the Internet (qv). The term is also used to describe a particular kind of Internet access architecture that uses a combination of HTML (qv) and various graphic formats such as JPEG (qv) to publish formatted text and pictures that can be read by Web browsers (qv).

INDEX

access groups 120 acetate windows 102 Acrobat PDF format 66 add-ons 52 additive color 190 addresses 158 Adobe 187 After Effects 172 GoLive 136, 153 Illustrator 95, 124, 202 InDesign 71, 202 LiveMotion 136 PageMaker 62, 202 PDF 172 Photoshop 95, 179, 198 PostScript 183 Premier 136 Streamline 202 Type Manager 185 Type Reunion 185 ADSL 69 advertising 14-15, 39, 49, 50, 84-97 After Effects 172, 213 Agfa Monotype 41 Aladdin 69 Alias/Wavefront Maya 179 alpha channels 210–11 ambient advertising 85, 92 animation 131, 136, 140, 154 games 179 multimedia 166-8, 171, 175 Animo 172 antialiasing 187, 209 Apple Final Cut Pro 168 iMovie 136 Macintoshes 175, 195 QuickTime 172 Apple Macintoshes 60, 62, 86-7 advertising 95 Internet 136, 143-4, 148, 162 resolution 206 Applets 158 APR (automatic picture replacement) 69 architects 120 area 30-1

Arial 149

art directors 86

Art Nouveau 9

brand guardians 86, 92

130, 196

briefs 43-4, 52, 87, 94, 109,

branding 84, 86, 90, 92-3, 98, 106

brightness 54, 56, 117, 195, 210
broadband cable connections 146
brochures 60
browsers 140-1, 143, 145, 148-9,
152, 154, 158, 161
bubble-jet 129
budgets 43, 80, 105, 120, 126, 129,
131, 171
bullet points 50
bureaux 66–7
business communications 60
buttons 154, 156–7
buzz stops 88
bytes 138
C - 2
CAD (computer-aided drawing)
62, 114
Cambridge Animation Systems
172
canvas 126
cap height 116
capital letters 46, 48
captions 65, 130
card packaging 105
cardboard 102, 103
case histories
advertising 96
exhibitions 132–3
Internet 164–5
multimedia 176–7
packaging 110-11
print 82
signage 122–3
catalogs 60
CD-ROMs 154, 166, 168,
171–2, 175
CDs 69, 140, 159
centered text 47
CGI scripting 162
character recognition 46
character style sheets 65
circle 29
client-side image maps 157, 158
clients 43-4, 51, 94, 109
exhibition 131
Internet 161-2
multimedia 171, 175
signage 119
CMYK (cyan, magenta,

yellow, black)

CMYK continued
color 188, 192–3
image creation 210, 212
Internet 148
print 68, 70, 72
Coca-Cola 106
code writers 138
coding 54, 116
Collect for Output facility 63–5
collections 65, 108
ColorSync 68
color 33, 41, 44, 50–2
attributes 188–95
balance 71
consistency 116
design 54–7
gels 129
halftones 66, 72
Internet 148–9
management 68
output devices 60
packaging 105, 106, 109
signage 116, 117
swatch books 68
technologies 63
wheel 54
columns 49, 62, 149
compatibility 66, 101, 168, 175
compression 45, 69, 87, 150-1, 154
159, 200
computer capabilities 161
conceptual artwork 178–9
consumer society 84, 106
contemporary typefaces 38
continuous text 46
continuous tone 199
contractors 131
contrast 32–5, 46, 210
control models 119
conventions 54
copyright 66, 186, 196
copywriters 86, 92
CorelDraw 101, 198
corporate identity 43, 49, 62, 84,
90–1, 120, 130
cotton 126
counter shapes 116
Courier 149
creasing equipment 105
creatives 86
Cromalin 71

index 219

INDEX

cropping 52 CSS (Cascading Style Sheets) 143, 149, 152

cube 29 curve handles 212 cutout 52 cutter guides 98, 101, 105 cutting equipment 105 cyan 68, 72, 148, 188, 190–3

D

decision-making 43-9, 120, 143 decorative frames 51 decorative typefaces 38-9 default systems 145, 148-9 delivery of work 69 Deneba Canvas 198 descenders 116 design community 171 diagonal layouts 49 die-stamping 78 digital files 45 digital printing 77, 115 dinabats 50 direct advertising 88-9, 92 directions 105 Director 154, 172, 175 Discreet 3D Studio Max 179 disharmonies 56 dismantling 127 display type 38, 41, 47, 57 disposition 33-4 distortion controls 101 DM (direct mail) 60,88 document signposting 50-1 doodling 43, 44 dot size 66 double hitting 68 double-page spreads 67 downloading 146, 154, 158-9, 161-2 dpi (dots per inch) 72, 187, 204 drawing 101, 198, 212 Dreamweaver 136, 149, 153, 156, 162 dry proofs 71 DTP (desktop publishing) 49, 51, 62-5

DTP (continued)
packaging 101
print 68–70
duotone 52
durability 127
dust jackets 79
DVD (Digital Versatile Disk) 69, 166, 168, 172, 175
DXF 114
dye-sublimation prints 71
dynamic white space 31
dynamics 32–5

F

e-commerce 138 162 educational exhibitions 126-7 elevations 131 email 45, 86, 95, 124, 138, 154 embedded files 154 embedded fonts 66, 70 embossing 78, 102 emphasis 32-5 encapsulation 115 Enfocus 70 environment 115, 117, 118 EPS (encapsulated PostScript) 69.105 exhibition 131 image creation 207, 213 Internet 153 signage 114 ESQ (Enhanced Screen Quality) 41.187 exhibitions 20-1, 39, 49, 54, 82, 124-33 expert sets 48 extended sets 48 extensions 65 eve-level 130 EyeCandy 211 eyesight 116

F

facilitators 86–7 fading 119 family of signs 118, 120 fast-loading pages 146, 158 fiber optics 138 file extensions 159 file formats 87, 150–1, 207 film 66, 70–1, 78, 129

Final Cut Pro 168 finishes 129 finishing 78, 126 Fireworks 136, 149-50, 153, 162 fixed-width fonts 149 fixing instructions 119 Flash 136, 140, 143, 146, 154, 159, 161.179 flashing text 158 flexographic printing 105 floorplan journey routes 119 fluid design 143 flush left 47 flush right 47 flvers 60 flyposting 119 Focoltone 63 focus groups 120 folding 78-9, 102 folds 98 fonts 44, 48, 65-6 image creation 200 Internet 140, 149, 168 multimedia 168 type 182-7 Form Z 124 formats 31, 49, 52, 69 formatting controls 149 four-color process 68, 74, 192 FPO (for position only) 65 frame rates 159 frames 50-1, 62, 143 FreeHand 63, 92, 124, 136 advertising 94 image creation 202, 212-13 Internet 149, 153-4 packaging 101 signage 114, 116 Freeway 136, 153, 156, 213 FrontPage 136 frosted film 129 FTP 87

filters 211, 212

G

G4 computers 168
galleries 126
games 24–5, 154, 172, 178–9
gamma 195
Garamond 36
gauze 126

GCR (gray component replacement) 72 gels 129 GIF (Graphics Interchange Format) 146, 148, 150, 153, 207 glass 102, 115 aluepoints 98, 105 glyphic typefaces 38 gobos 129 GoLive 136, 153, 162 graphics 126, 131, 146 Internet 150-1, 154 multimedia 166, 168, 171-2, 175 gravure 76 gray 194 green 54, 72, 148, 150, 188, 190, 194-5.210.212 grids 49, 65 auidelines 43 guillotine register 66

hairlines 69, 105 halftones 60, 66, 69, 71-2, 74, 101. 204, 206 handover documentation 119 hazardous products 105 headings 65, 149 headlines 32, 140, 149 height 48, 130 Helvetica 149 Hexachrome 72 hierarchy of information 50, 121 high compression 150 high resolution 65, 69, 129, 199, 204-6 hinting 185, 187 hooks 94 horizontal grids 49 horizontal spacing 41 hot spots 157 HSB 56, 117, 194-5, 212 HTML (Hyper Text Mark-up Language) 138, 140 Internet 143, 145-6, 148-9, 152, 157-8.162 multimedia 172 hue 54, 56, 117, 194 hyperlinks 152, 154, 156 hypermedia 166 hyphenation 47, 62, 65

Internet 153, 162

multimedia 175

M mounting 126, 131 justification 47, 62 movies 136, 154, 158, 161, 166 MacOS 149, 195 iCab 141 K Macromedia MP3 154, 158, 159 illumination 119 MPEG (Moving Picture Experts Kai's Power Tools 211 Director 154, 172 illustrations 106, 131 Dreamweaver 136, 153 Group) 159 kerning 41, 47, 62, 116, 140, 185 Illustrator 63, 92, 94, 136 multimedia 24-5, 39, 49, 69 Fireworks 136 key knowledge 104-5 image creation 202, 212-13 advertising 84 Flash 136, 154 Internet 149, 154 keywords 152 design 166-77 FreeHand 95, 202 kilobits 146 packaging 101 exhibitions 129, 131 kilobytes 146 Shockwave 167 sigmage 114, 116 Madison Avenue 86 image creation 206 knock out 66 illustrators 52, 131, 197 multinational companies 84 magazines 60 image creation 44-5, 52-3, 63, L magenta 72, 148, 188, 191-3 multipage surface design 49 156-7.196-213 lamination 102, 115 maintenance 119, 126 Multiple Masters 38, 184 ImageReady 150, 153 landscape 143 manuals 43, 70, 130 museums 126, 168 imagery 106 music 159, 167, 172 languages 116, 127 maguettes 44 iMovie 136 laptops 144 margins 49, 51 implementation 119 imposition 67, 69 laser prints 71 marketers 92 marketing information 70 navigation 50, 138, 154, 161-2, 171 InDesign 62, 202 laser-cut type 129 margues 91, 93, 158 Navigator 141 indexing tools 152 late binding 69 masks 210-11 NetObject Fusion 136 layers 62, 101, 210, 212 Industrial Light and Magic 172 Netscape Navigator 141 master pages 49, 65 layout 45, 49, 60, 65, 98, 106 information kiosks 166 newsletters 60 master tags 152 information requirements 108, 121 leading 41, 62, 140 newspapers 60 leaflets 60 Matchprint 71 ingredients 108 materials 102-3, 126 no frames 143 injection molding 102 leather 115 Media 100 172 non-Flash 143 legibility 46-7 inkjet 71, 87, 115, 129 inks 68, 115, 129, 188, 190, 192-3 non-linear systems 138, 162, 171 lenticular panels 129 media advertising 88, 89 Media Player 159, 172 non-lining numerals 48 letterheads 43 installation 127, 131 letterpress 76 medial letters 48 note-making 43 integrated advertising 85 lid mechanisms 98 menus 60 numerals 48 interactivity 127, 129 metal 102, 105, 115 Internet 138, 154, 156-7 lighting 41, 46, 54, 116, 119, 0 multimedia 166 129-30 metrics 185 object-oriented drawing Microsoft 158 Internet 22-3, 44, 87, 136-65, 168, line 30-1, 47, 69, 206 FrontPage 136 programs 101 175, 196 linear navigation 162 Internet Explorer 141, 158 offset lithography 67, 74, 80, Lingo 154, 172, 175 Internet Explorer 141, 145 105, 206 Verdana 149 Intranet 138, 168 lining numerals 48 Windows 187 old style numerals 48 liquid design 143 introduction text 65 onomatopeia 39 milling machinery 114 ISDN 69, 87, 124 lithography 74 mock-ups 44, 92, 94, 99, 136 Opera 141 ISP (Internet Service Provider) live links 172 exhibition 130 OPI (Open Press Interface) 65 138.154 live space 145 Internet 138, 153, 162 opposites 34 LiveMotion 136 italics 41,66 overprinting 66 lockable layers 101 packaging 102, 109 iTV 166 ozalid 71 locking text 65 signage 114 J logos 43, 98, 106, 130, 146, 150, 154 modeling programs 44-5 P modems 60, 146 lossless compression 151 Java 158-9 modular systems 126 package 54 low compression 150 Java Applets 158 monitors 56, 68, 129, 143-5, 148, packaging 16-17, 39, 43, 98-111 Java Virtual Machine 158 low resolution 65, 69, 150, 199, 204-6 150.187 packing 127 JavaScript 152, 156, 158-9 mono 159 page plans 67 lowercase 46, 48 Taz 69 lpi (lines per inch) 72, 204 mood 54 page structure 49 journey routes 120 PageMaker 124, 202 morphing 212 IPEG (Toint Photographic Experts luminosity 211 Group) 69, 146, 150-1, 153, 200, 207 LZW 200 motorway signs 118 pagination 67

INDEX

Painter 198

painting 198, 209-11

PaintShop Pro 150 panel spacing 130 panel systems 126 PANTONE 63, 68, 129, 148, 193, 212 paper 43-4, 60, 67, 74 exhibition 126 Internet 161 packaging 102 print 80 paragraph style sheets 65 PCs 60, 62, 143-4, 162, 175 PDF (Portable Document format) 45, 66, 69-70, 109, 172 perfect binding 79 permanent exhibitions 126 perspective 57 PET (polyethylene terephtalate) 102 photographers 52, 131, 197 photography 106, 131 Photoshop 63, 69, 87, 92, 136 advertising 94-5 exhibition 124, 129 games 179 image creation 198, 202, 209-11,213 Internet 149-50, 153, 162 multimedia 172 packaging 108 signage 114 pica 37 PICT 207 pictograms 116, 121 picture boxes 65 picture researchers 131 pie charts 54 pigments 190-1, 193 PitStop 70 pixelation 200 pixels 144-5, 150-1 color 188 image creation 198-9, 202, 209, 211 Internet 159 type 187 planning

planning (continued) Internet 162-3 multimedia 175 packaging 109 signage 120-1 plastic 115 plastic laminate systems 71 platemaking 67 platform compatibility 101 plug-ins advertising 95 Internet 140, 143, 149, 154, 159 print 65 PNG (Portable Network Graphics) 148, 150-1 point 30-1, 37, 144 point-of-sale promotion 88 pop-up windows 158 portable panel systems 126 portfolios 95 portrait 143 position-and-crop files 69 positioning 118-19 posters 60 PostScript 66, 69, 71, 183-4, 185 ppi (pixels per inch) 204 PreFlight Pro 65 Premier 136, 172 prepress 66, 70-1 presentation methods 52 press advertising 88 primary shapes 29 print 12-13, 39, 60-83, 143, 204-6 printing process 45, 60, 72-7 pro-sumers 168 processing power 168 product placement 92 production advertising 94 design process 43 exhibition 131 Internet 162-3 multimedia 175 packaging 109 print 60 signage 120-1 productivity functions 65 progressives 71

proportional sans-serif 149 proportional serif 149 prototypes 120-1 public buildings 121 publishing industry 60 purples 54 purpose-built exhibitions 126 PVC 126 pyramid 29 Q QuarkWrapture 98, 108 QuarkXPress 62, 66, 71, 136 exhibition 124 image creation 202 Internet 153 signage 114 questionnaire 43-4 QuickTime 108, 136, 140, 158-9, 172, 175 R raised type 129 **RAM 168** rasterization 202, 212 readability 46-7 real time playing 168 RealAudio 158, 159 RealPlayer 140 recycled cardboard 102 red 54, 72, 148, 150, 188, 190, 194-5, 210, 212 reflected color 188, 190-1 reflective materials 119 reports 60 reprographics 43, 66, 69-70 research 120 resolution 52, 199, 204-6 RGB (red, green, blue) 70, 72, 148, 150, 188, 212 RIP (Raster Image Processors) 66, 69-71,201 rollers 158 rollovers 154, 156-7, 158 roman 41 rules 50-1, 69

slate 115

satellites 138 saturation 54, 56, 117, 194, 210 scaleability 101 scaling 52, 62 scamps 91, 94 scanners 46, 60, 66, 199, 204-6 scatter proofs 71 screen to proof 66-70 screenprinting 77 screens 41, 66, 129, 144, 206 script typefaces 38 sealing 126, 129, 131 search engines 152 secondary file formats 70 secondary levels 52 section size 67 self-adhesive film 129 sell-by dates 108 serif 38, 39, 41, 116, 149, 187 server-side image maps 157 shell schemes 126 shiner colors 68 Shockwave 146, 154, 167, 172 short cuts 65 side bars 145 sign families 118, 120 signage 18-19, 39, 43, 54, 112-23 signatures 93 silkscreen printing 115, 129 SimpleText 152 site maps 161 site visits 120, 131 size 32, 47, 49-51, 80 exhibition 130 Internet 146 multimedia 168 signage 116 slow downloading 158 SLP (self-liquidating promotions) 88 small capitals 48 snagging 119 snap-to guides 62 soft proofs 70 Softimage 172 SoftPress Freeway 136 software 43-5, 56, 68 advertising 95 authoring tools 153-5 exhibitions 124 image creation 209-13

advertising 94

exhibition 131

design process 43-8

projectors 172

proofs 70, 71

promotions 60, 108

S

saddle-stitching 79

sans serif 38, 39, 149

safety 105, 108

wheelchairs 116, 118 television 85, 88, 166, 168 Type Manager 185 software (continued) templates 49, 98, 101, 105, 109 Type Reunion 185 white space 50, 51 Internet 136, 140 typography 51, 98, 106, 131, whites 54 tender submissions 121 multimedia 172, 175 148-9.182-7 Windows 62, 144, 148-9 terminal letters 48 packaging 108 color management 195 tertiary levels 52 print 60, 62-5 H image creation 206 prototypes 87 test assemblies 99 sound 136, 146, 154 testing 162, 175 underlining 51 Internet 162 Internet 158-9 text 46-7, 57, 62, 146 uniforms 43 Media Player 159, 172 multimedia 175 multimedia 166-8, 171-2, 175 TextEdit 152 Univers 41 uppercase 46 spacers 129 texture 51,98 type 187 URL 140, 156, 157 XP operating system 158 spacing 41, 46-7, 116, 130, 185 thermal-transfer prints 71 wobblies 88 special-access groups 116 three-dimensional (3D) components user requirements 121 specialists 86-7, 106, 115, 171 wood 115 ٧ word recognition 46 three-dimensional (3D) modeling specialized components 131 work-and-turn 67 101, 108, 114, 172 vandal proofing 119 specials 63 variables 144-5 three-dimensional (3D) site speech 159 varnishes 78, 102 woven fabric 115 sphere 29 maps 162 vector-based programs 63, 69 spi (samples per inch) 204 TIFF (Tagged Image File Format) 69. 131. 153. 207 advertising 92 You Get) 153-4 spot colors 63, 68, 72 Times 36, 149 exhibition 124 sprites 172 X Times New Roman 149 image creation 198, 202, 212-13 square 29 timetabling 43, 94, 161 Internet 154 X-height 116 squared-up 52 stapling 79 tints 68 type 183 XML code 143 stationery 60, 90 titles 130 vehicle livery 43 Verdana 149 stereo 175 Toblerone 106 vellow 72, 148, 188, 191-3 stickers 105 tonal range 159 vertical spacing 41 tone 57, 195 video 131, 140, 144 stone 115 Z touch screens 129, 166, 168, 172 Internet 146, 158-9 storyboards 88 multimedia 166-8, 171-2, Zip 69 straplines 50, 88 touring manuals 127 streaming technologies 158-9 tracking 41, 46, 62 175.178 trade shows 126 Video for Windows 159 Streamline 202 Stuffit 69 traffic 86, 94 viewing ergonomics 130 training manuals 60 vignetting 115 style sheets 65 sub-contracting 162, 175 transmissive light 148 vinyl 114, 126, 129 sub-headings 65 transmitted color 188, 190 Viola, Bill 166-7 subtractive color 191 transparencies 129 visitor flow 130 Suitcase 185 transparent stickers 105 W suits 86 trapping 66, 69, 70 Sun Microsystems 158 traveling exhibitions 127 WAP mobile phones 166 suppliers 45 triangle 29 warnings 105, 108 Web pages 10, 39, 57, 63, 136-65 surfing 140 TrueType 184, 185 swash character 48 two-dimensional (2D) artwork 179 web press 74 type 36-41, 44-6, 48 Web-safe palettes 148 T design basics 51, 56-7 websites 43-4, 50, 136-65 tables 149 exhibition 129 image creation 206, 213 packaging 99 multimedia 168, 175 tabs 145 weight 32-3, 46-51, 57 print 60 tagging 119, 152 exhibition 127 tamper-proof devices 105 range 182-7 signage 116 print 66, 80 technical data 108 type 187 technical drawings 70, 119 Type I fonts 183-5 Wham!Net 69 vectors 212-13 technical support 138

World Wide Web 44, 49, 138, 140 WYSIWYG (What You See Is What

PICTURE ACKNOWLEDGEMENTS

Abbreviations: t top; l left; r right; b bottom; c center; m middle

p2-3 Aston Leach / MacUser

Magazine; p12 Studio Myerscough; p13 t Phil Bicker / DPICT magazine, b Cahan & Associates; p14 t AMV BBDO Ltd, photography by Paul Zak, art director: Dave Dye, copywriter: Sean Doyle, account director: Oliver Forder, client: Hugh McCahey, b M&C Saatchi, creatives: Tiger Savage and Mark Goodwin, photography by Christopher Griffin; p15 t Bartle Bogle Hegarty, London br design by Wieden and Kennedy / graphics by VgL, br Peter Stimpson / courtesy of MCV; p16 t Area, br Summa, br Cahan & Associates; p17 t Simon & Lars, b Veuve Clicquot; p18 t Sussman/Prejza & Company Inc., b Ruedi Baur & Associates; p19 tr commissioned by Edogawa Ward, design unknown, m Sussman/Prejza & Company Inc., b Niklaus Troxler; p20 | Ralph Applebaum Associates Inc., r Design by IDEO; p21 top: Pentagram: partner/designer: Peter Harrison (graphics), partner/architect: James Biber, architect: Michael Zweck-Bronner, design by Christina Freyss, photography by Bill Jacobson and Peter Mauss, Esto, b Poulin & Morris: photography by Tim Wilkes, Tim Wilkes Photography; p22 br NB Studio, Courtesy of Knoll, tr Daniel Althausen, b Donna DiStefano; p23 t Memphis, b Imagination for Guinness PLC; p24 l Maddalene Beltrami and the Ospedale Maggiore di Milano, r InterStitch; p25 | RTKL, tr Blue Byte, br EA Sports; p28 Lance Wyman; p29 br Emery Vincent Design, tr: Carol

Naughton & Associates Inc., br Niklaus Troxler; p30 Produced by the Whitechapel Art Gallery to coincide with the exhibition Live In Your Head (Feb-Apr 2000), design by Jo Stockham and Herman Lelie, Concept and Edited by Alistair Raphael; p31 br Chermayeff & Geismar, tr Alan Fletcher, c Niklaus Troxler; p32 Barney Pickard; p33 t RTKL & Jonathan Spiers & Associates, b Tom Graboski Associates; p34 l Williams Murray Hamm, r Pentagram: design by John Rushworth, design assistants: Vince Frost and Nick Finney; p35 t Tenazas Design, br Niklaus Troxler, br Chronicle Books, USA; p38 l Adobe Systems; p39 Emery Vincent Design; p40 l Chermayeff & Geismar, br Adobe Systems, tr Swifty @ Swifty Typografix, cr Gensler, b Barney Pickard; p41 Regina Frank/SDA Creative; p42 Wink Design; p43 | Alan Fletcher, r Williams Murray Hamm; p44 br Bryn Jones, t Chronicle Books p45 t Cahan & Associates, b RTKL; p46 Lippa Pearce; p47 b Brian Coe; p48 b Mauk Design; p51 br Lance Wyman, tr Pippo Lionni; p52 t Agenda, b Cahan & Associates; p53 t Cahan & Associates, b Chronicle Books; p54 l Grey Worldwide, r Cahan & Associates; p55 t MetaDesign, br Alan Fletcher, br Cahan & Associates; p56 l Alan Fletcher, r graphic and interior design by Ashdown Wood Design for "Hang Out Laundry and Drycleaning," Sydney, Australia; p57 br The Partners, br Summa, r design by Holmes Wood at Tate Gallery, London; p60 l design by Harry Crumb for Durian Publications, r Teeranop Wangsillapakun, Segura

Inc., Chicago; p61 Why Not Associates, photography by Rocco Redondo and Photodisc, courtesy of Royal Academy of Arts; p75 Bill Douglas, The Bang, photography by Glenda Stuart and Bill Douglas; p77 Frederico d'Orazio, PlaatsMaken; p79 t Dom Raban, Eg.G, br Lippa Pearce Design, br Jon Raimes, Foundation Publishing; p81 t Pollard & Van der Water Golden, l SEA Design, r Epoxy, courtesy of Rolland Motif Paper; p83 Jon Raimes, Foundation Publishing; p84 Duckworth Finn Grubb Waters: p85 t McCann Erickson, b Rainey Kelly Campbell Roalfe; p86 Tribal DDB, Spain; p87 t Brook Street, b DDB; p88 Triangle Communications; p89 t Impact FCA!, b Duckworth Finn Grubb Waters: p90 r TBWA/Chiat/Day: p91 Craik Jones; p92 Tequila; p93 c KLP Euro RSCG, b Benetton; p95 BMP; p97 Duckworth Finn Grubb Waters; p98 Kenzo; p99 t Pentagram, b Paul Smith Ltd; p104 l SCA Packaging, r Fuji Seal Europe: p105 tr Lawson Mardon Packaging; p110-11: Richard Gooch, John Lewis Partnership; p112 Pentagram; P113 The Partners: p114 t North Design, b Atelier Works; p115 t MetaDesign, br Pentagram, br CDT Design; p117 br Pentagram, tr Royal National Institute for the Blind, b architects: Allford Hall Monaghan Morris, design by Atelier Works; p 118 t Atelier, b photography by Todd Gipstein, Corbis; p 119 CDT Design; p 121 Atelier; p122-23: CDT Design; p124 design by Euroculture, courtesy Jean Michel Folon, Sabam 2001, photography by Thiery Renauld; p125 br Guggenheim Museum, tr

Event Communications, b Event Communications: p 126 Perks Willis Design; p127 t Philip Miles Graphic Design, b Perks Willis Design; p128 t Land Design Studios and The Chase, bl & br design by DEGW, courtesy of the Trustees of the Imperial War Museum. photography by Philip Vile; p129–31 Exhibition Plus and Perks Willis Design; p132-33 Exhibition Plus and Perks Willis Design, courtesy of the Natural History Museum, London; p133 t illustration by Debbie Cook and Colin Mier; p136 Design by Ego Media; p137 r Yugo Nakamura, I Dennis Interactive; p138 Atlantic-Records.com; p139 tr Google.com, b Apple.com; p142 t Jakob Nielsen, b Typographic.com; p154 br & ct Powazek Productions, cb & br Biggles; p162 Nykris Digital Design, courtesy of the Tate Gallery; p163 t Nykris Digital Design, courtesy of the Tate Gallery, r Core Design; p164-165 Design by Headprecious Design; p166 Cognitive Applications; p167 Tomato Interactive; p169 InterStitch; p170 Tomato Interactive; p175 Phil Taylor and Phil Jackson; p177 Cognitive Applications; p188 photography by Bob Krist, Corbis; p189 Nicklaus Troxler; p197 Tom Hingston Studio, courtesy of MacUser Magazine; p200 photograph by Ed Seabourne p200 RTKL; p201 t Pamela Geismar, courtesy of Chronicle Books; p209 Lawrence Zeegen

Additional Photography by Rob Turner and Bob Gordon

Diagrams by bounford.com

Disclaimer All URLs (Internet addresses) in this book were correct at the time of publication. However, due to the changeable nature of the Internet some of these URLs are likely to expire or become the property of other organizations. The Publisher can take no responsibility for the contents of any Website featured in this book.